The Dog

5000 Years of the Dog in Art

D1340934

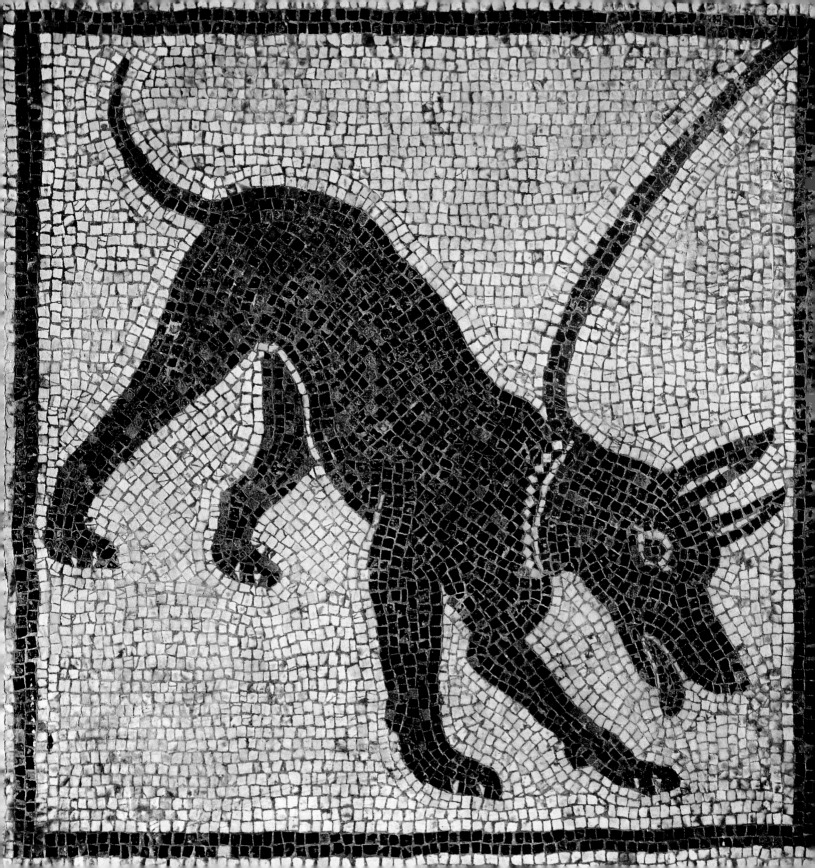

Tamsin Pickeral

The Dog

5000 Years of the Dog in Art

MERRELL
LONDON · NEW YORK

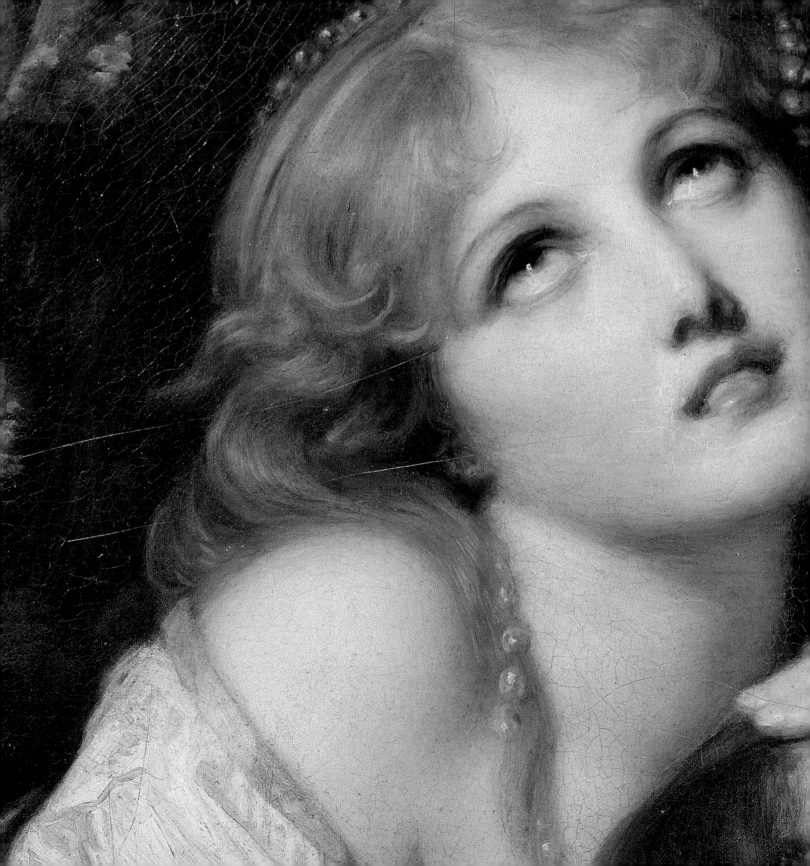

Introduction

> *'Strength without insolence,*
> *Courage without ferocity,*
> *And all the Virtues of Man*
> *without his Vices.'*
>
> FROM 'EPITAPH TO A DOG', LORD BYRON, 1808

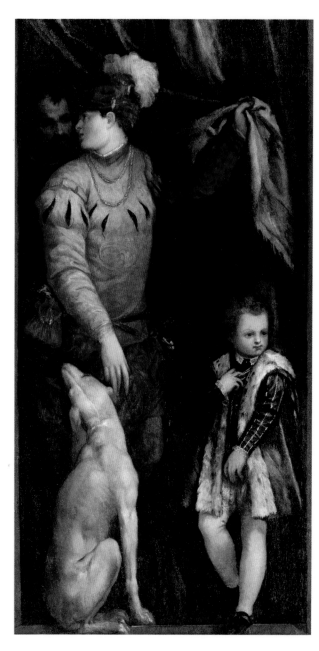

THE HISTORY OF THE DOG IN ART IS inextricably bound to the history of the dog itself, and the former can be understood only by looking at the broader picture, at the cycle of events that brought this creature so firmly into the realm of human culture. In many ways the emergence of the dog in art, from its first marginal depictions to its increasingly central role, particularly in paintings, mirrors the dog's creeping steps over the threshold of human society. Conversely, the prevalence of the dog's appearance in art through the ages has left a vivid account of its place, and role, in human history.

The dog, or rather its ancestors, is commonly credited as being the first animal to be domesticated – although that implies that man was the protagonist. Perhaps, instead, it was the dog itself that chose to initiate what would become the longest-enduring relationship between man and animal. It takes but a small effort of the imagination to see the dog's ancestors slinking ever nearer to the circle of warmth or the heap of discarded bones, hovering on the perimeters of the human forum, before finally entering it, and *allowing* themselves to become 'domesticated'. The emergence of the dog in art

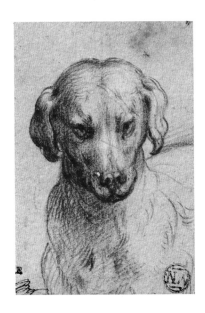

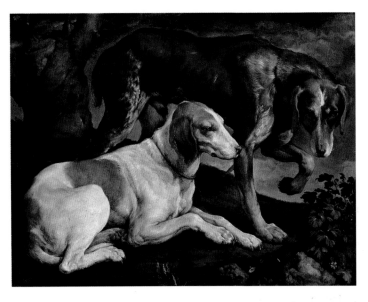

Jacopo Bassano
(c. 1510–1592)
Two Hunting Dogs Tied
to a Tree Stump
c. 1548–50
Oil on canvas
61 x 80 cm (24 x 31½ in.)
Paris, Musée du Louvre

might be said to have occurred along similar lines. The dog found its way into artistic representation in a slow but inexorable manner – just as it crept towards the prehistoric hearth, shadow-like and practically unobserved, so, too, it found its way into the visual arts. Its presence in Western art for hundreds of years could seem almost incidental: a common part of human life, it accompanies the hunter, the knight and the priest, crouches under the table at feasts and sits by the beds of women, as if it had just wandered into the canvas, as natural an inclusion as the scenery. These apparently random appearances, however, were governed by a certain specific symbolism attached to the dog, making its presence more than arbitrary or merely decorative. But it would not be until the fifteenth and sixteenth centuries that artists began, slowly, to elevate the dog to centre stage and make it the primary subject,

with compellingly realistic images of actual dogs, such as *Head of a Dog* (above, left) by Parmigianino, or the fine dogs depicted by Jacopo Bassano, in, for example, *Two Hunting Dogs Tied to a Tree Stump* (above, right). The tradition thus initiated reached its zenith during the eighteenth and nineteenth centuries, as reflected in such paintings as *Brown-and-White Norfolk or Water Spaniel* (page 199), by the master of animal painting, George Stubbs, or the work of Sir Edwin Landseer, who painted many portraits of Queen Victoria's and Prince Albert's favourite dogs, including *Dash* (1836) and the regal *Eos* (page 14).

There are various theories concerning the evolution of the dog, the most accepted being that dogs are descended directly from *Canis lupus*, the grey wolf. Evidence dating back 400,000 years (Boxgrove, Kent, England) suggests that wolves and early humans may have shared the same space,

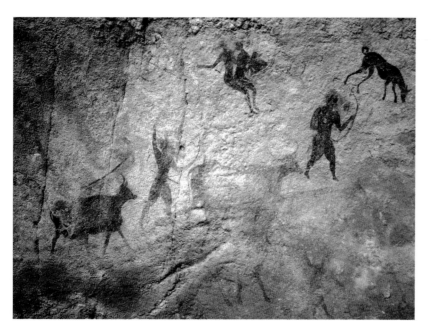

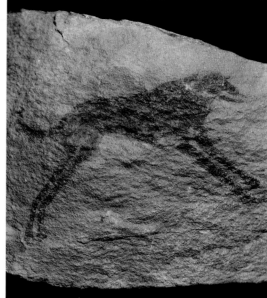

living and hunting in close proximity over the same territory. The earliest recovered signs of domesticated dogs, identifiable through skull shape, date to approximately 14,000 years ago, and were found at a site at Bonn-Oberkassel in Germany. One of the most extraordinary factors of the dog's development is the astonishing morphological diversity of the species, and the rapidity with which this occurred. Along with archaeological evidence, the depiction of the dog in art provides a fascinating visual record of this most beloved animal, from the long-legged, curly-tailed dog painted with such precision on the rock walls of Tassili N'Ajjer in the Sahara (above, left), to the basenji type with erect ears and expressive face that roamed ancient Mesopotamia and Egypt, as seen in the statue of a dog from about 5000–1000 BC, and the tiny hairless dogs of Mexico rendered so vividly in earthenware 2000 years ago (both opposite).

To trace the beginnings of the dog in art, the first visual representations of man's best friend, is to be faced with something of a mystery. Unlike the multiple depictions of the horse that we find in prehistoric art, there are very few of the dog – and yet the dog was the first animal truly to share man's life. Although the evidence dates domestication to approximately 14,000 years ago, the earliest images of the dog can be dated to only around 6000 years ago. This is of particular interest, and leads us to consider the early humans' approach to art, and to wonder why they painted what they did. Perhaps the most likely explanation for the dog's relative absence was that the dog was simply part of human life: it was not perceived as threatening, or game, or magical, but was just there – a companion and a hunting tool.

This simplistic explanation suffices only up to a point, however, because by about 3000 BC, in ancient Egypt, the dog had become the subject of some of the most complex and diverse associations of any animal in relation to man, and such associations have since been systematically explored

Mesopotamia
Statue of a dog
c. 5000–1000 BC
Limestone
Height 101 cm (39¾ in.)
Paris, Musée du Louvre

Colima culture
Half-seated dog
100 BC – AD 300
Earthenware
28.6 x 26.7 x 21 cm
(11¼ x 10½ x 8¼ in.)
Texas, Houston,
Museum of Fine Art

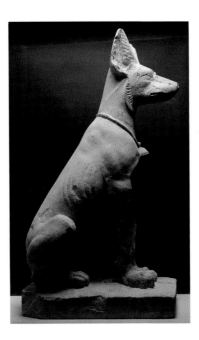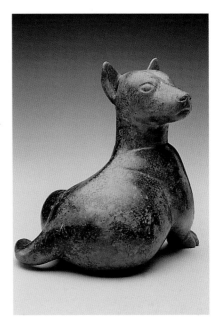

through the arts. Symbolically the dog figure has, in different times and cultures, represented a spectrum of identities that ranges from deity to devil, from noble to bestial and from adored to abhorred. It is an animal that has also aligned itself uncannily with its human counterpart. Contrary to the opinion of the philosopher René Descartes, the dog exhibits a range of emotions identifiably akin to the human, from love to fear, pain and jealousy. It is this element of identification that has fostered the tradition of projecting human characteristics on to the dog, a fact exploited by artists. This perceived commonality has also led to the dog being depicted as *symbol* of those very human qualities, both good and bad, a creature representing nobility and love, and also bestial carnality and depravity.

One of the earliest and most enduring beliefs was in the dog as deity, spiritual entity and psycho-pomp (conductor of souls), an association that was widespread from Africa and Asia to South America. Dogs were often seen as having the ability to dwell in the physical and supernatural worlds, traversing both, and in myth were frequently the guardians of the dead. The ancient Egyptians, for example, venerated the dog- or jackal-headed god Anubis, seen overleaf in *Anubis and the Soul of the Deceased*. Associated with death and the afterlife, Anubis was the guardian and guide of deceased souls. Depicted either as a black dog or as a dog- or jackal-headed human, he appeared frequently on Egyptian funerary monuments, and dogs themselves were often mummified and buried alongside their masters. Similarly, in Mesoamerica the god Xolotl, a human–dog hybrid and guide to the underworld, was worshipped.

Another widespread belief that was particularly prevalent among Native American peoples and through the nomadic tribes of Central Asia was that of the dog or wolf as the ancestor of man – a belief also held in many Turko-Mongolian and Siberian cultures. The notorious Genghis Khan, for example, allegedly traced his heritage back to the union of

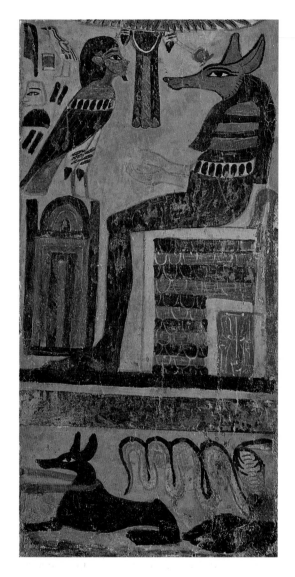

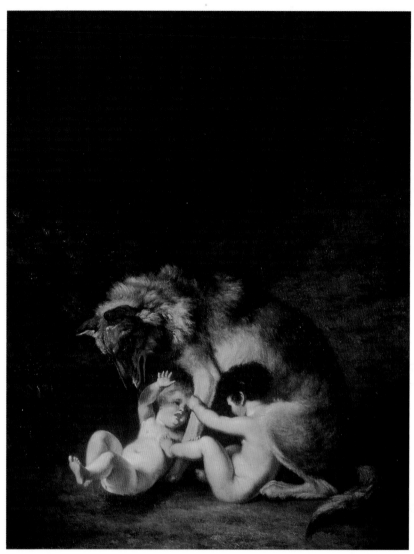

Egyptian School
**Anubis and the Soul
of the Deceased**, from
a sarcophagus
c. 664–525 BC
Painted panel
Dimensions unknown
Pennsylvania, Merion,
The Barnes Foundation

Jacques-Laurent Agasse
(1767–1849)
**Romulus, Remus and
their Nursemaid**
c. 1805
Oil on canvas
184 x 155 cm (72½ x 61 in.)
Geneva, Musée d'Art et d'Histoire

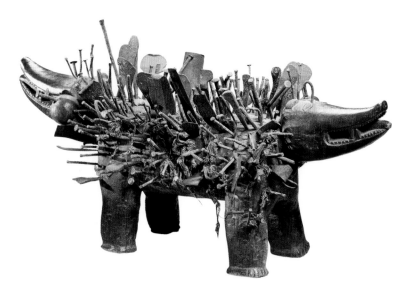

Central African: Kongo
***Nkisi nkondi kozo*, in the form of a two-headed dog**
19th century
Wood and iron
Height 67.5 cm (26⅝ in.)
Geneva, Musée Barbier-Mueller

William Blake (1757–1827)
Illustration to 'The Descent of Odin', an ode from *The Poems of Thomas Gray*
Published 1797–98
Watercolour and black ink on paper
41.9 x 32.4 cm (16½ x 12¾ in.)
Connecticut, Yale Center for British Art, Paul Mellon Collection

a grey wolf and a white doe. The dog was therefore respected in these cultures and became symbolic of such attributes as tenacity and bravery, to the extent that Genghis Khan called his four greatest generals the 'Dogs of War'. In Europe, Roman mythology has Romulus and Remus, the founders of Rome, being nursed by a she-wolf, while in Chinese myth the creator deity Pan Gu is sometimes depicted as a human figure with a dog's head, or as a black-and-white dog.

In common with other ancient civilizations, the Greeks and the Romans put the dog in the sky, in the form of the constellations Canis Major and Canis Minor – the great dog and the little dog – accompanying the hunter god, Orion (see the illustration of the constellation Sirius, page 95). Dogs were commonly associated with the gods in Classical mythology, sometimes as specific named entities, such as the Golden Hound (Kuon Khryseos), who guarded the Greek god Zeus as an infant, or Lailaps, the swift hound given by Zeus to Europa of Crete and later to King Minos; but more frequently they appeared as random companions, perhaps most famously alongside the Greek hunter goddess Artemis (Roman Diana), who was often depicted

accompanied by a dog or pack of dogs. Ares, the Greek god of war (Roman Mars), was associated with dogs and wolves, and the Greek goddess Hecate was occasionally depicted as dog- or wolf-headed. Terror surfaces with the dog in the form of Cerberus, the three-headed 'hound of Hades' (see *The Story of Orpheus*, page 108, by Edward Burne-Jones), which guarded the entrance to the underworld, its snarling heads ensuring that no one escaped from the realm of the dead. Cerberus had a counterpart in Nordic myth, a ferocious dog known as Garm, guardian of the gate of Hell. William Blake immortalized the monstrous venom of this hellhound in one of his illustrations to the poem 'The Descent of Odin' (below, left) by Thomas Gray (1716–1771), accompanying the lines 'His shaggy throat he opened wide, / While from his jaws, with carnage filled, / Foam and human gore distilled: / Hoarse he bays with hideous din, / Eyes that glow and fangs that grin'. The association of black dogs, in particular, with Hell continues to the present day, together with their being symbolic of evil. Interestingly, although black dogs do appear in art, they do so relatively infrequently; more commonly represented is their polar opposite, the white dog, symbolizing such qualities as purity, chastity, love and nobility.

Another manifestation of the dog as spiritual entity is seen in the *nkisi nkondi kozo* (above), a two-headed dog figurine. Made by the Kongo people of south-western Central Africa, *nkisi nkondi* charm figures arise from deeply held spiritual beliefs; *kozo* refers to such an object when it is given the form of a dog. Each nail embedded in the model represents an individual's appeal to the figure's power; such appeals were often associated with bitter grievances, since it was believed that the dog was capable of moving through both the real and the supernatural worlds to hunt down evil.

Right
Workshop of Antonio dei Fedeli (attrib.)
Floor tile decorated with the Gonzaga impresa (emblem), a white hound
c. 1492–94
Maiolica
23.9 x 23.9 cm (9 ⅜ x 9 ⅜ in.)
UK, Cambridge, Fitzwilliam Museum

Far right
Kate Leiper (born 1973)
Awaiting Artemis
2007
Pastel, ink and acrylic on handmade paper
100 x 100 cm (39 ⅜ x 39 ⅜ in.)
UK, Holt, The Red Dot Gallery

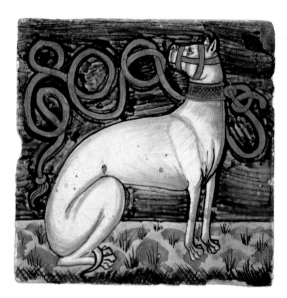

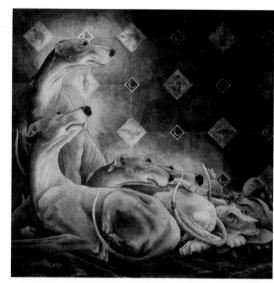

Right
Roman
Dog on a leash, from Pompeii
1st century AD
Mosaic
Dimensions unknown
Naples, Museo Archeologico

Far right
The Euergides Painter (active *c.* 500 BC)
Detail of a Laconian hound scratching its head, from an Attic red-figure cup
c. 500 BC
Painted pottery
Oxford, Ashmolean Museum

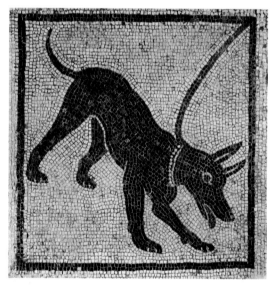

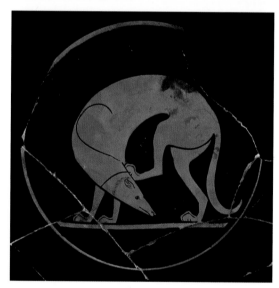

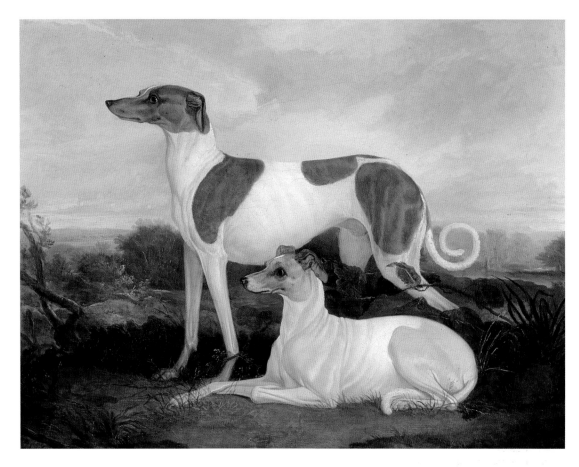

Depictions of dogs were common throughout many ancient cultures, including the Egyptian, the Greek and the Roman, and such images show certain distinct types of dog that are clearly related to modern breeds. Of these the most prepotent are the greyhound and mastiff types. The early hound dogs, swift, leggy, sleek and bearing a close resemblance to the modern greyhound and saluki, were highly prized, as they have remained through-out their history. Their general body type has changed relatively little, as can be seen by comparing, for example, the Laconian hound scratching its head; the white hound of the Gonzaga impresa, or emblem (both opposite); Charles

Hancock's *Two Greyhounds in a Landscape* (above); and Kate Leiper's *Awaiting Artemis* (opposite) – images the dates of which range from 2500 years ago to the present day. These ancient hounds were owned and used by the nobility and were symbols of prestige; as such the greyhound has been one of the most prolifically depicted dogs in the history of art, ranging from the decorative, as seen in Pietro Rotati's beautiful late eighteenth-century *Two Greyhounds*, to the realistic, as in Edwin Landseer's unsurpassable *Eos* (both overleaf).

In contrast to the slender, graceful greyhound type is the heavy and powerful mastiff type of dog, the history of which, in art at least, can be traced

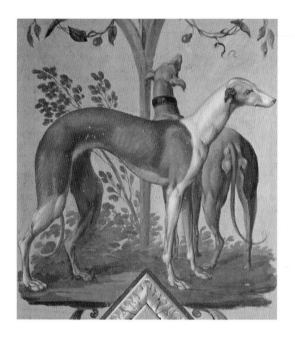

back to around 2500–2000 years BC, to prehistoric depictions in the Algerian Sahara. These dogs probably evolved in Central Asia, spreading across the continent, down into China and Japan and on into North Africa and Europe. By the time the powerful Asiatic Hyksos people were ruling ancient Egypt, from about 1700 BC, this heavy-framed dog had developed into two main types, one used for hunting and warfare, and one for guarding livestock. Their tenacity and bravery made these dogs, often wearing heavily spiked collars, an important part of military campaigns, and they were also used as watchdogs, for herding livestock and in a sporting capacity by the Romans, who baited them against other animals and slaves. Mastiff types were popular in ancient Assyria and are depicted in bas-relief on the Babylonian palace of Ashurbanipal, dating to about 669–631 BC; they also appear to have been selectively bred from pre-600 BC by the ancient Greeks and Romans, who called them Molossians. These dogs gave rise to all the massive mountain

breeds found in northern Europe as well as to the mastiff itself, and influenced other breeds: the blood of the mastiff type is even said to have contributed to the pug. The prepotency of the mastiff strain is admirably demonstrated by comparison of such beautiful images as the Chinese *Seated mastiff* (page 53), dating back to the second century AD, with, for example, the dog in *Las Meninas* (page 125) by Diego Velázquez.

A third type of prepotent prehistoric dog appeared in the arts and influenced many modern breeds. The spitz, with its distinctive curly tail, tapered nose and middleweight frame, can be seen in the many rock paintings that have been dated to between about 6000 and 1500 BC at Tassili N'Ajjer in the Sahara Desert (page 8). The precise origins of the spitz are unclear, although it is probable that it evolved in the Arctic regions, and may have interbred with wolves. From there the dogs migrated to the warmer climates of Europe, North America, Asia and North Africa. The spitz type

Pietro Rotati (c. 1770–1790)
Two Greyhounds
Late 18th century
Mural
Dimensions unknown
Rome, Galleria Borghese

**Edwin Landseer
(1802–1873)**
Eos
1841
Oil on canvas
111.8 x 142.3 cm (44 x 56 in.)
London, The Royal Collection

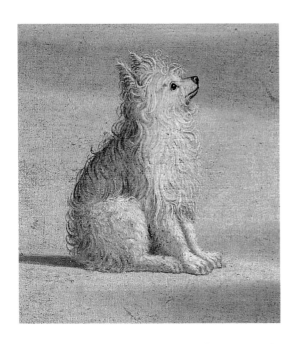

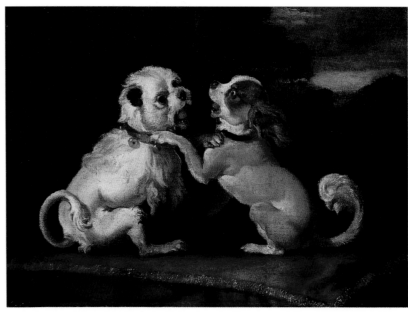

eventually gave rise to many different breeds, initially varieties that were used for hunting, herding and guarding livestock, and for pulling sleds. Such dogs were characterized by their thick insulating coats, small, pointed ears and great strength and stamina – characteristics that can be seen in such modern breeds as the Siberian husky, the Norwegian elkhound, the Japanese Akita Inu and the Chow Chow. Ancient spitz blood is also present in many of the smaller dog breeds, such as the Pomeranian (seen so delightfully in the *Vision of St Augustine* by Vittore Carpaccio, above), the French papillon, the Belgian schipperke and the Maltese, a particularly ancient lapdog that was popular with the Roman emperors.

Artistic representations and archaeological evidence indicate that dogs, used primarily at first for hunting and guarding, were popular across the ancient world, from the civilizations of Egypt in the fifth dynasty (*c.* 2600 BC) to the Near East, Persia, Assyria, China, India, South America and Europe,

and the countries inhabited by the Gauls. There is no evidence that pinpoints the emergence of the dog as specifically a domestic pet, rather than in its role as hunter or watchdog, although undoubtedly this occurred quite naturally. Many artistic depictions from ancient Greece and Rome reflect the popularity of the smaller dog kept as a pet in the domestic forum, including little dogs that appear very similar to the modern Maltese.

Little dogs have a long association with the Buddhist religion, which originated about 2500 years ago in India before rapidly spreading east throughout Asia and beyond. Small 'lion dogs' or 'fu dogs' were adopted as symbolic of the guardians of the Buddhist faith in China, and deemed to be lucky. These dogs, which first appeared in Chinese art in around 200 BC, were the ancestors of the Tibetan Lhasa Apso, the Chinese Pekingese and the Japanese Chin. They were adored by the emperors and kept in large numbers as pets, given free rein of the palaces and greatly revered. The

**Vittore Carpaccio
(c. 1460/65–1525/26)**
Vision of St Augustine
(detail)
1502–1508
Oil on canvas
Venice, Scuola di San Giorgio
degli Schiavoni

European School
Dogs at Play
18th century
Oil on canvas
35.6 x 53.4 cm (14 x 21 in.)
Private collection

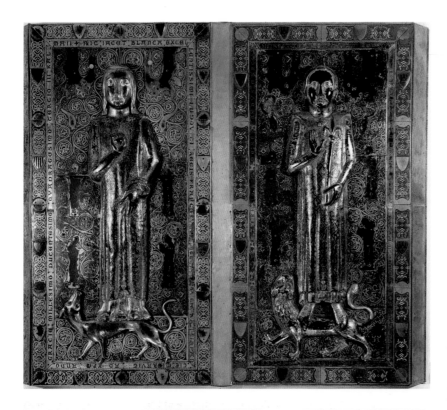

French School
Tomb of Jean and Blanche of France, children of Louis IX and Marguerite of Provence
13th century
Gold and enamel
105 x 126 cm
(41⅜ x 49⅝ in.)
Paris, Basilique St-Denis

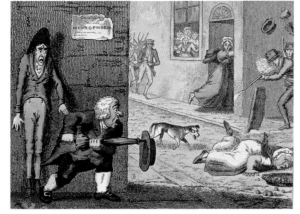

Thomas Busby
(active 1804–1821)
Mad Dog, a caricature of people's fear of a mad dog and of rabies
1826
Print
11.9 x 14.6 cm (4⅝ x 5¾ in.)
London, The British Museum

symbol of the fu dog is one that has endured and is still widespread, while small pet dogs, similar in appearance to their ancient ancestors, are still popular throughout not only the Far East but also much of the Western world.

For a period after the fall of the Roman Empire in the West in AD 476, the dog, too, fell from grace in Europe, as well as from the artistic arena. Packs of feral dogs roamed the countryside: ferocious dogs, bred for war but let loose or having escaped following battle. Dogs were viewed as unclean and as something to be feared, a belief underscored by the prolific spread of the disease rabies. This deadly virus causes the animal to foam at the mouth, behave erratically and become aggressive, so that it can seem almost demonic. Even today, people bitten by a rabid dog stand little chance of survival. Thomas Busby's wonderful caricature *Mad Dog* (left) illustrates lightheartedly just what terror a rabid dog could, and can, cause, despite its (in this case) diminutive size.

The dog's fall from favour did not last, however, and, with characteristic resilience and charm, it was to recover its popularity and again steal the heart of its human companion.

Two of the defining attributes of the dog, and ones that it manifestly embodies, are faithfulness and nobility. In ancient civilizations, the dog had been depicted as a deity or spirit being; entering the forum of Christian art, it became symbolic of faith. The dog appeared on many funerary monuments, and is most commonly seen curled at the feet of the deceased. The thirteenth-century tomb of Jean and Blanche of France, children of Louis IX and

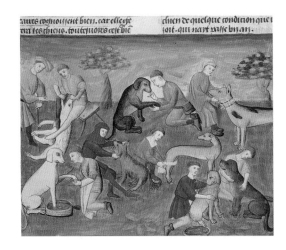

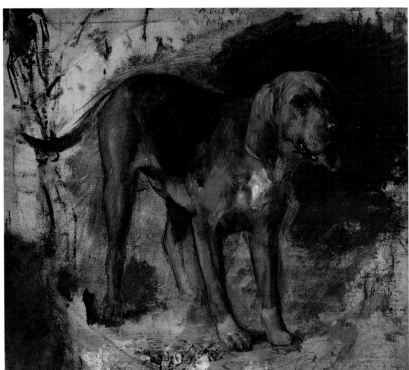

Marguerite of Provence, is especially moving, depicting the two children with a greyhound- or whippet-like dog and a lion (opposite). Nonetheless, the dog's frequent appearance on such monuments surely did not occur purely as a spiritual premise; the tradition of dogs sleeping on beds stretches far back, and was no doubt primarily instigated (probably by the dog) as a way of keeping warm.

By the fifth century in Europe, hunting was becoming more and more central as a social, political and sporting event rather than for the procurement of food, and – in this context – was the privilege of noblemen. Accordingly the need for hunting dogs increased, leading to the specific breeding of dogs for this activity. Among others, a group of monks from the Abbey of St Hubert at Mouzon, Ardennes, France, were particularly successful in breeding hunting dogs. These came to be called the St Hubert hound, the ancestor of the bloodhound (see William Holman Hunt's *Study of a Bloodhound*, left). With a stroke of marketing brilliance the monks of St Hubert realized the worth of their hounds, and began to send six of them annually as gifts to the king of France, who in turn bestowed them on his favourite noblemen. Thus the merit of the dogs became well known among the wealthy, leading to a great demand for the hounds. Ironically, these valuable hunting dogs began to be so highly treasured by their owners, who even brought them into church during services, that the Church decided its congregation was devoting more time to the dogs than to God. When the priests therefore objected and banned dogs from the church, the noblemen instead sat outside with their dogs,

**Henriette Ronner-Knip
(1821–1909)**
The Grocer's Dog
n.d.
Oil on panel
19.3 x 15.7 cm (7⅝ x 6¼ in.)
Private collection

Meno Muhlig (1823–1873)
Heavy Load
c. 1850
Oil on canvas
44.5 x 35.5 (17½ x 14 in.)
Private collection

forcing the priests to give the blessing in front of the church. This 'blessing of the animals' is a tradition that persists to this day.

The breeding of hunting dogs became increasingly specialized, and prize dogs were greatly sought after, valued and lavishly cared for. They accompanied their masters everywhere, from banqueting hall to church: the dog had firmly established its unshakeable popularity. During the two hundred years of Christian Crusades between 1095 and 1291, the dog accompanied the knights on their campaigns against the Moors, through Europe, along the Mediterranean and into North Africa. It was an important period for the development of different dog breeds, as dogs were exchanged and cross-breeding occurred between European hounds and those of Eastern origin. It is believed that the spaniel is one notable result of such cross-breeding.

By the end of the fourteenth century, dogs, in particular hunting dogs, were widespread in European homes, their popularity set on a path from which it now would not stray. It was around this time that the famous *Le Livre de chasse*, an early treatise on the science and art of hunting, was written by Gaston Phébus, comte de Foix. The manuscript describes in great detail every aspect of the hunt, and from the fifteenth century illustrated copies began to appear, depicting such delightful scenes as *Caring for the Hounds* (previous page), which documents the lavish care these hounds received.

During the Renaissance, dogs were active in all walks of life: working as 'turnspits', pulling carts, ratting, herding, guarding, competing in sporting events. And dogs have to a greater or lesser degree continued to be used as tools right up to the present day. Two contrasting nineteenth-century images, *The Grocer's Dog* by Henriette Ronner-Knip and

unusual dog paintings of this time is Hondius's *Amsterdam Dog Market* (right, bottom). This extraordinary work depicts a fictitious, highly animated scene of dog trading against a Classical background, and displays lively dogs of countless different types. Dogs had by this time become a commodity, and a trade in the animals was developing, in part bolstered by the increasingly wealthy bourgeoisie in The Netherlands and by the demand for pure-bred dogs, which were still scarce. Of particular note in this work are the carefully placed decorative dog collars in the foreground. The fashion for ornate collars is one that dates back to ancient cultures, and continues to this day.

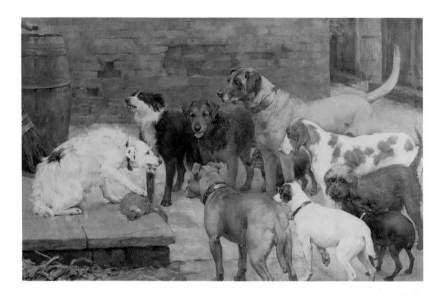

The individual dog portrait as a genre became very popular during the eighteenth century, and that in part reflected the enormous importance attached to hunting at the time, particularly in France. As hunting became ever more elitist and competitive, so the dogs increased in value, their painted images testifying to their physical impressiveness. In a century of astonishing artistic accomplishments, several names reverberate when it comes to dogs. The two leading French artists in this respect were Alexandre-François Desportes (1661–1740) and the younger Jean-Baptiste Oudry (1686–1755), who succeeded Desportes as court painter to Louis XV. The two painted many of the king's favourite hunting dogs as well as informal pet portraits. Of these, Oudry's *Bitch Nursing her Puppies* (overleaf) is one of the most groundbreaking in its depiction of a moment of canine intimacy that resounds with the selflessness of motherhood, conceived with an almost religious tone.

Jean-Baptiste Oudry
(1686–1755)
*Bitch Nursing her
Puppies*
1752
Oil on canvas
103.5 x 132.1 cm
(40 ¾ x 52 in.)
Paris, Musée de la Chasse
et de la Nature

Just as Desportes and Oudry committed to canvas the noblest of French dogs, so, some years later across the Channel, Thomas Gainsborough and George Stubbs painted their English counterparts. Gainsborough's dogs, such as the lovely white Pomeranian type in *Mr and Mrs William Hallett (The Morning Walk)* (page 130), are beautifully painted, as are those of Stubbs, but, as one would expect the latter's are imbued with depth of soul and spirit. Stubbs's portrayals of dogs, such as *A Spaniel* and *A Pointer* (both opposite), combine a sense of the domestic with an impression of the animal's wild heritage as they creep, shining with realism, through a dark and sombre landscape. His superb and precise rendering of anatomical detail makes his depictions of different breeds strikingly accurate and provides a clear record of breed development. It was around this time that the phenomenon of the pure-bred dog began to take off, the prestige conferred by the pedigree dog meriting

its immortalization in paint. With the emergence of dog shows and the increasing popularity of field trials and sporting events during the nineteenth century, combined with the founding of the Kennel Club in Britain in 1873, the creation of its studbook in 1874, the establishment of the French and Italian Kennel Clubs in 1882 and of the American Kennel Club in 1884, dog breeds began to be formalized and regulated. Other European countries then introduced their own Kennel Clubs and studbooks, which in turn led to the official recognition of many different breeds, and also ensured that the popularity of pure-bred dog portraits would continue to rise.

In nineteenth-century Britain, the propensity of the Victorians to sentimentalize their animals was reflected in the paintings of Edwin Landseer, one of that century's most popular and accomplished animal painters. A great favourite of Queen Victoria, he painted many of her numerous dogs, to which

Opposite, top
**After Francis Barraud
(1856–1924)
Reproduction of *His
Master's Voice*,
advertisement for
Victor Gramophones
from *The Theatre***
c. 1910
Colour lithograph
Dimensions unknown
Private collection

Opposite, bottom
**Lincoln Seligman
(born 1950)
*Art Lover***
2005
Oil on canvas
25.4 x 61 cm (10 x 24 in.)
Private collection

**William Ireland
(born 1927)
*The Chase***
2006
Oil on board
58.4 x 71.2 cm (23 x 28 in.)
Private collection

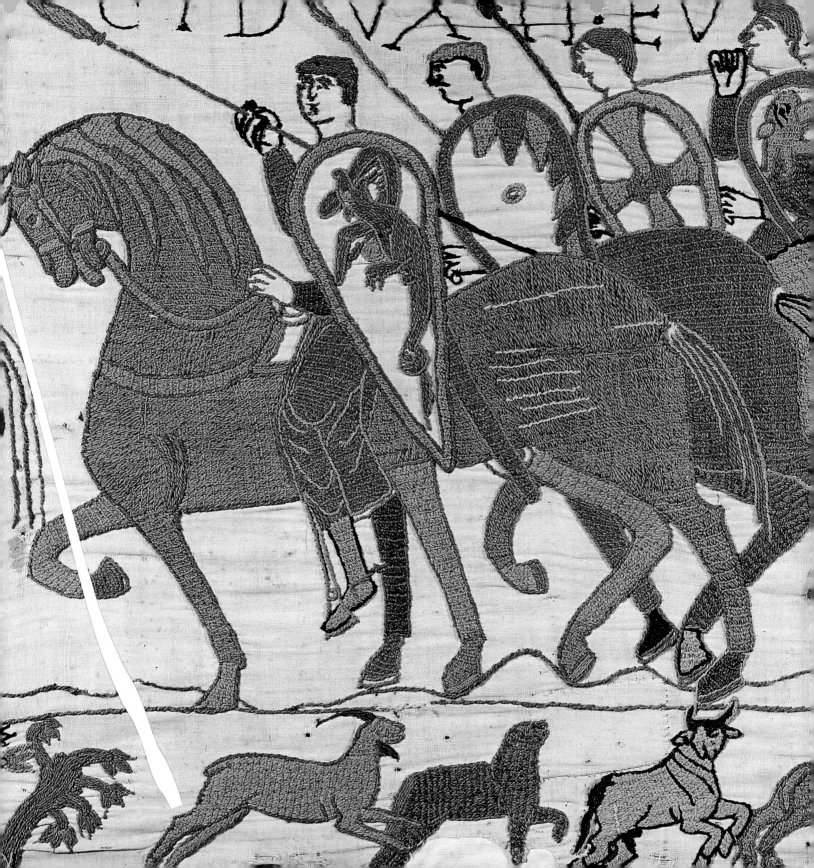

I N THE DISTANT PAST, WHEN THE SAHARA DESERT was carpeted with verdant foliage and the last ice age was coming to a close, a new branch of the Canidae family cautiously entered early man's domain. The earliest evidence for the 'domesticated' dog, whose closest relative is *Canis lupus*, the grey wolf, dates back to approximately 14,000 years ago, as disclosed by a double grave in Bonn-Oberkassel, Germany, containing the remains of a human and a dog. Equally compelling was the discovery of a grave in Ein Mallaha, Israel, dating back approximately 12,000 years, in which a human skeleton cradled that of a puppy. With such evidence begins the documented and extraordinary journey of a species the history of which is entwined with ours, and which has been recorded through the ages by the hand of the artist.

There are few known prehistoric images of the dog dating back to its emergence, probably owing to the very domesticity of its relationship with man; most cave paintings of Northern Europe, for example, depict threatening animals or those hunted for food, magical creatures, or human and shamanic figures. Perhaps, though, the dog sat in the shadows watching as the early humans recorded their world on the rock walls, its tail gently polishing the dirt floor with a rhythmic beat.

Some of the finest and earliest depictions of the dog are found in the Tassili Mountains of southern Algeria, deep in the heart of the Sahara, where a curly-tailed animal accompanies hunters. This long-legged creature, presumably a dog, and a similarly streamlined hound, seen in the rock paintings on pages 29 and 30, are among the first visual clues to the physical structure of the early dog, and its appearance within the domestic forum. These simple, striking images date to between 6000 and 1500 BC, and place the dog squarely within a tradition – in art as much as in society – that has endured to modern times.

One of the defining physical characteristics of the dog as a species is its morphological diversity, which over the last two centuries has increased almost beyond imagination, owing to selective breeding. However, even thousands of years ago distinct types of dog existed and were adopted for different roles, the two greatest of which were hunting and warfare. Early images from ancient Greece include – racing round pottery vases – sleek hound dogs, fleet of foot and slung low to the ground, not unlike the heavy-boned dog so beautifully rendered on the kotyle pictured on page 34. Heavier mastiff types wearing spiked metal collars were used for attacking the enemy. The unsurpassably elegant, sylphlike greyhound type or pointed-eared basenji was another form frequently depicted, seen in 'Detail of a Laconian hound' (page 35), while spitz-type, whippet-type and even smaller dogs appeared in painting and sculpture, often with their names recorded alongside them.

By the fifth century BC the dog was fully established in Greek literature and mythology,

The dog sat in the shadows watching as the early humans recorded their world on the rock walls, its tail gently polishing the dirt floor with a rhythmic beat.

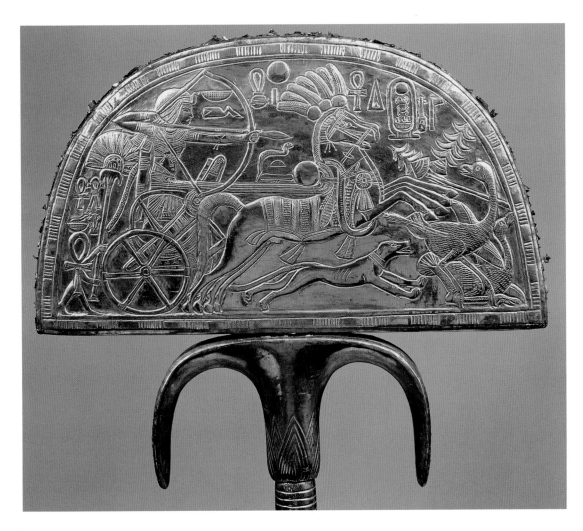

Egyptian School
Ostrich-feather fan from
the tomb of Tutankhamun
c. 1370–1352 BC
Wood covered with sheet gold
10.5 x 18.5 cm (4⅛ x 7¼ in.)
Cairo, Egyptian National Museum

In 1922 the archaeologist Howard Carter unearthed the extraordinary tomb of the boy king Tutankhamun, which revealed not only fabulous treasures and artefacts, but also considerable information about the king and his times. This gold ostrich-feather fan, still with remnants of brown and white ostrich feathers, is particularly interesting for both the exquisite heavy-boned hound dog depicted and the humour involved.

The scene on this side of the fan shows the king hunting fleeing ostriches, accompanied by a prized dog wearing a decorated collar. On the reverse the king is returning home, attendants carrying two dead ostriches, and he has the feathers for this very fan under one arm.

The dog is heavier in build than the slight greyhound type so often depicted, but is obviously extremely fast. Ostriches are known to reach speeds of 65 km/h (40 mph), and here the dog is keeping pace with the king's swift chariot and the birds. From the huge array of artefacts and painted scenes unearthed, it is clear that Tutankhamun was a keen sportsman, and in many of these images he is accompanied by his hounds, each one slightly different in appearance and depicted from life.

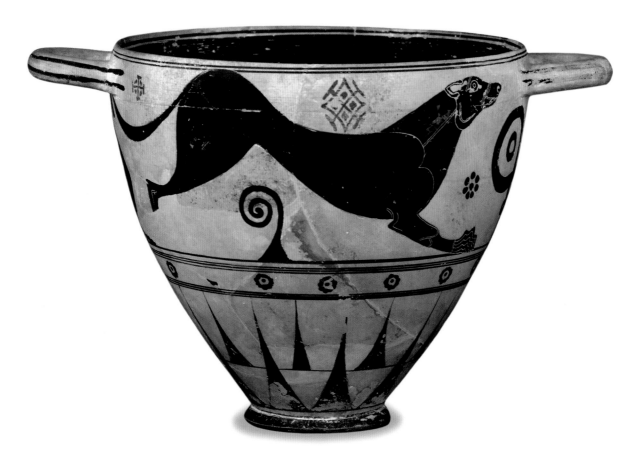

**The Hound Painter (attrib.)
Kotyle with a running
hound**
c. 670–650 BC
Painted pottery
Height 18.2 cm (7⅛ in.)
London, The British Museum

The ancient Greeks kept
and bred fierce watchdogs
that were used for guarding
livestock, property and
towns, as well as for hunting.
The Greek writer Oppian
of Apamea (third to second
century BC) described
them as 'impetuous and of
steadfast valour, who attack
even bearded bulls and rush
upon monstrous boars and
destroy them'. These dogs
were originally bred by the

Molossians (from whom they
took their name, Molossus) in
the mountains of north-west
Greece, and are generally
considered to be the
predecessor of such modern
mountain breeds as the
St Bernard, the alpine mastiff,
the Tibetan mastiff and the
Bernese Mountain Dog, as
well as being ancestors of
the rottweiler.
 The powerful, heavily
muscled black dog carefully

drawn on this pottery vase is
reminiscent of those ancient
canine warriors. Its head and
front have been depicted in
great detail, its facial features
and bulging shoulder
muscles highlighted through
the use of incised line drawn
through a silhouette of
black and red (black-figure
technique), much of which
has now faded.

**The Euergides Painter
(active *c*. 500 BC)
Detail of a Laconian hound
scratching its head, from
an Attic red-figure cup**
c. 500 BC
Painted pottery
Oxford, Ashmolean Museum

This is one of the more
unusual and touching
images from ancient Greece,
depicting as it does a slender
hound carefully scratching
the top of its head. It was
far more common for these
highly revered dogs to be
painted in action, racing after
prey, or sitting in a faithful
pose beside their master.
Here the artist has captured
the dog doing what dogs
do, but the actual rendition
of the animal is so fine and
so beautifully drawn that
it becomes elevated from
comedy to art. Such hounds
as this were among the most
commonly depicted type of
dog at this time and appear
consistently in artistic
representations. They were
generally sight hounds, or
gaze hounds, which hunt by
sight, and were the ancestors
of modern-day sight hounds,
of which the saluki, bred by
ancient Egyptian Bedouin
tribes, and the greyhound are
believed to be the oldest. The
Laconian hound, seen here
(to which Xenophon alludes
as not in fact being a sight
hound), was so called after
the region of southern
Greece whence it hailed, and
was frequently referred to in
ancient texts, including the
poem – attributed to Oppian
of Apamea – *Cynegetica*
('On Hunting'), from the third
or second century BC.

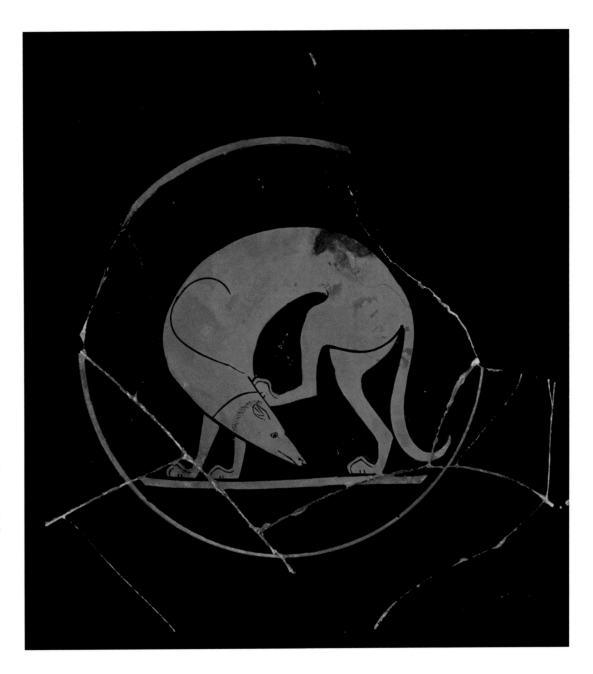

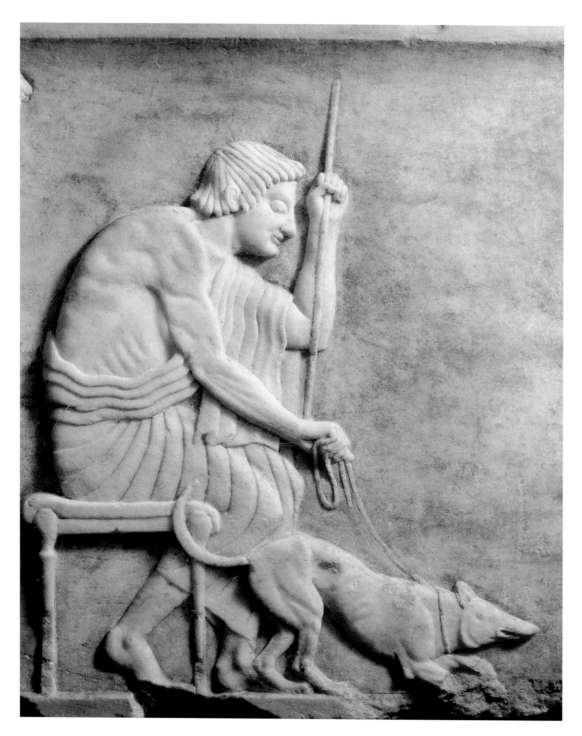

Greek School
Animal baiting, relief from a statue base found in the Dipylon cemetery, Athens
c. 510 BC
Marble
Athens, National Archaeological Museum

Animal baiting was popular in ancient Greece and Rome, using dogs bred specifically for their ferocious qualities. They were pitted against each other, against wild animals, including lions, leopards and elephants, and even against armed gladiators. One story passed down through time relates how a dog belonging to Alexander the Great, called Peritas, bravely killed first a lion and then an elephant, and was thereafter held in the highest esteem by the ruler.

This image, however, shows animal baiting on a rather different scale, with the small, leashed dog more in the proportion of a pet than a fighting hound. It has been set on an unfortunate cat, also leashed, which forms the other half of the scene, although the cat appears to be (albeit unhappily) standing its ground. The dog gives the appearance of playfulness rather than blood-getting fervour, and the expression of languid humour on its master's face further suggests that this is an impromptu event within a domestic setting.

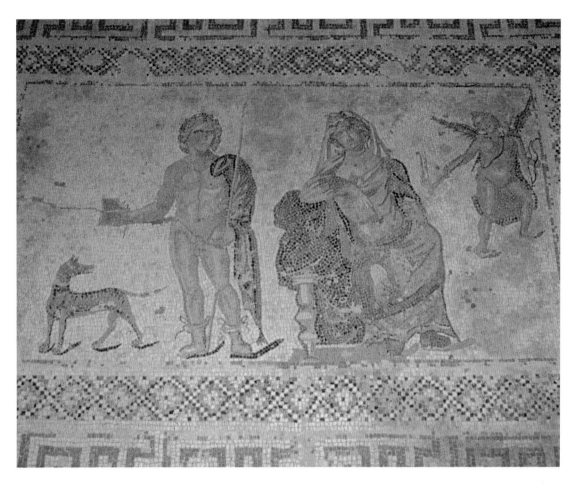

Greek School
Phaedra and Hippolytus

2nd to 3rd century AD

Mosaic

Dimensions unknown

Cyprus, Kato Paphos,
House of Dionysus

The dog played an active and varied role in Greek mythology, appearing frequently, and representative of a wide spectrum of emotion and symbolism. In this floor mosaic from the House of Dionysus depicting a scene from the tragedy *Hippolytus* by Euripides, the graceful hound turns its head back towards its master, in an image of faithfulness and trust – the very qualities on which turn so fatefully the events related by Euripides, which lead to the tragic deaths of Phaedra and Hippolytus.

Of all domestic animals it is the dog that has most commonly and consistently been anthropomorphized and used in art and literature to convey human emotions, virtues and vices. This is demonstrated here through the body language of the small hound, a device that was frequently used in ancient Greece and Rome and has continued to the present, with possibly its greatest manifestation seen in paintings of the nineteenth century.

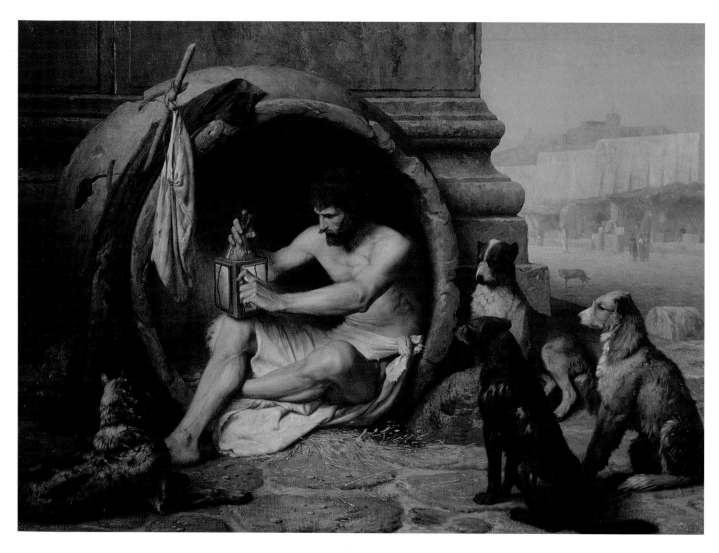

**Jean-Léon Gérôme
(1824–1904)**
Diogenes
1860
Oil on linen
74.5 x 101 cm (29⅛ x 39¾ in.)
Baltimore, Walters Art Museum

This nineteenth-century work by the French master Gérôme depicts in a wonderfully realistic manner a motley group of shaggy street dogs, each with its own character. Surrounding the figure of Diogenes in his barrel, these seem to be actual dogs: no doubt the artist was alluding to the large numbers of semi-feral dogs that populated the streets of the ancient world.

The painting portrays Diogenes of Sinope, who was the most famous and colourful figure of an ancient Greek sect of philosophers known as the Cynics. Their beliefs, in the broadest of terms, involved a return to simplicity and a rejection of the comforts of material life, and they used shocking tactics to display their ideals ostentatiously. Diogenes, for example, allegedly lived like a dog in all bodily ways, and praised the moral virtues of the dog. Accordingly, the word 'cynic' derives from the Greek words *kunikos*, meaning doglike, and *kuōn*, meaning dog. Later the term 'cynic' was used to mean 'faultfinder' (Cynics pointed out the faults in others), while today it describes a person distrustful of sincerity or scornful of others.

**Roman School
Roundel from a ceiling
mural depicting the
abduction of Ganymede**

2nd century BC
Wall painting
Germany, Xanten

The little dog in this ancient mural is one of the most delightful and unusual depictions of the dog from the ancient world. Its tiny frame and cheerful demeanour, emphasized through the upward-curving lines of its form, are at odds with the drama of the scene in which it appears, where Jupiter, disguised as an eagle, is in the process of abducting the beautiful young boy Ganymede. Many hundreds of years before this painting, a somewhat similarly shaped long dog with short legs appeared in ancient Egyptian works, and some believe that the modern dachshund, a traditional symbol of Germany, descended from these small hounds. The painting was excavated from the Roman settlement of Colonia Ulpia Traiana, where the modern-day German town of Xanten now stands. It is in Germany that the earliest known remains of the domestic dog have been found (dated to approximately 14,000 years ago), and a number of similar discoveries of prehistoric dog burials have been unearthed across the country.

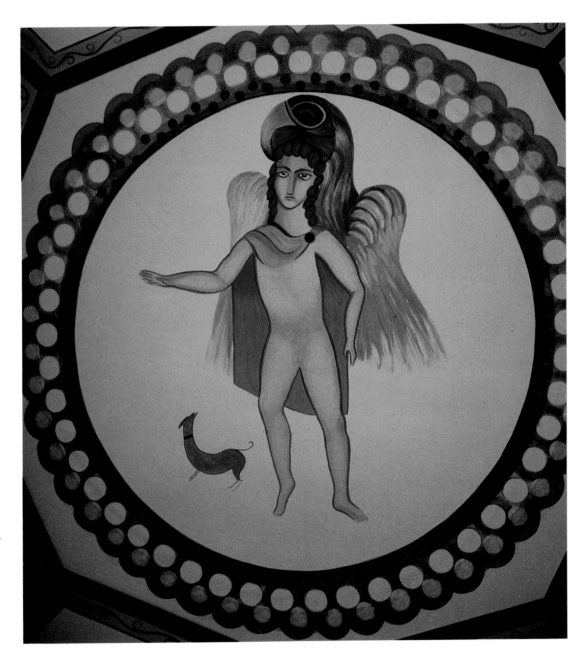

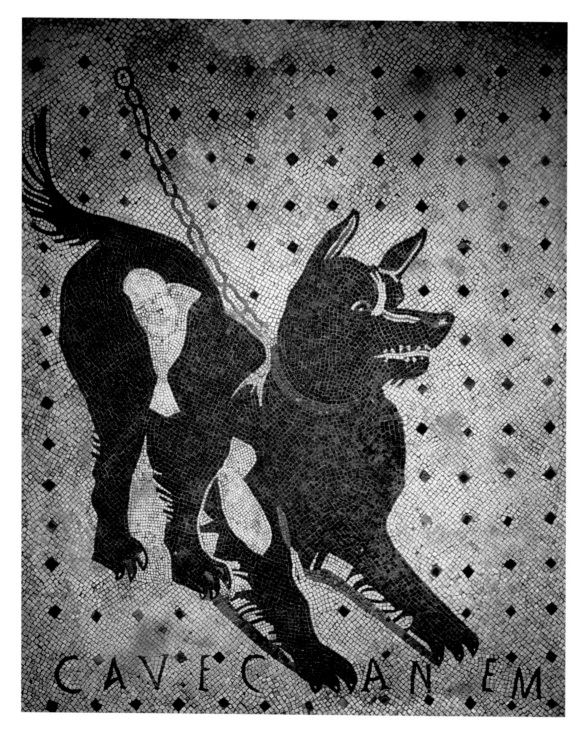

Roman School
Cave Canem
1st century AD
Mosaic
Dimensions unknown
Pompeii, House of the Tragic Poet

Dogs were as popular in ancient Rome as they were in Greece, with both societies favouring hunting and sports that involved dogs. This in itself led to the dog garnering a degree of status, with the best hunting and sporting dogs held in high esteem. Dogs were owned by the wealthy – who might own a guard dog like this fierce creature – while those with less money had to resort to using geese as their watchdogs. This almost life-size mosaic is in the entrance of a Pompeian house that, despite its moderate size, is one of the most lavishly decorated with mosaics and paintings. The dog crouches, barking, with front end lowered and haunches raised: it is depicted in great detail, down to its irregular white markings, sharp teeth and what would appear to be a red leather collar. Below the dog appears the warning *Cave Canem* – Beware of the Dog – a sign that appears not infrequently near the entrance of Roman houses, and that indicates the prevalence at that time of guard dogs in domestic buildings.

Roman School
Statue of a pair of dogs
Possibly 2nd century AD
Marble
Height 67 cm (26⅜ in.)
London, The British Museum

Few surviving works from ancient Rome depict the dog with such tenderness. This small sculpture is exquisite, in rendition, form and feeling. The anatomical accuracy of the work is absolute, and this, combined with the profound emotion instilled in the cool marble dogs, suggests that the original subjects might have belonged, or at least been well known, to the artist. The dogs appear very similar to the whippet or greyhound, and may have been modelled after the Vertragus, an ancient Celtic breed of swift running dog, described in glowing terms by the historian and senator Arrian of Nicomedia and the poet Grattius in their books on hunting, and believed to be an ancestor of the greyhound.

This work and another similar pair, along with other marble statues of dogs, were discovered in the eighteenth century near Civita Lavinia (today Lanuvio) to the south-east of Rome. The excavation site was referred to as 'Dog Mountain', although unfortunately there is no evidence to explain the concentration of dog sculptures unearthed there.

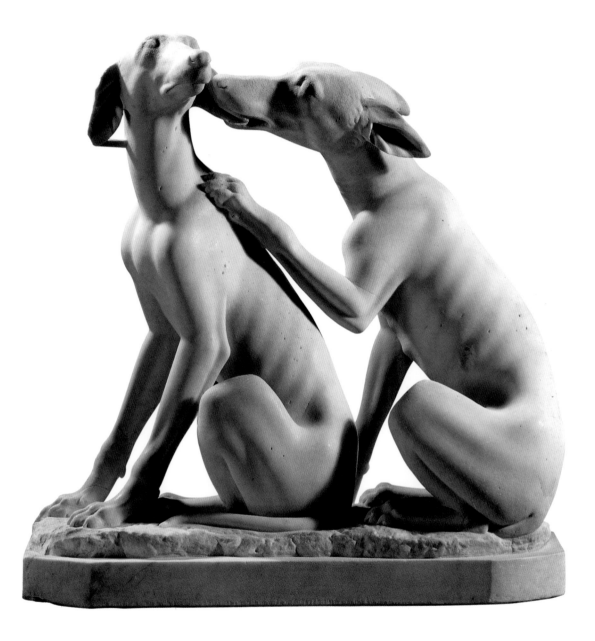

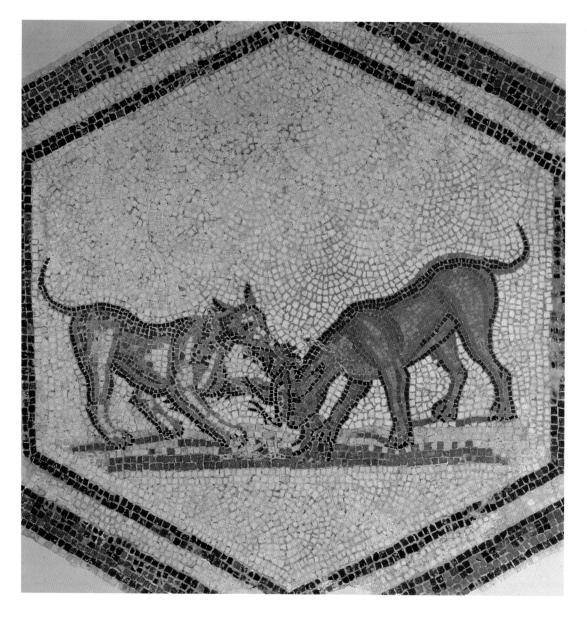

Roman School
Dogs Fighting for a Bird
2nd or 3rd century AD
Mosaic
84 x 84 cm (33 x 33 in.)
Tunisia, Le Bardo,
Musée National du Bardo

Dogs were important on many levels in ancient Roman life, not least being their use in the military. Great Molossian dogs from the mountainous areas of north-west Greece were used, bred specifically to be ferocious, as well as heavy-boned Celtic hounds, similar to the two seen in this mosaic. These battle dogs formed a vital part of the Roman military machine: trained to attack en masse, they wore heavy spiked collars both to protect them and to cause maximum damage to the enemy. They were often starved for several days prior to battle to heighten their blood thirst, a tactic also used with dogs that were pitted against each other and other animals in organized fights in the Colosseum and other arenas.

The rapacity with which the two large dogs in this mosaic attack the unfortunate bird reflects the nature of such fighting hounds, although these may not necessarily have been military dogs. Particularly fierce and fearless dogs conferred prestige on their owners, their bravery and strength supposedly reflecting those of the owner.

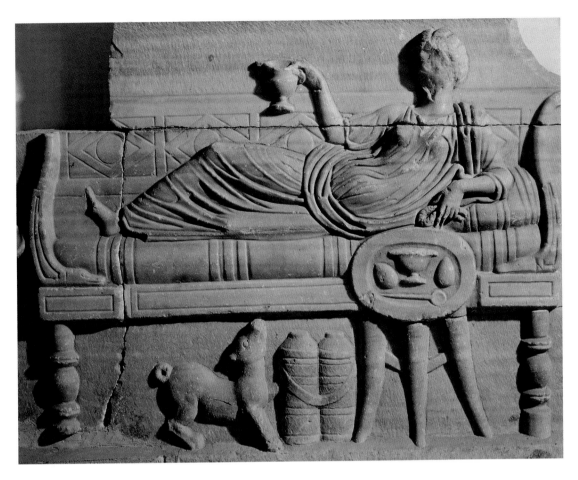

**Roman School
Woman reclining
on a bench, detail
from a sarcophagus**
2nd century AD
Stone
Beirut, Musée National

There are more depictions of the hunting dog than of almost any other kind in Greek and Roman art, but dogs were also popular pets in these ancient cultures, and few images so clearly show the dog in this role as the stone relief seen here.

In a posture familiar to dog-lovers everywhere, a small lapdog of indeterminate breed gazes up longingly at the woman reclining and eating above it. The little dog is unusual, with its tightly curled tail, small ears and snubby, snoutlike nose, and appears rather Eastern in character – certainly a far cry from the hound-dog type more commonly depicted. The food for which the dog is after can be seen on the table, the perspective of which the artist has deliberately distorted, while the woman's languid pose contrasts with the dog's eager demeanour. The cleverly balanced composition is particularly effective with regard to the jug the woman holds and the upturned nose of the dog. The woman appears to be on the point of pouring something from the jug, and if she did, it would land directly in the jaws of the waiting pup.

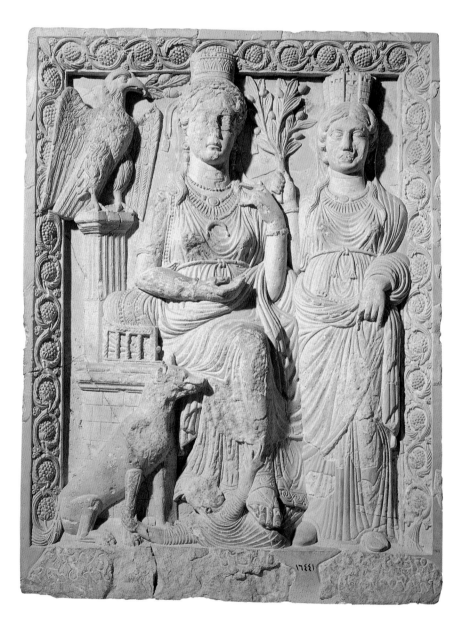

Syrian School
Relief depicting Princess Zenobia and a female companion
3rd century AD
Stone
Damascus, National Museum

The alert dog that sits by the side of the formidable Princess Zenobia is rendered as both pet and guard dog, leaning affectionately against the princess's legs, but with sharply pricked ears and watchful expression. It is quite different in appearance to the smaller dogs, which were more streamlined and greyhound- or whippet-like, that appear in ancient Greek and Roman works. Ancient Syria was home to a number of heavy-framed and fierce types of mastiff-like dog, which were highly sought after and sold for princely sums. The area came briefly under the dominion of Zenobia in c. AD 267–72, when, after the assassination of her husband, King Odaenathus of Palmyra (in which she allegedly played a part), she ruled on behalf of her young son; becoming known as a warrior queen, she conquered Egypt and other territories, greatly expanding the reach of her Palmyrene empire.

The importance of the dog through the earliest known history of the area encompassed by Syria, Persia and the Assyrian Empire is evident from archaeological and artistic finds. A valuable commodity, described as 'the guardian of flocks and defender of man', the dog was revered, beloved, feared and, at times, considered to have healing qualities. The killing of a dog was unlawful, and dead dogs were buried – a sign of the esteem in which they were held.

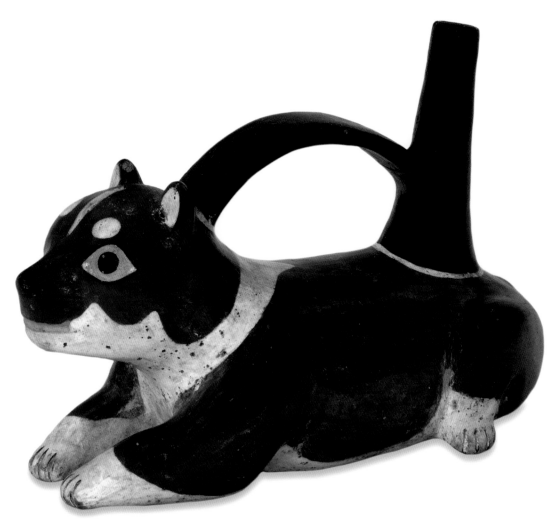

**Nasca Culture, Peru
Spout and bridge vessel
in the shape of a dog**
200 BC – AD 600
Pottery
12 x 15.5 cm (4¾ x 6⅛ in.)
London, The British Museum

This small, rotund pottery animal depicts the type of dog that roamed across Central and South America in the ancient world, in contrast to those seen across Europe and Eurasia. As the pre-Columbian societies of the Americas developed thousands of years ago, the dog entered their culture, and played important and diverse roles. Dogs were associated with the spirit world and were routinely buried on the death of their masters. They were believed – in particular a small, hairless type – to have healing properties; they were used as guard dogs and ratters; and they were eaten. Images of the dog appear throughout the artwork of ancient South America, attesting to their importance and providing valuable information about their physical characteristics. It is clear that they were diminutive in size, and of three principal types: a slightly larger spotted or patched dog thought to have been bred for food; a small dog that was an ancestor of the chihuahua; and a small hairless dog (the Peruvian hairless).

This pottery dog is interesting because it demonstrates the use of slip painting, a technique in which the pottery was painted with mineral pigments in black, brown and white before it was fired, so that the colours became indelible. Cultures prior to c. 200 BC painted their pottery after it was fired and used plant rather than mineral sources, which led to a very fragile finish.

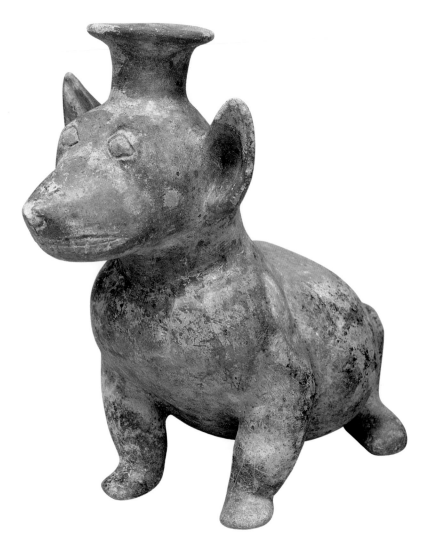

**Colima Culture, Mexico
Seated dog**
300 BC – AD 300
Pottery
Height 30.5 cm (12 in.)
London, The British Museum

The people of the ancient Colima culture, which flourished from *c.* 300 BC to *c.* AD 300 in western Mexico, produced some of the finest early clay pottery that has survived, and many of these pieces are images of dogs. The dogs are all similar in shape and proportion, being small, solid and invariably hairless, and are considered the ancestors of the chihuahua and the xoloitzcuintle (the Mexican hairless); they also resemble the ancient dogs of Peru and those along the western coast of South America.

In many pre-Columbian cultures, dogs were believed to guide the deceased's soul to the underworld, and to protect and guard it. In this capacity many of the hollow pottery figures, such as this one, functioned as funerary sculptures and were placed in tombs alongside the dead. This practice was seen in a number of the ancient cultures, including the Aztec, Toltec, Maya and Colima, and in some instances mummified dogs have been discovered alongside their masters in tombs. The dogs of Colima were specifically bred into two types, one to be fattened and used for food and for sacrifice at feasts, and the other to be used as guard dogs. Many images show dogs with an ear of corn in their mouth, alluding to their status as a much-appreciated edible delicacy. Over time and through selective breeding, the guard dogs became much larger than they had been originally.

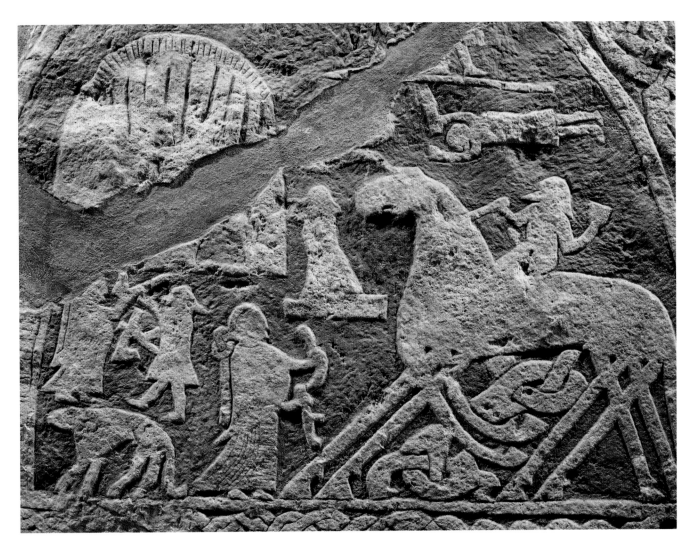

Viking
Figures illustrating a saga, from the Isle of Gotland, detail from the 'Tjängvide image stone'
9th century
Stone
Stockholm, Historiska Museet

For a period of several centuries roughly following the fall of the Roman Empire in the West in AD 476, the dog appeared only rarely in art, and its position in European arts and culture in general underwent a decline. This period, commonly referred to as the Dark Ages, was one of great struggle and hardship in Europe – hunger and poverty ran high, illiteracy was widespread and packs of feral dogs roamed, having been set loose after battle, abandoned or escaped.

By the time of this carving the dog had once again established a place in human society, and consequently began to appear anew in the visual arts. This Scandinavian battle scene depicts the large, raw-boned Nordic hounds that were used by the Vikings for hunting and herding and were descended from among the most ancient of dogs, tracing back to the spitz-type dog that evolved in the Arctic in prehistory. The scene shows the chief Norse god, Odin, riding his eight-legged horse Sleipnir, accompanied by his fierce hounds.

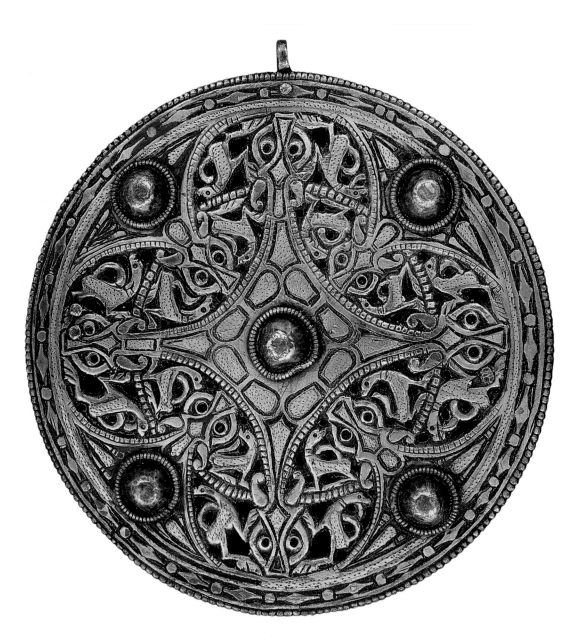

Mid-9th century
Silver with gold detailing
Diameter 11.2 cm (4⅜ in.)
London, The British Museum

Little is known about the history and origin of the Strickland Brooch, except that it is particularly unusual in the amount of gold used, and must therefore have been made for someone of great power and wealth. It is one of the best surviving examples of Anglo-Saxon decoration and was superbly crafted with great attention to detail. At first glance the dog motif carved into the silver of the brooch is barely discernible, but it is the form of dogs (or doglike creatures) that creates the patterned surface. The brooch is a quatrefoil design, with the raised animal heads separating the four sections, which contain dog figures in a regular pattern. These are decorated with gold detailing across their backs and collars carved out of the silver, while gold is also used to emphasize the surrounding structures of the decorative scheme.

Both men and women would have worn brooches like this, of which several have survived in excellent condition, pinned to such garments as cloaks. This brooch has a silver loop attached that would have enabled it also to be worn as a pendant.

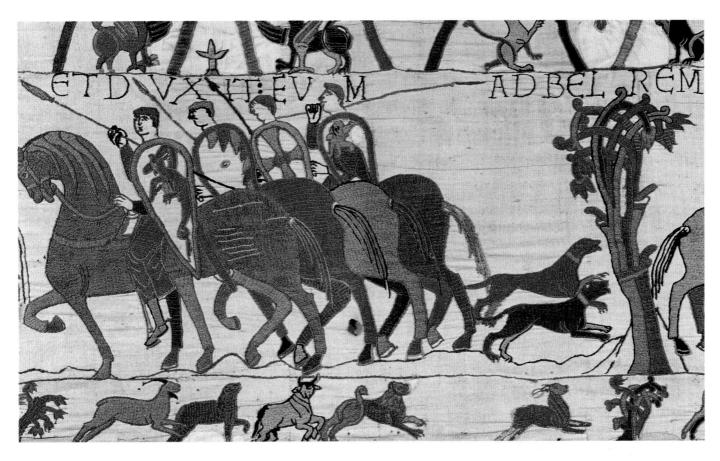

French School
Count Guy of Ponthieu takes Harold, his prisoner, to the castle of Beaurain, from the Bayeux Tapestry (detail)
1066–82
Wool embroidery on linen
France, Bayeux, Musée de la Tapisserie

The two French hounds that chase the heels of the horses in this detail from the famous Bayeux Tapestry are fine examples of their type. Numerous similar hounds appear along the length of the vast embroidered piece. French hounds were highly prized as far back as the days of the Roman Empire, and were particularly noted for their speed and their efficiency at hunting wild stag and hare. By the eighth and ninth centuries the French had adopted a specialized breeding system to create the best packs of hounds possible, and it had become an offence to kill a hound unless it had rabies. The monks of the Abbey of St Hubert in the Ardennes were particularly successful with their dog breeding and produced the St Hubert hound, a huge and powerful dog that was the ancestor of the bloodhound. The Norman invaders brought the bloodhound and the Talbot hound (a white variety, now extinct) with them to England during the conquest of 1066.

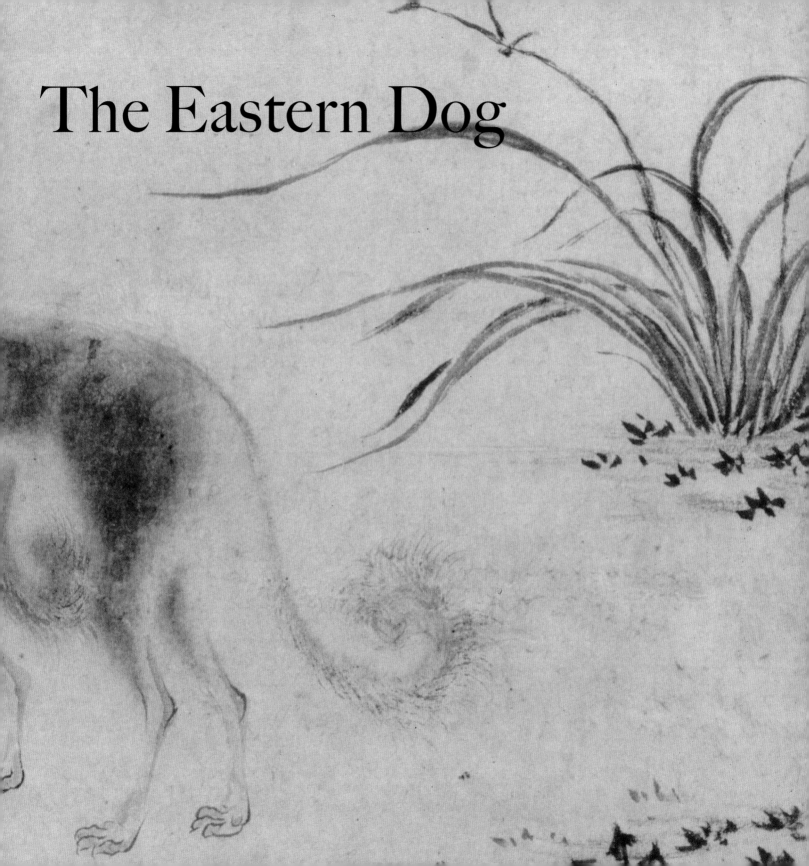

The Eastern Dog

PERHAPS NO OTHER ANIMAL MORE THAN THE DOG is so beset with ambiguity and conflicting perceptions on the part of human beings. The whole spectrum of contradictory beliefs can be seen in the long and rich history of the dog in Eastern cultures, from ancient Mesopotamia and the Middle East through India and China to Japan. Across this vast melting-pot of religions, traditions and cultural identities – an area as culturally diverse as it is geographically vast – the dog has ranged from being abhorred in some cultures to being worshipped in others. The dog or doglike creature is woven inextricably into the tapestry of Eastern history, art, mythology, religion and superstition: it has reigned alongside emperors; raced, claws clicking, through the palaces of ancient China; fought, bloodthirsty and ferocious, alongside the Japanese samurai; it has guarded the spirits of the dead, and been sacrificed, eaten and revered.

Virtually all the cultures of the ancient world assigned the dog (in some cases the wolf, jackal or coyote) a spiritual status, be it benevolent or malign; this may have involved the dog's being venerated or feared as an *actual* deity, such as the Egyptian god Anubis (see page 31) and the Sumerian goddess Bau, or its being revered or feared as the *companion* of deities. Bau was one of the three principal ancient Sumerian gods, and was associated with healing and life. She is often, although not always, depicted as dog-headed, and is usually accompanied by dogs; the ancient belief in the healing powers of a dog licking a wound can be traced back to Bau. Although not falling within our geographical definition of 'Eastern', many ancient Mesoamerican peoples shared similar beliefs about the dog, and worshipped the dog god Xolotl, a deity associated with the dead. Many Turko-Mongol and Siberian peoples of the Central Asian steppes worshipped the dog or the wolf as a spiritual entity, believing it to be an ancestral figure from which man was descended.

As the companion of deities, the dog is found in a wide range of religions and cultures, both Western and Eastern, including appearances alongside the well-known gods of Greece and Rome, and the perhaps less well-known Indian gods, such as the Hindu Bhairava (a manifestation of Shiva) and the ancient Vedic god Indra. In this capacity, as companion, the dog often represented the qualities of faithfulness and bravery. Both these aspects were inherent in the fierce little lion dogs (or fu dogs) associated with Buddhism. Buddhism developed in India about 2500 years ago and gradually spread through Tibet, China and Japan. The lion was the symbolic guardian of the Buddhist faith, but in China, there being no native lions on which to base artistic depictions, native dogs were used as a model, and in this way a mythical creature – half lion, half dog – was created. These are the lion dogs that guard the entrances to Buddhist temples across Asia, and which are widely depicted in Eastern art (see page 57).

The Chinese association with the dog dates to antiquity: as far back as the fourth millennium BC,

It has reigned alongside emperors; raced, claws clicking, through the palaces of ancient China.

Chinese School
Seated mastiff
Eastern Han Dynasty (AD 25–220)
c. AD 100
Earthenware
Height 58.4 cm (23 in.)
Indiana, Indianapolis Museum of Art

This handsome early Chinese pottery figure reflects the much sought-after mastiff type that was descended from the old Molossian dogs bred in the mountains of north-west Greece. These were the original guard dogs and hunting dogs used by the Assyrians, Babylonians, Greeks and Romans to protect their herds, for hunting wild horses, lions and other big game, and to fight their enemies. Quite how the mastiff type arrived in China is unclear, although records indicate that as early as *c.* 500 BC dogs of this type were being bred by the emperors and used for hunting quarry, including man. The Assyrians in particular had bred a prized strain of mastiff, which appears in exquisite detail in the bas-reliefs of Assurbanipal (*c.* 900 BC). It is conjectured that following the crumbling of the Assyrian Empire in *c.* 612 BC their valuable dogs were procured by Persians and possibly nomadic Asiatic tribesmen who may have returned with them to China. The mastiff is seen in varying forms throughout much of the surviving art of the ancient world, but perhaps nowhere quite so full of realism and life as in this figure.

The detail in the piece is quite extraordinary, with the wrinkles across the face typical of the breed lending the dog a particularly charming and charismatic quality. The heavy, though fit, frame and square front to the dog emphasize its power and stature.

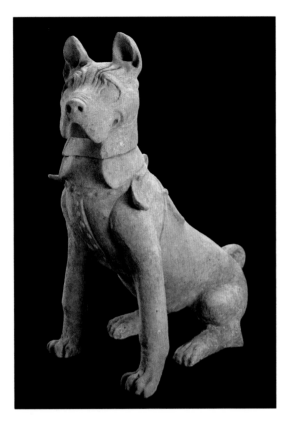

Fo-Hi, the mythical founder of the Chinese dynasties, extolled the virtues of so-called 'sleeve dogs' – dogs so tiny that they could fit into the sleeve of a garment and provide warmth and comfort to the wearer (see *Dogs*, overleaf, by the Emperor Hui-tsung). The importance accorded to dogs is indicated by evidence from tombs: the discovery near the modern city of Anyang, in Henan province, of a royal tomb from the Shang Dynasty (1600–1046 BC) revealed the remains of the queen consort Fu Hao, who was buried with six dogs; while a tomb in Hubei province was found to contain the remains of a dog in its own coffin, alongside that of its owner, Marquis Yi of Zeng. Large mastiff-type dogs, as portrayed in the pottery figure shown above, were kept for hunting and for guarding property. Small dogs, ancestors of the Pekingese, were highly prized, and were bred and kept by the Chinese emperors. They were assigned royal titles (first by Emperor Ling Ti in the second century BC) and their own guards, and were often given to dignitaries as precious gifts. Pekingese breeding in China reached its height during the nineteenth century, by which time the little dog with the big character was regarded as an exotic and pampered pet. Dowager Empress Cixi (Tzu Hsi) famously kept Pekingese and other small dogs, trying to breed them to appear as 'lion'-like as possible. In 1860 British and French forces took control of Beijing (Peking); on finding five Pekingese dogs that had survived in the Imperial Palace, British officers returned with them to England, where two of the dogs would become the foundation of the breed. However, the Pekingese's fabulous success and pampered status in China led to the blackest time in the breed's history, when it was all but wiped out during the Cultural Revolution of the late 1960s and Mao's backlash against decadence of any kind.

Little dogs, the ancestors of the Tibetan Lhasa Apso, were similarly popular in Tibet from ancient times, and there was – and continues to be – a tradition among the Dalai Lama and Panchen lamas of keeping small pet dogs, sometimes referred to as 'holy dogs'. Similar diminutive and irresistible dogs, in all their forms – Tibetan, Chinese, Japanese and Persian – are seen consistently in the visual arts, particularly in Eastern works, in their role as pet, such as the endearing black-and-white dog in the Persian *Young Portuguese* (page 66). Persia (Iran), in fact, is more commonly associated with the Persian

cat, but it was also in this area that the saluki, one of the oldest dog breeds still surviving, is believed to have evolved, whence it quickly romped through Egypt, the Arabian Peninsula and India. The noble saluki was often depicted accompanying princes and aristocrats, in such images as the endearing little saluki-like black dog in *Raja Medini Pal* (page 67), and the elegant hounds in *Maharana Jawan Singh of Mewar Hunting Wild Boar* (page 69).

The dog in ancient Japan was perceived as both a benevolent and a malevolent entity. The emperors favoured the small Japanese Chin breed, which became the imperial pet after being introduced to Japan from Korea in about AD 732, and played a similar role in the royal Japanese household to that of the small Chinese breeds in China. Dogs were considered lucky in much of Japan, and dog effigies, amulets and hair were carried about the person to bring luck and good health; dog sacrifice was carried out to ward off evil spirits. In some areas, particularly in rural locations, the Oki islands and parts of Kyushu and Shikoku, it was believed that in certain circumstances dogs could become powerful spirits, known as *inugami*. Such dog gods could be used by their owners (*inugami-mochi*) for vengeance, as guardians and to garner wealth and good fortune. People believed to be *inugami-mochi* (essentially witches) were often shunned by their community, even to the extent that in some rural areas, those owning dogs were assumed to be evil. Conversely, there are a number of dog shrines across Japan, including the Inunomiya Shrine in Takahata-Machi and the Yanahine Shrine at Shizuoka, where the dog is worshipped as a protective and lucky spirit. The samurai warriors used large dogs, such as the Akita and the Tosa, for fighting, while domestic pets tended to be small dogs, like the one illustrated in *A Woman Holding a Dog in her Arms* (page 61).

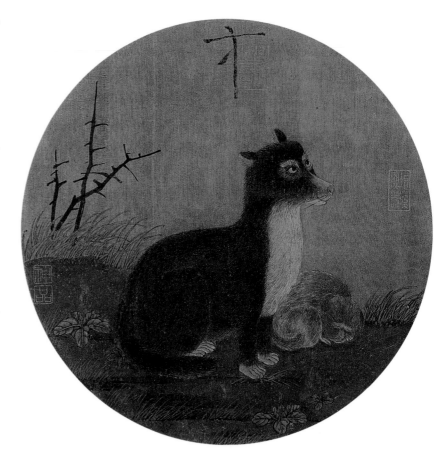

Emperor Hui-tsung (1082–1135)
Dogs
Sung Dynasty (960–1279)
c. 1100–1135
Ink on silk
Dimensions unknown
Pennsylvania, Merion,
The Barnes Foundation

The Chinese love of small dogs is legendary, and indeed many of the small dog breeds so popular in the Western world today originated in China, Tibet or Japan. It is of particular interest that small dogs, kept as pets by the wealthy, were so widespread almost two thousand years ago, despite the common perception that dogs were primarily kept for such useful services as hunting, protection and sport. Pet dogs (the original lapdogs) in ancient China were specifically bred for their size, colouring and endearing characteristics; the apogee of this tendency was the tiny 'sleeve dog', which was small enough to ride in the wide sleeves of dignitaries. Towards the end of the seventeenth century tiny dogs again became highly fashionable, and the trend has persisted until modern times, with increasing numbers of 'toy' breeds and miniatures.

These two delightful characters are typical of the small dogs bred in twelfth-century China, the tightly curled up and sleepy dog possibly an ancestor of the pug or the Pekingese, and its perky friend with pointed nose somewhat harder to define.

**Emperor Hsuan-tsung
(reigned 1426–35)**
Two Saluki Hounds
1427
Ink and light colours on paper
album leaf
26.2 x 34.6 cm (10⅓ x 13⅝ in.)
Massachusetts, Cambridge, Harvard
University Art Museums, Arthur M.
Sackler Museum

Culture, the arts, literature
and refinement were defining
aspects of the great royal
courts of China, many of
the emperors being avid art
collectors and some also
producing their own works.
Emperor Hsuan-tsung was
one of the most artistically
talented of these rulers, as is
admirably shown by this fine
pen-and-ink drawing of two
saluki hounds. His touch is
light, the colours delicate,
the foliage intricate and the
rendering of the two elegant
dogs masterly. Hsuan-tsung
not only captures their
particular physical form
with great accuracy but also
conveys the very specific
nature of this ancient breed
of dog. These are truly 'royal'
dogs, with noble bearing,
exquisite shape and an
apparent slight aloofness.

The saluki is one of the
oldest breeds of dog: a sight
hound, it originated in ancient
Egypt and Mesopotamia,
and was much prized for
its swiftness and hunting
abilities. It is thought to have
first entered China during the
Tang Dynasty (AD 618–907).

Dogs were commonly sacrificed in ancient cultures, both Western and Eastern, including in Greece, South America, China and Japan, for various motives: from warding off famine and disease to ensuring a safe and prosperous journey and 'placating the four winds'. In conjunction with sacrifice and as distinct from being a food source, dogs were also eaten. Since dogs were perceived as having a magical and spiritual nature, the consumption of their flesh was thought to heal as well as to combat fatigue. The philosophy behind this practice illustrates the role the dog was believed to have in bridging the spiritual and secular worlds, as a supernatural being with a physical manifestation.

On a different level is the tradition of eating dogs as food, with dogs specifically raised for the purpose. Eating dog is a custom that, although unpalatable to the sensibilities of most Western cultures, has existed since antiquity and is still practised in areas of China, India, Indonesia, Korea, Vietnam and Taiwan. However, it is impossible completely to separate the dog as a food source from the ritually sacrificed and eaten dog, with all its attached spiritual significance; and even today in cultures where dog is routinely eaten, its meat has certain associations, ranging from boosting virility to enhancing health and well-being.

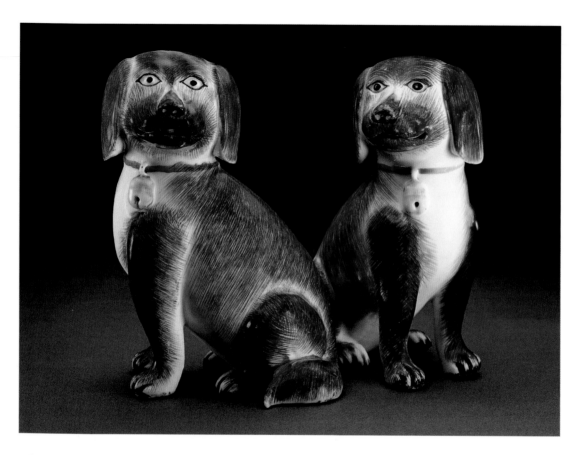

Chinese School
A pair of seated spaniels
Qing Dynasty (1644–1912)
c. 1750
Porcelain
Dimensions unknown
Private collection

The Qing Dynasty, which lasted for almost 300 years, saw a flowering of the arts in China and was a period of great artistic patronage by the royal courts, bolstered by a long phase of political stability. It is often considered to be the culmination of the preceding years of artistic development, and the quality of production in the ceramics industry in particular was exceptional. This pair of beautiful spaniels is an excellent example of the porcelain work of the time, with the deep, rich colouring and fine detailing indicative of advancements in pigment,

glaze and enamelling techniques.

Although the spaniel, of which there are many kinds, is most commonly thought of as a British breed, it is likely that the ancestors of the modern strain came from the East. The Tibetan spaniel, which these porcelain figures resemble, is an ancient breed that evolved in the Himalayan mountains, bred there by Buddhist monks. There are no precise dates pertaining to the beginning of the relationship between the monks and their dogs, although it is believed to

date back to the early history of Buddhism in Tibet (c. AD 500–800). Legend has it that the Tibetan spaniel was used to turn the prayer wheel, and became a symbol of good luck; they were also valuable as guard dogs, having excellent sight. They followed the monks closely and loyally, and were greatly prized. The dogs were frequently given as gifts, and sent to the palaces of China and other Buddhist countries, resulting in the breed becoming more widespread geographically.

Chinese School
Fu Dogs, Protectors
of the Faith
19th century
Porcelain
Dimensions unknown
New York, American Museum
of Natural History

Fu (or foo) dogs, also known as lion dogs, have been represented in Chinese art for more than two thousand years, tracing their symbolic importance back to the spread of Buddhism. The lion is a sacred animal in Buddhism, and when the faith spread to China the lion was adopted as the 'defender of the law and protector of sacred buildings'; however, since it is not indigenous to China, visual representations of the animal were based on native dogs – the ancestors of, among others, the Pekingese and the pug. In this way the lion became a lion dog, a mythical creature, which, however, retains a strongly canine appearance. 'Fu dog' is another term used to describe this sacred creature; the Chinese *fu* means 'happiness', further associating these little dogs with good fortune and joy.

Traditionally fu dogs are depicted in pairs, a male and female, with the male resting his paw on a globe and the female resting her paw on a sleeping pup or cub. The figures are invested with great symbolism, the male figure generally representing the guardian spirit and the female the maternal nature.

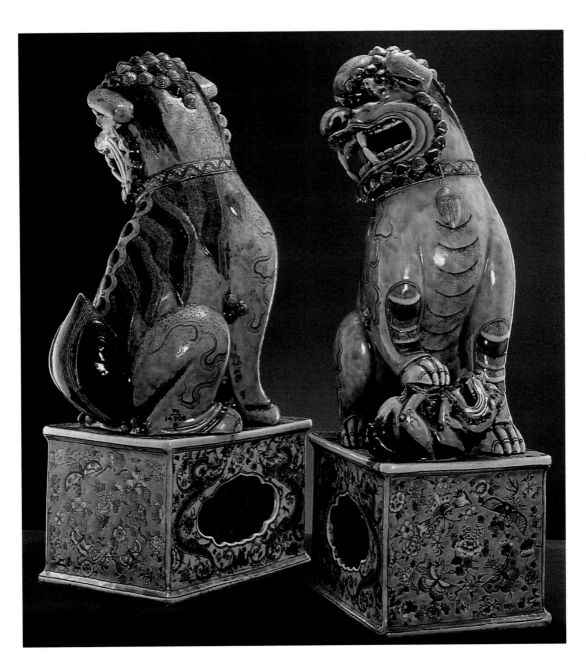

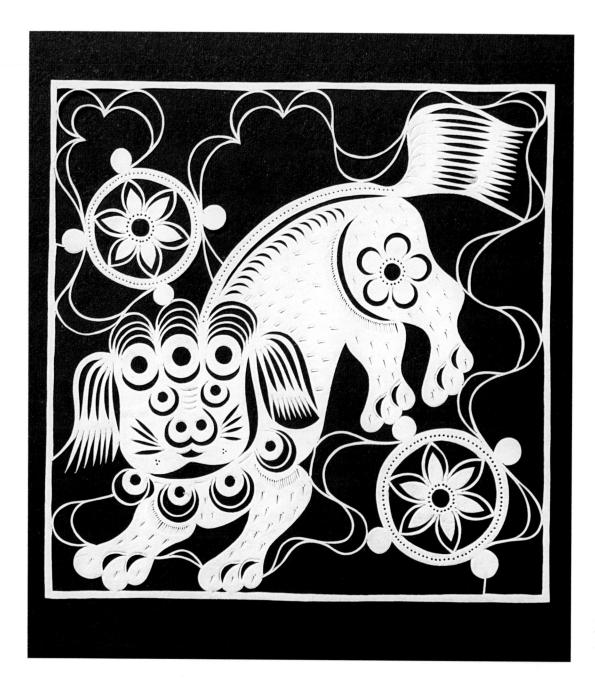

Chinese School
Lion dog
1985–88
Papercut
11.7 x 11.7 cm (4⅝ x 4⅝ in.)
London, Victoria and Albert Museum

This twentieth-century papercut is an unusual and delightful interpretation of one of the oldest Chinese symbols, the lion dog – a mythical creature modelled on the ancient Chinese and Tibetan small breeds of dog, and important within the Buddhist faith as a protector and defender. Traditionally lion dogs were sculpted, often out of precious and semi-precious materials, and placed in pairs at the entrances to sacred buildings, government offices and the homes of the wealthy. They are one of the most famous and deeply ingrained symbols in Chinese culture and continue to be incorporated into decorative schemes, as well as being produced on a smaller scale and used as amulets to bring happiness and good fortune.

There are many legends surrounding the lion dog and how it came to be, one of the most appealing being particularly popular among Pekingese-lovers. The story goes that a lion fell in love with a marmoset, and begged the patron saint of animals to reduce his size so that he could be wedded to his lady, but for him to retain his lion's heart and courage. The progeny of this surprising union were the lion dogs of China – the ancestors of the Pekingese.

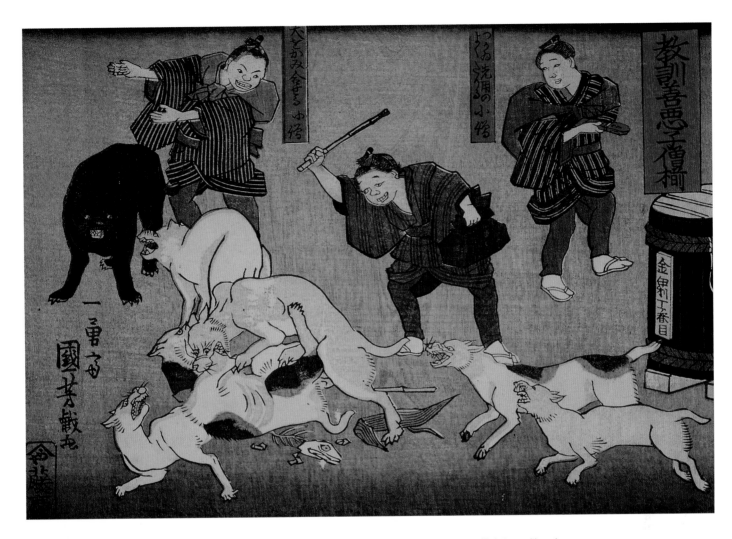

**Utagawa Kuniyoshi
(c. 1798–1861)
*Moral Teaching for Shop
Boys, Giving Good and Bad
Examples of Behaviour***
1857
Colour woodblock print
17 x 24 cm (6¾ x 9⅜ in.)
London, University of London, School
of Oriental and African Studies Library

During his long career, the
Japanese master Utagawa
Kuniyoshi proved himself to
be one of the last and greatest
artists working in the *ukiyo-e*
('pictures of the floating
world') style of woodblock
prints. He produced a huge
volume of characteristic
prints, featuring a clearly
defined line, a vibrant use of
colour and often some sharp

humour or subtly disguised
political content.
 This print was one of a
series of some twenty-six
works on the same subject,
the teaching of morals to shop
boys. Here the 'good' shop
boy sets off to run an errand,
while the 'bad' shop boy sets
the dogs on one another
and encourages a fight. The
dogs themselves are rather

unspecific in type, although
they have a general houndlike
appearance; the same dogs
play a part in many of the
other prints in the series.
The large black creature
in the background is more
akin to a feline, although
disproportionately big – it is
known that Kuniyoshi was a
great lover of cats and kept
many in his studio.

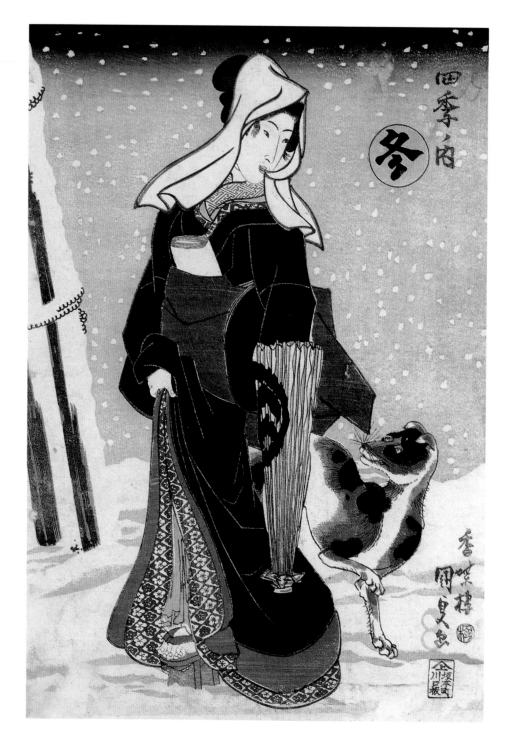

**Utagawa Kunisada
(1786–1864)**
***Winter**, from the series **'Shiki
no uchi'** ('The Four Seasons')*
c. 1835
Colour woodblock print
35 x 23.8 cm (13¾ x 9⅜ in.)
France, Giverny, Musée Claude Monet

The master woodblock artist
Utagawa Kunisada, about
whose life relatively little is
known, was one of the most
prolific and distinctly original
printmakers of his era. During
his lifetime he was extremely
popular, his unique artistic
expression and ability to
capture the public taste earning
him considerable esteem. His
work also had a significant
influence on the Impressionist
painters of France.

This exquisite print of a
woman and her dog picking
their way through a chilly winter
landscape in a snowstorm is a
particularly compelling example
of Kunisada's work. The
pattern of the two-dimensional
surface of the print, with its
flat areas of clearly defined
subdued colour enhanced
by the dotted snowflakes,
is a visual delight, but it is
the relationship between the
woman and her dog, their
unspoken bond and dialogue,
that turns this into a true work
of art. With front paw lifted and
delicately curled above the
cold ground, the dog gazes
at the woman, who returns
the look with an expression
that conveys compassion, a
mutual understanding of their
situation, the bone-numbing
chill, and a sense that respite
is not far away. It is an
extraordinary achievement
to evoke such an intense
emotional exchange between
woman and dog through
posture and a look.

**Kitagawa Utamaro
(1753–1806)**
*A Woman Holding a Dog
in her Arms*, from 'Five
Physiognomies of Beauty'
c. 1804
Colour woodblock print
38.5 x 25.5 cm (15⅛ x 10 in.)
London, University of London, School
of Oriental and African Studies Library

This print depicting a
beautiful Japanese lady
cradling an equally charming
small pet dog with inquisitive
little eyes and long, silky tail
is typical of the works that
made Kitagawa Utamaro
famous. He was one of
several great woodblock
artists of this time and
specialized in paintings of
bijinga (beautiful women)
and subjects from nature,
including animals and insects.

The delicate and perky
dog in this work gives the
piece a dynamic edge: the
depiction of the relationship –
both physical and emotional
– between the dog and the
woman adds an extra
dimension. The smooth,
richly coloured form of the
dog enlivens the surface
pattern created through the
clearly defined and simple
lines of the woman, while
also projecting a three-
dimensional quality that
the woman herself lacks.
Through such contrasting
elements, which at the same
time enhance the overall
decorative nature of the
work, the dog becomes the
heart of the image. There
is a vivacity in the animal
as it stares intently from
the picture, focusing, like the
woman, on a diversion that
remains tantalizingly obscure
to the audience – the two
joined in their mutual interest.

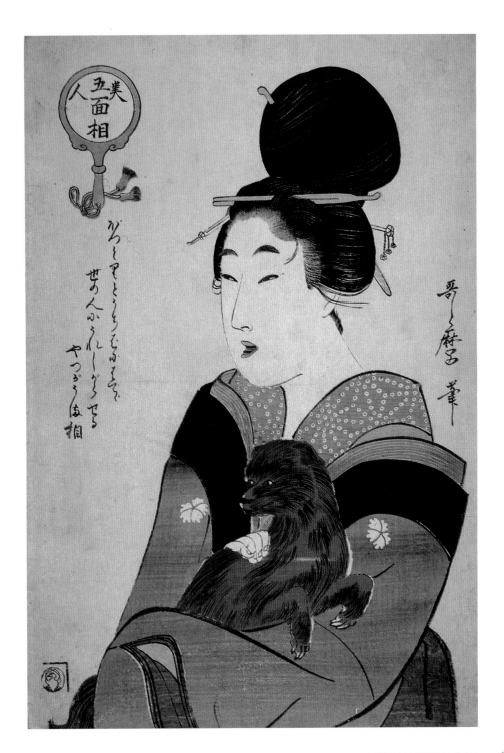

Japanese School
Netsuke: Shishi (lion dog)
on a seal base
Edo Period (1603–1867/8)
18th century
Ivory
Height 5.1 cm (2 in.)
London, The British Museum

This beautiful little sculpted dog is modelled on the lion dog form (*shishi* means lion dog), and its physical aspect has much in common with Pekingese, pug and Japanese Chin breed characteristics. It is an endearing piece, the dog sitting with its weight back on its haunches and gazing upwards, in a pose very commonly seen in dogs as they eagerly await food. In this way the artist has melded the traditional lion dog symbol with the very real, physical presence of a little dog.

Netsuke were first carved during the seventeenth century, but became most popular during the latter half of the Edo Period. They were designed to function as a type of button or toggle, and were used to secure decorated pouches or boxes via a piece of cord to the sash of the traditional kimono. Kimonos had no pockets, hence the need for these pouches and the consequent development of the netsuke. They were carved in innumerable different forms and are artworks in their own right, this lion dog being especially fine.

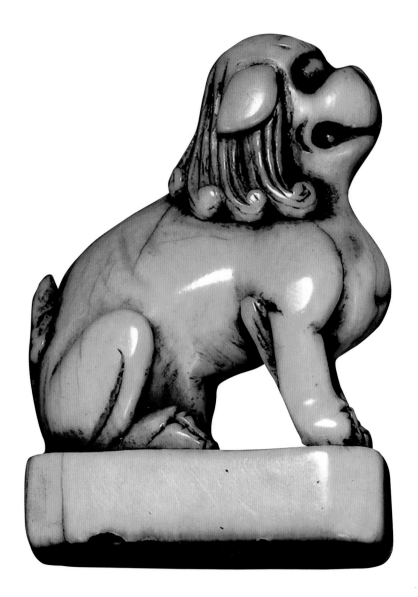

Islamic School
Islamic lustre-ware tile decorated with two dogs and a floral design
c. 1267
Ceramic, frit, underglaze and lustre overglaze
20 x 20 cm (7⅞ x 7⅞ in.)
UK, Durham, Durham University, Oriental Museum

This beautiful tile was crafted during a period when Islamic ceramics and other arts were flourishing, using a technique known as lustre-painting, which produced a soft metallic sheen on the surface of the ceramic. At this time the use of actual precious metals was forbidden, which led to the development of this innovative technique, unique to the Islamic world, that gave the appearance of metal. Here, the stylized dogs are beautiful, curious hound types with large, pointed ears, and have great decorative appeal. Interestingly, dogs were unpopular animals with some of the Muslim community, by whom they continue to be viewed with ambivalence or dislike. Such tiles as this, however, were often used in the decoration of the tombs of Shiite imams in the ancient Shia holy cities of Persia, including Mashhad and Qom (in present-day Iran) and Najaf (in present-day Iraq). This tile comes from the tomb of Imamzadeh Jaffar at Qom.

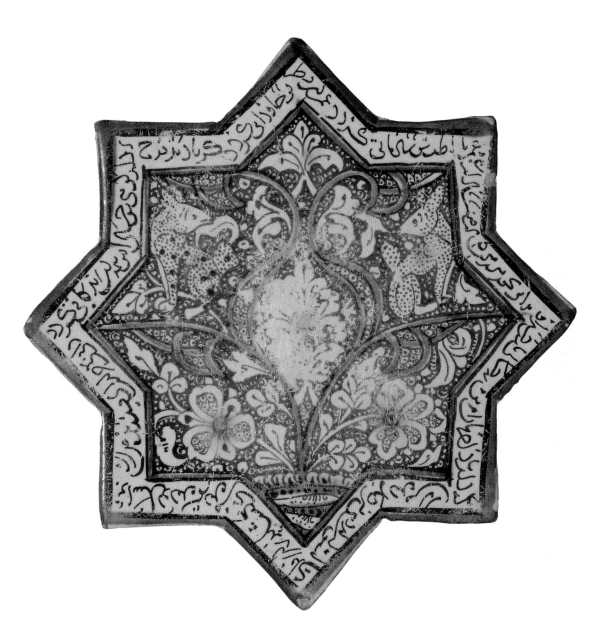

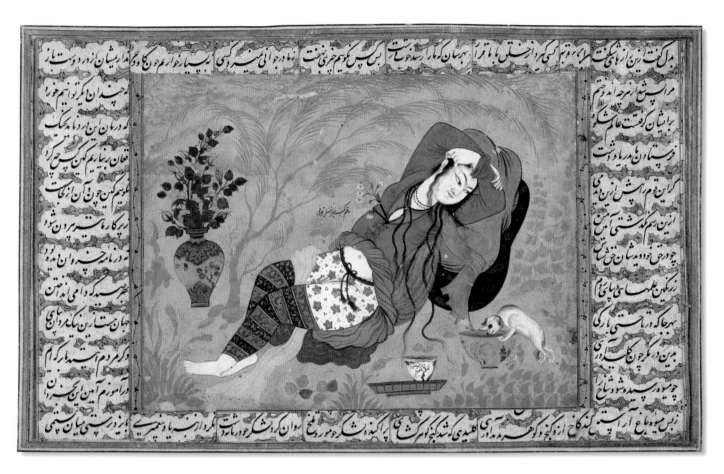

**Mir Afzal of Tun
(dates unknown)**
*A Lady Watching her Lapdog
Drink Wine from a Bowl*
c. 1640
Printing on paper
15 x 25 cm (5⅞ x 9¾ in.)
London, The British Museum

Isfahan, the city where this exquisite illustration was made, was the heart of ancient Persia (now Iran) and a centre of great artistic activity during the Safavid Dynasty (1501–1736). Isfahan's 'golden age', at its height in the sixteenth and seventeenth centuries, began with the reign of Shah Abbas I, the unifier of Persia, who made the city his capital. During this period Isfahan was a great cultural as well as trading centre, and its arts were influenced by Turkoman, Chinese and European sources. It was also a time when Isfahan was, by some accounts, home to a number of high-class courtesans, such as the lady pictured here.

There is a delightful humorous quality to this decorative painting of a languid courtesan reclining slothfully, watching her lapdog drink wine. The little dog seems all the more diminutive against the ample proportions of its owner, and indeed against the size of the bowl into which it eagerly thrusts its nose. The woman, whose lavish clothing is in a state of partial disarray, is an example of promiscuity, laziness and indolence, and the whole picture was conceived as a warning against such behaviour. The style shows the influence of Riza-i Abbasi (c. 1565–1635), a noted artist, and this work has much in common with his *Young Portuguese*, depicting a similarly curvilinear figure feeding wine to a small dog (page 66).

Iranian School
*Hunter on Horseback
Attacked by a Lion*
Mid-18th century
Oil on canvas
95 x 86 cm (37 ⅜ x 33 ⅞ in.)
New York, Brooklyn Museum of Art

The slender, saluki-type hound that cavorts across this canvas has a rather cheerful demeanour, at odds with the violent scene of which it is a part. Compositionally there are two strong forces of converging movement at work, with the horse and its generously moustached rider coming from the left, and the lion and dog moving from the right. Through the use of such compact pictorial space, the energy of movement meets in a crescendo in the middle, where the lion's head attacking the man forms the central point of the picture. The dog, however, is separate from the tightly joined figures of man, horse and lion, and its graceful white form attracts the eye, which is then guided through its upturned head and elegant neck towards the centre of the picture in a very cleverly contrived composition.

This was a period of political instability for Persia, which saw the start of the collapse of the Safavid Dynasty in 1722 and the subsequent invasion of the country by European, Russian and Ottoman forces. Partly through Ottoman influence, there developed a fashion for oil painting, such as this, where, previously, small-sized works for manuscripts and albums had prevailed.

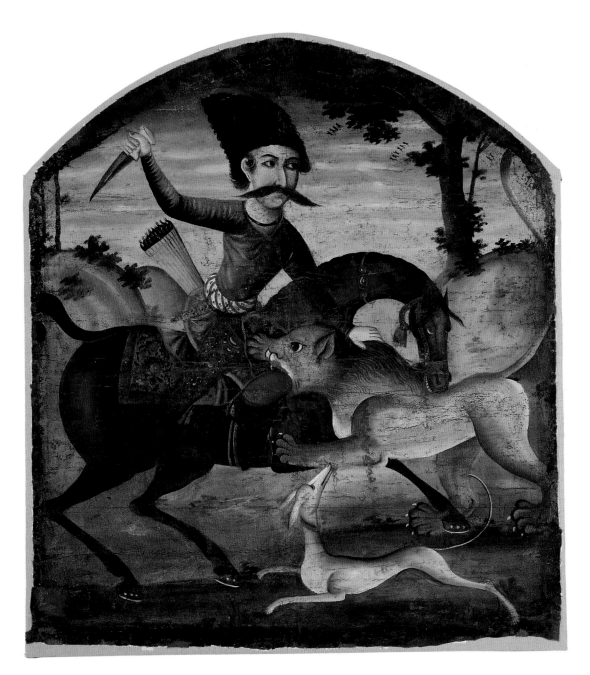

Riza-i Abbasi (c. 1565–1635)
Young Portuguese
1634
Watercolour, gold and ink
on paper
14.6 x 19.2 cm (5¾ x 7½ in.)
Michigan, The Detroit Institute of Arts

Riza-i Abbasi was widely considered to be the leading Persian painter of his time, and this is one of the most charming Persian images depicting the relationship between man and dog of the seventeenth century. There is genuine affection in the posture and countenance of both the man and the dog, which is so small that it clambers up his leg to lap wine from his hand.

The dog occupied a slightly ambiguous position in much of the Muslim world, owing to differing interpretations of the Koran, and images of the dog are therefore found less frequently there than in Europe, for example. The exception is in hunting pictures, where hounds accompany royalty, or in such small works as this, where tiny dogs appear as the archetypal pet or lapdog. The tradition of owning such diminutive pets began in antiquity and has persisted to modern times, reflecting the enduring appeal of these little dogs.

Riza-i Abbasi (c. 1565–1635)
Miniature of a Young Man in European Costume Holding a Gold Carafe
17th century
Watercolour, ink and gold
on paper
32 x 20 cm (12⅝ x 7⅞ in.)
Geneva, Musée d'Art et d'Histoire

The sensuous curvilinear form of the young man here, his tiny dog at his feet, was one that influenced a succession of artists. Riza-i Abbasi was the foremost miniature painter of his time, and trained at the court of Shah Abbas I – from whom he took his name – who was the most powerful ruler of the Safavid Dynasty in the Persian Empire. The Safavids sought to open lines of communication with Europe, and this led to a European influence in the Persian arts. Figures were depicted, like this one, dressed in European clothing, and eventually such European techniques as oil painting were adopted.

After training at the royal court, Riza-i Abbasi spent many years living and working among the lower strata of society, before returning to the court, where he stayed until his death. He made numerous paintings of slightly effeminate, graceful male figures, and included tiny pet dogs to accentuate the sense of femininity and sensuality. This particular jaunty white dog appears to be playing, possibly biting at its owner's heels, while the man himself seems gently indulgent and slightly surprised.

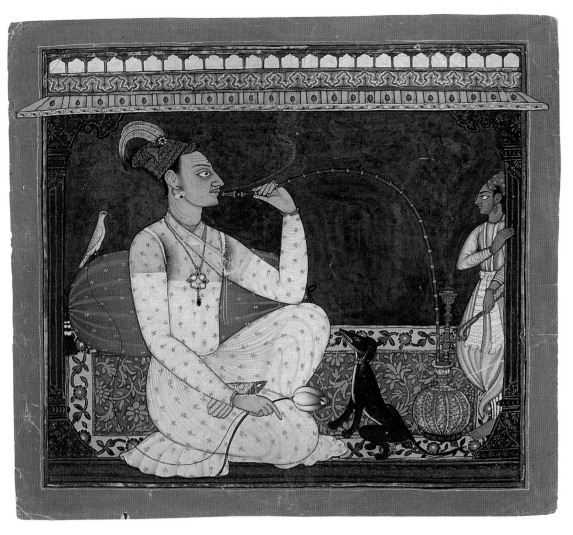

Pahari School
Raja Medini Pal,
inscribed on the reverse
in Takari characters
'Bilauria Medina Pal'
1735
Painting on paper
20 x 20.3 cm (7⅞ x 8 in.)
New Delhi, National Museum of India

The Pahari school of painting flourished from the seventeenth to the nineteenth centuries in the sub-Himalayan state of Himachal Pradesh, the beautiful hillside town of Basohli being particularly active. The ruling Rajput kings, of whom Raja Medini Pal was one, were great patrons of the arts, and their consistent interest and collecting contributed to the rich artistic culture of the time.

Works made in Basohli during the early eighteenth century were distinctive through their use of vivid colour, as seen here, and exaggerated facial features. The ruling raja was a popular subject, and here Raja Medini Pal is seen smoking the ubiquitous hookah, watched almost enviously by his most charming little houndlike dog. The diminutive creature with the silky ears of the saluki is a

rather surprising addition to the work, and, compared with the highly decorative and stylized treatment of the raja and the background, has been painted with a greater degree of realism. An added dimension is present through the dynamics of the bird–dog relationship, with the elegant bird peering at the dog, which returns the look, somewhat disdainfully.

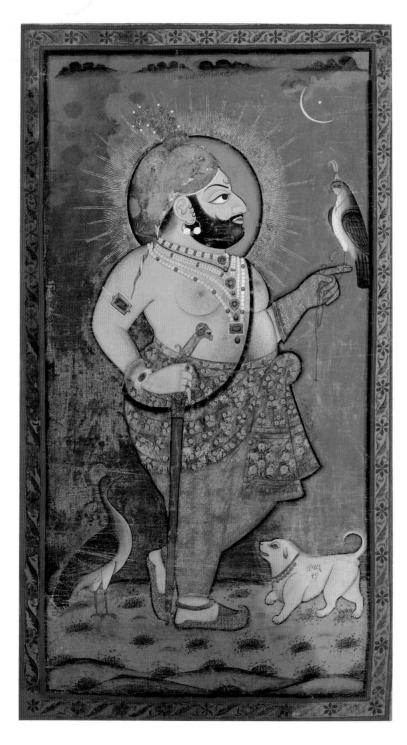

Chokha (active 1799–1824)
Maharana Bhim Singh of Mewar with a Hawk
c. 1805
Gouache with gold on cloth
107 x 59 cm (42⅛ x 23¼ in.)
Oxford, Ashmolean Museum

The powerful Maharana Bhim Singh ruled the Hindu kingdom of Mewar in India's Rajasthan region for many years (1778–1828), and during those occasionally turbulent times was painted on numerous occasions. Perhaps the most familiar images are of him hunting, accompanied by attendants, fine horses and slender, saluki-type hounds, but this unusual painting is one of the more delightful. Gone are the heroic and romantic hunting dogs, and in their place is this appealing pug type, clearly a pet and, amusingly, of similar bodily proportions to its well-rounded owner. The extrovert-looking little dog raises one paw, which reflects compositionally the maharana's own foot, while the diagonal lines of the dog's front and hind legs mirror those of the maharana's leg and his bent arm. This is a clever approach to the picture structure that creates balance through the play of powerful diagonal and vertical lines.

The painting is by Chokha, who, along with his father, Bakhta, was one of the leading artists in Mewar. They produced a number of exquisite works in this vein, and were of some influence on other artists of the time.

Indian School
Maharana Jawan Singh of Mewar Hunting Wild Boar
1835
Watercolour on paper
39.5 x 26 cm (15½ x 10¼ in.)
London, Victoria and Albert Museum

The art of India's Mewar kingdom is rich and decorative, that of the eighteenth and nineteenth centuries being among the most visually stunning. The maharanas were one of the principal subjects, and were frequently depicted hunting, almost always in the company of dogs. This example is no exception, with the fine saluki-type hounds forming a key motif within the patterned composition. This type of dog was akin to royalty, and specimens of the strain were much sought after and prized for their great speed. It is no coincidence that the maharanas were seen on the finest-looking horses and that their dogs were of the highest quality.

This interesting painting is composed of two scenes. In the background the maharana and his dogs chase boars: he has run his quarry down and, aided by his brave hound, is killing one boar, while in the foreground the main scene is played out, and more dogs kill another. A green tonality runs through the painting, and the maharana and attendants are also dressed in green. This probably alludes to a ritual spring hunt called the Aheriya, where everyone wore green, and at which a successful catch by the maharana would signify a fertile year ahead for the kingdom.

The Religious Dog

THE RICH AND ELOQUENT ART OF THE Renaissance abounds with images of the dog, usually secondary to the principal subject, but playing, nonetheless, a vital symbolic, compositional, didactic or emotional role. Dogs romp through hunting scenes, grace portraits and add to the popular mythological paintings, but it is their place within that most hallowed of genres, the religious picture, that has such an interesting and poignant history.

Having flourished for thousands of years alongside humans, guarding their dwellings and flocks, hunting for food and gradually creeping into their hearts and homes, after the fall of the Roman Empire in the West in AD 476 the dog found itself thrust into the wilderness. Great packs of dogs – war dogs left behind following battles, and those that had lost their homes and owners – roamed the lands, becoming objects of fear and harbouring disease. During this period the monotheistic religions – Judaism, Christianity and Islam (founded in the seventh century) – grew increasingly influential, and the attitude of these faiths towards dogs was, at first, one of ambivalence or outright abhorrence. Not only was the dog thought to represent all the bad qualities of human nature, but it was also (especially black dogs) at times considered symbolic of the devil and of pestilence, and was considered an unclean animal. It is significant that these three religions hailed from one of the geographical areas most plagued by packs of feral dogs, and that these dogs were afflicted by the devastating disease rabies. The symptoms of rabies – frothing at the mouth, extreme aggression and erratic behaviour – were understandably seen as 'demonic', and the result of a rabid dog bite was certain death. The monotheistic religions, reacting against the polytheistic traditions of ancient Egypt, Greece and Rome, also now turned against the dog, which had been worshipped as a deity. Thus 'man's best friend' fell from favour across parts of Europe and the Middle East, and from art – but it would not fall far or for long. It was the domestic dog that seems primarily to have been affected, and moved outdoors to join the hunting and guard dogs, both of which were still a necessity. By the time of Clovis I (*c.* 466–511), first king of the Franks, however, dogs appear to have been becoming popular again, at least in Europe. Clovis laid down several laws pertaining to their care, and Frankish noblemen kept packs of hounds for hunting, which from this time became increasingly favoured as a sport. This in turn led to a renewed interest in breeding hounds, and heightened the value attached to dogs. It was a small step for favourite hounds to move from the kennel to the house and towards the hearth again.

One of the most striking features of the human–canine relationship is its ambiguous nature, and contradictory aspects were evident even within the rigid dogmas of organized religion, for while the dog was shunned, its name used as a slur and the

The dog gradually rekindled its affair with man, fanning the embers of a latent fire, until once again it took its place on the painted canvas, this time alongside saints and sinners.

Spanish School
***The Annunciation to the Shepherds*, from the vault of the King's Pantheon (detail)**
12th century
Fresco
Spain, León, Colegiata de San Isidoro

This striking fresco cycle on the ceiling of the magnificent King's Pantheon (Panteón de los Reyes) in the Colegiata de San Isidoro is a beautiful example of the dog's appearance in early Christian works. The dog is not simply included; it forms a significant part of the composition, both in actual, physical size – it being a colossal guard dog – and in the role it plays with its shepherd master. The man is tenderly feeding the dog, even holding the bowl up for it, at the moment that the archangel Gabriel appears to him. Although the rendition of the dog is unrealistic, the animal would certainly be representative of one of the large mountain types that were bred to watch over herds of livestock.

The artist has taken considerable care to paint an animal of some status, emphasizing its size and muscularity to reflect its importance to the shepherd. Despite the dog's physical presence it is clearly subservient and unthreatening to the man, and he is treating it with affection.

behaviour of reprobates described as doglike, the animal was paradoxically also associated with fidelity. The concept of faithfulness being one of the underlying principles of Christianity, and the dog being the most faithful of creatures – who could doubt the little white dog in Carpaccio's *Vision of St Augustine* (pages 82–83)? – it gradually rekindled its affair with man, fanning the embers of a latent fire, until once again it took its place on the painted canvas, this time alongside saints and sinners. Even in the culture of Islam, where the dog was

particularly derided – the word for dog, '*kelb*', was commonly used as a derogatory term – it was still recognized as an important tool for hunting and guarding, and the saluki was referred to as '*el hor*', 'the noble one'.

In Europe, by the twelfth century the dog had started to appear in Christian religious works as a subsidiary but not unimportant element of the painting construct, such as the powerful dog being fed from a bowl in *The Annunciation to the Shepherds* (above). Concurrent with the gradual acceptance

**Guido da Siena
(active ?1260–?1270s)**
The Nativity
c. 1275–80
Oil on panel
36 x 47 cm (14⅛ x 18½ in.)
Paris, Musée du Louvre

Nothing is known about the life of this Sienese painter, who is hailed by some as the founder of the Sienese School – Siena was a prominent centre of panel painting in the thirteenth century. Guido was one of the first artists to break with the rigid frontal structure of Byzantine painting and to introduce more gesture and human interaction into his work. This small panel is believed to be one of twelve relating to the Nativity and the Passion that may have been associated with his large panel *Madonna and Child Enthroned* at San Domenico, Siena.

The little white dog that sits in the foreground of this Nativity scene is a surprising and slightly incongruous element of the painting, and is particularly emphatic against the background because of its bright white colouring. It sits expectantly, watching its shepherd owner, who emerges from the shadows on the right. The dog's brilliant whiteness forms part of a central triangle – together with the white swaddling clothes of the baby Jesus and the white cloth of the attendant at bottom left – that draws the eye into the heart of the busy painting and on to the figures of Mary and Jesus.

and appreciation of the dog by Christianity was the rise of the knights of the Crusades, who streamed on horseback across Eastern Europe and the Middle East, accompanied by their dogs. This led to cross-breeding between dogs belonging to noblemen from Europe and those of Eastern stock: such inter-breeding is thought to have given rise to the spaniel. This breed, of which there are many varieties, became very popular, and it appears frequently in the arts.

The presence of dogs in religious works grew through the thirteenth and fourteenth centuries and into the Renaissance, when strikingly realistic dogs began to appear, often with saints. The artist Andrea da Firenze, for example, showed distinctive black-and-white hounds aiding St Dominic in a series of frescos (pages 76 and 77), while later, in the sixteenth century, Titian and Jacopo Bassano in particular captured the true nature of dogs in their religious paintings (pages 80, 84 and 85). Dogs were, as ever, used for hunting, although for the upper classes the hunt took on a new importance as a predominantly sporting and social event. The Church was supported by money from the nobility, and as dogs became more accepted in this significant social context, so their move from abhorred to adored was complete and they took their place in art as symbols of faithfulness and companions of saints.

Pietro Lorenzetti
(active *c.* 1306–1345)
***The Last Supper* (detail)**
14th century (before 1320)
Fresco
Assisi, San Francesco, Lower Church

The fourteenth-century painter Pietro Lorenzetti and his brother Ambrogio (active *c.* 1317–1348) were among the first of the Sienese painters to start working in a more naturalistic manner, incorporating drama, greater narrative and architecturally defined spatial areas into their compositions. Both brothers were innovative, perhaps one of the most unusual and delightful instances being Pietro's inclusion of this small domestic genre scene in his *Last Supper* fresco in the Lower Church of San Francesco in Assisi.

The little dog, complete with decorative collar, and barely bigger than the furious cat, is happily cleaning up the plates that have been brought through by two servants deep in conversation. Next to this humble room, with its projecting fireplace and shelves, is an octagonal architectural area where the Last Supper is taking place. Lorenzetti's juxtaposition of the obviously religious scenario with the curious incidental secular scene of the pet dog marked the beginning of a tradition that saw religious subjects depicted with increasing realism, with the inclusion of extraneous details of a domestic nature, such as dogs.

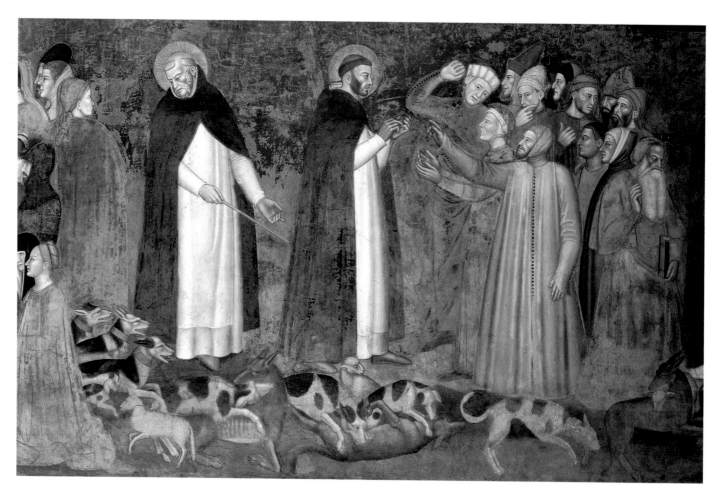

**Andrea da Firenze
(Andrea di Bonaiuto)
(active *c.* 1343–1377)
*St Dominic Sending Forth
the Hounds and St Peter
Martyr Casting down the
Heretics* (detail)**
c. 1365
Fresco
Florence, Santa Maria Novella

The impressive Dominican priory of Santa Maria Novella in Florence is home to an extensive collection of late medieval and Renaissance art, including one of the best examples of Dominican art produced in the fourteenth century. This is Andrea da Firenze's fresco cycle *Via Veritatis*, which decorates the chapter house, also known as

the Spanish Chapel, and was conceived as a glorification of the Dominican Order.

This segment of the complex narrative cycle shows St Dominic sending out his hounds, the symbol of the faithful, to drive off the wolves, symbolic of heresy. Clearly shown is the dog's role as companion and servant of the saints, indicating how far

the dog had by this time ingratiated itself with the Church, and, by extension, become a feature of religious iconography. Interestingly, the wolf, which has never been successfully tamed on a large scale by man, has invariably been used as a negative symbol in religious art.

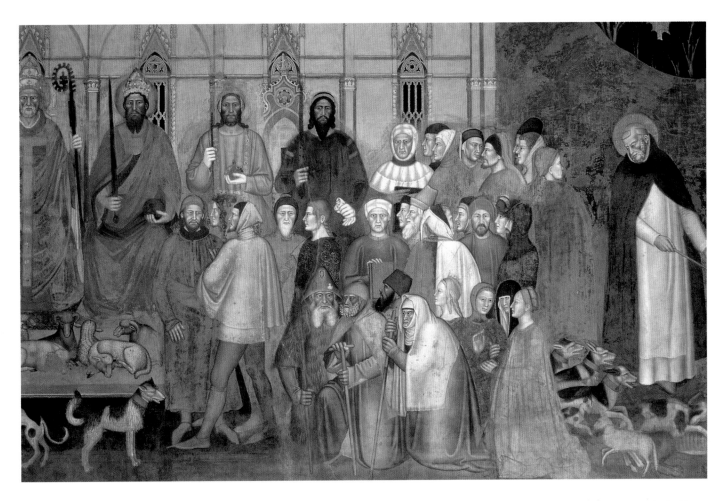

**Andrea da Firenze
(Andrea di Bonaiuto)
(active c. 1343–1377)**
***The Church Militant and
Triumphant* (detail)**
c. 1365
Fresco
Florence, Santa Maria Novella

This scene forms part of
Andrea da Firenze's fresco
cycle in the Spanish Chapel
of Santa Maria Novella,
and is directly to the left of
*St Dominic Sending Forth
the Hounds* (opposite).
Together these two pictures
demonstrate Andrea's use
of animal symbolism, which
became increasingly popular
in religious paintings. Here

the figure on the far left is
the pope; to the right is the
emperor, flanked by the
king and a group of secular
figures, while the black-
cloaked St Dominic is on the
far right. Below the emperor
are two sheep that represent
humankind under God's
protection, and at the bottom
stand two impressive
collared guard dogs (only

one of which is visible here) –
these are 'Domini Canes',
or 'dogs of the Lord',
which were symbolic of
the Dominicans as well as
protectors of the faith. The
dogs look to the right, where
more hounds chase down
wolves (heretics), as seen
also in the preceding picture.
 The dogs here are fine-
looking hound types,

distinctively marked, with
black-and-white coats
symbolizing the black-
and-white colours of the
Dominican Order.

**Antonio Pisanello
(1395–1455)**
The Vision of St Eustachius
c. 1438–42
Egg tempera on wood
54.8 x 65.5 cm (21⅝ x 25¾ in.)
London, The National Gallery

Antonio Pisanello was one of the first masters of the Renaissance truly to observe and record the natural world of animals and plants. His beautiful, detailed works reflect his understanding and exploration of anatomy, and this painting is of particular interest for its depiction of a number of different types of dog, each exquisitely rendered.

Two elegant greyhounds, the ubiquitous dog of the courts, take up the right foreground, while to the left a pair of charming spaniel-type dogs busily follows a scent trail. Behind the horse's shoulder are two heavy hound dogs, one having an altercation with one of the greyhounds, while behind them is an even heavier dog, which looks similar to the mastiff type of guard dog used for protecting livestock. Pisanello made a number of studies from life of dogs, as well as other animals, which are included in his sketchbook housed at the Louvre in Paris.

Albrecht Dürer (1471–1528)
The Vision of St Eustachius
c. 1500
Oil on panel
47.5 x 34.5 cm (18⅞ x 13⅝ in.)
Rome, Galleria Doria Pamphili

One of the greatest artists of the Northern European Renaissance was Albrecht Dürer, who painted this version of *The Vision of St Eustachius* around fifty years after Pisanello had produced his (opposite). Dürer, like the Italian Pisanello, was a keen and exceptional observer of nature and worked in a meticulously detailed manner. He became most famous for his graphic works, woodcuts and engravings, although his painted œuvre, as can be seen here, was just as virtuosic.

He has perfectly captured the nervous energy of the hunting dogs that wait anxiously for their master, who kneels before a vision of Christ seen between the antlers of a stag. Two different types of dog can be identified: a male and a female greyhound, and three heavier hound dogs that sit grouped as if in silent dialogue.

Interestingly, the story of St Eustachius's vision is remarkably similar to that of St Hubert, the patron saint of hunters. Like Hubert, Eustachius is fabled to have been out hunting a stag when his quarry turned to him and revealed among its antlers an image of Jesus. Both saints subsequently dedicated their lives to Christianity and good works. While Eustachius was eventually condemned by the Emperor Hadrian and roasted alive for refusing to take part in pagan sacrifice, St Hubert became Bishop of Liège and bred hounds at his abbey in the Ardennes.

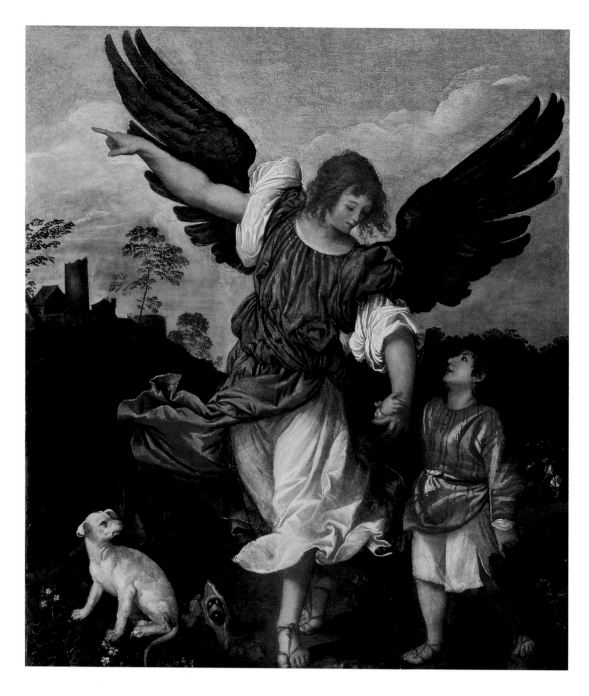

Tiziano Vecellio (Titian)
(c. 1485/90–1576) (attrib.)
The Archangel Gabriel
and Tobias
n.d.
Oil on panel
170 x 149 cm (70 x 58⅝ in.)
Venice, Gallerie dell'Accademia

The great Titian was one of the many masters of sixteenth-century Italian painting who displayed a particular affinity for and adeptness at depicting the dog. He often included dogs in his paintings, especially portraits – famously in his *Venus of Urbino* (page 102) – and painted them with the hand of one who had a personal understanding and love of these animals. His dogs are full of vitality and express the particular, almost human quality that sets them apart from other domestic animals.

This painting is no exception, and important as the subject is, the dog commands its equal vertical third of the canvas. The archangel Gabriel and the boy Tobias were a popular subject in Christian iconography, and Tobias is almost always accompanied by his dog, generally depicted as small and white, as in this canvas. What is extraordinary here is the dog's expression and emotion. It looks across at its master questioningly, slightly affronted by the presence of the mighty Gabriel, who has taken the dog's normal place at Tobias's side. Titian conveys the thoughts of the dog with the subtlest nuance, a stroke of brilliant line and a tilt of the head.

**Hans Memling
(c. 1433–1494)**
Vanity, central panel from
the triptych *Earthly Vanity
and Divine Salvation*
c. 1485
Oil on panel
20.2 x 13.1 cm (8 x 5⅛ in.)
Strasbourg, Musée des Beaux-Arts

Dogs, often small lapdog types similar to the Löwchen (little lion dog), the Affenpinscher (griffon) and the Maltese, appeared frequently in the work of Northern European Renaissance artists. In this painting, which forms one part of a triptych, the theme is that of Vanity, as personified by the beautiful woman who shamelessly admires her naked reflection. She is accompanied by a charming little white dog, similar in appearance to an unclipped Löwchen or a Maltese, while behind her two whippet-type dogs lounge flirtatiously, the nearest one in an unsettlingly human posture. It was fashionable at this time – as now – for women (generally of means) to own a lapdog, a trend that was particularly reflected in portraiture. Here, however, Memling has used the little dogs, associated as they were with luxury, to emphasize the frivolity and indulgence of the central figure of Vanity. Conversely, dogs were also used to represent a model of good behaviour that a woman should follow, namely to be faithful, happy to follow her master and totally subservient.

**Vittore Carpaccio
(c. 1460/65–1523/26)
Vision of St Augustine
(detail)**
c. 1502
Oil on canvas
Venice, Scuola di San Giorgio
degli Schiavoni

There is an air of infinite wisdom about this little white dog that sits back on its haunches and gazes towards its master, St Augustine, and beyond to the window (see opposite). Carpaccio frequently included dogs, sympathetically depicted and strikingly realistic, in his paintings, often using the creature as a symbolic vehicle to accentuate the attributes of his principal characters. This one is no exception: the thoughtful and intelligent dog that sits in quiet contemplation suggests the scholarly character of St Augustine.

The dog resembles a Pomeranian, with its short, pointed ears and fuzzy coat, but also bears similarities to the Maltese and the Bichon Frise. The Pomeranian is thought to have evolved from working spitz types in Greenland and Lapland before entering Europe, while the Maltese and Bichon Frise were ancient toy breeds thought to have originated in the Mediterranean area. The Maltese in particular was enjoying the company of humans before the birth of Christ; it was known in Latin as 'canis Melitaeus', probably from the Latin name for Malta, and was popular in ancient Egypt, Greece and Rome.

**Vittore Carpaccio
(c. 1460/65–1523/26)**
Vision of St Augustine
c. 1502
Oil on canvas
141 x 210 cm (55½ x 82⅝ in.)
Venice, Scuola di San Giorgio
degli Schiavoni

It is instructive to see the detail of the charming dog (opposite) in the context of the whole picture, especially in light of the dog's important compositional function. Sensitively painted, it anchors the entire left side of the painting. The long, sharp shadows draw the eye from the densely structured and complicated pictorial space occupied by St Augustine and his desk towards the quieter area of the study, the focus of which is the dog. As well as functioning visually, it also creates an emotional contrast between the startled saint, interrupted during his letter-writing by the voice of St Jerome, and the calm little dog sitting in contemplative stillness.

Carpaccio was a master of creating a domestic scene, and here he has fashioned a Renaissance study in great detail. Every object – book, globe, altar, mitre, dog – plays a role in the dialogue of the picture. In the British Museum, London, there is a preparatory drawing for this work that shows the artist's method. Originally, he used in place of the dog an ermine-type animal, which compositionally, because of its horizontal shape, is less satisfactory, as well as lacking the emotional power of the dog.

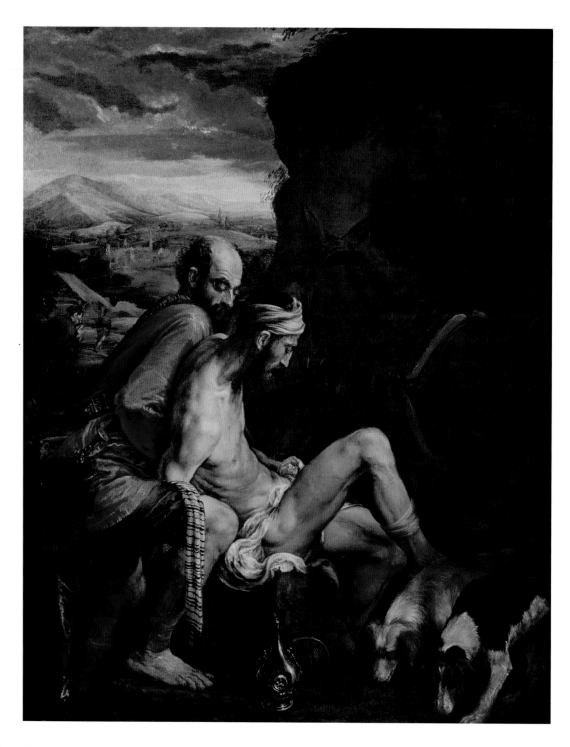

**Jacopo Bassano
(c. 1510–1592)**
The Good Samaritan
c. 1550–70
Oil on canvas
101.5 x 79.4 cm (40 x 31¼ in.)
London, The National Gallery

Throughout his long career
Jacopo Bassano continually
used animals, especially
dogs, as important elements
in his compositions, and he
was one of the first artists to
paint a picture with dogs as
the sole subject matter (see
page 188). His works are
typified by their naturalistic
character, to the extent that
his religious subjects, as here,
become almost secondary
within what were essentially
rustic genre paintings. He
also habitually painted his
characters as peasant stock
with the physical aspect of
those who have laboured hard
on the land, and accompanied
by hunting or working dogs
rather than pets.

Here, one of the two
beautifully painted hunting-
type dogs in the foreground
cleans the wounds of the
injured man who is helped
by the Good Samaritan. The
action of the dog is totally
natural, as would be
expected from Bassano,
but also perhaps recalls the
beliefs of the ancient world,
where a dog's licking a
wound was thought to have
healing properties.

Tiziano Vecellio (Titian)
(c. 1485/90–1576)
The Last Supper
n.d.
Oil on canvas
Dimensions unknown
Urbino, Palazzo Ducale

The Last Supper was a popular subject for artists in Renaissance Italy, and invariably included images of dogs – food and dogs being generally inseparable. The inclusion of dogs in religious paintings that incorporated domestic interiors reflected the role of the dog in human society. The dog was not only present throughout the household (kitchen, bedroom, study, dining area), but was also of sufficient importance that it was almost natural for it to appear in paintings. Religious scenes were depicted with increasing realism, and Titian was one of the leading Venetian artists of his time to paint with virtuoso naturalism, especially in his portrayal of dogs.

The subject matter of this work gives the artist a chance to display his great talent for painting both dogs and still life. These are two aspects often overlooked in view of the monumentality of Titian's artistic achievements, but he was one of the most proficient dog painters of his time, as shown by the spaniel-like animal in the foreground here. This type of dog appeared frequently in paintings of the time, as spaniels had become very popular. Here, the little dog gnaws on a discarded bone, grounding the scene in reality.

**Francesco Salviati
(1510–1563)**
*Saul Throwing the Lance
at the Head of David*
After 1539
Oil on canvas
Dimensions unknown
Venice, Santa Maria della Salute

Born Francesco de' Rossi,
Francesco Salviati was one of
the leading Italian Mannerist
painters. His work is defined
by the use of bold colour,
complicated figural
compositions and ambiguous
spatial arrangements. He is
not known as a painter of
nature, and naturalistic detail
is generally absent from his
works, this extraordinary
painting being an exception.
His inclusion of a fine, expertly
rendered spaniel-type dog is
surprising in the light of his
œuvre, and even more so for
the tender, sympathetic and
convincing way in which he
has captured the dog's nature.

 With head on one side, the
dog sits patiently and loyally
by the side of its master,
but surveys the scene
questioningly – there is a
sense of melancholy in its
posture that reflects the nature
of the scene itself. The style of
the painting of the dog, which
is somewhat monumental but
grounded in naturalism, is also
different from the rest of the
work, which is Mannerist and
rather contrived in feel.

**Leandro Bassano
(1557–1622)**
The Rich Man and Lazarus
1590–95
Oil on canvas
134 x 181.5 cm (52¾ x 71½ in.)
Vienna, Kunsthistorisches Museum

The parable of the Rich Man and Lazarus relates how a rich man feasted daily and indulged in luxuries while a beggar lived near by, dogs licking his sores. After both men died, the beggar went to live in comfort in Heaven while the rich man suffered for eternity in Hell. This was a subject painted by both Jacopo Bassano and his son Leandro, each working in a different style but both depicting the dogs with convincing naturalism. Those seen here would seem to be a type of spaniel, which was a popular hunting breed and frequently depicted in art.

Jacopo Bassano developed an approach to religious painting in which his works were conceived within a domestic genre, and Leandro, who trained in and then ran his father's workshop, also adopted this style, although in a more Mannerist way. This painting is full of detail, with a complicated and busy spatial arrangement, but it is the two dogs and the figure in the foreground that first catch the eye.

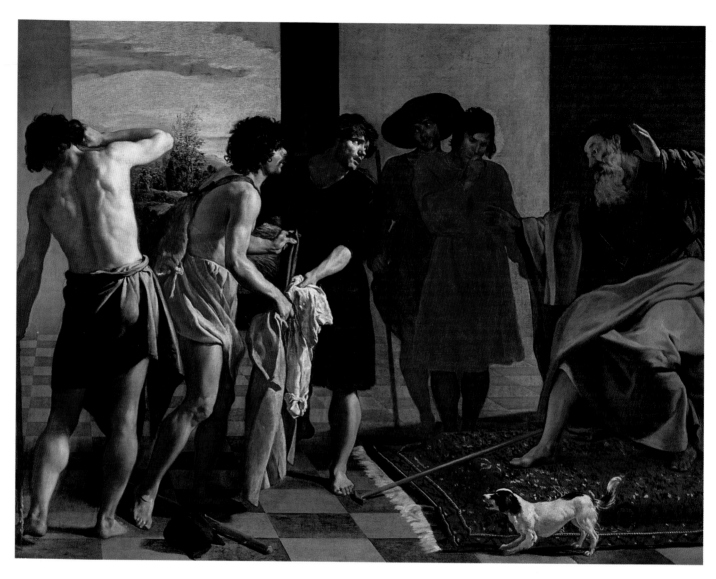

Giuseppe Velasco or Velasquez (born 1540)
Joseph's Coat
1630
Oil on canvas
223 x 250 cm (87⅞ x 98⅜ in.)
Spain, El Escorial, Monasterio de El Escorial

This huge and dramatic painting by the poorly documented Spanish artist Giuseppe Velasco demonstrates the use of a dog to enhance and enlarge the narrative of the story. Spatially, the picture is relatively narrow, with a band of sculptural figures forming a frieze across the picture plane; and a small pet dog is thrust into the foreground, almost projecting out of the picture and into the viewer's space, thereby making the observer a part of the scene.

The painting shows a moment of treachery and deceit, and it is this that the figure of the little dog conveys, with its frantic barking and almost denunciative demeanour. The figures are some of Joseph's brothers, and they have brought his blood-covered coat to Jacob, their father. But the blood is that of a goat they killed after selling Joseph into slavery, driven by their jealousy of him, as their father's favourite son. Old Jacob is horrified at (as he thinks) Joseph's death, while the little dog, seemingly all-knowing, barks its warning and accusation.

Rembrandt Harmensz. van Rijn (1606–1669)
The Good Samaritan
1633
Etching
25.7 x 20.8 cm (10¼ x 8¼ in.)
London, Wallace Collection

By the seventeenth century, northern European society was alive with dogs. A distinct shift in dog-keeping practices saw the dog become the universal pet, owned and loved by all classes. Previously it was the wealthy who had primarily owned both hunting and pet dogs, but now dogs of every shape and size wagged their way into the home, and nowhere more so than in The Netherlands.

The great Rembrandt frequently used dogs in his paintings, often to comment on the scene of which they were a part. He also depicted dogs going about their doglike business, such as this large, hairy fellow defecating in the foreground. The dog has considerable prominence in this scene, which, although religious in subject, has been conceived typically by Rembrandt as a rustic genre. Interestingly, Rembrandt painted a similar scene some thirty years earlier (also in the Wallace Collection), but omitted the dog.

**Pieter Jansz. Saenredam
(1597–1665)**
*The Interior of the Buurkerk
at Utrecht*
1644
Oil on panel
60.1 x 50.1 cm (23⅝ x 19¾ in.)
London, The National Gallery

In The Netherlands at the end of the sixteenth century a trend for architectural painting developed that included secular interiors and exteriors and, perhaps more famously, the cool, soaring interiors of churches. Saenredam was one of the first artists to use the methods and techniques of architectural surveyors when constructing his composition. As a result his paintings of churches are recognizable and accurate, although some of his contemporaries employed greater artistic licence.

These paintings were full of the details of everyday Dutch life, and invariably included dogs, which were so great a part of the fabric of Dutch culture. Here a dog in the middle ground has wandered off alone and stands dwarfed by the tall, slender columns and arches, while in the foreground a boy is training a small toy-spaniel type to stand on its hind legs. Characteristic of Saenredam's subtle use of nuance, the dog is used as a symbol of faithfulness, obedience and learning, three qualities that were intrinsic to the Christian religion.

Emanuel de Witte
(c. 1617–1691/92)
Interior of the Nieuwe Kerk,
Delft
1656
Oil on canvas
97 x 85 cm (38¼ x 33½ in.)
Lille, Musée des Beaux-Arts

Emanuel de Witte was one of the leading masters of Dutch architectural painting and brought a new dynamism to the genre, working with greater freedom than Saenredam (opposite), employing diagonal views through the church and using dramatic plays of light. He painted this church in Delft, and the city's Oude Kerk (Old Church), on many occasions, and, like the majority of Dutch architectural artists, he typically included a number of dogs in his works. The same dogs, including these three greyhounds, appear frequently in de Witte's various views of the Nieuwe Kerk and the Oude Kerk, suggesting that the animals might have belonged to the artist himself, or certainly that they were very familiar to him.

Likewise, the striking figure in the vibrant red coat also appears in several of de Witte's church interiors, the cloak probably being one of the artist's props. Here de Witte has depicted a cross-section of society, from the nobleman and children to beggars and dogs, grouped together near the tomb of William of Orange.

dicunt ea cane tuisse et europe cu dracon

Quidã uero dicunt hunc canem o

exercuisse. Habe

Magna q

obscuras in

femore .i. iex tremo

pede .i. clara .i cauda

iiii. sunt xvi.

ncuſtode datu ecaioue inter aſtra

ſ fuiſſe eccu eo inmonab: uenationem

cē ſtellas iliñgua una qua ſiria eccane uocant·

··e· ecſplendida ·indrmiſ ſinguliſ ſingulaſ·

·e· ·ıı· inpede priori ·ııı· inueñtre ·ıı· inſiniſtro

The Mythical Dog

THE ANCIENT WORLD WAS ONE OF MYTH and magic, superstition, legend and lore brought about by the human desire to explain the workings of life and death and contemplate what might lie beyond. Woven into many of those early tales is the dog, a creature that thrived throughout the different world cultures – an animal that spanned the divide between the physical and the spiritual, providing a manifest bridge from this world to the next. The dog was not alone in being used as an iconographic and symbolic creature in ancient cultures, but it was celebrated above and beyond its animal companions. Dogs have an indefinable quality that conveys a sense of 'humanity' in an animal form, and it is surely this – the ability of man to identify 'self' – that makes the dog both a confederate and an adversary of humans. Dogs epitomize that which is most lauded, but can also represent that which is most fearsome or despicable. The dog therefore came to symbolize the extremes of the spectrum, from the terrifying three-headed Cerberus of Greek myth, as drawn by Edward Burne-Jones (page 108), to Odysseus's faithful hound Argus, as seen in *Ulysses Accompanied by Telemachus is Recognized by his Dog Argus*, after Simon Vouet (page 105).

The dog as a creature to be feared – a notion fostered through conflict between early humans and ancient wild dogs, and through dogs with rabies, the symptoms of which appeared demonically induced – is represented in innumerable myths, with black dogs frequently being associated with death. People who were feared often had doglike characteristics attributed to them, as seen in the ancient tales of the cynocephalus figures – humans with canine heads – who were accused of eating human flesh and barking, among their other crimes. As with many ancient myths, the history surrounding the cynocephalus figures has been confused through the years. It evolved from Greek and Roman descriptions of peoples who lived beyond the fringes of those empires. Such unknown people were deemed to be uncivilized, and were described in such derogatory terms as being cannibalistic and dog-headed. One of the early tales of dog-headed people was by Gregory of Nazianzus, who came from the cultivated area of Cappadocia in the fourth century AD, and described the monstrous hybrid men. Hundreds of years later, in the tenth century, monks in the same area of Turkey were still producing images of dog-headed men. The *Wolf-Headed People of the Andaman Islands* (page 96) and the primitive, undated *Dog-Headed St Christopher* in the Byzantine Museum of Athens (page 97) were inspired by such tales. St Christopher was associated with the myth of the cynocephalus because he came from the North African tribe of the Marmaritae, who were described as savages in early Greek and Latin accounts. He is frequently depicted in this way in Byzantine icons.

A canine–human hybrid of a different kind was the ancient Chinese god Pan Gu, descriptions of

Woven into many of those early tales is the dog, an animal that spanned the divide between the physical and the spiritual, providing a manifest bridge from this world to the next.

whom vary, but often portray him as having the head of a dog and being covered in fur. In one of the most important of the Chinese creation myths, Pan Gu is the creator of the world. The dog features prominently in Chinese myth, allegory and astrology; it is one of the twelve animals in the Chinese zodiac. The association of the dog with the creation of the Earth and with human ancestry featured in many cultures; some Native American peoples, Australian Aborigines and Mongolian nomads trace their origins back to a dog figure. The canine in a parental role is seen again in the stories of Romulus and Remus, founders of

Rome, who were nursed by a she-wolf as babies. The ancient Greeks and Romans put the dogs Sirius and Procyon in the night sky, to follow Orion, the Hunter: they are respectively part of the constellations Canis Major and Canis Minor, as seen in the eleventh-century illustration of the constellation Sirius (below). Sirius, also known as the dog star, was important to the ancient Egyptians, who calculated their calendar by its position in the sky. For Egyptians, the dog star followed Osiris, god of life, death and fertility. Some myths relate that Osiris was the father of Anubis, the dog-headed guardian of the underworld, who often appears in ancient

English School
Illustration of the constellation Sirius, with text, from the Cotton Tiberius B.V., Part I
c. 1025–50
Vellum (illuminated manuscript)
26 x 21 cm (10¼ x 8¼ in.)
London, British Library

Sirius, in the constellation of Canis Major, is the brightest star in the night sky, and is commonly referred to as the 'dog star'. Since ancient times this star has had special significance attached to it and has been identified as a dog form in many different cultures. To the ancient Chinese it was the 'heavenly wolf', in ancient Assyria it was 'the dog of the sun', in Chaldea (southern Iraq) 'star of the dog', in Greece 'Sirius' and to the Egyptians 'Sothis' or 'Sopdet'. The Egyptians fixed their calendar by the heliacal rising of Sirius: in other words, the first time the star is visible in the dawn sky after a period of not being visible at all (being below the horizon). For Sirius, three to five millennia ago, this occurred in early July and thereby coincided with both the annual flooding of the Nile

and the hottest days of the year. The period of intense summer heat when Sirius was briefly visible at dawn was called the 'dog days' – a term still in use today – by both the Egyptians and the Greeks. Some sources suggest that this was a common time of dog sacrifice in ancient Greece, which might have been pragmatically related to an increase of rabies during the summer, and a corresponding cull, rather than to spiritual fervour.

This image of Sirius in its constellation comes from an Anglo-Saxon illuminated manuscript. It is one of a cycle of twenty-four illustrations to the Latin translation (by Marcus Tullius Cicero, 106–43 BC) of a Greek poem (*Phaenomena* by Aratus, *c.* 315/10–240 BC) describing the constellations and other celestial phenomena.

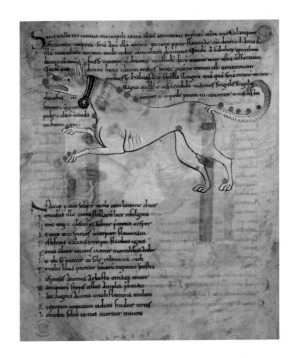

depictions, and a modern interpretation of whom, *Anubis and Charon* (page 113) by Chris Gollon, is full of dark foreboding.

The Greeks and Romans were among the greatest of the ancient storytellers, and it is their myths that have perhaps been most widely represented in Western art. Dogs weave their way through these tales, accompanying the gods, goddesses and mythical heroes on their journeys. Who could fail to be moved by the grieving dog painted so tenderly by Piero di Cosimo in *Satyr Mourning Over a Nymph* (pages 100–101)? One of the most famous Classical dogs is the aforementioned Argus, who appears in Homer's *Odyssey* (eighth century BC) and has become immortalized as the symbol of the loyal canine companion. Another frequently painted figure is Diana, the Roman goddess of the hunt (the Greek Artemis), who often appears with her hounds; an unusual depiction of her is *Artemis and Endymion* (page 110) by the Russian artist Nikolai Kalmakov.

The Boucicaut Master (active 1390–1430) (and workshop)
The Wolf-Headed People of the Andaman Islands in the Indian Ocean
c. 1390–1430
Vellum
Dimensions unknown
Paris, Bibliothèque Nationale

Surrounding the dog-headed human figures known as cynocephali were a number of myths, often describing feared or unknown races. These tales were born of the ignorance, prejudice and superstition of European peoples (generated initially through early Greek and Roman descriptions dating back to the fourth century or even earlier) about far-flung and little-known exotic lands, generally in the East. The Andaman Islands, situated in the Bay of Bengal, may have been named by the second-century Greek geographer and astronomer Ptolemy, but remained little explored by Europeans until at least the mid-fifteenth century. Marco Polo left an account of an island of Angamanain, which was possibly the Andamans, and described its people as being dog-headed, cruel and apt to eat everyone they could find, although it is doubtful that he actually visited the place. Later explorers did reiterate that the indigenous people were particularly hostile.

The Boucicaut Master, who painted this beautiful picture of the wolf-headed Andaman people trading, was the leading painter of illuminated manuscripts of his day in Paris, and would have been commissioned to paint it by a wealthy citizen or nobleman. There was at this time a fashion for this type of 'exotic' work that recorded the alleged travels of explorers in the Orient.

**The Dog-Headed
St Christopher**

n.d.

Tempera on wooden panel
Dimensions unknown

Athens, Byzantine Museum

Pictures that portray St Christopher as dog-headed are seen relatively rarely in modern times; most commonly he is depicted in a more acceptable way, as a giant of a man carrying Jesus across a swollen river. There are, however, a number of Byzantine icons that depict the saint as dog-headed, an idea deriving from one of the several ancient myths that surround him. He was born in the second century, and belonged to a North African tribe called the Marmaritae, who lived in what is now Libya, which at that time was on the very perimeter of lands explored by the Greco-Roman empires. People from these outlying areas were viewed with suspicion and deemed to be cannibals, uncivilized and even dog-headed. Thus the depiction of St Christopher as a dog–human hybrid is thought to be a literal interpretation of the ancient Greek accounts of his life. Latin accounts of the Marmaritae, on the other hand, described the tribe as doglike in behaviour rather than appearance.

The Roman army, operating under Emperor Diocletian, captured the man who became St Christopher when it was warring against the Marmaritae. Christopher was then conscripted. Accounts indicate that he was called Reprebus, before changing his name to Christopher (bearer of Christ) on being baptized. Such tales may be fictitious, since the word *reprebus* relates to the Latin *reprobus*, meaning reprobate, and thus serves a useful purpose as part of a moralizing tale in which a reprobate becomes a saint. Christopher was martyred in AD 308.

Italian School
Mandrake
14th century
Vellum
Dimensions unknown
Vienna, Österreichische
Nationalbibliothek

The legend of the dog and the mandrake plant is an ancient one, but it became particularly popular in the Middle Ages, and was often depicted in such manuscripts as this. The plant was thought to be magical, a belief based primarily on the resemblance of its roots to the human form, and was used as an aphrodisiac and to promote fertility. As the legend goes, however, when the plant is pulled from the ground it lets out a shriek so terrible that it can send a person insane, or even result in his or her death. To harvest the deadly plant it was therefore necessary to tie a dog to it and then quickly run away. The dog would follow, thereby pulling up the plant, and be killed in the person's place by the scream. The mandrake was believed to be harmless once uprooted, but actually it is poisonous.

The beautiful black-and-white greyhound type seen here would seem to be enjoying a last supper before going to meet its fate. This image comes from a *Tacuinum Sanitatis*, which was a detailed illustrated medieval book on health and the properties of different plants and foods.

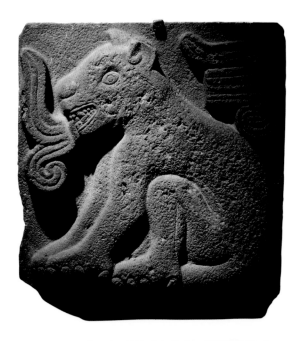

Aztec
Glyph of King Ahuitzotl
15th century
Stone
Dimensions unknown
Mexico City, Museo Nacional
de Antropología

The Ahuitzotl was a legendary beast in the Aztec culture. It had the appearance of a dog and was black and shiny with a long tail, at the end of which was a human hand; the beast devoured human flesh and lived near bodies of water. It would mimic the sound of a crying baby, and when people went to investigate, it snatched them with the hand on its tail and dragged them into its lair.

King Ahuitzotl, the powerful eighth Aztec ruler, took the name of this fierce mythical beast as his own, and used the creature as his mascot. It was a fitting image for this king, who was one of the most successful military leaders of the period, and whose immense power led to the rapid expansion of Aztec territory. Legend has it that he sacrificed 20,000 people at the dedication of his Great Pyramid, or Templo Mayor.

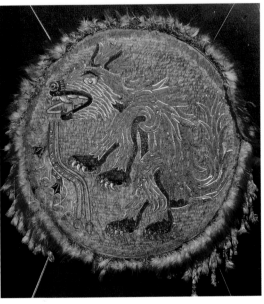

Aztec
Shield
c. 1500
Feathers, sheet-gold, agave paper, leather and reed
Diameter 70 cm (27½ in.)
Vienna, Museum für Völkerkunde

The fearsome dog–wolf creature depicted here was a popular symbol in Aztec culture, a mythical animal to be feared and respected, known as Ahuitzotl. Appearing on this shield, the creature's image represented power and aggression, a force to be reckoned with and an indication of the mighty Aztec fighting skills. The image would have been a warning to enemies and a totem and talisman to the shield's owner. It is interesting to compare this image with the one by Piero di Cosimo on pages 100–101: both were created about the same time, but they offer vastly different perceptions of the dog.

Dogs played an important part in this pre-Columbian civilization, which flourished in Mexico from the twelfth to the fifteenth centuries. The god of lightning and guide to the underworld, Xolotl, was often shown as a dog-headed man, a skeleton or a monstrous doglike creature with reversed feet. Legend claims that Xolotl created the xoloitzcuintle (the Mexican hairless dog) to protect and guide humans in the physical world, while he took care of the spiritual realm.

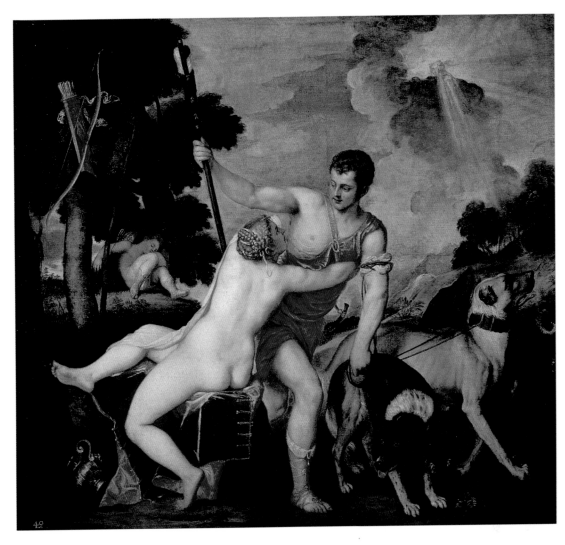

**Tiziano Vecellio (Titian)
(c. 1488–1576)**
Venus and Adonis
1553
Oil on canvas
168 x 207 cm (66¼ x 81½ in.)
Madrid, Museo Nacional del Prado

Titian, along with Paolo Veronese, was one of the masters of depicting the dog, and frequently included realistic dogs in prominent roles in his paintings. The hunting dogs seen here reflect his knowledge of the nature of dogs as well as demonstrating his skilful rendition of their physical characteristics. These dogs are eager to go hunting, the mastiff type straining at its leash, nose in the air to catch the quarry's scent, while the hound in the foreground turns back towards Adonis with a slightly doubtful look. Its hesitancy predicts – or reminds the viewer of – the coming events and the death of Adonis on this, his last hunt. In this subtle way Titian uses the dogs and the nuances they imply to add greater emotional depth to the painting.

Titian painted this subject on several occasions, each time slightly differently, but always bathed in characteristically rich and warm colours that enhance the sensuality and passion of the scene.

Paolo Veronese (1528–1588)
Esther and Ahasuerus
n.d.
Oil on canvas
208 x 284 cm (81⅞ x 111¾ in.)
Florence, Galleria degli Uffizi

Dogs appear in many of Veronese's paintings, from works of a religious nature to allegorical subjects and portraits. In all of them, the dogs are painted with precise realism and great sympathy: not only was Veronese able to capture the essence of dogs on canvas, but also it would seem from his pictures that he had a genuine affection for them. In many of his paintings,

such as this one, the inclusion of one or more dogs might seem to be random – just because the artist wished to paint them – but in reality dogs had by this time become an integral part of daily life and were widespread throughout domestic and public spaces, making it natural to include them in scenes, even when depicting events from history or myth.

This large greyhound type sits, unusually, with its back to the viewer, but turns its head towards the action. There is a sense of wisdom about this dog quietly watching the human antics, as King Ahasuerus chooses his new wife – Esther – from a selection of hopeful and beautiful women.

**After Simon Vouet
(1590–1649)**
***Ulysses Accompanied by
Telemachus is Recognized
by his Dog Argus***
n.d.
Wool tapestry
320 x 105 cm (126 x 41⅛ in.)
France, Besançon, Musée des Beaux
Arts et d'Archéologie

The beautiful brown-and-white dog in this delicately coloured French tapestry presents a highly idealized portrait of Odysseus's dog Argus. Here, the dog, which has the appearance of a working-spaniel type, jumps joyfully at its master, whom it recognizes after a long absence. This is a particularly exquisite scene, a moving display of a man's love for his dog, which at this time was not frequently depicted in such an explicit way.

The story is taken from Homer's *Odyssey*, and relates how the Greek king Odysseus (called Ulysses by the Romans) returns home after twenty years of war, wearing a heavy disguise so that, without being recognized, he can see what has happened at his palace in his absence. His faithful hound, Argus, beloved as a young pup by the king, recognizes him by his voice and struggles to get up and wag its tail. Having laid eyes on its master one last time, the old hound dies, finally at peace. Argus, an unambiguous symbol of faithfulness and patience, was frequently depicted in art.

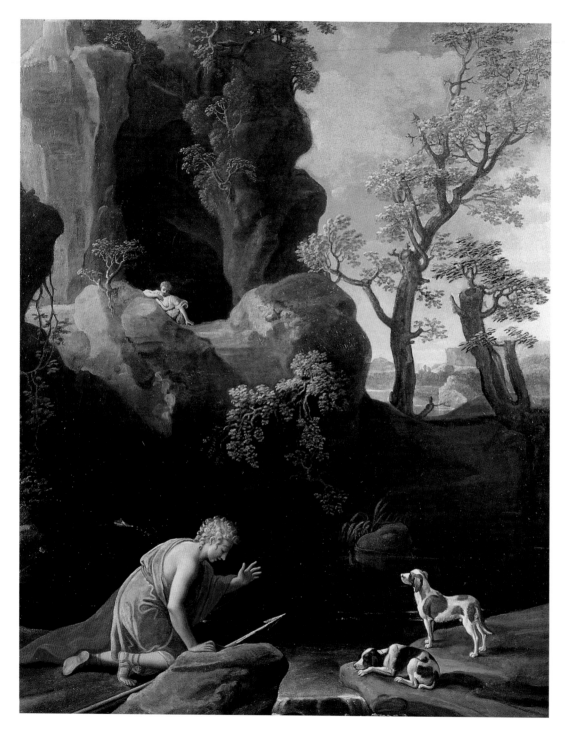

**François Perrier
(1590–1650)**
Narcissus
17th century
Oil on canvas
Dimensions unknown
Private collection

This painting is unusual within Perrier's œuvre and is of particular note for its inclusion of two beautifully painted hunting dogs of working-spaniel type. The dogs play an important role structurally, forming the lowest point of a triangular composition, but have also been used by Perrier to comment on the scene, and, indeed, to draw attention to the artist's prowess at painting dogs. There was a growing trend from the early 1600s for the depiction of prime hunting dogs in their own right, and this bottom corner of the canvas could essentially stand on its own in this capacity.

The tan-and-white dog looks to the figure of Echo, who hovers above Narcissus, desperately in love but unable to tell him. With its head cocked slightly to one side, the dog conveys sympathy for the nymph, and draws her into the heart of the scene. The other dog lies staring at the water in a dejected and forlorn manner, as if foreseeing the tragedy that is about to unfold. It is in this pool that Narcissus views his own reflection and falls in love with it; refusing to leave, he pines away and dies.

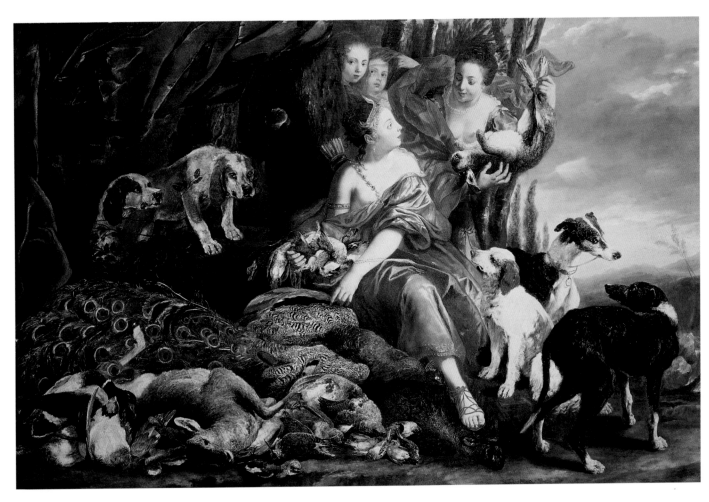

Jan Fyt (1611–1661)
Diana and her Handmaidens After the Hunt
n.d.
Oil on canvas
175 x 257 cm (68⅞ x 101⅛ in.)
London, Johnny van Haeften Gallery

The Netherlandish artist Jan Fyt was one of the most convincing and talented painters of dogs in the seventeenth century, having trained for several years under Frans Snyders, who was one of the first artists to feature the dog as the sole subject of his work. Fyt's particular talent, as is evident in this painting, was the rendition of the different textures of fur and feather, a skill that lent his works great realism.

The Classical subject of Diana and her handmaidens here is quite secondary to the painting itself, which is a virtuoso study of dogs and game, arranged much in the manner of a still life. The five dogs – two greyhound types and three working-spaniel types – are each painted with quite distinct character and appearance, with the spaniel type seated beside Diana being especially endearing. Fyt's skill at painting animals, especially dogs, at times eclipsed his artistic abilities in other areas, and on several occasions he collaborated with other artists, who inserted figural and architectural details into his paintings: the figures here are believed to be by Thomas Willeboirts Bosschaert (1614–1654).

**Edward Burne-Jones
(1833–1898)**
*The Story of Orpheus:
Cerberus*
1875
Pencil on paper
24.4 x 24.3 cm (9⅝ x 9⅝ in.)
Oxford, Ashmolean Museum

Burne-Jones has captured the monstrous three-headed dog of Greek myth, Cerberus, in an unusually poignant light here, creating an image of infinite sadness, in contrast to the typical depiction of Cerberus as a frightening aggressor. There is an almost human element to this drawing of the dog, emphasized by its prominent hind leg, the muscularity of which has more in common with a man than a dog, and reinforced by the very human emotion that the dog displays.

In Greek mythology, Cerberus was the guardian of the gate of the underworld, preventing mortals from entering the realm of the dead, and dead souls from leaving. This drawing relates to the story of the poet and musician Orpheus, who, heartbroken at the death of his wife, the nymph Eurydice, travels down to the underworld to try to bring her back. His music soothes Cerberus, so that the creature lies down and allows Orpheus through. Burne-Jones reflects the dog's confusion at this moment, its recognition that it is failing in its duty but is unable to act. The sense of sadness prefigures the tragic outcome of Orpheus's journey, which would result in Eurydice's being lost for ever.

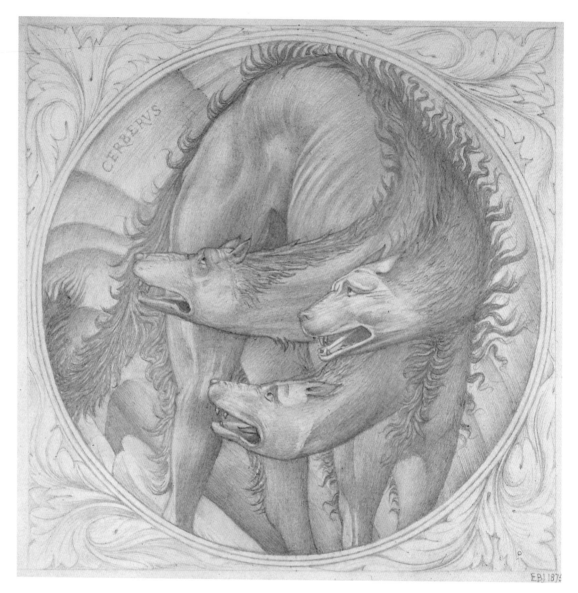

William Morris (1834–96)
Sir Tristan is Recognized by Isolde the Fair's Dog, from *The Story of Tristan and Isolde*
1862
Stained glass
68 x 60.5 cm (26¾ x 23¾ in.)
UK, West Yorkshire, Bradford Art Galleries and Museums

The medieval legend of Tristan and Isolde is one of the great early love stories, and, along with the Arthurian legends (into which myth cycle it was incorporated early on), has influenced the arts up to the present day. The origin of the tale, which has been retold and rewritten throughout the centuries, is Celtic: Tristan was the nephew of King Mark of Cornwall, while Isolde the Fair came from Ireland. This glass panel is one of several that relate the story of their doomed love, the rest being designed by such other Pre-Raphaelite masters as Dante Gabriel Rossetti (1828–1882), Edward Burne-Jones and Ford Madox Brown (1821–1893). The panels are believed to be based on the version of the legend related by Sir Thomas Malory in *Le Morte D'Arthur*, in which he gathered together a lengthy cycle of Arthurian legends.

This panel is especially touching, with Isolde's lovely white lapdog joyously recognizing the recumbent figure of Tristan. The little dog appears again in another panel, *The Death of Tristan*, by Brown, where it turns its head away from the tragic scene of the dead knight being embraced by Isolde.

How Sir Tristram slew a giant who would have slain King Mark and how King Mark not knowing him brought him to Tintagel, and how he got his wit again and how Isoude knew him again because of the brachet which Tristram had given her which leaped upon him and licked him

Nikolai Konstantinovich Kalmakov (1873–1955)
Artemis and Endymion
1917
Oil on canvas
Dimensions unknown
St Petersburg, State Russian Museum

There is an extraordinary intensity in this Russian surrealist work that is primarily focused on the penetrating stare between a woman and her dog. It is this that is so compelling: the dog's fine head at the centre of the composition and the unwavering stare between it and its mistress, Artemis, goddess of hunting: a look of complicity between partners in crime. Beneath the dog, with its striking black-and-white coat, is the ultimate quarry of the hunt, the beautiful shepherd Endymion, who sleeps eternally and so remains ever young. Artemis beseeched her father, Zeus, to place this spell on Endymion, thus robbing him of his natural life and allowing her to covet him at will.

The magical and mystical are central to this work, with its other-worldly atmosphere and iridescent core that projects the notion of the moon, another element associated with Artemis. The inclusion of the dog as such a focal point, both physical and spiritual, makes this a particularly unusual portrayal of a popular subject, and lends the painting an added dimension.

The voracious dog.....sprang forward, and tried to fasten himself upon Odin

C.E. Brock (1870–1938)
'The voracious dog …
sprang forward, and tried
to fasten himself upon
Odin', illustration from
*The Heroes of Asgard:
Tales from Scandinavian
Mythology* by A. and
E. Keary
1930
Colour lithograph
Dimensions unknown
Private collection

This fearsome dog, the guardian of the entrance to the underworld and, as such, the Nordic version of Cerberus, is a terrifying image, its lips curled back to expose dagger-sharp teeth. It is, however, an image grounded in reality, and is accurately drawn, being a good representation of a real dog. The same could not be said for Sleipnir, the magical eight-legged horse that carries the Norse god Odin.

This picture by the renowned book illustrator C.E. Brock represents the meeting of two deadly forces: the mighty Odin, god of war, death, wisdom, victory and magic, and the hound of Hell's gate. Both are prepared to battle to the death. Brock creates a moment of suspense by depicting the scene immediately pending violence – there is no contact yet between the pair, but only a hair's breadth separates them. At this point the dog is the aggressor, lunging forward against its restraint to reach Odin, but the god's lance is drawn back, and the power he emanates predicts the outcome of the encounter.

Eleanor Fortescue Brickdale (1871–1945)
The Arrow
c. 1890–1925
Watercolour on paper
76 x 53 cm (29⅞ x 20⅞ in.)
Leeds, Leeds Museums and Galleries

Eleanor Fortescue Brickdale was one of the leading female artists of the Pre-Raphaelite movement, and worked in a highly distinctive style, often in watercolour, using brilliant colours and finely painted detail.

She was not known for her paintings of dogs, so this work is a beautiful exception. The elegant greyhound type is convincingly real within a highly romanticized context, and looks towards Diana (Artemis), the goddess of hunting, with a noble and wise expression. Diana has just shot her arrow, and Cupid's gesture suggests suspense as to whether it will hit its target. The dog remains rather aloof, taking in the scene, but showing no great desire to chase down the quarry – which underlines its regal demeanour. The greyhound also forms a distinct third of the triumvirate composition and commands equal focal importance with the figure of Cupid behind Diana. Interestingly, the dog is the only part of the painting that is depicted in its natural colours – brown and white – while the rest of the painting is enlivened through Brickdale's characteristic use of vibrant hues that saturate even the background foliage.

Chris Gollon (born 1953)
Anubis and Charon
1997
Mixed media on panel
122 x 61 cm (48 x 24 in.)
Private collection

The work of the much sought-after British artist Chris Gollon is often infused with an eerie or macabre feel and presents a surreal and inventive world. This painting, featuring Anubis, the Egyptian guide to the underworld, and Charon, the Greek ferryman of dead souls, is no exception.

Although Anubis is often depicted as having a human body and the head of a dog or a jackal, here he is a finely drawn dog, of vaguely Doberman-pinscher type, with a level stare that seems to follow the viewer. The great dog figure occupies most of the canvas, a potent presence, but is not entirely threatening; instead there is a sense that although it rules this dark underworld, the creature is not to be feared. More disturbing is the figure of Charon, primarily because of his lack of facial features. Charon was the ferryman of Greek myth who, for the price of a coin, would take newly dead souls across the River Styx, or Acheron, to the underworld. He was characteristically portrayed as an unpleasant entity, whereas Anubis was viewed as a protector of souls and therefore more benevolent.

The
Portrait
Dog

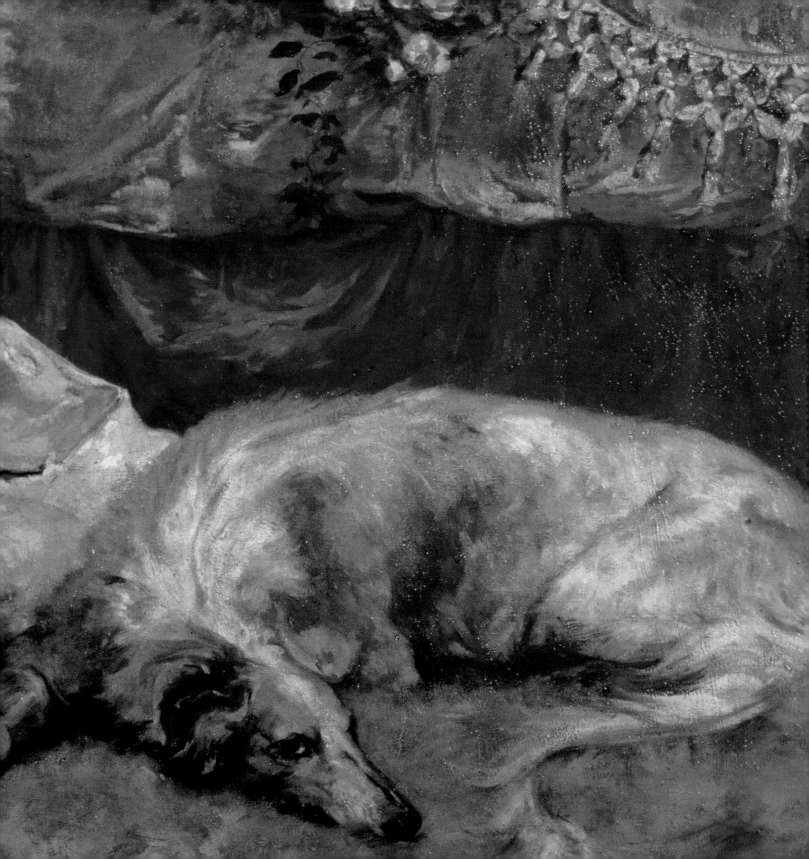

For centuries man has used art as a means of recording the individual, giving form and face to people who would otherwise be no more than names floating down to us through the ages. Federico Gonzaga, Duke of Mantua, for example, was immortalized by Titian as not only bearded and handsome but also beloved by his dog, and our perception of this man, a member of one of Italy's most powerful ducal families and reputedly an avid collector of dogs, is immediately informed by Titian's depiction (page 119). The painting speaks to the viewer and creates a persona, a character that endures, perhaps, above and beyond what has been written about Gonzaga – in literally giving him a face, it shows us his humanity. As we know so well from modern-day advertising techniques, the visual medium has enormous power to affect the viewer's subconscious.

The many thousands of historical portraits that have survived present an encyclopedic catalogue of humanity, each one crafted by the artist to present precisely the character intended – although the accuracy of this must be balanced by a recognition of flattery where it occurs. Most interesting for the purpose of this book is the patter of canine feet that has trailed through the centuries of portrait painting, so definitively that in some cases and at some times the dog became essential to the portrait, and lent those pictures into which it ambled an entirely different dimension, one that could be manipulated by the artist. The dog offered endless opportunity for artists to reflect characteristics of the portrait model, be it nobility, fidelity or wantonness, to suggest emotion, to indicate status or wealth, to glorify the subject, or to add narrative. In the painting *Sarah Bernhardt* (page 133), Georges Clairin created an image of quintessential feminine beauty and extravagance, and the inclusion of the actress's borzoi, then a rare and sought-after breed, emphasized the luxurious, exotic flavour of the work. By contrast, Thomas Gainsborough's painting (page 129) of the nervous William Lowndes with his uneasy dog – the pair being of striking physical similarity – evokes an entirely different atmosphere.

Titian was one of the great dog painters of the Renaissance, along with Paolo Veronese, and frequently included dogs in his works, painted with detailed understanding. His portrait of Federico Gonzaga, mentioned above, is exquisite. The affection between man and dog is tenderly rendered and touching. The duke's hand rests lightly on the long-haired little dog, which in turn raises its paw to him. This relationship gives the duke's character an aspect that would otherwise be missing, and the work makes an interesting contrast to the portrait of Baldassare Castiglione, also by Titian. That painting depicts the author and diplomat Castiglione alone against a simple background, the figure lacking the warmth inherent in the portrait of Gonzaga with his dog. Dogs were used by artists in portraits to convey a wide range of subtle messages, and in various different symbolic roles, but their inclusion can in

Their inclusion is almost always significant, their actions or their placement subtly commenting on the subject matter or the scene unfolding.

Jan van Eyck (c. 1390–1441)
The Arnolfini Marriage
1434
Oil on oak panel
82.2 x 60 cm (32⅜ x 23⅝ in.)
London, The National Gallery

The famous Arnolfini portrait is infused with symbolism. Every element in the painting is deliberate and significant, from the scattered oranges that imply wealth to the charming little griffon terrier-type dog, which stares boldly from the canvas and represents fidelity. The good qualities of dogs, including their faithfulness and subservience, were often used as symbols of the behaviour expected from a wife.

This was one of the earliest portrait paintings to be set in such an obviously domestic setting, and although the scene is probably partially fabricated, it does reflect the lifestyle of a wealthy young couple. The male figure, who is believed to be Giovanni Arnolfini, a merchant from Bruges, is dressed in expensive though restrained clothing. His wife is similarly lavishly attired in a fur-trimmed dress; she is not pregnant but wearing a fashion of clothing in vogue at that time. Their pet, the little terrier, was then a popular type of dog in northern Europe and appeared frequently in art.

many instances be distilled to one simple reason – they were beloved companions, and as such it was a matter of course for them to be painted alongside their masters. Thus, even at a time when prestige, power and wealth meant everything and the great Italian ducal families were trying to outdo one another, Federico chose to be painted not with the standard attribute of nobility, the greyhound, but with his fluffy little white dog.

Since it first raced into man's world, the greyhound, with its arguably unequalled beauty, has been treated just a little differently from the rest of the pack. The royalty of the canine world, it saunters down the avenues of life with an effortless grace that is born and bred. Symbolically, greyhounds represent nobility, fidelity and good breeding, and were often used in heraldry. They were owned by the aristocracy and their inclusion in portraits had obvious significance. There are few depictions of the greyhound quite so moving as that in Anthony van Dyck's painting *James Stuart, 4th Duke of Lennox and 1st Duke of Richmond* (page 124): like Titian's earlier work, this shows genuine devotion and affection between man and dog. It is the most beautifully painted and strikingly realistic image of a greyhound, and possibly ranks as Van Dyck's greatest painting of a dog.

Typically, although not always, large dogs of mastiff or hound type were painted accompanying men in portraits, while women were joined on the canvas by little dogs, such as the Chien de Lion in *Duchess Katharina of Mecklenburg* (page 118) by Lucas Cranach. A comment on sexual stereotypes hardly needs to be made. By the seventeenth century, however, more small dogs were seen in male portraiture, and their popularity as pets for men increased, particularly in Italy, where the ducal families kept many lapdogs, customarily cared for by dwarves, and helped in great part by the enthusiasm for small dog breeds that the royal families of Europe had fostered since the fifteenth century. Perhaps the culmination in artistic terms of this trend might be the idiosyncratic *Lord of the Chihuahuas* (page 137) by the contemporary artist Isabelle Rozot.

**Lucas Cranach the Elder
(1472–1553)**
*Duchess Katharina
of Mecklenburg*
1514
Oil on panel transferred
to canvas
184 x 82.5 cm (72⅜ x 32½ in.)
Dresden, Gemäldegalerie Alte Meister

The German artist Lucas
Cranach the Elder was
extremely popular during
his lifetime and was highly
sought after for his portrait
paintings. This portrait and
its pair, *Henry the Pious,
Duke of Saxony*, are of
particular interest because
of Cranach's inclusion of the
dog, and also because they
marked the beginning of his
true official portrait style.

Here, Katharina, in her
exquisitely detailed and
elaborate dress, is portrayed
accompanied by a charming
white Petit Chien de Lion-
type dog that sits demurely at
her feet. These little lapdogs
were extremely popular in
Europe, having probably
developed in the French
Mediterranean area. Typically
their coats were shaved and
coiffed to give them the
appearance of a lion.

Cranach's portrait of
Katharina's husband, Henry,
includes a large, rather
fierce-looking hound-type
dog, so that when seen
together the two portraits
present the classic formula
of masculinity and femininity,
with the dogs being used to
accentuate the concept of
gender in a way commonly
applied by artists at the time.

Tiziano Vecellio (Titian)
(c. 1488–1576)
Federico II Gonzaga,
Duke of Mantua
c. 1525–30
Oil on panel
125 x 99 cm (49¼ x 39 in.)
Madrid, Museo del Prado

Titian included dogs in many of his paintings, depicting them with great naturalism and vitality. He painted dogs of every shape and size, from diminutive toy-spaniel types to great hounds; here, it is an endearing Maltese type that entreats Federico Gonzaga with a lifted paw. Titian's treatment of the dog's coat is quite extraordinary, with every hair painstakingly detailed – even Gonzaga's fingers, where they rest on the dog's back, leave subtle, gently shadowed indentations. Not only have the range and scope of Titian's dogs left evidence of the types of canines popular during his time, but also his paintings illustrate the great affection in which the dog was held in Renaissance Italy.

Federico II Gonzaga was apparently a great dog enthusiast. At his ducal palaces he kept many dogs, especially hunting types, which, along with his great stables of horses, would have been highly prized and regarded as evidence of his power and wealth.

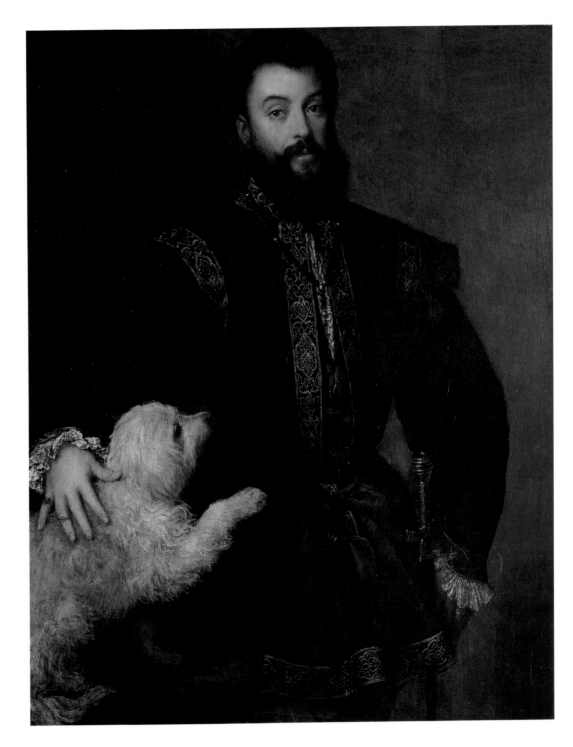

Diego Rodríguez de Silva y Velázquez (1599–1660)
Philip IV, King of Spain
c. 1634–35
Oil on canvas
191 x 126 cm (75¼ x 49⅝ in.)
Madrid, Museo del Prado

Velázquez was appointed court painter to Philip IV of Spain in 1623, and the following year was paid by the king to move his family to Madrid, where he lived for the rest of his life. He painted more than forty known pictures of Philip and the royal family, although some have been lost or destroyed, and is widely regarded as one of the most influential seventeenth-century artists.

This is one of the more informal paintings of Philip and depicts him out hunting, accompanied by his Spanish mastiff-type dog. The work was one of several intended to emphasize the king's skill as a hunter. It accompanied the painting *Philip IV Hunting Wild Boar* (1636–38), which shows him in a more active pose, and *Prince Baltasar Carlos as a Hunter* (1636), which shows his son in a similar role. The works were destined to hang in Philip's private hunting lodge, the Torre de la Parada, not far from Madrid.

Typically of Velázquez, the detail and realism in this portrait are astonishing, with the dog being particularly beautiful, its expression one of wisdom and serenity as it waits to be directed by its master. Velázquez, like Titian before him, often included dogs in his paintings and was virtually unsurpassed in his ability to lend life to their painted images.

Tiziano Vecellio (Titian)
(c. 1488–1576)
Charles V, Holy Roman
Emperor and King of Spain,
with his Dog
1533
Oil on canvas
192 x 111 cm (75⅝ x 43¾ in.)
Madrid, Museo del Prado

Titian met the Emperor
Charles V in 1530, the same
year that the artist's wife died.
It was around this time that his
style became somewhat more
sombre and reflective than it
had been in his earlier works.

This painting of Charles V
with an enormous and
prestigious hound-type dog
was the first portrait of the
emperor that the artist
undertook, and it was based
on a work painted the year
before by the artist Jacob
Seisenegger (c. 1504/05–1567).
Other than the similarity in
composition between the
two, there is little comparison.
Titian's work is vibrant,
the detail in the emperor's
clothing so tactile that each
thread gleams, and the dog
so real its skin practically
quivers, rippling across its
muscled shoulders and
sinuous veins and tendons.
This is an exceptional dog,
and would undoubtedly have
been a prized hunting animal
– although there is genuine
affection here, too, with
Charles's fingers casually
slipped beneath the collar
in a gentle caress.

Rembrandt Harmensz. van Rijn (1606–1669)
Self-Portrait in Oriental Costume
1631
Oil on panel
66 x 52 cm (26 x 20½ in.)
Paris, Musée de la Ville de Paris

Rembrandt often included dogs in his paintings, typically depicting them in a very naturalistic manner as they go about their doglike business. Yet their inclusion is almost always significant, their actions or their placement subtly commenting on the subject matter or on the scene unfolding. Self-portraits with dogs are of particular interest, because generally these are dogs that belonged to the artist, and so they lend the work an extra dimension. It requires just a short stretch of the imagination to see the artist's dog wandering through the studio, perhaps witness to the painter working on another masterpiece, or curled up beneath the easel, coat covered with flecks of hand-ground paint.

In this characteristically sombre self-portrait, Rembrandt and his dog pose separately; there is no real communication between the two, and this creates a rather melancholy atmosphere. There is a visual similarity between them, in the shape of the cloaked man and that of the dog, and with the curly fur of the dog's ears mirroring the artist's wavy hair. There is also a sense that this dog might be a reluctant sitter. Its shoulders are slightly hunched, head tilted down, although it acquiesces.

**After Anthony van Dyck
(1599–1641)**
*Full-Length Portrait
of Charles II as a Boy,
with a Mastiff*
n.d..
Oil on canvas
133 x 104 cm (52⅜ x 40⅞ in.)
Private collection

Van Dyck, along with Peter Paul Rubens (1577–1640), was one of the most important Flemish artists of the seventeenth century, and had a profound influence on generations of portraitists. Although he painted grand allegorical and religious works, it is for his portraits that he is most famous, especially those he painted during his time in London at the court of Charles I.

This painting was made after Van Dyck and retains the character and flavour that typified his portraits, although it is technically less accomplished. Here the future Charles II is seen with an enormous mastiff-type dog, almost as large as the young prince. The dog commands as much attention in the painting as the child, but the artist has cleverly depicted the boy resting his hand on the dog's head in a manner that is affectionate yet at the same time indicates his dominance over the powerful animal, creating a suitably flattering allusion for the future king. The juxtaposition of a small child or a dwarf with a huge dog in paintings was popular at this time, a notable example being *A Buffoon Sometimes and Incorrectly Called Antonio the Englishman*, by Velázquez.

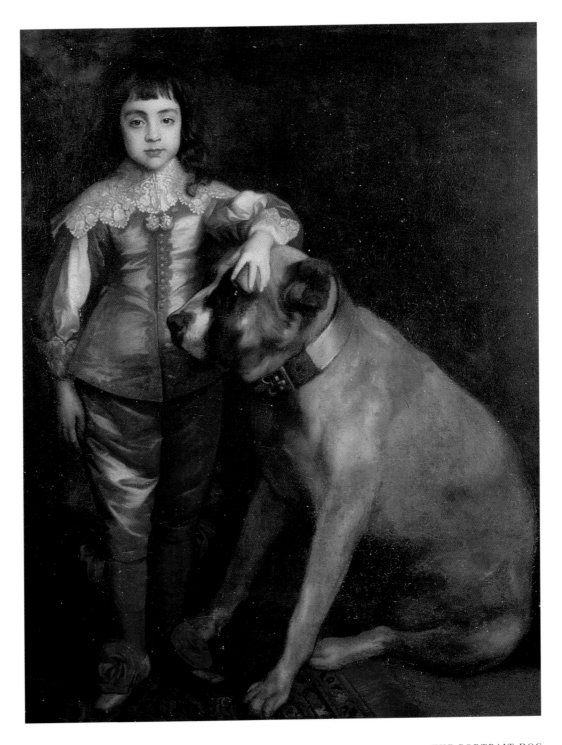

**Anthony van Dyck
(1599–1641)**
*James Stuart, 4th Duke
of Lennox and 1st Duke of
Richmond*
c. 1634–35
Oil on canvas
215.9 x 127.6 cm (85 x 50¼ in.)
New York, The Metropolitan Museum
of Art

Van Dyck was one of the finest painters of dogs of all time, and this magnificent greyhound is perhaps his crowning achievement in the field. There are few images that touch the soul quite like this. The dog leans into its master, James Stuart, its head pressed against the man's side, while Stuart rests his hand on the dog's brow in a gesture of infinite tenderness. As with the portrait of the future King Charles II and his mastiff (previous page), the gesture speaks volumes about the intimacy and devotion that exist between dog and master.

The greyhound in this painting has been regarded as a symbol of nobility, and also as reflecting Stuart's devotion to the king: both are possible interpretations. However, what is clear is that this dog must have been included at Stuart's insistence. Through the subtle use of gesture, Van Dyck has captured a love between man and dog that could not have been fabricated, one that is perhaps partly explained by the fact that this dog had reputedly saved the life of its master.

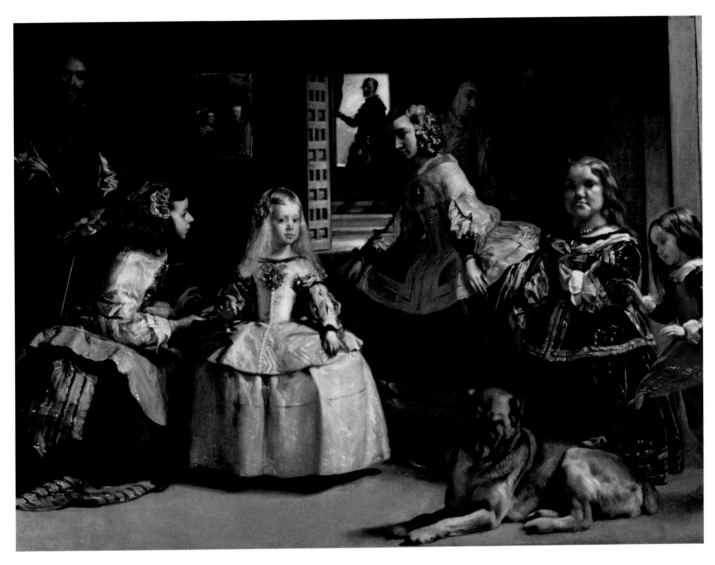

Diego Rodríguez de Silva y Velázquez (1599–1660)
Las Meninas (detail)
1656
Oil on canvas
Madrid, Museo del Prado

This extraordinary painting is one of Velázquez's most famous works, and the most complicated in terms of structure and content. Ostensibly it is a group portrait, centred on the figure of the Infanta Margarita, daughter of King Philip IV of Spain and his second wife, Mariana of Austria, who themselves are portrayed reflected in the framed mirror in the background. Velázquez himself can be seen to the left, partially behind a large canvas, the subject of which remains unseen to the viewer.

The large Spanish mastiff-type dog in the foreground is a compelling part of the work, even being designated as the greatest dog in art by the art historian Kenneth Clark. The wrinkled folds of skin across its face, characteristic of the breed, lend it a look of resigned patience and affability. Behind the dog, the dwarf Nicolasico Pertusato puts his foot on its back, perhaps testing its kind and implacable nature, or possibly rubbing its fur as a sign of affection. The prominence of this great animal in the picture suggests that it was a well-loved member of the household, a pet and guardian, and indicates the popularity of this large breed within the Spanish court.

Alexandre-François Desportes (1661–1743)
Self-Portrait as a Hunter
1699
Oil on canvas
197 x 163 cm (77½ x 64⅛ in.)
Paris, Musée du Louvre

The French artist Alexandre-François Desportes was one of the greatest painters of dogs in the eighteenth century, and specialized in hunting scenes and portraits of individual prized dogs. His understanding of canine anatomy and behaviour was translated into paint with such flourish that he earned the esteem of two French kings, Louis XIV and Louis XV.

This self-portrait is a virtuoso display by Desportes of his talent for depicting hunting scenes, and as such it can almost be seen as a form of advertising for what he did best. The tactic must have paid off, for the following year he received his first commission from Louis XIV. Desportes was a master of detail, and this painting is no exception, from the highlighted tip of the greyhound's tail to the lustrous sheen of his own blue velvet coat. Both dogs are beautifully rendered, the pointer type delighting in the man's touch, and convincingly real despite the still-life-like artifice of the staged scene; the picture is only slightly marred by the artist's apparent self-glorification, but the portrayal of the greyhound, in particular, redeems him.

**William Hogarth
(1697–1764)**
Self-Portrait
1749
Engraving
38.1 x 28.7 cm (15 x 11¼ in.)
Private collection

Pugs became extremely popular in The Netherlands during the sixteenth and seventeenth centuries, and were the pet of choice of the House of Orange. In 1688, when William of Orange and his wife, Mary, sailed to England to take the English throne, they were accompanied by their many pugs, and this began a fashion in England for the breed, a little dog with a big character.

Hogarth had two pet pugs, one called Pug and the other Trump. It is Trump that appears in this famous self-portrait, and the dog is as much the subject as the artist himself. Placed near the front of the canvas, it sits in contemplative quiet, and is depicted with a particularly intelligent face that creates the impression that it is the intellectual equal of the man. The physical similarity between the two is also apparent, and drew some comment from the critics of the day, in particular the satirical poet Charles Churchill.

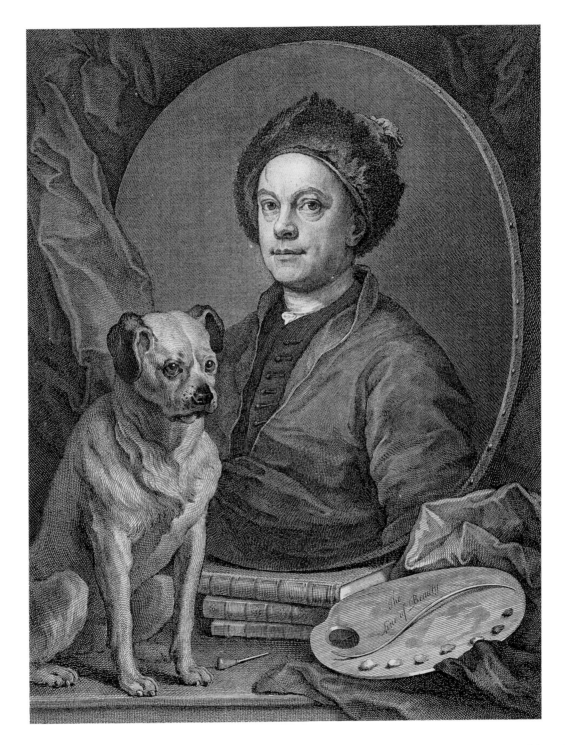

Girolamo Pompeo Batoni (1708–1787)
Charles Lennox, 3rd Duke of Richmond
1755
Oil on canvas
135.4 x 97.8 cm
(53⅓ x 38½ in.)
UK, West Sussex, Goodwood House

There is great feeling in this work, which depicts the young Charles Lennox with two fine spaniel-type dogs against a Classical background. His demonstrative pose, caressing the silky ears of the dark-brown dog with both hands, is unusual in male portraiture, the traditional gesture being one hand resting, often with a degree of detachment, on the dog's head. It is touching to see the young man, who would become one of the great parliamentary reformists, expressing such obvious sentiment towards the dog.

The artist Girolamo Batoni specialized in portraits of wealthy Europeans and dignitaries, painting them from his studio in Rome as they passed through the city on their Grand Tour. He included Classical references in the paintings in order to reflect the Grand Tour's cultural purpose, although that aspect is understated here, with the focus being on the dogs and man. The affection between Lennox and these dogs suggests they were beloved pets, in which case they would have been accompanying him on his tour.

**Thomas Gainsborough
(1727–1788)**
*William Lowndes, Auditor
of His Majesty's Court of
Exchequer*
1771
Oil on canvas
126.8 x 102 cm (49⅞ x 40⅛ in.)
Connecticut, Yale Center for British Art,
Paul Mellon Collection

Thomas Gainsborough,
along with Joshua Reynolds
(1723–1792), was one of
the masters of eighteenth-
century British painting, and
established a reputation as a
leading portraitist. Portraiture
at this time was in vogue,
with the economy boasting
a healthy market for portrait
commissions, which attracted
such artists as Gainsborough
who might perhaps otherwise
have concentrated on
landscapes. He brought to
his portrait painting a depth
of understanding and a
perceptive eye that allowed
him to convey accurately the
character of his sitter, and he
often included a dog or dogs
that emphasized the sitter's
characteristics.

William Lowndes was a
Member of Parliament and
Secretary to the Treasury,
and it might have been this
weighty responsibility that sat
so heavily on his shoulders.
In this work, painted after his
death, he appears an uneasy
model, hands clasping his
stick, shoulders tense and
mouth drawn. His little dog,
its curly hair and droopy
ears somewhat echoing
Lowndes's physical
appearance, has its front legs
slightly braced and looks as
though it is about to move.

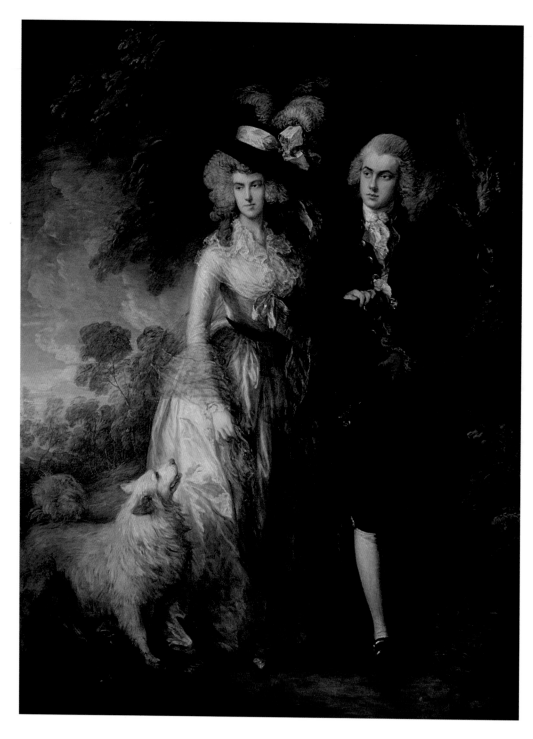

Thomas Gainsborough
(1727–1788)
*Mr and Mrs William Hallett
(The Morning Walk)*
c. 1785
Oil on canvas
236.2 x 179.1 cm (93 x 70½ in.)
London, The National Gallery

Gainsborough was a great dog painter and often included dogs in his portraits, as well as painting portraits of individual dogs. He seems to have had a genuine affection for 'man's best friend', which is conveyed through the subtle and captivating way in which he painted them.

This painting depicts an elegant young couple and was commissioned to commemorate their marriage. They are both fashionably dressed, their clothes picked out with exquisite detailing, especially in the lace ruffles along the sleeve and neck of Mrs Hallett's dress, created through bare, tiny strokes, teased almost from the surface of the canvas. The handsome, animated dog that accompanies them has the appearance of a Pomeranian (which was bigger then than it is today), a member of the spitz family. This dog may not have belonged to the couple, but may have been used by the artist because it complements the scene so well. One of Gainsborough's friends, the famous cellist Carl Friedrich Abel, owned Pomeranians, and some years earlier Gainsborough had painted Abel's dogs in the delightful *Pomeranian Bitch and Puppy* (c. 1777). It may be that this dog is the puppy grown up.

**Joshua Reynolds
(1723–1792)**
A Young Girl and her Dog
c. 1780
Oil on canvas
77.5 x 63.5 cm (30½ x 25 in.)
Tokyo, Tokyo Fuji Art Museum

In 1753 Joshua Reynolds
moved to London, where
he would remain for the rest
of his life, producing a huge
number of portraits from his
busy studio. His work and
his discourses on art had a
profound effect on the course
of British portraiture, and his
influence was further secured
when in 1768 he was elected
first president of the Royal
Academy. In 1769 he was
awarded a knighthood by
George III, although the
royal family never really
took to Reynolds and he
received relatively few
royal commissions.

He painted instead the
fashionable, wealthy set in
their finery, as well as many
delicately coloured pictures
of young children, who were
often depicted in a highly
sentimental way, as seen
here. This image, although
saccharine, includes a
skilfully painted dog, which
seems to smile with just the
faintest upcurl of its lips,
while its eyes droop slightly in
pleasure, in a characteristic
canine way. The dog's coat is
finely painted, with sweeping
short strokes and glistening
highlights that reflect its
excellent condition.

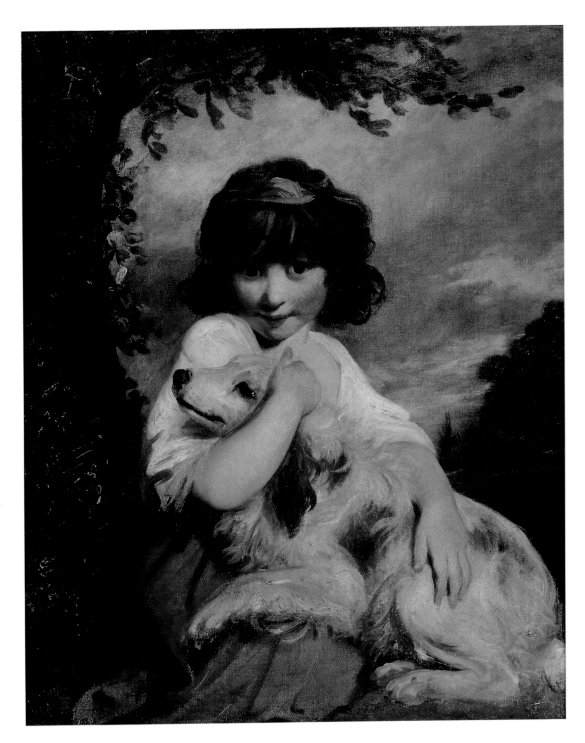

**Gustave Courbet
(1819–1877)**
Courbet with his Black Dog
1842
Oil on canvas
46.3 x 55.5 cm (18¼ x 21⅞ in.)
Paris, Le Petit Palais, Musée des
Beaux-Arts de la Ville de Paris

This self-portrait of a dapper-looking Gustave Courbet and his elegant black dog was painted early in his artistic career, and in 1844 became his first work to be accepted by the Paris Salon. Courbet went on to become one of the leading realist painters of the nineteenth century. He was strongly political in his outlook, a champion of the working people and a socialist, and his art reflected his beliefs. Here he is seen still developing his style: this work is rather romantic, and finely executed with a smooth and polished paint surface, in contrast to his later works.

Courbet frequently included dogs in his paintings, often using them to comment on the scene or to add social narrative. This particular dog, which commands as much attention as the figure of the artist, is especially fine, with its drooping silken ears. Pure black dogs had traditionally not appeared in art a great deal, because of mythical and folkloric associations linking them with the devil. Courbet, ever the controversial breaker of convention, may perhaps have painted this black dog, so prominent beside him, with a slightly humorous intent.

Georges Clairin
(1843–1919)
Sarah Bernhardt
1876
Oil on canvas
250 x 200 cm (98⅜ x 78¾ in.)
Paris, Le Petit Palais, Musée des
Beaux-Arts de la Ville de Paris

The borzoi that lies at the
feet of the charismatic Sarah
Bernhardt is as elegant and
beautiful as the famous
actress herself. This is
an image of pure luxury.
Bernhardt reclines on a sofa
amid a profusion of Oriental-
style cushions and patterned
material, while the dog
seems to match her easy,
abandoned pose, and sinks
into the thick pile of a fur
rug. Clairin, whose work
was typified by its Oriental
character, was one of several
artists who painted the
actress, and he reputedly
also had an affair with her.

The borzoi is characterized
by its great beauty, and had a
long association with nobility.
Its inclusion in this painting
is designed to emphasize
the qualities of beauty and
refinement in the actress.
The breed was developed
in Russia by the imperial
court, and later imported into
England, a pair being given to
Queen Victoria. It is, however,
Alexandra, queen consort
to Edward VII, who is most
associated in Britain with
the breed. She was given a
borzoi called Alex, whom she
adored, by Tsar Nicholas II
of Russia. Alex became a
champion show dog, and
is reputed to have been her
constant companion.

Claude Monet (1840–1926)
*Portrait of Eugénie Graff
(Madame Paul)*
1882
Oil on canvas
63.1 x 53 cm (24⅞ x 20⅞ in.)
Massachusetts, Cambridge,
Harvard University Art Museum,
Fogg Art Museum

The old adage that people grow to look like their dogs, or dogs grow to look like their owners, seems to hold true in this delightful painting by Claude Monet. The elderly Madame Paul, owner of the patisserie in the French seaside resort of Pourville, and her little Yorkshire terrier-type dog bear a striking and amusing resemblance to each other, and it seems that the artist approached this work with a degree of lightheartedness. The dog and the woman share equal importance as subject matter, the dog commanding attention through its direct stare straight from the canvas to the viewer. It has an almost human quality to it, based in part on its shining, intelligent eyes, and on the head-and-shoulder pose that Monet has used. Madame Paul's gaze falls to the left, perhaps to the object of her mirth; or it may be that her wry amusement, so subtly conveyed by Monet, is at her fate as artist's model.

Monet stayed in Pourville for a short period in 1882, and while there painted a number of characteristically Impressionist works. Following his stay he moved with his family to Giverny, where he lived for the rest of his life.

Berthe Morisot (1841–1895)
Julie Manet and her Greyhound, Laerte
1893
Oil on canvas
73 x 80 cm (28¾ x 31½ in.)
Paris, Musée Marmottan

Berthe Morisot was one of the leading female Impressionist artists; throughout her later career she remained faithful to the Impressionist style, and was an important supporter and collector of many of her contemporaries' work. Significantly, the subject matter available to women artists at this time was still predominantly limited to the domestic sphere, so many of Morisot's works are of her beloved family – her husband, Eugène Manet (brother of Edouard), and her only child, Julie.

Morisot married relatively late in life, in 1874, and did not give birth to Julie until 1878, when she was thirty-seven years old. Julie became the light of Morisot's life, and she painted her many times as she grew up. Morisot's portraits of her daughter are particularly sensitive: her emotion is tangible with every brushstroke. Here Julie is seen with the family's pet greyhound (*lévrier*), called Laerte, which Morisot also painted on several occasions. The relationship between Laerte and Julie is especially tender in this image, with the dog's head resting on the girl's lap, and a distinct similarity evident between the dog with its silken ears and Julie with her long tresses.

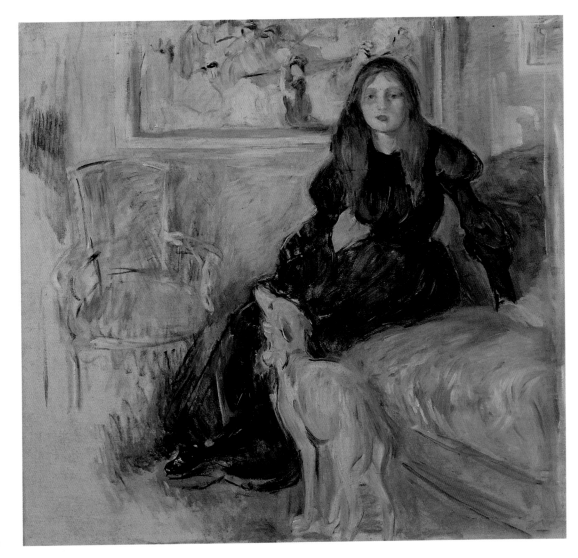

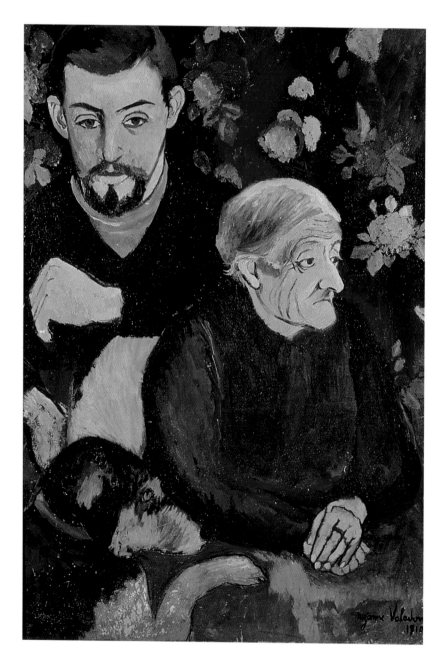

**Suzanne Valadon
(1865–1938)**
***Portrait of Maurice
Utrillo, his Grandmother
and his Dog***
1910
Oil on canvas
70 x 50 cm (27½ x 19⅝ in.)
Paris, Musée National d'Art Moderne,
Centre Pompidou

This intense painting is a portrait, but more than that it is a study of human lives, expressing enormous emotion. The dog, which has the appearance of a mongrel (itself symbolic of being set apart from the mainstream), touchingly raises a paw to the old lady, Maurice Utrillo's grandmother. The woman wears an expression of exhaustion and worry, and significantly is turned away from the man, who stares blankly from the canvas. The painting tells of a family beset with troubles.

Suzanne Valadon was a former artist's model and taught herself how to draw by watching such artists as Pierre-Auguste Renoir (1841–1919), Edgar Degas (1834–1917) and Henri de Toulouse-Lautrec (1864–1901) at work. She gave birth to Maurice Utrillo (1883–1955) when she was eighteen – his father has never been irrefutably identified, although the child was adopted by the Spanish art critic Miguel Utrillo, from whom he took his surname. Maurice was raised by his grandmother while Valadon worked, but he developed mental health problems and struggled persistently against depression and addiction, despite which he became one of the great twentieth-century artists. Valadon herself also grappled with personal problems throughout her life. This painting speaks volumes about the fragile tenacity of the human spirit, with the dog's gentle gesture, in its expression of unconditional love, balancing the traumatic undertone.

Isabelle Rozot (born 1962)
Lord of the Chihuahuas
2006
Oil on canvas
64 x 46 cm (25¼ x 18⅛ in.)
Private collection

Contemporary artist Isabelle Rozot conveys the blatant superficiality of the idle side of life in her paintings with a wonderful sense of whimsy. This magnificent figure, a foppish male consumed with self-absorption and self-love, lounges languidly in a thronelike chair, bent arm resting on one leg with affected naturalness. He is surrounded by tiny, perfect chihuahuas, one of which stares with challenging directness straight from the canvas. It is a humorous inversion of traditional male portraiture – gone is the hound, and in its place are the lapdogs of women.

A further sly wit is apparent in the artist's choice of dog. Although the chihuahua is one of the smallest breeds of dog in the world, it has been known to believe that it is actually one of the biggest, and to act accordingly. It is thought to have descended from small ancient dogs (Techichi) in Mexico and Central America, where diminutive dogs were widespread and important within early cultures.

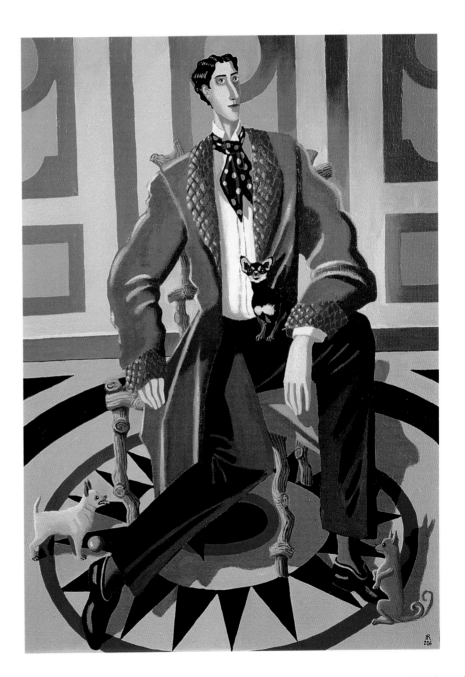

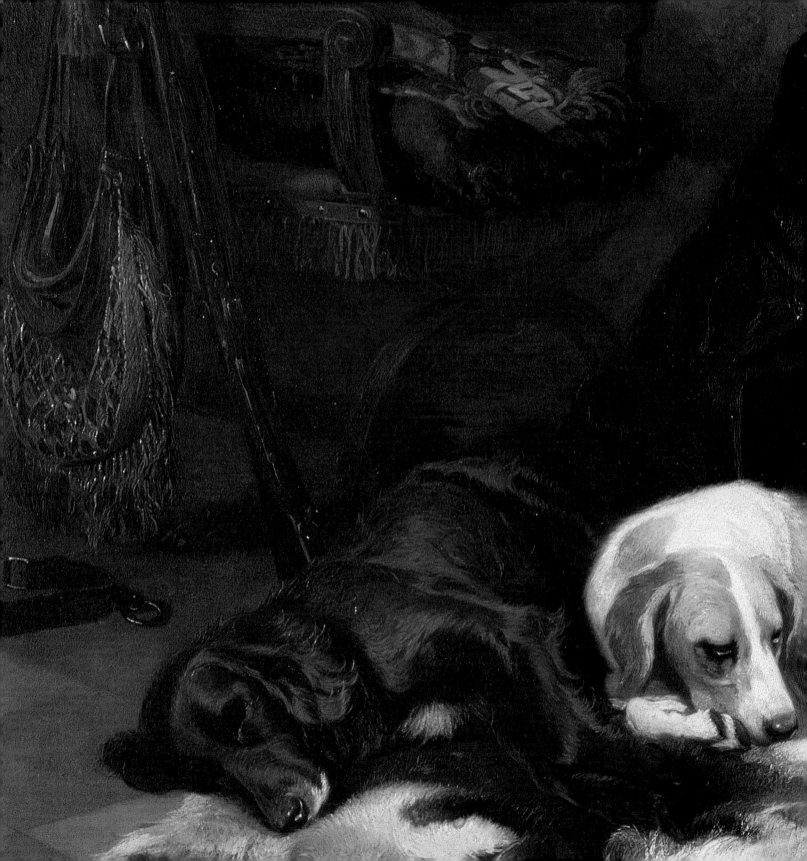

The Domestic Dog

THE DOG IS THE MOST ENDURING OF MAN'S companions, and has for millennia been welcomed into the home. The differentiation between dogs used for hunting and working, and those kept as pets, is one that may have been blurred at times – with prized hunting dogs being kept, as their domestic fellows were, in royal palaces, allowed to roam free and even, in some cases, to sleep on the royal bed – but, as far back as the ancient civilizations of Egypt, Greece, Rome and China, a general distinction was made between a working dog and a domestic pet. The pet dog was most often much smaller in stature, and many ancient artworks depict these little dogs in the domestic interior. It is through the evidence of such imagery that the earliest types of domestic or pet dog are known, the principal ones appearing similar to the Italian greyhound, the Maltese, the toy spaniel and other, Eastern breeds, such as the Pekingese, the Lhasa Apso and the Japanese Chin.

In ancient China tiny dogs known as 'sleeve dogs' were bred, small enough to be carried in the wide sleeves of the garments of the time. Some of the earliest depictions of small dogs in Chinese art date back to around 200 BC, although the breeding of these dogs has its roots in prehistory. They were particularly popular with the emperors, and accounts suggest that many little dogs were kept in the Imperial palaces, and given free rein. The Emperor Ling Ti is even said to have bestowed royal titles on his dogs and made them the official guardians of his palaces.

The tradition of keeping very small dogs as pets was not confined to China, but was in fact widespread, occurring in ancient Egypt, Greece, Rome and across Europe, as well as in North and South America. It persisted partly for practical purposes – small dogs being easier, cleaner and cheaper to keep – but also for reasons of fashion. An early work by Jan van Eyck, *The Birth of John the Baptist and the Baptism of Christ* (page 143), depicts a tiny, long-haired dog going about its business in the bedroom where an event of some consequence is occurring. It is a charming episode that reflects the fact that the predominance of dogs in the domestic environment, especially in northern Europe, was such that they were naturally included in almost every genre of painting. Renaissance Italy, too, was awash with dogs. The palaces and mansions of the nobility were overrun with dogs; they spilled into every room, lorded it up in the bedroom, chased rats through the corridors and were captured in paint on canvas – often causing havoc at feasts (see 'January', page 142, by the Limbourg brothers and 'Month of January: Rich Lord at the Table', page 145).

As with virtually all representations of dogs, the pet dog embodies a whole spectrum of symbolic meanings, from the ultimate manifestation of faithfulness to the embodiment of carnal desire. As the

> *The palaces and mansions of the nobility were overrun with dogs; they spilled into every room, lorded it up in the bedroom, chased rats through the corridors and were captured in paint on canvas – often causing havoc at feasts.*

Italian School
Preparation of White Cheese
14th century
Vellum
Dimensions unknown
Vienna, Österreichische Nationalbibliothek

Beautifully decorated tabular manuscripts on medicine, food and managing a household were popular in medieval Italy, and were used by wealthy women as reference books. This detailed sheet comes from such a book and is one of many illustrations showing the preparation of different foods. These expensive books were based on an eleventh-century Arabic treatise called the Taqwim as-Silha, compiled by the physician Ibn Butlan. The original Arabic work was written in tabular form without illustrations, and the first translations of it into Latin, in the thirteenth century, were also text-based. In the fourteenth century in northern Italy, however, a series of illustrated manuscripts was produced, from which this image comes, possibly commissioned by the Count of Milan, Giangaleazzo Visconti.

This is one of the more charming of the illustrations. The enormous black-and-white mastiff-type dog here was probably a guard dog rather than a pet, but it looks wonderfully relaxed within its domestic environment, and is obviously a regular attendant at such scenes. Its mouth open, on the point of drooling, its tail wagging in anticipation, the dog is willing the figure to share some of his whey.

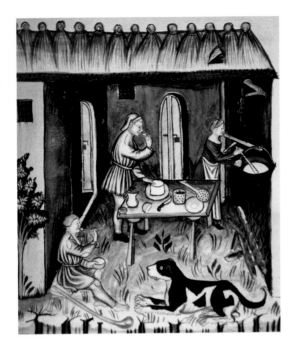

sleeping spaniel in Titian's *Venus of Urbino* (page 102) can be interpreted as 'promiscuity' or as 'faithfulness', so in Vittore Carpaccio's *Two Venetian Ladies* (page 144), the dog can represent 'carnality' and imply that the women are prostitutes, or 'nobility', suggesting their wealth and stature.

With the growth of genre scenes – scenes of everyday life – in the art of northern Europe, paintings of domestic events, such as *The Morning Toilet of a Young Lady* (page 148) by Frans van Mieris, began to include dogs from all walks of life. The dog was shown accompanying different classes, living with the peasant as well as the wealthy merchant or the nobility. Never before had it been acceptable to project the protagonists of low-class culture,

and their dogs, on to the canvas. From this point onwards, dogs are seen in churches, brothels, bars, bedrooms, kitchens and the street, and these are real dogs, painted lovingly, with individuality and character. It was during this time that the dog grew to become a subject in its own right, with the seventeenth-century Dutch artists greatly influencing the dog painting that developed in England some one hundred years later. There was also a thriving trade in pet dogs, which had become a commodity, and merchants flocked to dog markets, much like the traditional Romany horse fairs.

Dogs in art have always had symbolic associations to varying degrees, but dogs in Dutch genre scenes often embodied a complex moral didacticism or served to comment on a scene; an example is the unsettling *The Doctor's Visit* (page 146) by Jan Steen, or the romantic *The Cello Player* (page 147), after Gabriel Metsu, where the little dog represents love and fidelity. In this capacity the dog often features in art, as can be seen particularly in Dutch art of the seventeenth century, and in eighteenth-century English and French works, such as Gainsborough's *Mr and Mrs William Hallett (The Morning Walk)* (page 130), and *The Souvenir (Fidelity)* (page 219) by Jean-Baptiste Greuze.

The nineteenth century saw an explosion in European dog painting, with some artists using the dog as a vehicle for social commentary, reflecting the increasing gap between the wealthy and the working classes. For example, the desperate bitch scavenging for food in a chaotic kitchen in Philippe Rousseau's *Chacun pour soi* (page 151) echoes the deprivation suffered by the working classes in France at the time.

It was during the nineteenth century that formalized breed societies and standards were developed, alongside the increasing fashion for dog shows. The distinction between pet dogs and hunting dogs became ever more eroded, as highly prized working dogs began to be kept in the home and treated in the manner that pet dogs had enjoyed for so long. *By the Fireside* (page 152) by Conradyn Cunaeus, for example, depicts three gorgeous sporting dogs just back from the day's work; clearly these are not kennel-kept hounds. Similarly, and some years later, Pierre Bonnard painted *Greyhound and Still Life* (page 157). The oldest and most elegant of all dogs, originally used for hunting, then primarily for racing, is here part of the domestic scene; and, indeed, the greyhound retired from the track is today one of the quintessential beloved pets of the British.

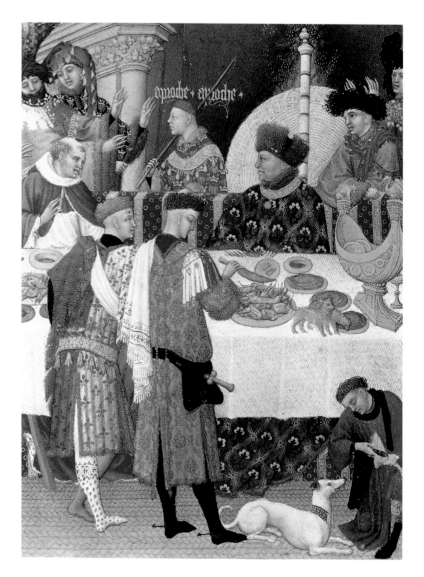

Opposite
**Limbourg brothers
(active 1400–1416)
'January', from** *Les Très
Riches Heures du duc
de Berry* **(detail)**
c. 1415
Vellum
France, Chantilly, Musée Condé

This exquisite piece is taken
from *Les Très Riches Heures du
duc de Berry*, the most lavish
and beautiful Book of Hours
that survives from the fifteenth
century. Jean, duc de Berry
was a figure of considerable
power in France, and enjoyed
tremendous wealth. He was
an avid patron of the arts,
and led a sumptuous and
lavish lifestyle, admirably
demonstrated in this detail from
'January', where he is seen
hosting an enormous feast.

The duc de Berry was also
a great dog-lover, and bred
special mastiff-type dogs for
hunting, as well as owning
many small dogs that lived
in his various palatial homes.
Here two tiny dogs feed from a
plate on the table (it is possible
they were 'testing' the food
before the duke tried it, to
make sure it was not poisoned),
while a splendid white
greyhound type with ornate
collar is fed by hand in the
foreground. The duc de Berry
was painted several times
accompanied by two dogs
similar to these, this very small
kind being typical of the lapdog
seen in depictions of this period.

**Jan van Eyck
(c. 1390–1441)**
*The Birth of John the
Baptist and the Baptism
of Christ* **(detail)**
c. 1424–41
Body colour on parchment
Turin, Museo Civico

This extraordinary miniature
is from the Turin-Milan Book
of Hours, a work that took
more than seventy years
to complete and which
comprises one of the most
important bodies of medieval
paintings, bringing together
French and Netherlandish
artistic traditions. Jean, duc
de Berry commissioned the
book, probably in the 1380s,
but Jan van Eyck did not
begin work on it until around
1424, some years after
Jean's death.

Van Eyck's immense
attention to detail and
characteristic diffuse light
can be seen in this apparent
genre scene. This is a real
bedroom, with all the
minutiae of an everyday
setting, right down to the
little dog that has stolen a
bone from the angry cat. The
presence of both dog and
cat not only in the bedroom
but also during childbirth –
and furthermore, the fact
that they are also being fed –
indicates the extent to which
these domestic animals had
infiltrated human life.

Vittore Carpaccio
(c. 1460/65–1523/26)
Two Venetian Ladies
c. 1490–95
Oil on wood
94 x 64 cm (37 x 25¼ in.)
Venice, Museo Correr

There is some debate surrounding the content of this painting, part of the confusion having arisen in the nineteenth century after the art critic John Ruskin described it as *The Courtesans*. Considered in the light of that title, the little dog, a characteristic companion of prostitutes, could be symbolic of carnality. Yet the painting can also be seen as representing two gentlewomen of class and wealth, as implied by their fashionable hairstyles, expensive clothing and such elements as the dove and handkerchief, which, together with the little dog, symbolize purity, love and fidelity.

The painting forms the lower section to another panel, *Hunting in the Lagoon*, the two representing the contrasting worlds of women and men in the Renaissance. Whether it portrays courtesans or noblewomen, the painting embraces the notion of love, and a languid sensuality permeates the scene.

This is one of Carpaccio's best-known works, and was particularly popular in the nineteenth century. The little dog in the foreground became one of the most recognized dogs in Renaissance art.

Ghent–Bruges School of Book Illustration, possibly Gerard Horenbout (c. 1465–1541)
'Month of January: Rich Lord at the Table', from *Breviarium Grimani* (detail)
c. 1510–20
Print of illuminated manuscript
Venice, Biblioteca Marciana

The *Breviarium Grimani* (*Grimani Breviary*), a Book of Hours, was the work of several artists, not all of whom have been categorically identified, and was produced over a period of years. The calendar miniatures were based on those in *Les Très Riches Heures du duc de Berry* made by the Limbourg brothers a century earlier, and a comparison with the detail shown on page 142 is interesting. In particular, the charming white greyhound- or whippet-type dog in the foreground is treated in both images with great care and detail. This must surely have been a prized pet belonging to Jean, duc de Berry, and is being fed by hand. The dog is especially jaunty here, with its upturned tail and pricked ears.

The little spaniel-type dog sits on its haunches begging, although any spare morsel is destined probably for the bird of prey on the attendant's arm. There is great feeling here between the attendants and the dogs, with the men's facial expressions reflecting genuine humour at the dogs' antics. This little scene in the foreground is a picture within a picture, and functions quite independently of the action of the feasting duke and his men behind.

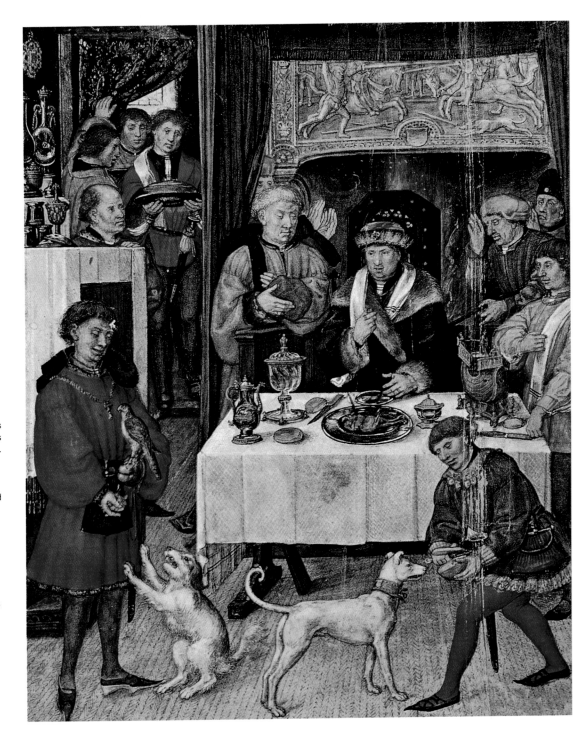

**Jan Havicksz. Steen
(1625/26–1679)**
The Doctor's Visit
c. 1665–70
Oil on panel
46 x 38.5 cm (18⅛ x 15⅛ in.)
Private collection

Dogs, especially little ones, were enormously popular throughout northern Europe in the seventeenth century, when there was a flourishing trade in dogs for the pet market. At the same time, genre painting had become established, depicting the details of everyday life, morality and behaviour. Almost all such art included a dog, somewhere, doing something within the confines of the picture frame.

Jan Steen painted this subject – 'the doctor's visit' – on many occasions, but this is possibly the most disturbing, and the little dog stark against the dark background is particularly poignant. The lady, who is lovesick, languishes in bed, while the entire left side of the canvas is taken up by a gaggle of malevolent-looking attendants. Most grotesque of all are the doctor and his assistant, who appear to take great pleasure in preparing an enema for the patient. The right side of the canvas is, by contrast, very still. The dog sits by its mistress's bedside and looks up at her and at the doctor with an air of infinite sadness. It appears full of wisdom, seeming to understand the patient's angst and also the doctor's inappropriately prurient demeanour.

**After Gabriel Metsu
(1629–1667)**
The Cello Player
c. 1700
Oil on canvas
61.6 x 51.4 cm (24¼ x 20¼ in.)
Private collection

Dutch genre scenes, which presented such a seemingly straightforward, definitive reflection of contemporary life, at the same time often conveyed a complex moral question or narrative, evoked through the use of symbolic elements. The dog, which was so much a part of everyday life anyway, was frequently used in a symbolic capacity, either to comment on the scene or to suggest certain qualities.

This expressive painting, which follows closely the version by Gabriel Metsu, is a study of love, as were so many seventeenth-century Dutch genre scenes. Here the figure on the stairs, love letter in hand, gazes adoringly at the musician, who returns the look. The dog that has come to greet the woman also looks at her with devotion, but its tucked tail and flattened ears suggest that it is aware that it has been replaced in the woman's heart by the musician, just as the figure at the top of the canvas also seemingly pines in unrequited love. The dog represents love and fidelity, while references to music and letters, both elements suggestive of love, were also frequent in these types of work.

**Frans van Mieris
(1635–1681)**
*The Morning Toilet
of a Young Lady*
c. 1659–60
Oil on board
51.5 x 40 cm (20¼ x 15¾ in.)
St Petersburg, The State
Hermitage Museum

This scene was a popular
subject in seventeenth-
century Dutch art, and,
perhaps not surprisingly, often
included a small dog. Here,
a tiny toy spaniel-type dog
stands expertly on its hind
legs and performs a trick for
the lady. The artist uses the
dog to symbolize obedience
and the desire to learn, which
was a common representation
and can be seen in a great
number of paintings, including
*The Interior of the Buurkerk at
Utrecht* by Pieter Saenredam
(page 90).

Van Mieris has perhaps
included the dog also to
emphasize the woman's good
moral fibre; or, conversely,
while the dog is the model of
obedience, the woman may
be fickle and wasting her time
in playing with it. This second
interpretation is, in fact, more
likely, especially in view of
the disapproving look the
attendant in the background
casts on the scene.

The model used in this
painting was also used by
Van Mieris for his painting
The Brothel (1658), which also
features a similar small spaniel
type in the background,
copulating with another dog.

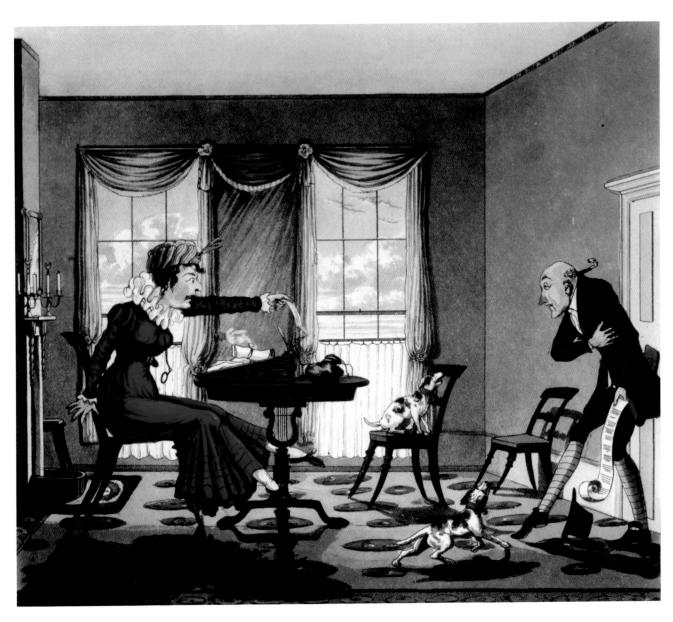

English School
Dove-tailing
Engraved by George Hunt
Published by Thomas Mclean
1827
Colour lithograph
20.6 x 27.2 cm (8⅛ x 10¾ in.)
London, Geffrye Museum

This cartoon is a perfect example of the dog being used to emphasize both character and narrative. Two ferocious tan-and-white spaniel types bark at the lanky clerk with a vigour matching that of their wild-haired owner. Such is her fury, echoed by her dogs, that it would seem the very fire in her words has blown the man's hat off, and the brave little dog on the floor veritably dares him to set foot one inch further into the room.

The woman herself bears a deliberate resemblance to her watchdogs, her pointed nose and slender frame mirroring theirs.

It is of some note that the dogs appear at all in this scene of an elegant office interior, and it reflects how pet dogs had become a part of most aspects of English life by the nineteenth century.

**John Sell Cotman
(1782–1842)**
*Interior of the Eastern
Ambulatory of the Apse
of Norwich Cathedral*
c. 1806–12
Watercolour on paper
38.9 x 27.3 cm (15¼ x 10¾ in.)
Oxford, Ashmolean Museum

There is a tangible sadness in this deeply moving painting by John Sell Cotman, one of the leading artists of the Norwich School, and a man troubled by depression throughout his life. Dwarfed by the great cathedral, the small pet dog lies waiting, a silent, still and infinitely poignant symbol of patience and faithfulness. It brings to mind such tales as those of Greyfriars Bobby, the Scottish dog that visited its master's grave every day for fourteen years, and the Japanese Hachiko, who waited for nine years by a subway station in Tokyo for its dead master to return. There is a similar sense of lonely waiting in this painting, with the dog lying near a shadowy under-floor tomb, echoing the sculpture of certain ancient funerary monuments, in which a carved dog lies at the feet of a recumbent figure.

Of all the symbols that have been attached to the dog in art, the quality of faithfulness is the most enduring. The dog by its very nature is faithful, often in the face of adversity, and it is this that has in great part contributed to its continued place in our societies.

Top
**Philippe Rousseau
(1816–1887)**
Chacun pour soi
1864
Oil on canvas
97 x 130.5 cm (38¼ x 51⅜ in.)
Private collection

The title of this work translates
as 'Everyone for himself',
and Rousseau conveys this
notion with striking clarity
through his strenuous realism
and attention to detail. A
desperate bitch, left to fend
for herself and her puppies,
can be seen rummaging
through old dishes in a
sordid and filthy kitchen. Her
emaciated frame, emphasized
by her swollen teats, is
in contrast to her rotund
puppies, two of which suckle
while two others play. The
suggested selflessness of the
mother, who scrabbles for
food while raising fat and
happy puppies, is strong:
they appear literally to be
draining her of nourishment.
The picture acts as a social
commentary, with the dog's
situation paralleling the
deprivation of the struggling
poor. This was a fairly popular
theme at this time and was
explored by a number of
artists in Europe, although
simultaneously during the
nineteenth century there was
a fashion for excess and
show, which was also seen in
contemporary dog paintings.

Rousseau was extremely
popular and produced various
paintings of dogs and cats in
a domestic environment. His
works are characterized by
the almost still-life quality of
the extraneous detail, here
particularly evident in the
collection of cutlery seen
in the foreground.

Bottom
**Charles van den Eycken
(Charles Duchène)
(1859–1923)**
*Dog in a Military Hat and
Collar with a Trumpet
and Dice*
n.d.
Oil on canvas
Dimensions unknown
Private collection

During the late nineteenth
century there developed a
fashion, especially popular
in northern Europe, for
depicting dogs dressed up
in various regalia, including
circus outfits. Charles van
den Eycken often chose such
subjects, and specialized in
paintings of dogs and cats.
He trained under the Belgian
realist master Joseph Stevens
(1816–1892), and brought
enormous and realistic detail
to his paintings.

This work is slightly
unusual within the artist's
œuvre because the dogs are
static and seemingly posing
for their portrait, whereas
in general Van den Eycken
depicted his subjects
romping through the interior
scene or interacting with one
another. Here, the exacting
realism for which he was
renowned is seen in, for
example, the rough-coated
little dog and the smooth
shine of the trumpet. Van den
Eycken's works often convey
a sense of still life, which is
much in evidence here, while
there is also in this painting a
hint of melancholy, deriving
perhaps from the lack of
communication between
the two dogs.

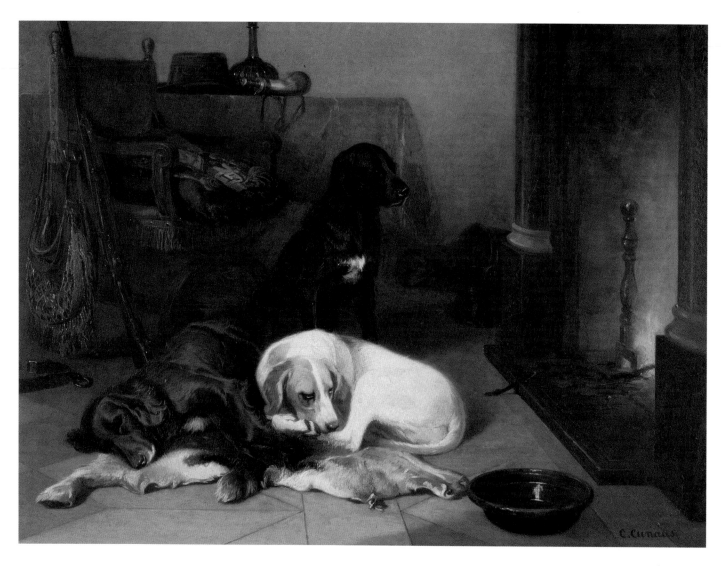

**Conradyn Cunaeus
(1828–1895)**
By the Fireside
n.d.
Oil on canvas
Dimensions unknown
Private collection

Conradyn Cunaeus was a popular nineteenth-century Dutch painter who specialized in depicting dogs, and whose works exhibit his thorough understanding of the physical anatomy and the inner nature of his subjects. His images of dogs are never simply blank depictions or virtuoso displays of painting, but always reveal the individuality of each one of his canine subjects. This painting is a delightful image of three beautifully conditioned hunting dogs, exhausted at the end of a hard day's work and basking in front of a glowing fire. The sitting black dog has an air of almost paternal wisdom, while the red-setter type sleeps deeply, having bagged the best of the bed. The tan-and-white hound is curled tightly, trying to get the rest of the rug, and is consequently less relaxed.

Cunaeus typically included background detailing to underline the main subject. Here, one can see the accoutrements of the hunt – the rifle, the shooting bag and, perhaps rather humorously, the fur rug (an earlier prize?) on to which two of the dogs try to squeeze.

**Conradyn Cunaeus
(1828–1895)**
Spilt Milk
n.d.
Oil on panel
69 x 55 cm (27⅛ x 21⅝ in.)
Private collection

This painting is one of the best known by Cunaeus, and recently set a record for his work when it sold for a considerable sum at auction. It is an exquisite piece that reflects the artist's talent for capturing personality as well as realism in his dog painting, and also demonstrates his extraordinary adeptness at still life. The objects on the tabletop that form the upper corner of the work have been drawn in a masterly way, with the single glass, brought to life through minimal strokes of paint, being the most impressive.

The three dogs reflect three pure-bred breeds, although it is difficult to ascertain precisely what they may have been; more importantly, this is a painting of three pets, done with some measure of humour. Staring straight from the canvas, the large working-spaniel type connects directly with the viewer, while the two smaller dogs interact over the plate of spilt milk. Particularly appealing in this work is the Chien de Lion or griffon-terrier type that has emerged from under the table, with its tail still caught behind the tablecloth.

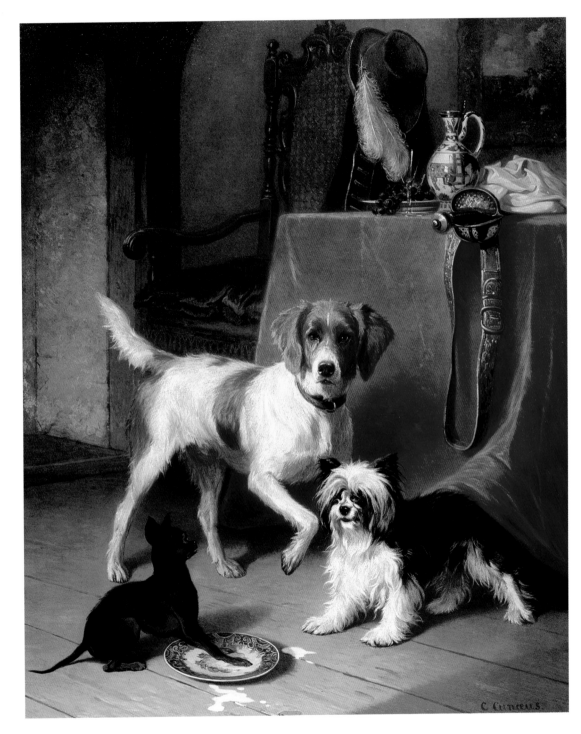

Carl Larsson (1853–1919)
Cosy Corner, **from *A Home***
c. 1895
Watercolour on paper
32 x 43 cm (12⅝ x 16⅞ in.)
Stockholm, Nationalmuseum

There are few sights quite as heart-warming as that of a dog fast asleep in the domestic interior; some would argue that the dog makes the home. This delicate watercolour by the much-loved Swedish artist Carl Larsson strikes a special note because it is a work taken from his own home. The house was given to the artist by his father-in-law, and it became the centre of a happy and productive family life, so much so that in 1899 Larsson published a book, *Ett hem* (*A Home*), in which he discusses how a lovely, peaceful family home can be created. This painting is one of twenty-six that appear in the book, and reflects the relaxed nature of a slightly chaotic artistic home life, of which this recumbent dog is an important part.

The cool, pure tones of this Swedish painting and the finely drawn interior make an interesting comparison with the work by the Dutch artist Conradyn Cunaeus on page 152, with its rich palette and textured finish, both in their different ways depicting the pet dog in the domestic interior.

Pablo Picasso (1881–1973)
Reading
1901
Pastel on paper
43.5 x 30 cm (17⅛ x 11¾ in.)
Private collection

Picasso produced this small pastel work while still a young man, following his first trip to Paris after studying art in Madrid. The subject of a woman reading was one to which he would often return later in his career, when he was working in a Cubist style, but what makes this work so compelling is the presence of the little black dog. Of indeterminate breed, it is echoed in the seated figure's black topknot hairstyle in a way that creates a powerful balance through the picture plane, and also some degree of humour. The work is somewhat reminiscent of traditional portrait forms, particularly of the eighteenth century, in which women were depicted with little dogs, but the scene is revisited by Picasso with a modern eye. In 1938 Frida Kahlo (1907–1954) painted *Itzcuintli Dog with Me*, and although very different in character and style from Picasso's *Reading*, it reflects a similar juxtaposition of woman and dog.

This painting is of note within Picasso's œuvre because it sits on the cusp of change. It was painted at a time when the artist's style had matured following exposure to contemporary French influences, and directly before he entered what is now known as his 'Blue Period'.

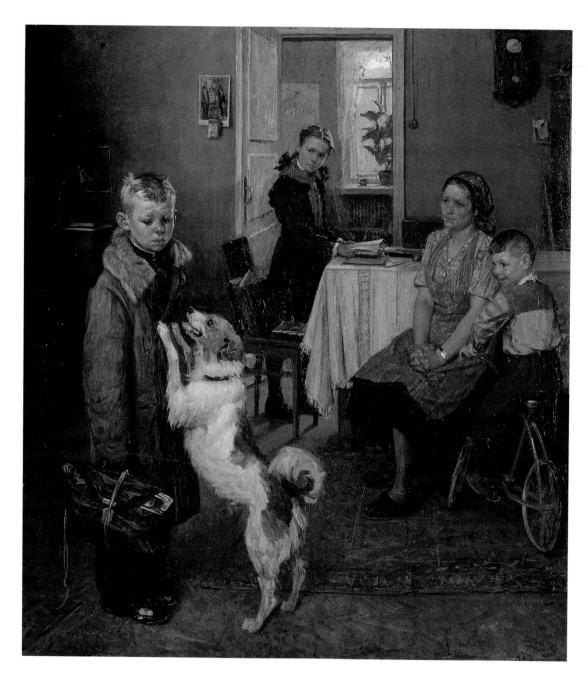

Fedor Pavlovic Reshetnikov (1906–1983)
Bad Marks Again
c. 1952
Oil on canvas
198 x 183 cm (78 x 72 in.)
Private collection

This touching painting by the respected Russian artist Fedor Reshetnikov is designed to tug at the heartstrings, and therefore was conceived in a similar spirit to a significant number of popular Victorian animal paintings, chief among them works by Edwin Landseer.

It is the dog that gives this work its emphatic emotional tone. The young boy has returned home from school with a bad report card, much to the disappointment of his mother and the apparent anger of his sister. His younger brother, perhaps unaware of the seriousness of the situation, smiles at the older boy's downfall. There is a sense that the father is absent, and that the family's eventual future rests on the shoulders of the errant schoolboy, who has the air of one much older than his years – weighed down by the pressures on his young life. The pet dog, however, joyfully welcomes the boy home, tail wagging, its love unconditional and unstintingly given, and that in relation to the overall tone of the painting can hardly fail to elicit an emotional response in the viewer.

Pierre Bonnard (1867–1947)
Greyhound and Still Life
c. 1920–25
Oil on canvas
70 x 70 cm (27½ x 27½ in.)
Private collection

Bonnard drew his inspiration from life around him, typically depicting his home, domestic scenes, his wife, family and pets. For a man so essentially private in all aspects of his life – the rest of his family learned of his marriage only after his death – it is extraordinary that he chose to commit his domestic world to canvas. He worked primarily from memory, taking a scene and re-creating the image he sought, using a flattened perspective reminiscent of Japanese woodcuts and a sensual, emotive palette.

Many of Bonnard's paintings include images of dogs, often seen in the company of his wife; this work is particularly striking, with the dark, elegant form of the greyhound so brilliantly contrasted against the richness of the table laden with deliciously rendered offerings. The dog, turned to gaze wistfully at the food, is tantalizingly close to it, its head almost level with the top of the table. There is a hint that an act of plunder might not be far off: will the dog be able to resist helping itself to a morsel?

P.J. Crook (born 1945)
Time and Time Again
1981
Acrylic on canvas and wood
91.4 x 122 cm (36 x 48 in.)
Private collection

The contemporary artist P.J. Crook works in a distinctive, instantly recognizable style that reaches out to the inner spirit. Her works are typically imbued with a surreal, dreamlike quality, and inspire reflection and contemplation. By her own admission Crook is obsessed with time – past, present and future – and she brings this concern to many of her paintings, including this one.

The sequence of mirrors and reflections here creates an ambiguous reality and gives a sense of the perpetual motion of time, of leaving the past and its experiences behind and looking to the future. The composition is underpinned by the magnificent dog in the centre, which looks with an air of anticipation towards the opening door. Its black-and-white colouring, neither completely one thing nor the other, reflects the way in which past and future are balanced in the painting, so that its role resembles that of the scales of life. It is a surreal, nightmarish image, with faint religious overtones derived from the two priests tucked in the corners, yet a tentative sense of enlightenment and optimism is also suggested by the fact that the dog is bathed in light, and by the opening door.

William Ireland (born 1927)
Garonne
2003
Oil on canvas
75 x 60 cm (29½ x 23⅝ in.)
Private collection

The domestic dog is here to stay, having been so great a part of man's life for so long. With each new century the dog's place is reaffirmed, be it languishing on the rug, as seen here, lounging on the bed, staking a claim to a comfortable chair, causing havoc in the kitchen or being toted under an arm as the latest fashion accessory.

In this painting the white dog, based on the Ireland family's beloved standard poodle, Gemma, is in that state of semi-sleep so perfected by dogs, with one eye open, waiting for its master's return. Beyond the dog and through the open door the River Garonne winds through the bright Bordeaux landscape. Ireland's works are typically light-filled and warm – scenes of domestic tranquillity or landscapes of inspiring breadth – and through all there is consistent vivacity in his use of colour. Here the white dog, the red rug, the yellow floors, the green scenery and the blue walls collide with an energy that brings the canvas alive with Ireland's characteristic *joie de vivre*.

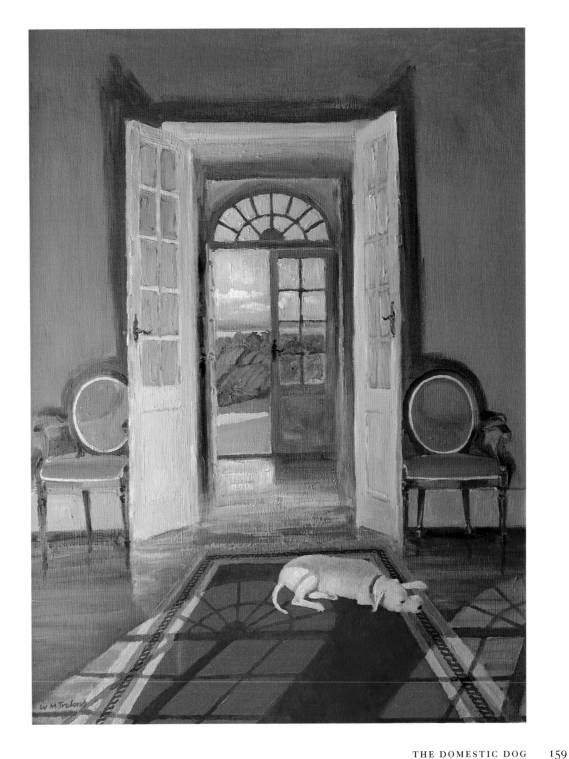

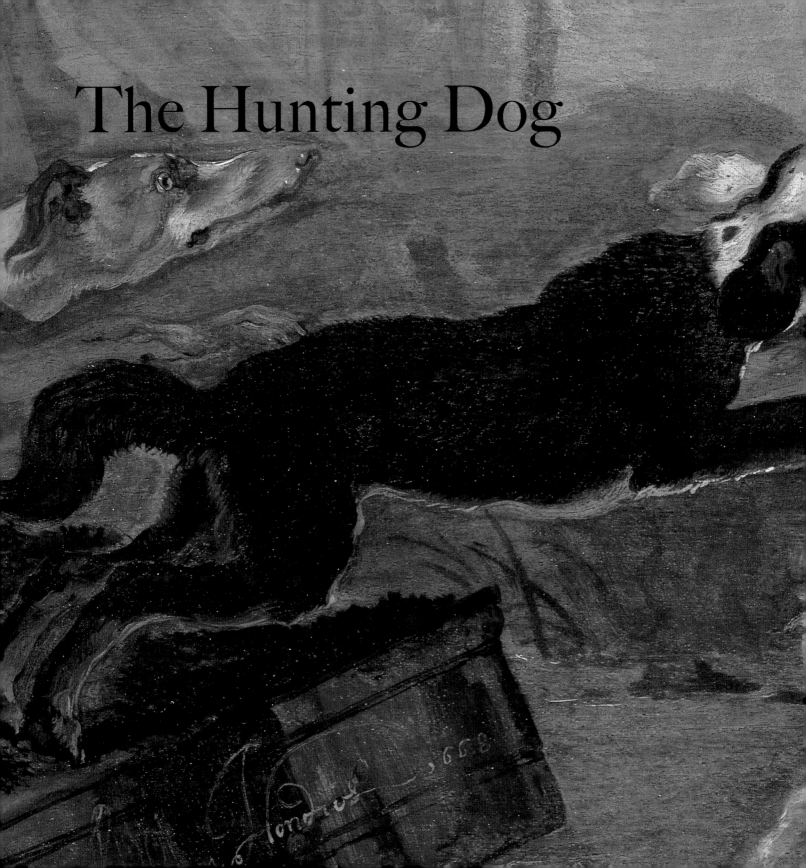

The Hunting Dog

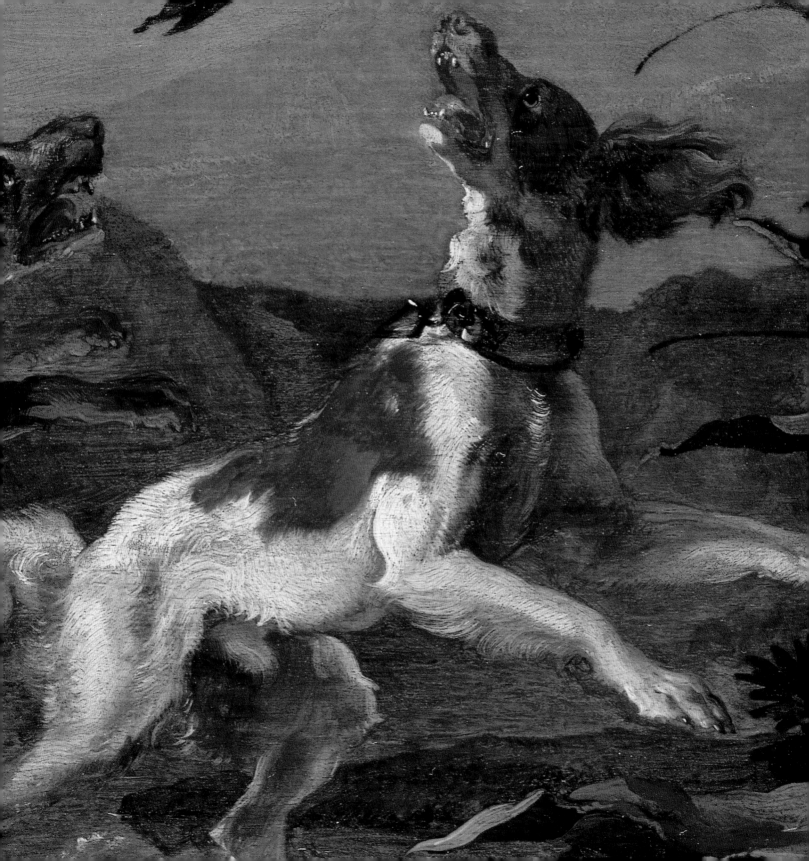

THE DOG AS A HUNTER IS CLOSEST TO ITS origins: this is the dog allowed to exhibit its primary instincts, able to become again the wolf of its distant past, just barely clothed in the skin of domesticity. This is the dog portrayed by an artist after Paul de Vos as it battles ferocious wild bears in *Bear Hunt* (page 170), and depicted by Jean-Baptiste Oudry in *A Deer Chased by Dogs* (page 172): images that illustrate the gossamer divide between the wild and the tame.

The hunting dog can be traced back to some of the first recorded instances of man and canine: rock paintings dating to *c*. 6000 BC depict hunters accompanied by dogs. By the time of the great ancient civilizations, dogs were firmly established in human culture on every level. Hunting remained a highly specialized event, which gradually also became a sporting occasion. The best hunting dogs were prestigious and brought honour to their masters. In return they were generously cared for, as is famously illustrated in the fourteenth-century hunting manual *Le Livre de chasse* by the French nobleman Gaston Phébus de Foix (page 167). An enthusiastic hunter himself, reputedly owning more than 1500 hounds, Phébus discussed in his book the art of hunting and the different types of hound, including greyhounds, coursers and pointers, providing what is now valuable information on the development of these breeds.

The greyhound, a sight hound of unmatched speed, could chase down hares, an attribute that very early on led to the growth of coursing (chasing the animal) as a sport. For boar-hunting, heavier types more similar to mastiffs were used, including the Mâtin, a favourite type bred by Jean, duc de Berry in his extensive kennels and seen in the miniature 'December' by the Limbourg brothers (page 165). The St Hubert hound was also bred to hunt boar, by monks in the Ardennes, from about AD 800; it was an ancestor of the bloodhound, a breed beautifully represented in *Study of a Bloodhound* by William Holman Hunt (page 180). During the reign of Charlemagne, who is widely regarded as the original Christian knight, and in the early Middle Ages across much of Europe, hunting became inextricably linked to the knightly culture, within which dogs were, equally, a passion. Favoured hounds accompanied their masters everywhere, including to church, which angered the religious authorities. Priests were temporarily prohibited from keeping dogs, and dogs were banned from churches; this simply led to their masters congregating with the hounds outside the building, forcing priests to give the blessing at the door – a custom that gave rise to the tradition of 'blessing the hounds'. This spread across Europe, and is also practised in North America. The tradition was also linked to the Feast of St Hubert, the patron saint of hunting, and included a general blessing of animals, particularly those associated with the hunt. It has since become a customary way of opening the

The dog as a hunter is closest to its origins: this is the dog allowed to exhibit its primary instincts, able to become again the wolf of its distant past, just barely clothed in the skin of domesticity.

fox-hunting season, and is still widely observed.

There are many different breeds of hound, the fox-hound being one of the best known, as well as one of the oldest – it is mentioned from the time of King John of England (1166–1216). Louis IX of France, a devoted huntsman, is credited with bringing the first 'gaze hounds' to Europe from the Middle East – where he is reputed to have used them for hunting gazelle – thereby introducing the exotic blood of these swift, strong dogs. The term 'gaze hound', meaning a hound that hunts by sight rather than by scent, is one that covers all such dogs, including the greyhound, whippet, borzoi and Afghan. Other gaze hounds, such as the saluki, with its distinctive silky ears, were also brought back from the Holy Land by the knights of the Crusades.

The spaniel, another ancient breed, is also thought to have developed through cross-breeding between European dogs (belonging to the crusading knights) and the Middle Eastern and Oriental dogs they encountered. Spaniels first evolved into two distinctive types, the water spaniel and the field spaniel; these in turn gave rise to a number of different varieties, including the small lapdog and working-type spaniels. They are first mentioned in fourteenth-century texts, including Phébus's *Le livre de chasse*.

Many breeds of hound emerged in France, including the ancient Great White Dogs of royalty,

believed to have been the ancestors of several modern breeds and to have indirectly influenced the famous Talbot hounds of medieval France. It was also from French and English hounds and terriers that the otter-hound – an old breed, first mentioned in the twelfth century – developed. It is portrayed in a painting by Edwin Landseer (page 177).

In the Middle Ages hunting became the preserve of royalty across England and France. In the eleventh century, severe Forest Laws were introduced in England, under which the forests became parts of the royal domain, and restrictions over forest inhabitants were enforced – no one living inside the forest, for example, was allowed to own a greyhound or a spaniel. William I of England (William the Conqueror) ordered that three toes be amputated from any hound not in his pack. Centuries later Francis I of France dictated that peasants' dogs must wear a wooden block around the neck to prevent them from hunting and from breeding with the prized royal dogs. Hounds were bred specifically for different quarry: Elizabeth I

The fierce hunting dogs depicted in this ancient manuscript appear to be hybrids of a mastiff–hound type, with the heavy, muscular frame of the mastiff and a more houndlike head and countenance. They accompany a hunting group bearing the fruits of their day's hunt – three boars – although, perhaps as a cautionary note, one of the beasts has escaped and is attacking the attendant. The dogs, however, attracted by the blood, appear to be more interested in the two dying boars, and leave the struggling man to fight his own battle.

This small illustration is one of 167 that accompany the lengthy poem *Cynegetica* (*On Hunting*), about the art of hunting, written by the poet Oppian of Apamea in *c.* AD 215 for the Roman Emperor Caracalla. The work forms a valuable body of information about the types of dog used, their quarry and the methods of hunting popular at that time.

of England kept otter-hounds, buck-hounds, hart-hounds and harriers (for hunting hares); small terriers were used for ratting, rabbiting and flushing out foxes. Ratting would later become a popular sport, as depicted in the mid-nineteenth-century painting *Rat-Catching at the Blue Anchor Tavern* (page 178). The 'terrier' nomenclature now covers a large number of different breeds, including the indomitable Jack Russell and the less common though equally charming Dandie Dinmont (see *Yorkshire Dandies* by Lucy Waller, page 179).

Having been for centuries a social event and a stage on which to show off the merits of the hounds, hunting reached a peak of popularity and excess in France during the reigns of Louis XIV and Louis XV. In a whirlwind of extravagance, both kings kept enormous kennels, employing hundreds of staff and spending exorbitant amounts on their dogs. Portraits of favourite hounds were commissioned, such as *Baltazar* by Alexandre-François Desportes (page 193). The French Revolution of 1789 and the fall of the monarchy brought to an end hunting as a sport exclusive to the aristocracy. With the core fabric of France profoundly altered on every level, there also came a change in animal painting, which, formerly grounded in the opulence of court life, was now influenced by the more austere tradition of the Low Countries of northern Europe.

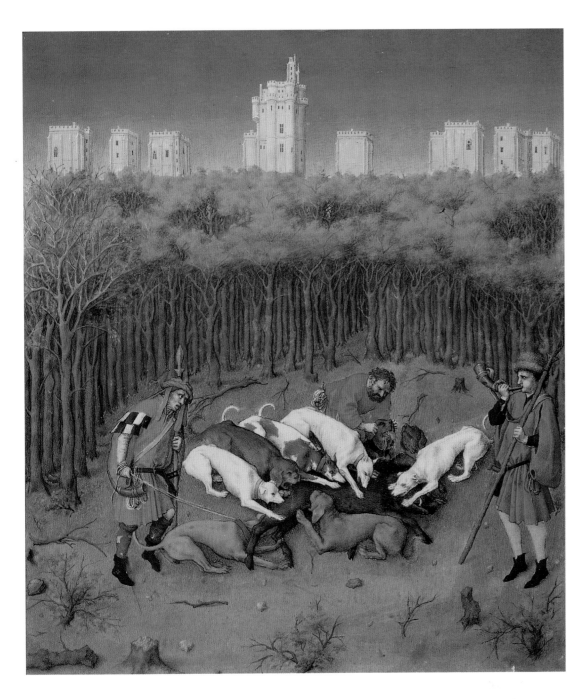

**Limbourg brothers
(active 1400–1416)
'December: Hunting Wild
Boar', from *Les Très Riches
Heures du duc de Berry***
c. 1415
Vellum
24.2 x 21 cm (9½ x 8¼ in.)
France, Chantilly, Musée Condé

Jean, duc de Berry, brother
of Charles V of France, was
one of the most powerful and
wealthy noblemen of France,
and a great patron of the arts.
He lived a lavish lifestyle and
was a keen hunter, running
huge kennels of hounds that
were specially bred for their
different skills. One type
that he is thought to have
favoured was the Mâtin,
a heavy, muscular hound
similar to those depicted
by the Limbourg brothers in
this illuminated manuscript.
These dogs have also been
variously described as
bloodhounds or boar-hounds.
The twelve pages of the
manuscript that represent the
twelve months of the year
were painted in extraordinarily
naturalistic detail and are
probably the most renowned
of all surviving medieval
manuscript illumination.

In the background is the
Château de Vincennes, where
the duke was born, while the
action in the foreground takes
place in Vincennes forest,
the famed hunting ground of
kings and nobles. The boar
has been chased down by
the dogs and speared by the
attendant on the left, while
to the right another attendant
blows on his horn the *mort* –
a note signalling the death
of the quarry.

**Circle of Konrad Witz
(c. 1400/10–c. 1444/46)**
Three Hunting Dogs
c. 1440–45
Pen and ink with watercolour
on paper or card
15.6 x 9.5 cm (6⅛ x 3¾ in.)
Vienna, Kunsthistorisches Museum

This is one of a set of playing
cards that depict courtly
falconry in elaborate detail,
providing an important visual
record of this traditional form
of hunting. On many of the
cards, slender hound dogs
similar to the greyhound
appear, and this card is
particularly charming. The
three dogs, two facing one
way and one the other,
provide a balanced
composition that has an
almost musical quality in
its simple movement from
left to right and back again.
The dog in the background,
with its open mouth and
jaunty tail, is especially
jolly, while the dog in the
foreground holds its nose in
the air, catching a scent.

Falconry is an ancient
form of hunting that has
always been associated
with nobility. Traditionally,
falconers are depicted on
horseback, accompanied by
attendants and hounds. The
hounds were used to retrieve
the wounded prey after the
goshawk had made its attack.
These playing cards detail
the capture of a silver heron,
which, along with the bittern
and crane, was considered
one of the noblest quarries.

German School
The Pursuit of Fidelity
c. 1475–1500
Tapestry
76.2 x 86.4 cm (30 x 34 in.)
Glasgow, Burrell Collection

This delightful late fifteenth-century tapestry symbolizes love and fidelity, with the hart representing the faithfulness of the young couple. The three dogs allude to the same notions, and gambol along after the hart in an entirely non-threatening manner. The dogs themselves are particularly fine, with a perky greyhound type leading the trio and two silken-eared spaniel types following behind.

Although conceived as a traditional hunting scene, this work evinces none of the drama associated with the kill, and instead functions as a testament to the young couple's love. It may have been commissioned to mark their engagement or marriage, and is fairly typical of Northern European Renaissance tapestries of the time. Tapestries were extremely popular among the wealthy, and were hung on walls to serve as both decoration and insulation. As they were easily transported, noblemen would sometimes take them on their travels, to be hung in their rooms along the way.

After Paul de Vos
(*c.* 1591/95–1678)
Bear Hunt, or Battle
Between Dogs and Bears
n.d.
Oil on canvas
202 x 342 cm (79½ x 134⅔ in.)
France, Caen, Musée des Beaux-Arts

Paul de Vos worked in a highly realistic, dramatic manner, influenced by his brother-in-law, Frans Snyders. Although this work was made after de Vos, it is representative of his subject matter and style. He was an accomplished painter of dogs, and concentrated on fierce hunting scenes like this one, as well as still-life compositions. His hunting scenes tended to be violent and dramatic, heightened by his use of strong lights and darks and complicated compositions. His understanding of animal anatomy underpinned his highly realistic depictions, among which individual types of dog can be discerned.

Snyders, the more renowned of the two artists, painted a very similar work, *Wild Boar Hunt* (Rockox House, Antwerp), although in the painting shown here the bears appear to be destroying the dogs, which are seen in various expressions of agony.

It was typical at this time in Flanders for several artists to work on one canvas. De Vos is believed to have painted several animals in hunting scenes by Peter Paul Rubens, while the landscape artist Jan Wildens (1585–1653) sometimes painted de Vos's backgrounds.

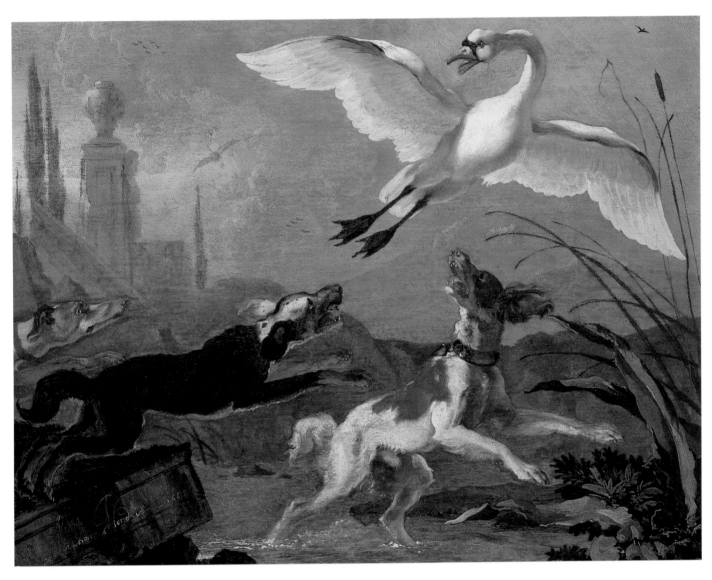

**Abraham Hondius
(c. 1625/30–1691)**
*Swan Being Chased
by Three Dogs*
1668
Oil on panel
27.3 x 35.5 cm (10¾ x 14 in.)
London, Johnny van Haeften Gallery

It was in the Dutch and Flemish tradition of the seventeenth century that animal painting first truly gained respect as a genre in its own right. In turn, this tradition strongly influenced the development of animal painting in Britain, which reached its apogee in the nineteenth century. The Dutch artist Abraham Hondius, who is perhaps not as well known as some of his contemporaries, moved to England in 1666 and brought his dramatic and assured style into direct contact with English artists and patrons. He was a particularly accomplished painter of dogs and hunting scenes, which form the bulk of his artistic œuvre.

This painting, done in England, depicts a clear springer-spaniel type and two hounds in a realistic manner, with a frightened swan shooting forwards and into the viewer's space. This type of subject, with dogs putting up birds, was popular at the time and allowed the artists to demonstrate their skill in visual illusion as well as anatomical detail.

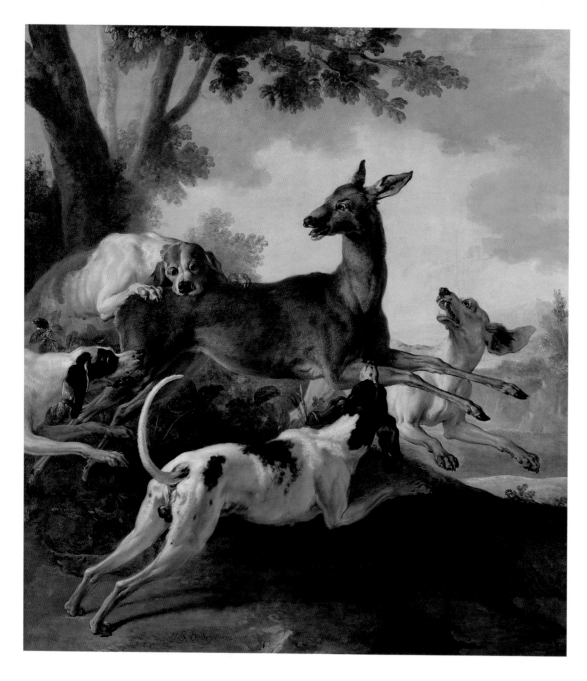

**Jean-Baptiste Oudry
(1686–1755)**
A Deer Chased by Dogs
1725
Oil on canvas
171 x 156 cm (67½ x 61⅜ in.)
Rouen, Musée des Beaux-Arts

Jean-Baptiste Oudry is widely regarded as one of the best dog painters of the eighteenth century, his images combining precise details, which captured the individual character of each dog, with a light, often decorative Rococo touch. He succeeded that other great French painter of dogs, Alexandre-François Desportes, as Louis XV's favourite artist, and produced many portraits of the king's beloved dogs.

This scene of fine hounds bringing down a deer was painted the year that Oudry completed his first picture for Louis XV, and was a popular subject at the time. It depicts the hounds working, displaying the bravery, tenacity and ferocity that were required of good hunting dogs, while also demonstrating Oudry's considerable skill at creating movement and drama. The idealized, rather beautiful backdrop counterbalances the violence of the action and lends the work an aesthetic quality that was often lacking in other artists' attempts at this type of painting.

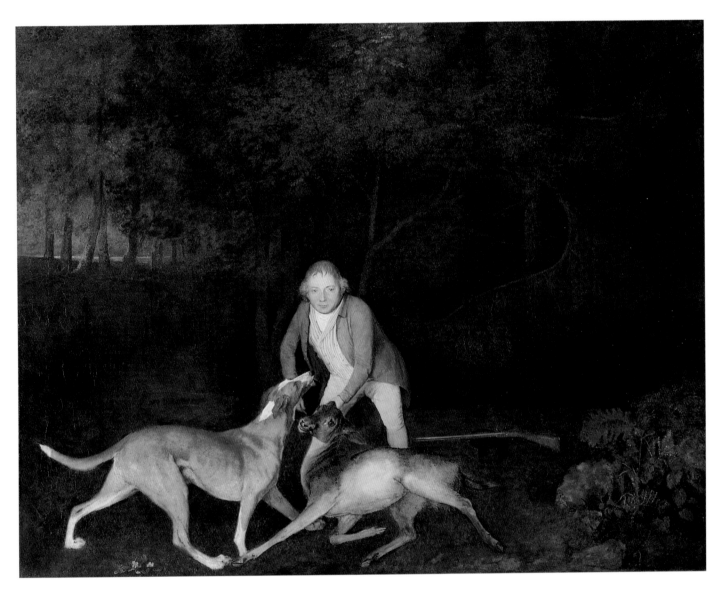

George Stubbs (1724–1806)
Freeman, the Earl of Clarendon's Gamekeeper, with a Dying Doe and Hound
1800
Oil on canvas
101.6 x 127 cm (40 x 50 in.)
Connecticut, Yale Center for British Art, Paul Mellon Collection

The works of George Stubbs are rarely straightforward, concealing a depth of meaning and commentary beneath the surface that lends them soul and elevates his portrayals of animals to an entirely different level. This example is particularly poignant. It was painted at the very end of the artist's career, and in a sense is the culmination of his life's work.

Against a dim background of forest bathed in fading light, a gamekeeper stands, caught between life and death. In one hand he holds the head of the dying doe, its expression infinitely sad, the last flash of life draining from the creature, while in the other is his knife, which he is about to use to finish the kill. Almost touching the doe is the nose of the hound, the epitome of strong, healthy lust for life: its eagerness to attack the doe matches the latter's horror at impending death. The gamekeeper is the pivotal point, holding as he does life and death, fear and joy, in balance, but his face belies the heavy toll of such a position, in an indefinable expression that surely reflects the artist's acknowledgement of his own waning days.

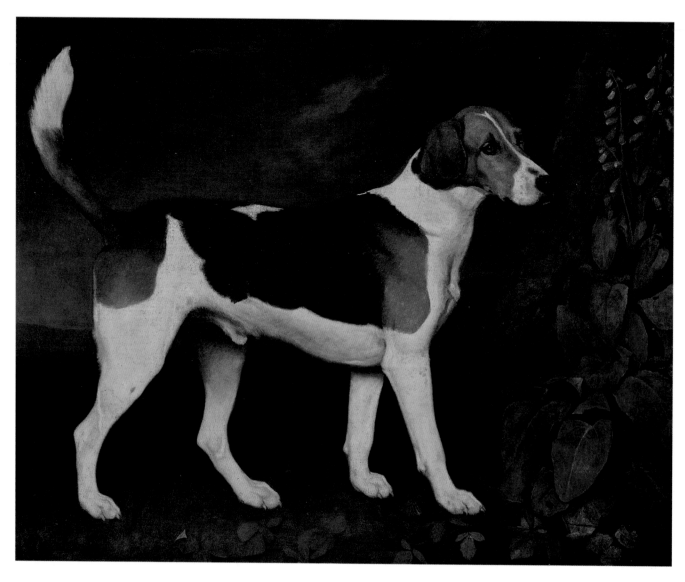

George Stubbs (1724–1806)
Ringwood, a Brocklesby Foxhound
1792
Oil on canvas
100 x 126 cm (39⅜ x 49⅝ in.)
Private collection

The lovely Ringwood was the lead hound in the Brocklesby Pack in 1792, and was a particularly fine-looking dog. As Stubbs did in all his depictions of animals, he has invested this dog with tremendous expression and character, so that it brims with a sense of wisdom and carries itself with noble bearing. The work is a typical pure-bred painting (see page 185), with Ringwood posed so as to display all those points that mark its superiority as a working dog. In the same year Stubbs also painted a bitch and dog hound from the pack, posed together in a more informal and relaxed manner.

The Brocklesby was one of the leading packs in the eighteenth century, and its bloodlines were influential in the development of the foxhound breed in Britain. Three local Lincolnshire families, the Vyners, the Tyrrwhitts and the Pelhams, bred the hounds, and both the Pelham family and the Reverend Thomas Vyner commissioned portraits of their hounds from Stubbs. The pack itself was formed around 1700, and has been consistently hunted to the present day by the earls of Yarborough.

**Henry Thomas Alken
(1785–1851)**
Duck Shooting
n.d.
Oil on canvas
26 x 31.4 cm (10¼ x 12⅜ in.)
Connecticut, Yale Center for British Art,
Paul Mellon Collection

The charismatic artist Henry Thomas Alken specialized in sporting pictures, including hunting scenes, such shooting scenes as this, and images of horse racing and coursing with greyhounds. His works were often humorous and poked gentle fun at the characters he painted. Alken was a keen sportsman and hunted with the fashionable Quorn Hunt, from which he derived much of his painterly inspiration. The linear quality of his style lent itself to graphic work and illustration, his precise brushwork and attention to detail putting him at the top of his field.

This small painting of a duck shoot includes two very eager dogs, one a spaniel type and the other resembling a retriever. They bound after the duck, which will fall just beyond the picture frame. As one dog leaps upwards, the other comes down, their complementary movements adding to the sense of speed from left to right and to the overall balance of the composition. This type of painting showed the sporting dog at work, and reflected the qualities of the dogs – speed, retrieving skill and obedience – that made them valuable assets.

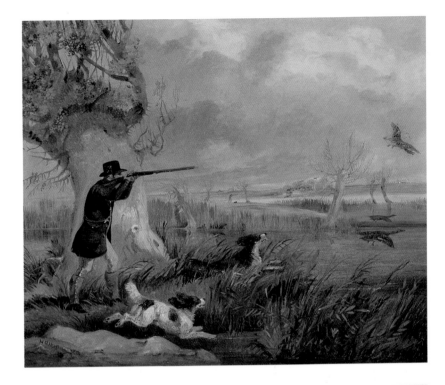

**Edwin Landseer
(1802–1873)**
Otter-hounds
n.d.
Oil on canvas
Dimensions unknown
London, Roy Miles Fine Paintings

Otter-hounds were first mentioned in the twelfth century, during the reign of King Henry II of England, while in the sixteenth century Queen Elizabeth I was recorded as the first Lady Master of Otter-hounds. The dogs' history is therefore long, although it was not until the eighteenth century that the type was firmly established, and it is likely that this occurred through a cross between bloodhound types, terriers and rough-coated French hounds. As the name suggests, otter-hounds were used in packs to hunt the otter, a devastating predator of fish and particularly unpopular among fishermen. During the hunt the hounds needed great tenacity and bravery, since the chase usually lasted many hours, and otters themselves are extremely ferocious when attacked. Traditionally the otter would eventually be speared by the huntsman, an end Landseer also painted in his famous work *The Otter Speared* (c. 1844).

Otter-hunting reached its peak during the nineteenth and early twentieth centuries, and was not banned in England until 1978 (1980 in Scotland). Sadly, both the otter-hound, so skilfully depicted by Landseer, and the otter exist only in very small numbers today.

Top

English School
*Rat-Catching at the Blue
Anchor Tavern*
c. 1850–52
Oil on canvas
42.2 x 52.5 cm (16½ x 20⅝ in.)
London, Museum of London

Cock-fighting and rat-catching were popular pub sports in Britain during the nineteenth century, and few dogs could equal the Manchester terrier in the rat-catching arena. The breed is believed to have developed through terrier and whippet crosses to produce a small, very fast dog with great tenacity, the perfect combination for rat-catching.

This unattributed painting depicts a Manchester terrier called Tiny the Wonder, who was a champion rat-catcher, having twice killed 200 rats in less than an hour, in 1848 and 1849. Tiny belonged to Jimmy Shaw, the proprietor of the Blue Anchor Tavern in Finsbury, London, where the action of this painting occurs, who is said to have had the dubious merit of being able to store 2000 rats on his premises. The timekeeper, holding his watch, presides in the centre, while the dandy and amateur artist Count d'Orsay (1801–1852) can be seen fourth from the left in a brown coat. Rats were widespread during the nineteenth century, and terriers were popular for their rat-killing abilities, not just in the sporting arena, but also for fulfilling a crucial function in the domestic environment.

Bottom

**John Marshall
(active 1840–1896)**
*Hare-Coursing in
a Landscape*
1870
Oil on canvas
31.7 x 73.6 cm (12½ x 29 in.)
London, Wingfield Sporting Gallery

The primitive or naïve style of this work seems particularly suited to the sleek lines of the two greyhounds and the hare. The whole image has a slightly magical or mystical quality to it, with the white greyhound shimmering against the dark landscape and the graceful hare just avoiding capture. Light breaks through the heavy clouds in the distance, but the scene remains bathed in a misty translucence out of which the figures on horseback loom in the distance (coursing competitions were judged from horseback).

Coursing is an ancient sport documented in the Roman hunting manual *Cynegetica* by Oppian of Apamea, written in c. AD 180. It used the Vertragus, a sight hound believed to be the ancestor of the greyhound, and the aim was not to kill the hare, although this was often inevitable, but instead concerned the speed and agility of the dog. Although originally a single dog may have been used, traditionally the dogs coursed in pairs and were judged against each other. Greyhounds and lurchers were the most prized, although other gaze hounds, such as the saluki, whippet and borzoi, may also have been used.

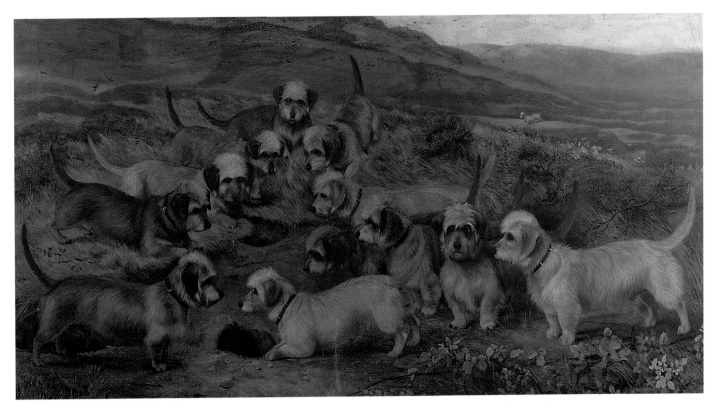

Lucy Waller
(active 1882–1906)
Yorkshire Dandies
1889
Oil on canvas
91.4 x 167.6 cm (36 x 66 in.)
Private collection

The artist Lucy Waller painted several pictures of the Dandie Dinmont, one of the most charismatic of small dog breeds, which developed in the rough border terrain between Scotland and England. The breed's ancestry is not recorded, but it is likely that it evolved from the local wire-haired terrier types, perhaps crossed with otter-hounds. It was used for hunting rats, rabbits, foxes, otters and even badgers, and is particularly brave and tenacious, especially in view of its small size.

This is the only breed to derive its name from a figure in literature, being called after a character named Dandie Dinmont, a jovial farmer who keeps this type of small, wiry terrier in Sir Walter Scott's highly popular novel *Guy Mannering* (1815). The two different basic colours of the breed are called after the same farmer's six dogs, all of which are named either Pepper or Mustard. The Dandie Dinmont Terrier Club was formed in 1875, and set a standard to maintain the breed's admirable qualities.

**William Holman Hunt
(1827–1910)**
Study of a Bloodhound
1848
Oil over pencil on board
25.6 x 28.8 cm (10 x 11⅓ in.)
Sydney, Art Gallery of New South Wales

The bloodhound is an ancient and much-loved breed, characterized by its particularly loyal and gentle nature – except when hunting. It was frequently depicted in art, often accompanying knights, a fact that has increased the sense of chivalry surrounding it.

This drawing by William Holman Hunt was done as a preparatory piece for his painting *The Flight of Madeline and Porphyro (The Eve of St Agnes)*, which includes two bloodhounds and was based on the poem *The Eve of St Agnes* by John Keats. Hunt's painting played a part in the formation of the Pre-Raphaelite Brotherhood, of which Hunt was a founder member, along with Dante Gabriel Rossetti and John Everett Millais (1829–1896).

Millais worked on the painting with Hunt, and it was after seeing it in the Royal Academy Exhibition of 1848 that Rossetti sought out Hunt and the three young men embarked on their collaborative enterprise. The model for this sketch was a dog belonging to John Blount Price of Islington, London. When Hunt exhibited the painting at the Royal Academy it was accompanied by these lines from Keats's poem: 'The wakeful bloodhound rose, and shook his hide, / But his sagacious eye an inmate owns', indicating the importance of the dog in the work as a whole.

Charles Edward Stewart
(active 1887–1938)
After the Battue
c. 1920
Oil on canvas
108 x 151 cm (42½ x 59½ in.)
Private collection

This is a particularly atmospheric painting by the relatively little-known Scottish artist Charles Edward Stewart, depicting hounds returning to the kennel after the hunt. Traditionally 'battue' refers to a method of hunting by which the quarry is driven out by a series of 'beaters' on foot who work a specific area together. This is common in highland areas, where the terrain is unsuitable for horses, and requires great stamina in both the hounds and the huntsmen.

Here the hounds, led by a perky terrier, trudge along the wet, muddy track. Stewart effectively creates an 'end of day' feeling through the hounds' expressions; with their heads mostly down, showing little anticipation, these are tired dogs that have done their job and are not interested in anything but a warm, dry kennel. The sky is heavy with moisture – it is a chilly scene, with the wind whipping the attendant's coat back, but there is also a sense of accomplishment, of a job done and the anticipation of finding comforting shelter from the elements.

The Real Dog

UNDER THE SHARP MEDITERRANEAN SUN OF Renaissance Italy and through the wide corridors of the ducal palaces, the dog strolled with particular aplomb. These were the dogs of the wealthy, much prized and lavishly cared for – such dogs as Rubino, the russet-red hound immortalized on the walls of the Palazzo Ducale in Mantua (page 187). This dog, which belonged to and was dearly loved by Ludovico II Gonzaga, Marquis of Mantua, was painted by Andrea Mantegna, who also depicted other favourite Gonzaga dogs in his fresco cycle. Here the dogs appear alongside the Gonzaga family, whose affection for them was legendary. The appearance in art of specific dogs, drawn from life with character and individuality, can be traced back to this period, although it was not until the sixteenth century that the dog truly nosed its way into the centre of the frame; even then, it was a long journey before the dog was master of its own canvas.

It is these images of the dog, so clearly taken from life, that have left such a potent legacy, for not only are these depictions of individuals, as in human portraiture, but also they act as a record of different types of dog and the way in which they developed over the centuries. Certain distinct types had already emerged by the time of the great early civilizations, including the greyhound, the saluki, the mastiff, the spitz, the hound and the lapdog. The spectrum of dog breeds that we know today developed much later from these basic types. These earliest varieties have in great part retained their defining characteristics: the saluki in Benvenuto Cellini's bronze relief (page 186), for example, differs little from the modern version, while the greyhound must surely be one of the most prepotent breeds.

Early civilizations recognized the qualities inherent in the various types of dog – the mastiff's natural guarding instinct, the greyhound's speed – and would have bred their dogs accordingly. Pliny described in his *Natural History* of AD 77 the characteristics associated with different types of dog, but it would be a further 1500 years before Konrad Gesner published his *History of Animals* (1551), in which he discussed specialized dog-breeding with the aim of fixing specific characteristics. Nineteen years later, Dr Johannes Caius published the first known book devoted solely to dogs, *Of English Dogges* (1570 in Latin; English translation 1576), which described different breeds and the variations in anatomy and nature. The breeding of hunting and sporting dogs, in particular, had already become of great importance by the fifteenth century, with a pair of fine specimens seen in Jacopo Bassano's *Two Hunting Dogs Tied to a Tree Stump* (page 188), one of the first examples of dogs being presented as the sole subject of a work of art. With the increasing prestige attached to hunting and sporting activities, the dogs that took part became of correspondingly increased value, and that led

These paintings are of real dogs … and they live and breathe with the glisten of years-old oil paint: skin moving over bones and lusty blood coursing through veins, these are dogs ready to leap from the canvas.

**Antonio Pisanello
(1395–1455)**
Head of a Dog
n.d.
Pen and ink on paper
Dimensions unknown
Paris, Musée du Louvre

This extraordinary drawing of a little spaniel-type dog with its lip just faintly curled is one of the earliest examples of an artist's drawing a dog directly from life. The dog, right down to its finely drawn toenails, brims with vitality and personality, and, through the drawing, is almost as alive today as it was in Pisanello's studio 500 years ago. Pisanello drew with astonishing accuracy, capturing not only anatomical details but also the very nature of the animal. His attention to detail is exhaustive, with virtually every hair depicted individually here, so that they seem to bristle and move as the dog itself appears ready to jump from the page.

Pisanello made numerous sketches of animals, including dogs, horses, hares, deer and birds, which he later included in his paintings, as well as a number of human anatomical drawings. This little dog is similar to both of the small dogs that appear in the foreground of *The Vision of St Eustachius* (page 78), a painting that is full of animal life and includes several distinct canine types.

the fashion for dog painting to take off in earnest. Prized dogs were committed to canvas, their owners basking in the reflected glory of the dogs' beauty and sporting achievements.

The two French artists Jean-Baptiste Oudry and Alexandre-François Desportes painted some of the most striking images of dogs in the eighteenth century, notably the favourite hunting dogs of Louis XIV and Louis XV. These paintings are of *real* dogs, such as Baltazar, the hound from the Condé Pack painted by Desportes (page 193), and they live and breathe with the glisten of years-old oil paint: skin moving over bones and lusty blood coursing through veins, these are dogs ready to leap from the canvas. Nevertheless, despite the naturalism of these dogs, the flattering hand of the artist should

not be forgotten, as the odd nip and tuck with the brush was surely performed on occasion to please the patron.

During the eighteenth century and into the nineteenth, dog painting as a genre in its own right truly took form, a development that can be linked to the new interest in the creation of different breeds. This, in turn, led to the formation of stud-books; to the foundation of kennel clubs in Europe, including the British Kennel Club in 1873, and in America, with the American Kennel Club being established in 1876; and to dog shows – the ultimate in competitive arenas. Also affecting this surge in dog painting was an enormous increase in the popularity of dogs as pets, together with a distinct shift away from the predominance of dogs deployed in a working or sporting capacity. The owning of pure-bred dogs became extremely fashionable, fuelled by – and fuelling – the emergence of dog shows. A sub-genre of dog painting developed, dubbed by the renowned nineteenth-century dog-painting expert William Secord the 'pure-bred painting', as distinguished from the 'pet portrait' or the 'sporting portrait'. These pure-bred paintings were specifically to demonstrate the physical breed characteristics of the dog in question, and were all about the appearance of the dog, rather than reflecting it in an active role. Pure-bred paintings follow fairly typical lines, the dog being depicted standing in profile, sometimes with its head turned slightly towards the viewer. This allows its overall conformation to be displayed.

Pet portraits differ in that their purpose is to reflect the actual pet, its character and endearing or

**Benvenuto Cellini
(1500–1571)**
Relief of a Saluki
1544–45
Bronze
17.8 x 26 cm (7 x 10¼ in.)
Florence, Museo Nazionale del Bargello

This is a particularly interesting piece because it is one of the earliest known works of the Renaissance to take a dog as its sole subject, and as such it reflects the increasing importance attached to the dog as an individual. Moreover, it is an exquisite depiction of a saluki, one of the most ancient breeds, and shows how little it has changed in appearance over the centuries. This relief is also unusual because there were very few sculptures of dogs made at this time, yet it is its very sculptural quality that reveals so much about the exact physiological details of the dog. This was a highly prized animal that belonged to Cosimo I de' Medici, who commissioned the work; the dog was probably used for the sport of coursing, which was very popular in Renaissance Italy, and to which the saluki and the greyhound were well suited. Both these breeds of dog were frequently depicted during and after the Renaissance, and were considered highly prestigious. Although greyhounds remain popular today and are still widely used for racing, salukis are now far rarer.

unique qualities as well as its general appearance. Such portraits invariably depict the dog within its domestic environment, whereas pure-bred paintings often show the dog against either a plain background or a sweeping landscape. Sporting portraits depicted the sporting dog in action. There are instances where the lines between these three sub-genres become blurred, as for example in Edwin Landseer's masterpiece *Eos* (page 205), clearly a pet portrait, although also displaying the defining characteristics of a pure-bred painting. The incomparable George Stubbs, renowned for

the anatomical accuracy of his depictions, painted a number of early pure-bred portraits, including *Brown-and-White Norfolk or Water Spaniel* (page 199). In contrast to this dog is the portrait by Emily Brontë, *Keeper* (page 204), about the subject of which so much is known, from the dog's quirky idiosyncrasies to its faithful devotion. Brontë, who was a talented artist, has here depicted the dog exactly as it was: far from pretty, just a bit lopsided and endearingly gruff.

**Andrea Mantegna
(1431–1506)**
*Rubino, the Favourite Dog
of Ludovico II Gonzaga of
Mantua and his Family*
1465–74
Fresco
Dimensions unknown
Mantua, Palazzo Ducale, Camera
degli Sposi

Rubino, the russet-red
bloodhound type seen
here, was the favourite
dog of Ludovico II Gonzaga
of Mantua, who was so
distraught at the dog's death
that he buried it in a tomb
with an epitaph. The dog
appears in an honoured
position, lying peacefully with
a worldly-wise air beneath
Ludovico's chair, in this detail
from the fresco cycle that
decorated the Camera degli
Sposi (Bridal Chamber), also
known as the Camera Picta
(Painted Room). The room
took Mantegna ten years to
complete, and depicts the
Gonzaga family and friends,
with many of their dogs and
horses. It was conceived to
celebrate the great Gonzaga
dynasty, which ruled Mantua
from 1328 to 1708, but above
all it shows the Gonzagas
en famille, and it is significant
that the favoured Rubino rests
beneath the great patriarch.

The Gonzaga family were
tremendous dog and horse
enthusiasts and kept large
numbers of fine hunting dogs
as well as pets, examples
of which are also depicted
in the Camera Picta.

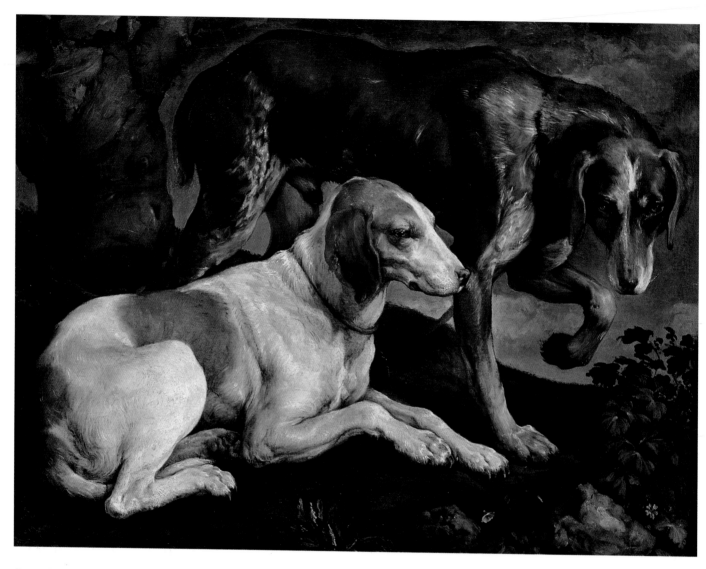

**Jacopo Bassano
(c. 1510–1592)**
*Two Hunting Dogs Tied
to a Tree Stump*
c. 1548–50
Oil on canvas
61 x 80 cm (24 x 31½ in.)
Paris, Musée du Louvre

Jacopo Bassano was a master of depicting dogs, and included them as incidentals in many of his paintings. This work (like that by Cellini on page 186) was one of the earliest paintings to use dogs as its sole subject matter. The painting was commissioned by Antonio Zentani, a wealthy Venetian art collector, and

depicts two hounds from his hunting kennels. The two dogs, which resemble pointers, fill the canvas, so that they are thrust into the viewer's focus. This lends them great monumentality and puts them on the same level as the viewer, with the standing dog making direct eye contact. The realism with which they are depicted is

quite extraordinary, the tactile quality of their coats convincing and the life beneath the surface of the paint almost tangible.

The dogs themselves are significantly more realistic in their portrayal than the expertly painted but contrived foliage in the right foreground, and this contrast accentuates their animal quality, lending

them the movement and spirit of a pair of real hunting dogs.

This work set something of a precedent for the depiction of dogs, and influenced other artists, while Bassano later produced several more paintings with dogs as the sole subject.

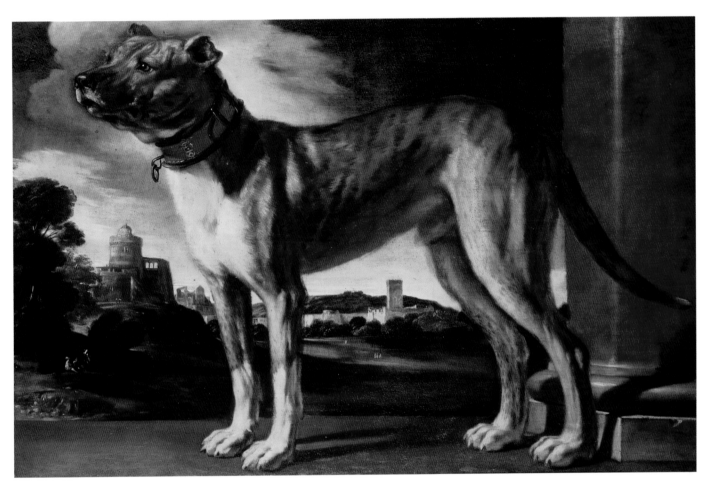

Giovanni Francesco Barbieri (Guercino) (1591–1666)
A Dog Belonging to the Aldovrandi Family
c. 1625
Oil on canvas
111.8 x 173.4 cm (44 x 68¼ in.)
Pasadena, The Norton Simon Foundation

In this work Guercino, who was not generally known for his animal painting, created one of the most convincing images of a dog. The great mastiff type fills the canvas, with the low horizon in the background adding to the effect of the dog looming over the viewer. In the distance is what is probably Aldovrandi Castle, the substantial home of Count Filippo Aldovrandi, Guercino's patron and owner of this prized guard dog – his coat of arms has been carefully transcribed on to the dog's sturdy collar.

The architectural details in the background are depicted with a fine, sharp clarity. In contrast, Guercino has captured the slightly fuzzed edge of the dog, the nature of its coat, the wetness of its nose and the fluid gleam in its eye. Against the Classical and rather idealized landscape the dog is monumentally real, down even to the greying round its muzzle and its alert, watchful gaze.

The structure of this work is comparable to the earlier painting of *Two Hunting Dogs Tied to a Tree Stump* by Jacopo Bassano (opposite), and can be seen again in Paulus Potter's *A Watchdog Chained to his Kennel* (page 192), although the character of each of the three works is different.

**Jan Brueghel the Elder
(1568–1625)**
Studies of Dogs
c. 1616
Oil on wood
34.5 x 55.5 cm (13⅝ x 21⅞ in.)
Vienna, Kunsthistorisches Museum

Jan Brueghel was a particularly gifted painter of dogs, and included them in many of his works. He paid great attention to detail, and depicted a wide range of different types, which are for the most part recognizable from his paintings. Such studies as this show the way in which the artist worked from life, jotting down the individual characteristics of different dogs in a very naturalistic way. Here he has painted greyhounds, spaniels and pointer types, including the uncommon subject of a pregnant greyhound bitch with swollen teats. The spontaneous nature of this work and the fluidity with which the dogs are rendered combine to invest the individuals with great character – each dog, whether cavorting, sitting or sleeping, comes to life under Brueghel's painstaking brush.

Brueghel's patrons in Antwerp, the Archduke Albert and the Infanta Isabella, kept large kennels of hunting dogs, to which the painter would have had access and which he doubtless used as models. He frequently painted hunting dogs in his allegorical scenes, and collaborated with his friend Peter Paul Rubens in the 1620s, painting the dogs in *Diana's Departure for the Hunt* and *Sleeping Nymphs with Satyrs*.

Frans Snyders (1579–1657)
Dogs Fighting in a Wooded Clearing
n.d.
Oil on canvas
173.4 x 241.9 cm
(68¼ x 95¼ in.)
Private collection

This monumental painting of dogs fighting is full of energy and violent passion, and is characteristic of Snyders's tumultuous hunting and fighting scenes. Snyders was one of the leading animal painters of his day, and is credited with being one of the first artists to bring the dog to the forefront of the canvas and turn it into an acceptable subject. His depictions of dogs are highly realistic and vibrant, and at the same time he invests them with human characteristics that make them vehicles of empathy and lend the works a symbolic function that relates to human nature, often at its basest. Here he depicts an inversion of the traditional hunting scene: the hounds have set upon one another, the prey long since forgotten – and it is 'each dog for himself'. It is not difficult to see in this an analogy with human behaviour, where, within groups, power struggles are normal and the strong sometimes turn on the weak.

Snyders's dog paintings enormously influenced his contemporaries and successive artists, especially such nineteenth-century British practitioners as Edwin Landseer.

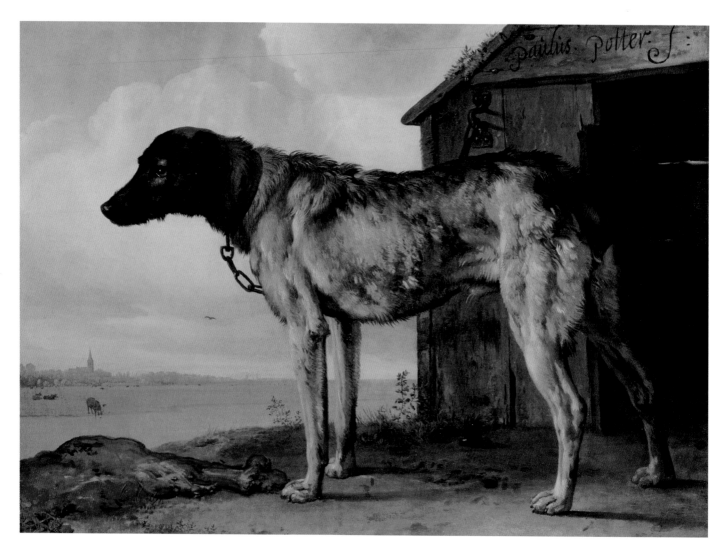

Paulus Potter (1625–1654)
A Watchdog Chained to his Kennel
c. 1650–52
Oil on canvas
96.5 x 132.1 cm (38 x 52 in.)
St Petersburg. The State
Hermitage Museum

It was the Dutch painters of the seventeenth century who truly opened the door for dog painting and animal painting in general, and it was in The Netherlands that this genre gained acceptability. Of all the Dutch animal painters of this period, few could rival the extraordinary vision of Paulus Potter, who died tragically young at just twenty-nine years old. In his short working life he created some of the most realistic and moving images of animals, of which this watchful guard dog ranks among the best.

This is no idealized dog; rather, it is rough-coated, ageing and soulful, but keeps the watch with an attention unbroken even by the temptation of the bone at its feet. Here is a dog that is down at heel, but convincingly noble, the most reliable of watchdogs, and an image of timeless dignity. Potter's exquisite brushwork lends the dog's coat a tactile quality; the hair is wayward, matted in places and finely drawn against the expansive Dutch sky. The eye is luminous and intelligent.

Alexandre-François Desportes (1661–1743)
Baltazar, a Dog from the Condé Pack
n.d.
Oil on canvas
88 x 103 cm (34⅔ x 40½ in.)
France, Chantilly, Musée Condé

Alexandre-François Desportes is one of the two artists from eighteenth-century France – the other being his younger contemporary Jean-Baptiste Oudry – whose paintings of dogs are truly captivating. Desportes's knowledge of hunting and of dogs was extensive and heartfelt, and his understanding of canine anatomy and behaviour is clearly apparent in his paintings. He executed many for Louis XIV and later Louis XV, including several individual portraits of dogs, such as this one of Baltazar, whose name appears in gold letters below the dog. Not only is this an exquisite painting of a dog, taken from life, but also the hound is a fine example of its type. It is seen posed in the classic breed stance, designed to reflect all the key anatomical points that denote its quality, and would have been a top hunting dog.

Hunting was extremely popular and highly formalized at this time in France, and both Louis XIV and Louis XV kept extensive and lavish kennels, said to house up to 400 dogs. Desportes's interest in and knowledge of hunting was such that he painted his self-portrait dressed as a huntsman and surrounded by his dogs (page 126).

MISSE

TVRLV

**Jean-Baptiste Oudry
(1686–1755)**
*Misse and Turlu, Two
Greyhounds Belonging
to Louis XV*
1725
Oil on canvas
127 x 160 cm (50 x 63 in.)
France, Seine-et-Marne, Château
de Fontainebleau

Oudry began his career as a portrait artist and painter of still lifes before turning to hunting scenes and dog painting in the early 1720s. His brilliant works, which so successfully brought his subjects to life, earned him the recognition of the French court, and he replaced Alexandre-François Desportes as Louis XV's favourite painter.

Under the patronage of the flamboyant French king, Oudry produced a number of striking hunting scenes as well as individual dog portraits, such as this one.

Misse and Turlu are described as greyhounds, but the comparative size of the foliage behind them makes them appear small in stature and more like whippets. Their

names are painted in fine gold lettering beneath them. Misse in particular was a favourite pet of the king, and Oudry painted her portrait several times.

There is a distinction between such works as this, which portray a beloved pet and its charming nature, and those paintings designed to reflect the characteristics and

qualities of the breed, as seen in Desportes's painting *Baltazar* (previous page). Misse and Turlu are set against a fictitious landscape painted with a delicate, Rococo touch that captures their refined and elegant nature.

**Jean-Baptiste Oudry
(1686–1755)**
Bitch Nursing her Puppies
1752
Oil on canvas
103.5 x 132.1 cm (40¾ x 52 in.)
Paris, Musée de la Chasse
et de la Nature

This is an unusually emotive work for Oudry, and an important piece in the development of dog painting. Here he depicts a fine-bred *braque*- or pointer-type bitch nursing her plump and contented puppies in a rustic environment. The bitch raises her leg protectively and to allow the puppies in to nurse, stoically maintaining an uncomfortable position for the sake of their well-being. Oudry has invested the animal with a deeply maternal and human-seeming nature, her face in particular taking on an echo of humanity, especially in the eyes. Across the room a brilliant patch of light falls – perhaps a door has been opened – and her worried and protective countenance is directed towards this spot.

Paintings of this subject were unusual at this time, but by the nineteenth century they were popular, and the attribution of human characteristics to dogs was not just commonplace, but taken to excess in Victorian Britain. Some 180 years before Oudry, Titian had also captured a bitch nursing her puppies in his painting *Boy with Dogs* (c. 1570–76). There the very realistically painted bitch likewise lifts her back leg to allow the puppies to suckle, and stares balefully towards the viewer, but she lacks the human quality apparent in Oudry's work.

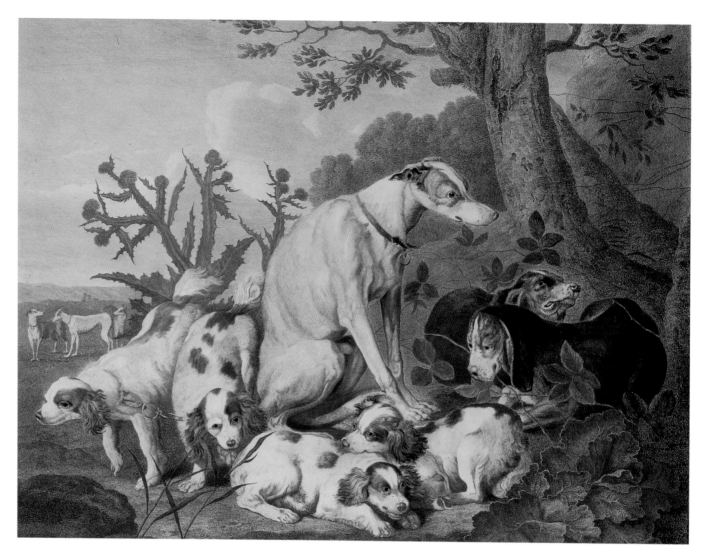

After Jan Fyt (1611–1661)
Portraits of Dogs
Engraved by Daniel Lerpinière
(c. 1745–1785)
Published 1799 by John and
Josiah Boydell
Stipple engraving
45.7 x 67.3 cm (18 x 26½ in.)
Private collection

Although this engraving was made after Jan Fyt, it represents well the style of the renowned Antwerp artist. Fyt trained under Frans Snyders, one of the greatest dog painters of the time, and was greatly influenced by him – an influence seen especially in the earthy realism and texture of his canvas and his often dramatic subject matter.

Fyt's work became extremely popular in his native Antwerp during his lifetime, and he was one of the city's most prosperous artists. His hunting scenes and pictures of dogs, full of vitality, were particularly sought after. Fyt was able to characterize individual dogs with great detail, and during his career he depicted a wide range of

different breeds, some of which, including greyhounds, spaniels and a rather lovely basset type, can be seen in this engraving. In 1642 he made a series of engravings for Don Carlo Guasco, Marqués de Solerio, a counsellor to Philip IV of Spain, set against landscape backgrounds and showing different breeds of dog, and

it is on these examples that the engraving shown here was based.

Fyt's paintings had a profound influence on several younger artists, including his pupil Pieter Boel (1622–1674) and David de Coninck (1636–1699), as well as the French artists Alexandre-François Desportes and Jean-Baptiste Oudry.

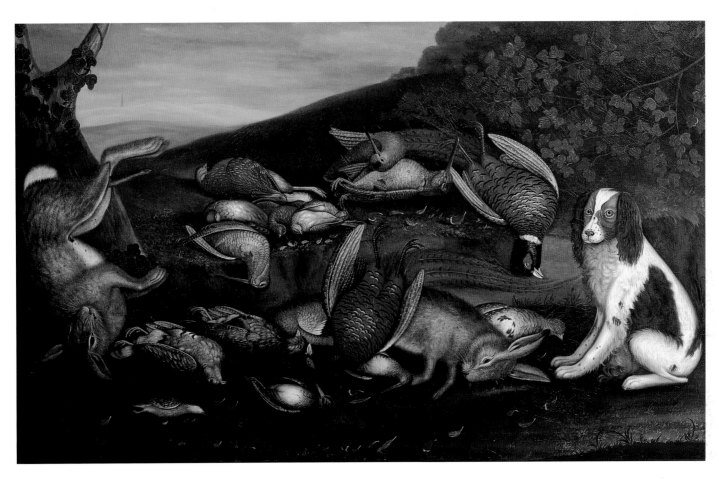

John Reade
(active 1773–1798)
Mr R. Forrest's Prize-
Winning Spaniel and
his Winning Bag
n.d.
Oil on canvas
94 x 152.4 cm (37 x 60 in.)
Private collection

This is a particularly appealing painting, although sadly there is little ready information pertaining to 'Mr R. Forrest' or his delightful champion dog. Nor is the artist, John Reade, from the mainstream of eighteenth-century sporting painters, but the picture is so beautifully executed and the spaniel sits alongside its quarry with such aplomb that the work merits consideration.

The painting was commissioned to commemorate the working skills of this little dog, which is diminutive beside the mountain of game it has caught. Indeed the dog itself is hardly bigger than the hares or pheasants, its extraordinary accomplishments further accentuated by its small size in comparison to the great bag. Evidently, this was a dearly loved and highly prized sporting dog, its talents permitting Mr R. Forrest himself to bask in the glory of his dog's achievements.

While the painting is primitive and naïve in style, and lacks the technical accomplishment of other artists, such as George Stubbs, working at this time, it nonetheless conveys a subtle humour and an undeniable charm.

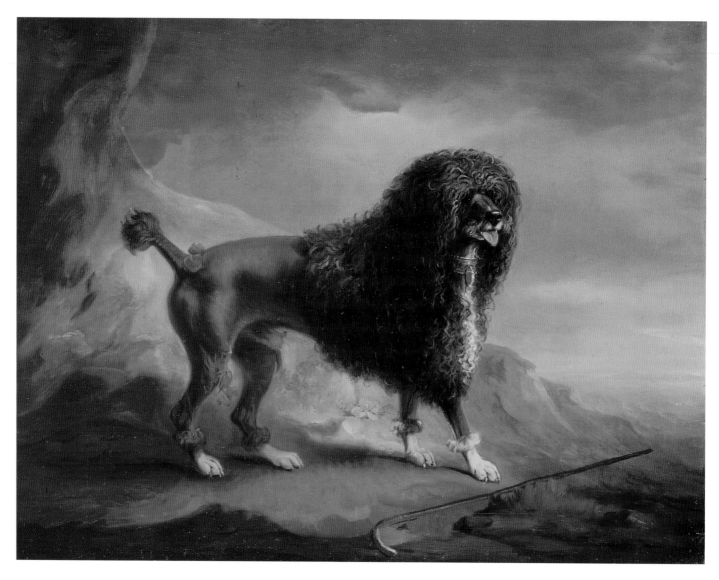

**John E. Ferneley
(1782–1860)**
A Clipped Water Spaniel
n.d.
Oil on canvas
86.3 x 109.2 cm (34 x 43 in.)
Private collection

This pure-bred painting of a clipped water spaniel is similar to Stubbs's *Water Spaniel* (opposite) in the way that it depicts the dog filling the foreground and set against a wide landscape background free from human intervention and suggestive of its wild origins. Even so, Ferneley's spaniel, with its manicured and clipped hair, remains firmly of the domestic world. The painter specialized in hunting scenes and portraits of horses and dogs, and gained a large and loyal following in his home area of Melton Mowbray in central England. His paintings are skilfully constructed and accurate in detail, particularly those showing pure-bred dogs like this one, but they lack the depth and emotion of his predecessor, Stubbs.

The spaniel is a breed with ancient origins, and first evolved along two clear lines, land-based and water-based working dogs. Later, a number of different types were developed, from the irresistible King Charles lapdog to the dedicated working breeds, such as the water spaniel seen in this painting.

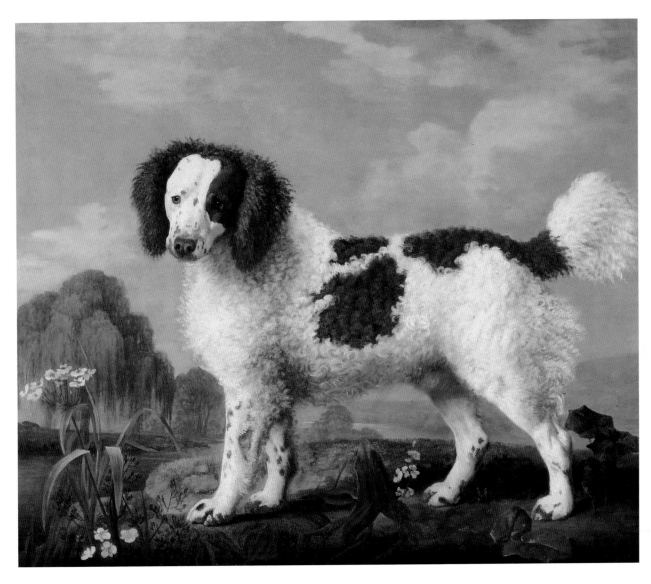

George Stubbs (1724–1806)
Brown-and-White Norfolk
or Water Spaniel
1778
Oil on panel
80.6 x 97.2 cm (31¾ x 38¼ in.)
Connecticut, Yale Center for British Art,
Paul Mellon Collection

The name George Stubbs can hardly be breathed without mention of *Whistlejacket*, or the artist's paintings of elegant racehorses, but the consummate portrayer of horses was also a master of dog painting, as is admirably demonstrated in this picture of a curly-coated water spaniel. Animals come to life under the steady brush of Stubbs, whose extensive knowledge of anatomy was based on years of study and dissection during which he made precise anatomical drawings. His measured and scientific approach to his subjects was combined with brushwork of tremendous depth, so that such paintings as this seem to make their subjects real – the dog's coat springs, the delicate curled hair trembles and vibrates as blood moves through veins beneath the surface.

Stubbs's paintings are also, without exception, invested with a depth of feeling, a profound sense of soul, that set them apart from those of the majority of his contemporaries.

This picture is a classic pure-bred painting that displays all the qualities of this fine spaniel. For all the detail of the expertly painted background, the dog fills the canvas, lord and master of all that surrounds it.

**Théodore Géricault
(1791–1824)**
Portrait of a Bulldog
c. 1816–18
Oil on board laid on panel
27.7 x 23.2 cm (10⅞ x 9⅛ in.)
Private collection

There is an intensely
unsettling quality to this
painting of a bulldog's head
and chest emerging pale and
ghostly from a thick black
background. It is an unusual
study of a dog, and by
depicting the animal in this
way, rather in the manner of
a human portrait, Géricault
forces the viewer to confront
the dog eye to eye. Yet its
gaze slips away nervously,
the sense of its agitation
compounded through the
use of short, blocky, hurried
brushstrokes. The dog's
head and face take on an
almost human aspect, the
animal quality diminished,
with the ears small, the hair
so fine it appears like skin,
the eyes almost human
and the entire facial plane
flattened. Some years
later the artist would paint
a series of harrowing and
groundbreaking portraits of
the mentally ill, capturing the
same sense of fear and dark
psychological undercurrent
that are present in this dog.

Bulldogs, one of Britain's
oldest and most iconic
breeds, were bred for their
fearlessness, strength and
tenacity, and were used as
guard dogs and for baiting
bulls, a barbaric practice that
was not abolished until 1835,
with the introduction of the
Cruelty to Animals Act.

**John Frederick Herring, Sr
(1795–1865)**
*The Greyhounds Charley
and Jimmy in an Interior*
n.d.
Oil on canvas
Dimensions unknown
Private collection

John Frederick Herring, Sr, is perhaps best known for his coaching scenes and paintings of horses, but he was also a highly accomplished painter of dogs, as can be seen here. He painted greyhounds many times during his prolific career, and was particularly skilful at capturing the exact physical likeness of dogs, showing his understanding of their anatomy and musculature, creating the texture of their fine, smooth coats and imbuing the animals with character. This image has great appeal and is invested with more emotion than many of his works, which suggests that either these were his own dogs or they belonged to someone close to him.

The tan-and-white dog, in particular, has a very intelligent countenance and is clearly the leader of the two, while the other, dressed in a bow, has a slightly nervous presence. These are finely detailed records of character translated into paint.

Herring received little formal artistic training, and worked as a coach-driver for seven years, painting in his spare time. He later had some instruction from the artists Abraham Cooper (1786–1868) and Sawrey Gilpin (1733–1807), and achieved some measure of success during his lifetime.

Pierre-François-Grégoire Giraud (1783–1836)
Hound
1827
Marble
53 x 82 x 50 cm
(20⅞ x 32¼ x 19⅝ in.)
Paris, Musée du Louvre

In the mid-nineteenth century a school of animal sculptors developed in France, led by Antoine-Louis Barye (1796–1875), whose subjects ranged from the dog and the horse to exotic wild animals. In 1831 Barye exhibited *Tiger Devouring a Gavial of the Ganges*, which led an acerbic critic to dub him an *animalier*, maker of animals. The term stuck, and the growing group of sculptors around Barye became known as *Les Animaliers*.

Giraud is perhaps one of the less well-known figures in the group, but this piece of work in particular is hard to equal. The hound rests, alert and watchful, on a substantial oval plinth, which elevates the sculpture from a simple, realistic depiction of a dog to something symbolic and important, evoking the statues of ancient Greece and Rome. Around the edge of the plinth runs a bas-relief that represents the enduring, unmatched qualities of dogs, such as their fidelity and bravery, in scenes depicting a dog rescuing a baby from a deadly snake, and another attacking a bull, so that the piece becomes the embodiment of noble attributes and takes on a universal meaning.

**Edwin Landseer
(1802–1873)**
*Newfoundland Dog
called Lion*
1824
Oil on canvas
149.8 x 195.6 cm (59 x 77 in.)
London, Victoria and Albert Museum

Landseer is one of the best-known nineteenth-century animal painters. His works are strikingly realistic from an anatomical perspective, and his animals, especially his dogs and horses, are invested with human-like emotion or character. Of the many different types of dog that the artist painted, the Newfoundland, originally

from Canada, was one of his favourites. This painting of the magnificent Lion, a dog owned by William H. de Merle, was one of Landseer's earliest depictions of the breed and marked the start of his long love affair with the dogs. So great was his affection for these animals, in particular the black-and-white variety, that Newfoundlands

of this colouring were named after him, and are still known as Landseers.

The romantic associations attached to the Newfoundland were doubtless of great appeal to this artist, whose works were often sentimental. The dogs were thought to have an innate aptitude for saving lives, and were prized for their intelligence, loyalty

and quiet nature. Many stories tell of them rescuing people from water (they actually have webbed paws and an almost waterproof coat), and not surprisingly they had a long association with fishermen.

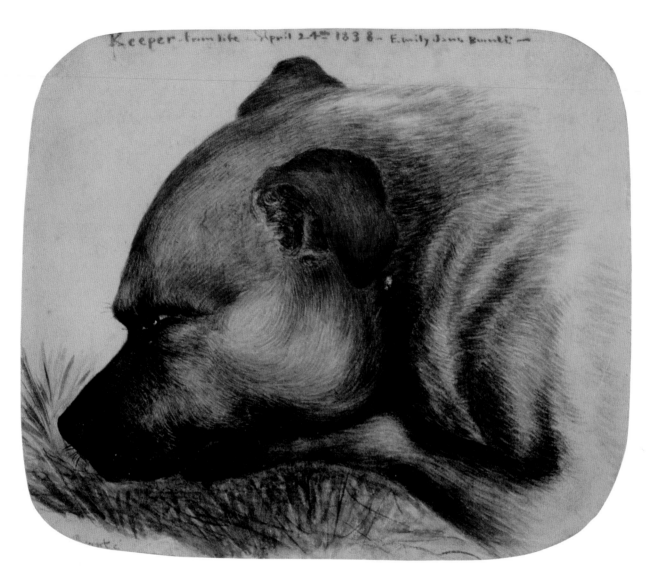

Emily Brontë (1818–1848)
Keeper, from Life
1838
Pencil and watercolour
on paper
13.2 x 15.7 cm (5¼ x 6⅛ in.)
UK, Yorkshire, Haworth,
Brontë Parsonage Museum

Keeper is a dog from history about which a remarkable volume of information survives through the written accounts of Emily Brontë herself, as well as those of the local villagers who became accustomed to the sight of Brontë and her irascible canine partner. This drawing of Keeper captures the dog exactly as it was, according

to all accounts. It lies watchfully, slightly unpredictable-looking (indeed, it had a tendency to bite the unsuspecting), with one ear cocked towards its mistress. The picture is powerfully personal, conveying a sense that the artist has depicted the dog as perhaps no one else could have done.

Brontë and Keeper had a precarious relationship in the early days, a kind of struggle for power, which Brontë eventually won. Keeper was, however, unerringly faithful to the young woman, and a devoted pet and guard: in return, she came to adore the dog, her relationship with it seemingly closer than those she formed with people. As

she lay dying, Keeper kept vigil by her bed; at her death the dog was grief-stricken, and it continued to sleep each night outside her bedroom door, waiting and whining.

Rosa Bonheur (1822–1899)
Brizo, a Shepherd's Dog
1864
Oil on canvas
46.1 x 38.4 cm (18⅛ x 15⅛ in.)
London, Wallace Collection

Rosa Bonheur devoted most of her working life to depicting animals in paintings and sculptures and was recognized as one of the leading artists of this genre in France. Her career was concurrent with that of Landseer's in England, and his work had some influence on hers, although Bonheur avoided overt sentimentality, while still capturing the soul and spirit of her subjects. She withdrew from the society scene of France, moving to the Forest of Fontainebleau in 1860, and worked instead in a solitary manner, studying anatomy in great detail and living surrounded by the animals she loved to paint.

Bonheur is more commonly associated with paintings of horses, in great part because of her monumental *Horse Fair* (1855), but her paintings of dogs, such as *Brizo*, are equally accomplished. Here the shaggy dog is depicted in the manner of a human portrait, showing just the head and shoulders, which is slightly disconcerting. There is an air of sadness to the image; the dog has great depth to its partly concealed eyes and appears to gaze wistfully just beyond the shoulder of the viewer.

**Frederick Thomas Daws
(1878–?)**
Scotties in a Landscape
1924
Oil on canvas
Dimensions unknown
Private collection

Frederick Daws is not one of the better-known dog artists, but his works nonetheless admirably capture the nature of his subjects. He tended to paint pure-bred portraits, often of prize-winning dogs for wealthy patrons, and established quite a following in the world of dog-fanciers.

This painting of three Scottish terriers amid the wild Scottish Highlands is rather romantic in nature, and presents the dogs free of human intervention, harking back to their wild roots. The dogs themselves are fine examples of this plucky breed, which became very

popular during the late nineteenth century, and the origins of which were the subject of great debate. A number of different terriers from Scotland, including the Cairn, the West Highland White, the Skye and the Dandie Dinmont, had been systematically grouped

together and called Scottish terriers, and it was not until around 1883 that there was a concerted effort to breed like to like and finesse a unique Scottie character. The Scottish Terrier Club was formed in 1887 in England and in 1888 in Scotland to oversee the breed.

Derold Page (born 1947)
Gyp
1980
Oil on canvas
61 x 76 cm (24 x 29⅞ in.)
Private collection

The South African-born, self-taught artist Derold Page brings tremendous charisma to his works, which are often conceived with a subtle humour and are particularly warm and joyous. Although he also frequently works to commission, as in the case of this work, his subjects, especially his cats and other pets, or those of close friends, are often taken from the world around him, and it is this familiarity and love that come across in his paintings.

The structure of this work is interesting because Page has recalled the technique of such old masters as Jacopo Bassano, Guercino and Paulus Potter by filling the canvas with the image of the dog, the landscape sweeping away into the distance (pages 188, 189 and 192). He has combined it with the traditional pose of the pure-bred portraits of the eighteenth and nineteenth centuries, in which the dog is seen laterally to emphasize its conformation. Both of these devices lend the work a sense of history. A further dimension is added by the seemingly precipitous edge that Gyp stands on, which creates a degree of tension, with the farm buildings small by comparison and far below.

The Romantic
Dog

THROUGHOUT HISTORY THE IMAGE OF THE DOG has remained – among other things – one of the most recognizable and sustained symbols of fidelity, devotion and love, in an artistic tradition stretching back to antiquity. The dog hovers on the sidelines of great painted love scenes, such as *Venus and Adonis* (page 216) by Abraham Janssens, its presence, whether large or small, signifying devotion. For an element so often overlooked by viewers and even by critics, and considered a minor part of a larger story, the dog symbolically is one of the most resonant images in paintings of romantic subjects. We see this explicitly in the exquisite fifteenth-century Arras Tapestry *Offering of the Heart* (opposite), for example, which depicts an elegant nobleman offering his love to a lady. As he moves his body towards her, he is matched by the small white dog that jumps attentively at her knees, mirroring the devotion offered by her suitor. This was a pictorial device used time and again in works of a similar subject, and shows the way in which artists used the dog, symbolically and visually, to enlarge the narrative and the emotion of a painting's human subject.

Dogs are naturally aesthetically pleasing elements in a picture, their fluid lines and endearing qualities conducive, on a purely visual level, to artistic inclusion, but it is their underlying significance in paintings, especially in those of a romantic subject, that is of such interest. From early on, although not in all cultures, man identified something – a commonality – within the domestic dog that stirred his soul, and it is this sense of reciprocal understanding that has caused the dog to be used so extensively in art. The domestic dog expresses simple emotions – fear, anger, joy, love – that are easily recognizable and that do not seem so far from the same emotions as felt by humans: this has led to a level of understanding and communication not experienced between man and most other animals. The detail of the small child and the large dog in Veronese's *Portrait of a Woman with a Child and Dog* (page 215) leaves little doubt as to the existence of an unspoken discourse between them, and although the scene forms only a fraction of the canvas, it is one of the most touching corners of Renaissance art to be found. This sense of commonality, which was not scientifically explored until the nineteenth century but, rather, delicately wove its way into the consciousness of artists, was a significant factor in the inclusion of dogs and the symbolism invested in them.

The use of the dog in a symbolic capacity is one that has been subject to various interpretations, and ranges from devotion to fidelity to the opposite end of the scale, and to being representative of lust and carnal urges. Most frequently, the dog is used to embody noble attributes, which are clear from the context of the painting. There are, however, exceptions, an interesting one being *The Arnolfini Marriage* by Jan van Eyck (page 117). This painting has been the subject of extensive and varied

The noble greyhound's delightfully pricked ears and the precise angle of its head, set back, convey a canine expression that every dog enthusiast will know

French School
Offering of the Heart
c. 1410
Arras Tapestry
Dimensions unknown
Paris, Musée National du Moyen Age
et des Thermes de Cluny

Until the fifteenth century France was a major centre of tapestry-making, with Paris and the north-eastern town of Arras in particular producing finely woven tapestries of the highest quality. From the mid-fifteenth century the centre of the industry shifted to Flanders, and Flemish works would be the most sought after for several centuries.

This is an exquisite tapestry probably made by the workshops of Arras, and is one of very few that have survived the ravages of time and war. The detail is extraordinary, and reveals every element symbolic of love, fidelity and nobility. The ardent suitor presents his heart, token of love, held between finger and thumb, to the lady, who is dressed in blue, the colour associated with fidelity. The little dog, a toy-spaniel type, jumps at her knee in an expression of devotion (reflecting the suitor), and she extends her hand towards it. Her gesture to the dog foretells her impending acceptance of the man's heart in a gently humorous and subtle manner.

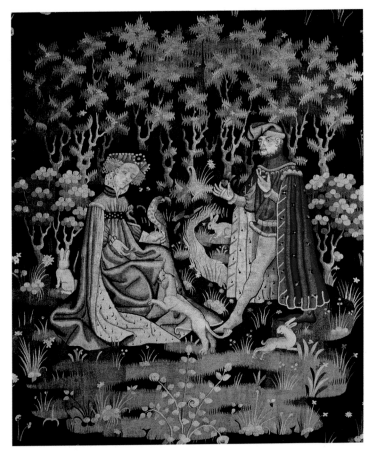

interpretation because of the symbolic elements within it. The little dog of griffon-terrier type has been cast variously as symbolic of marital love and fidelity, as representing the subservient behaviour expected of a wife, and as reflecting the lust and desire of the young couple with a view to procreation. Without the words of the artist himself, the significance of the dog remains ambiguous, but that is certainly not the case in such works as *The Souvenir (Fidelity)* (page 219) by Jean-Baptiste Greuze. Here, the delightful silky dog of spaniel type, clutched to the breast of a dewy-eyed girl, is unequivocally symbolic of love and fidelity. Works of this nature – love and romance – were popular in France during the eighteenth century and were frequently painted by such artists as Greuze, Jean-Honoré Fragonard (1732–1806), François Boucher (1703–1770) and Jean-Antoine Watteau (1684–1721), working in the Rococo style.

Throughout the eighteenth and particularly the nineteenth centuries, dogs were increasingly endowed with anthropomorphic qualities, a trend that reached its peak in the work of such artists as Edwin Landseer (*Attachment* and *The Old Shepherd's Chief Mourner*, pages 222 and 223) and Arthur John Elsley (*Her First Love*, page 225). It was during this period that animal psychology began to be studied from a more scientific angle, which gave further (and, some would argue, incorrect) weight to the attribution of human-like emotions to dogs. In art, this was manifested in works reflecting human-seeming communication and relationships among dogs, rather than between humans and dogs, as had been the case up to this point. So Landseer's *Doubtful Crumbs* (page 224), for example, invests the little dog with anxiety but pluck and the big dog with paternal tolerance but definite ownership of the bone: in its evocation of a line to be crossed and a decision with certain consequences to be made, this is a canine scene of human deliberation.

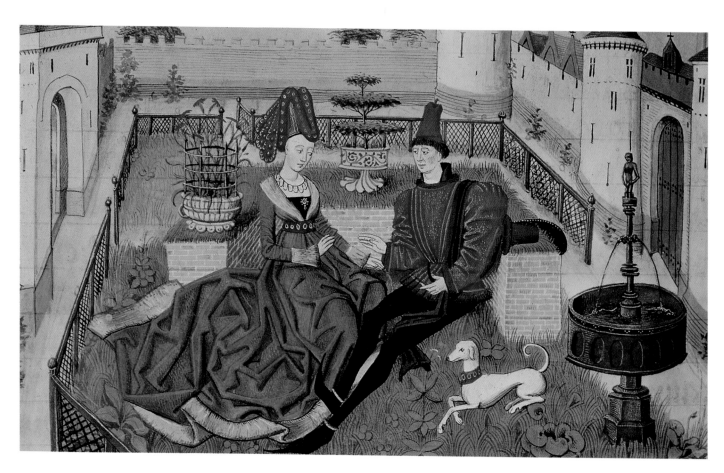

**Loyset Liedet
(active 1448–1478)**
The Garden of Love
n.d.
Vellum
Dimensions unknown
Paris, Bibliothèque de l'Arsenal

The medieval garden here, with its soaring perspective and prominent well, is the setting for a scene from an old tale of heroics, romance, rejection, love and death – all the ingredients of a dramatic, sweeping saga.

The little white dog, a greyhound type although with the silky ears of a saluki, watches the two figures, its tail wagging. It is the symbol of nobility and fidelity, but is also the audience to an unfolding narrative. This is not a straightforward romance, however. The beautiful lady is Angelica, a fictional character from two medieval poems, *Orlando Innamorato* by Matteo Maria Boiardo and its continuation, *Orlando Furioso* by Ludovico Ariosto. The lady's charms have caused havoc at the court of Charlemagne, king of the Franks, and his knights – in particular two cousins, Renaud de Montauban and Orlando – have fallen in love with her. Orlando loses his mind with unrequited passion. Renaud and Angelica drink, on various occasions, from a magic well, seen here in the garden, which causes one to be madly in love while the other is indifferent.

Paolo Veronese (1528–1588)
Portrait of a Woman with a Child and Dog (detail)
c. 1546–48
Oil on canvas
Paris, Musée du Louvre

This is one of the most lovely details of the human–canine bond from a Renaissance work of art, and was painted by one of the greatest dog artists of the time. In many of his canvases Veronese included dogs going about their doggy existence, with a superbly rendered naturalism that speaks of the artist's understanding of the true canine character. The extent to which he painted them in all his works – religious, allegorical and genre alike – and the incredibly lifelike presence he brought to the depictions suggest that Veronese, like Titian, had a genuine and deep-felt appreciation of the dog. Those he painted are not only realistically depicted, but also imbued with soul and spirit, as can be seen here.

The little boy, thought to be the son of Isabella Guerrieri Gonzaga Canossa, connects with the dog with a serious and meaningful look. The dog returns the gaze, its eyes luminous and full of life; it appears sympathetic, protective and almost paternal towards the young child.

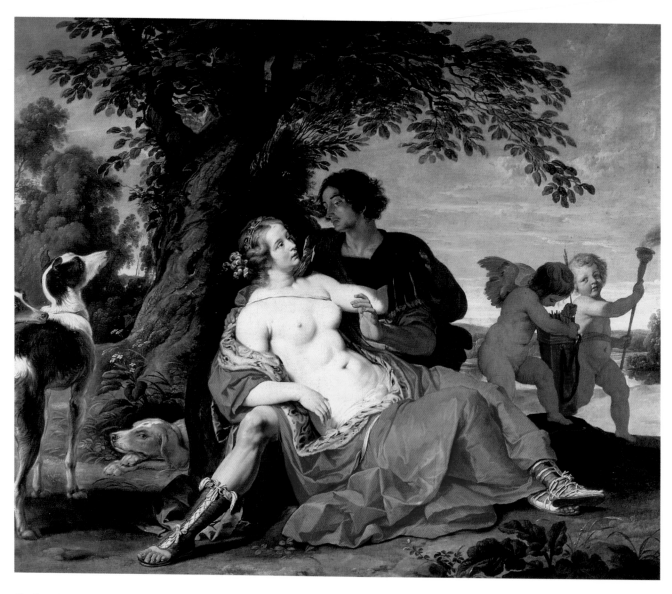

**Abraham Janssens
(1575–1632) and
Jan Wildens (1586–1653)
(landscape detail)**
Venus and Adonis
c. 1620
Oil on canvas
200 x 240 cm (78¾ x 94½ in.)
Vienna, Kunsthistorisches Museum

Flemish artist Abraham Janssens has created a wonderful sense of balance and narrative through the structure of this painting of Venus and Adonis. The focus of the composition is, of course, the central figures: Venus reclines wantonly in Adonis's lap as he looks down on her (and where will his hand end up?). On the left, the group of dogs continues the structural harmony, with the large greyhound type looming over the smaller, feminine hound in a way that mirrors the postures of Venus and Adonis. The greyhound stares directly at Adonis, linking the human and canine elements, while the undulating, almost musical rhythm of the canvas is continued in the two cherubs on the right, one of which looks down and one up.

It is the details, particularly regarding the dogs, that make this painting so appealing. The noble greyhound's delightfully pricked ears and the precise angle of its head, set back, convey a canine expression that every dog enthusiast will know, while the hound type has an almost human eye, and furrows its brow, displeased perhaps by its mistress's blatant promiscuity.

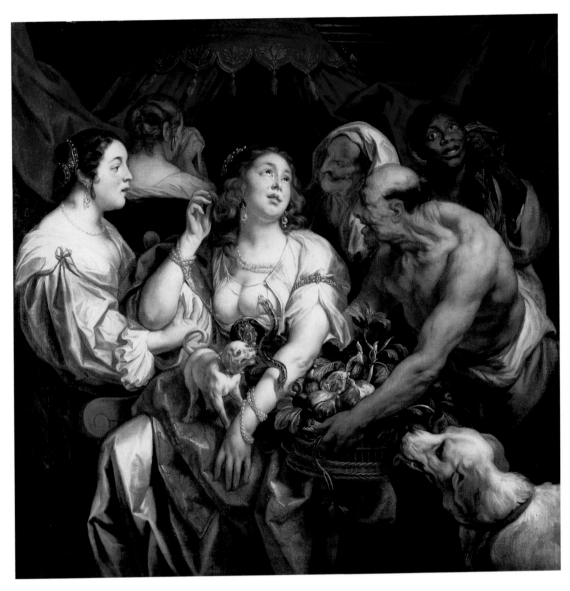

**Jacob Jordaens
(1593–1678)**
The Death of Cleopatra
1653
Oil on canvas
171 x 172 cm (67⅓ x 67¾ in.)
Kassel, Gemäldegalerie Alte Meister

This is a rather unusual depiction of Cleopatra, who is rarely portrayed accompanied by dogs. Her little pet barks furiously from her ample lap at the deadly asp; the dog's large, luminous eyes are strikingly human and full of sadness at the death of its mistress. The large,

retriever-type dog also stares up at the central group, its brow furrowed, with an expression of infinite sorrow.

Jacob Jordaens assisted and was heavily influenced by Rubens, as is evident here, and after the death of the older artist Jordaens became the leading figure-

painter in Flanders. Many of his works include coarse peasant types, almost caricatures, as can be seen here, where he has contrasted the brutish features of the peasant figures with the delicate rendering of the dying queen and her handmaiden. The two

dogs carry this theme further, the tiny, fragile and ultimately feminine lapdog forming a sharp contrast with the large, muscular and masculine dog in the foreground.

**Jean-Honoré Fragonard
(1732–1806)**
The Souvenir
c. 1776–78
Oil on walnut panel
25.2 x 19 cm (9⅞ x 7½ in.)
London, Wallace Collection

Paintings of this nature,
depicting beautiful young girls
reading love letters or lost in
reverie about their lovers, and
accompanied by little dogs,
were extremely popular
during the eighteenth century,
and were most often small in
scale and painted in pure and
delicate colour. Fragonard
was one of the leading artists
in this respect, and was rarely
equalled in his lightness of
touch and detailing.

The girl, whose curling
tendrils of hair mirror in
appearance the silky spaniel's
ears, is carving her initials
into the bark of a tree, while
her devoted dog, a symbol of
fidelity, looks on. According
to a sale catalogue of 1792,
the figure of the girl was
based on Julie, the heroine
of Jean-Jacques Rousseau's
novel *Julie; ou la nouvelle
Héloïse*, published in 1761.
The book, a best-selling love
story, charted a passionate
affair between a tutor and his
pupil, their separation and
her subsequent marriage
to another. In Fragonard's
painting the girl's demeanour
is wistful and lovelorn as
she dreams of her beloved,
while her exquisite dog
watches her intently.

Opposite, left
**Shên Ch'üan
(active c. 1725–1780)**
Dogs and Peony
1750
Colour on silk, hanging scroll
100 x 33.8 cm (39⅜ x 13⅛ in.)
London, The British Museum

The delicate colouring and
finely drawn details of this
exquisite scroll add to the
romantic nature of the piece,
which depicts a beautifully
feminine Chinese lapdog with
her puppies, under a peony
plant. The little dog is the
epitome of maternal grace
and beauty, her puppies
clambering across her, while
her dignified and loving
expression is utterly
charming. Such small dogs
as this enjoyed a long and
popular history in China,
and were common pets,
especially among the wealthy.
The peony is a bloom highly
valued in Chinese culture,
and during the late Qing
Dynasty it was designated
the national flower. It was
considered an emblem of
love and feminine beauty,
both of which, in this picture,
are further emphasized by
the dog. The peony is also
associated with wealth,
nobility and good fortune,
and its inclusion in this work,
together with the dog, which
represents maternity, love
and fidelity, suggests that
the painting may have been
made to celebrate a marriage.

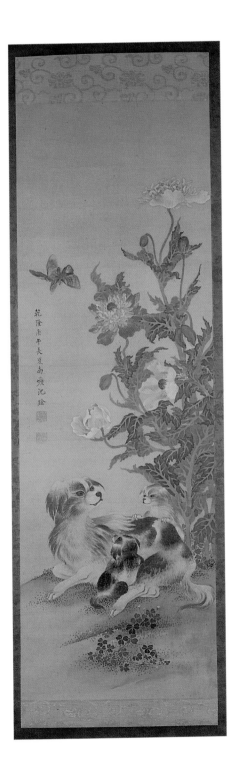

**Jean-Baptiste Greuze
(1725–1805)**
The Souvenir (Fidelity)
c. 1787–89
Oil on canvas
52.2 x 42.3 cm (20⅝ x 16⅝ in.)
London, Wallace Collection

By the eighteenth century the hounds of the nobility were being challenged as the predominant canine presence by the increasing numbers of small pet dogs, of which the spaniel type seems to have been most prevalent. France was full of lapdogs, which were frequently depicted in art, with François Boucher, Jean-Honoré Fragonard and Jean-Baptiste Greuze in particular depicting some of the finest little dogs of the time.

It was also during this period that the high drama of Baroque art was replaced by the light, delicate and often frivolous Rococo style, which reached its zenith in France. Such subjects as the one seen here were popular, showing beautiful young women in love, at leisure or writing letters – invariably accompanied by that potent symbol of love and fidelity, a little dog. The girl clutches the spaniel type to her breast, its little head turned towards her with silken ears and dewy eyes. It is full of vitality, its coat glistens and it seems almost to move, making it a strikingly real dog in a scene that is otherwise highly sentimental and contrived.

Briton Riviere (1840–1920)
Sympathy
1877
Oil on canvas
121.8 x 101.5 cm (48 x 40 in.)
UK, Surrey, Royal Holloway and
Bedford New College

Briton Riviere was one of a
number of artists working
in Britain at this time who
frequently included dogs
in his paintings. In particular
he used dogs in his works
to emphasize the drama
of a situation and its human
emotion, and he often
depicted a dog with its owner
in a predicament of shared
adversity. Here, the little
white dog sits with devotion
and patience, sharing its
young owner's troubles. The
child has been sent to sit
on the stairs, and the dog
has joined her. Possibly the
pair were involved in some
mishap that has led to their
temporary banishment. The
dog is exquisitely rendered,
and the artist has perfectly
captured its expression of
doleful loyalty. The strikingly
realistic depiction of
the animal reflects the
artist's affection for and
understanding of his subject.
 An earlier and similar work
painted by Riviere is *Fidelity*
(1869), where again the dog
shares its master's woes.
This time the faithful hound
is seen incarcerated with its
poacher owner who, head in
hands, awaits his fate.

**Richard Ansdell
(1815–1885)**
The First Watch
c. 1840–60
Oil on canvas
Dimensions unknown
Private collection

Richard Ansdell was one of several leading artists in the nineteenth century whose reputation rests on their paintings of animals, notably dogs. He frequently painted scenes of the Scottish Highlands and of shepherds with their dogs, and owned several Border collies during his life, which he often included in his works. Ansdell's dogs are without exception strikingly realistic: his works are extraordinarily detailed, and the rendering of the textures of different dogs' coats is so convincing that the paintings have a very tactile quality.

Ansdell invariably depicts a close and loving relationship between human and dog – or dogs, as in this work. Here the man sleeps, a small terrier type curled up and pressed blissfully against his side, while an elderly hound dozes at his head. Watching over the recumbent trio is an alert lurcher type, its tail tucked – no doubt it would rather be sleeping in the close, bonded heap of man and dog. It is a touching scene, as are many of Ansdell's works, and is tinged with melancholy.

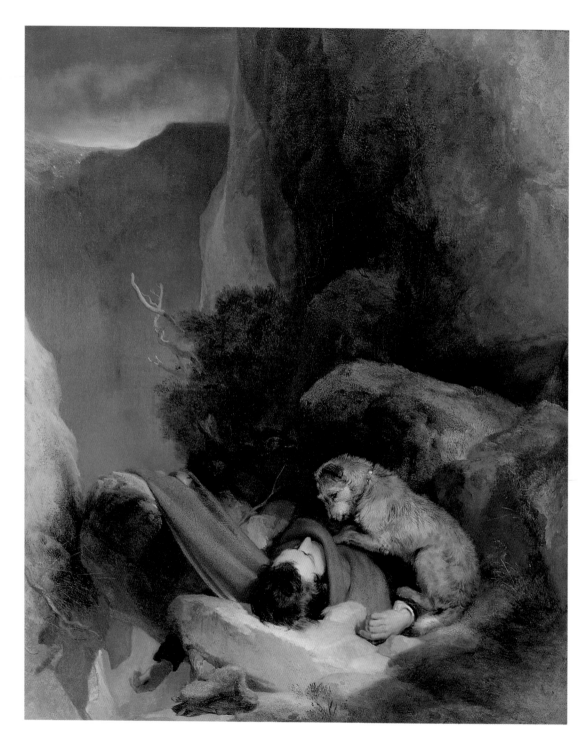

**Edwin Landseer
(1802–1873)**
Attachment
1829
Oil on canvas
99 x 79.5 cm (39 x 31¼ in.)
St Louis, St Louis Art Museum

This painting – both dramatic
and poignant – can hardly
fail to move even the most
dispassionate viewer.
Landseer has created a
scene of sweeping high
drama and heart-wrenching
emotion, at the centre of
which is the bond between a
man and his dog, the ultimate
faithful companion.

The scene was based on
a real event: the tragic death
in 1805 of a young artist,
Charles Gough, who,
accompanied only by his
dog, set out to climb Helvellyn
Mountain in England's Lake
District. Gough was never
seen alive again; some three
months later his body was
discovered by a shepherd,
alerted by the bark of Gough's
dog. Gough had fallen during
his ascent and died from head
injuries, and his dog had
stayed with him, watching
over his body. Adding to the
pathos of the incident, it was
discovered that the dog had
given birth to a puppy during
its vigil, and that the puppy
had also died. The event
was recorded by William
Wordsworth in his poem
'Fidelity', and by Sir Walter
Scott, also a great dog-lover,
in his poem 'Helvellyn'; it
became one of the great
Romantic tales of the time.

**Edwin Landseer
(1802–1873)**
*The Old Shepherd's
Chief Mourner*
c. 1837
Oil on panel
45.6 x 61 cm (18 x 24 in.)
London, Victoria and Albert Museum

The nineteenth-century art critic John Ruskin discussed this painting at length, calling it a work of 'high art' that 'stamps its author, not as the neat imitator of the texture of a skin, or the fold of a drapery, but as the Man of Mind'. While some might take issue with that, there is no denying the technical brilliance of the painting, nor its heavy emotional weight. Works on this theme – the enduring faithfulness of dogs – were extremely popular in Victorian Britain, where dogs were the pet of choice; and no one was better at the genre than Landseer.

Here the Border collie's heartfelt grief is tangible, as it rests its head against the coffin of the dead shepherd, its body pressed into the wood as though trying to reach its master. The room is sparsely furnished, but reveals something of the life of the highland shepherd in his discarded Bible and glasses, the simple rustic furniture, his walking stick and cap. The shepherd's life was a solitary and hard one, shared only by his dog, which now mourns utterly alone.

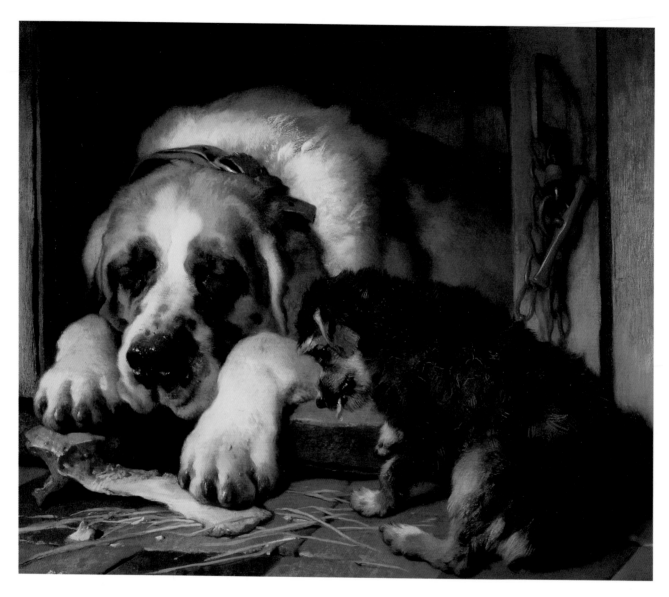

Edwin Landseer (1802–1873)
Doubtful Crumbs
1859
Oil on canvas
63.4 x 75.9 cm (25 x 29⅞ in.)
London, Wallace Collection

Landseer depicted dogs of all shapes and sizes in his paintings, from the royal dogs of Queen Victoria to ferocious fighting dogs and pampered family pets. Sentimentalized works of the type seen here were extremely popular during this period, and indeed their continued widespread reproduction to this day attests to their enduring appeal. Reinforcing Landseer's painterly abilities, which bring his dogs to life on the canvas, his anthropomorphic approach allows us to identify emotionally with the dogs he depicts. By investing his canine subjects with such feeling he places them on an equal footing with their human counterparts, and accords them character and individuality.

In this humorous painting an unspoken debate is in progress between the magnificent St Bernard type and the mischievous puppy, a comical predicament that makes the scene instantly enjoyable. Yet the quality and detail of the painting, from the glistening wet nose of the big dog to its pearly nails with the translucence of the real thing, outshine its subject.

**Arthur John Elsley
(1861–1952)**
Her First Love
1894
Oil on canvas
132 x 110 cm (52 x 43¼ in.)
UK, Cleveland, Hartlepool Museum

Such paintings as this, depicting children with dogs, became very popular among the affluent middle classes in mid-nineteenth-century Britain, where Arthur John Elsley was one of the leading painters of this domestic genre. The works functioned as straightforward portraits of the child, but also as depictions of the family pet. That in itself was pertinent because it was during this period that pure-bred dogs became very popular and highly valued, and paintings of this nature therefore implied the family's prestige in owning a dog of this kind. The period also saw the establishment of breed books, and there was a rapid increase in different dog breeds.

This scene, rather saccharine by today's standards, is nonetheless beautifully rendered. The enormous St Bernard is a fine example and would have been a highly prized family pet. The little girl, almost dwarfed by the dog's head alone, cradles it sweetly – an artistic device that faintly echoes works by Titian and Velázquez from hundreds of years earlier that similarly placed small children in the presence of very large dogs.

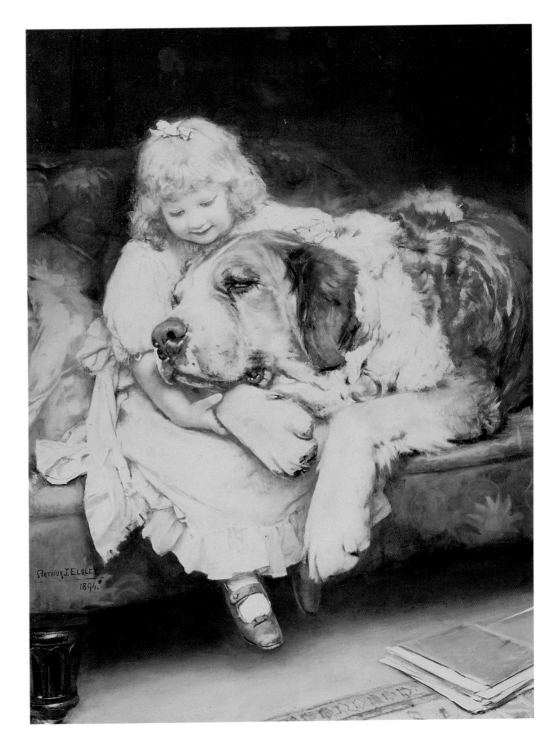

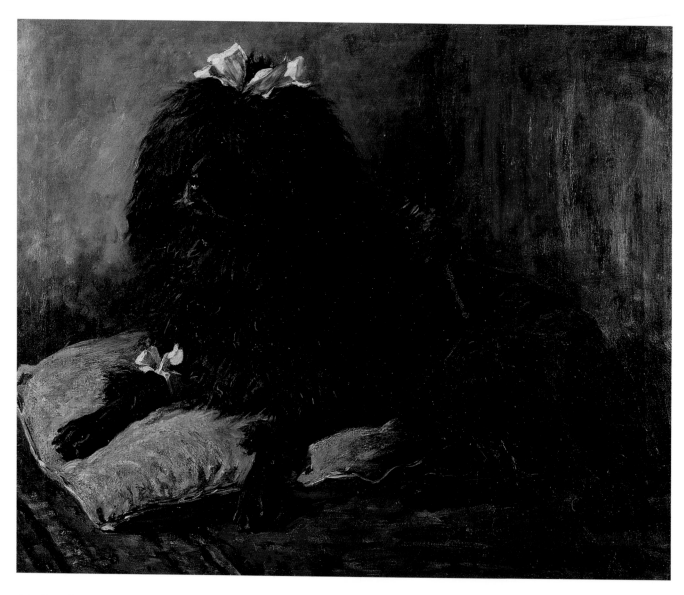

John Emms (1843–1912)
A Black Standard Poodle
on a Blue Cushion
1895
Oil on canvas
54.5 x 67.3 cm (21½ x 26½ in.)
Private collection

This romantic portrait shows a pet dog of some breeding, carefully groomed and turned out, down to its matching yellow ribbons. The poodle was first developed as a breed in Germany, although it later became popular in France, and was originally a working dog, used on bird shoots as a retriever. By the late nineteenth century, however, poodles had become favourite pampered pets, and were also frequently used in the circus, owing to their intelligence and willingness to be trained.

John Emms is most famous for his paintings of sporting dogs, terriers and hounds, and for hunting scenes, although he also painted portraits of horses and pet dogs. In this painting he has captured the slightly aloof character of this well-manicured dog, and lent it a romantic note as it reclines on the blue cushion, the yellow of its ribbons creating a striking note of pure colour.

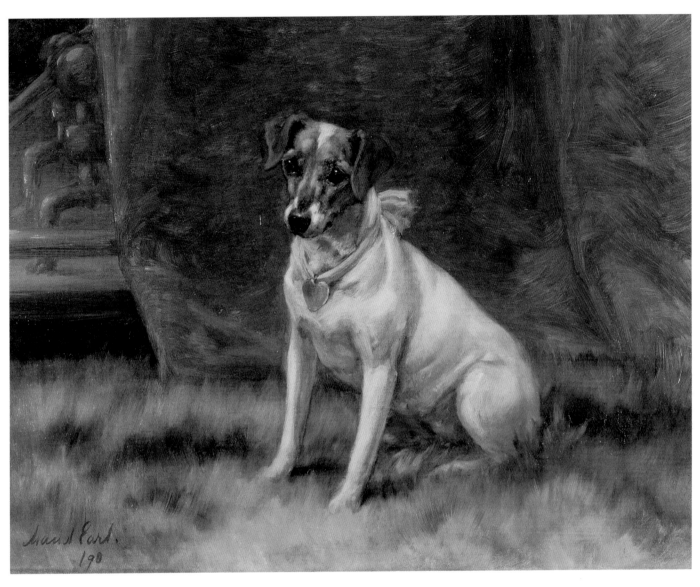

Maud Earl (1864–1943)
The Pink Bow
1898
Oil on canvas
45.5 x 61 cm (17⅞ x 24 in.)
Private collection

Maud Earl was the foremost painter of pure-bred dog paintings specifically designed to reflect the characteristics particular to different dog breeds. This type of painting developed from the growing interest in individual breeds, the formation of breed studbooks, the founding of kennel clubs and the start of dog shows. Earl was an authority on dogs, highly respected by both the British and the American kennel clubs. Her profound and sympathetic understanding of canine nature allowed her to bring tremendous realism to her work.

This painting is unusually romantic in character for Earl, and although the subject is obviously a fine Jack Russell, the nature of the work is more a pet painting than a pure-bred one. The artist has captured the most charming expression on the little dog, which sits perkily, complete with a golden heart hanging from a pink ribbon around its neck, on a luxurious fur rug.

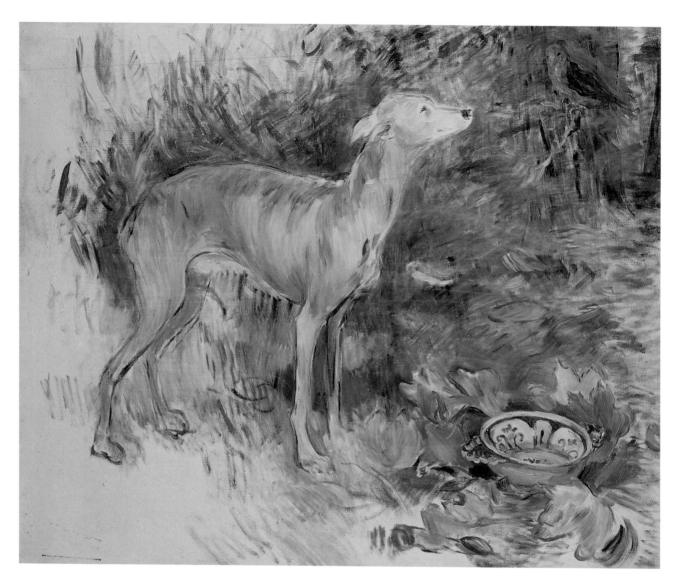

Berthe Morisot (1841–1895)
Laerte the Greyhound
1894
Oil on canvas
81 x 100 cm (31⅞ x 39⅜ in.)
Private collection

In this beautiful painting by the Impressionist Berthe Morisot, the artist's greyhound, Laerte, is set against a wonderfully light-strewn background of delicately coloured leaves and flowers. Hovering above the dog, and barely discernible, is a green parrot, which emerges from the dappled tapestry of pure, clear colour, while below is Laerte's crisply painted blue-and-white china bowl.

Laerte – the dearly loved pet of Morisot, her husband, Eugène Manet (who had died in 1892) and their daughter, Julie – was painted several times by the artist, perhaps most famously in *Julie Manet and her Greyhound, Laerte* (page 135). The Symbolist poet Stéphane Mallarmé had given the elegant little dog to the family as a gift. Mallarmé was a close family friend, and on Morisot's premature death in 1895, the year after this painting was made, he took over the care of Julie, who was just sixteen, and her two cousins.

Pierre Bonnard (1867–1947)
Two Poodles
1891
Oil on canvas
37 x 39.7 cm (14½ x 15⅝ in.)
UK, Hampshire, Southampton City
Art Gallery

This energetic painting of two boisterous poodles playing in the grass captures all their *joie de vivre*. Seen from above, the contours of the dogs create a strongly circular composition, which adds to the sense of centrifugal movement they create as they tumble across the canvas.

Pierre Bonnard, whose work is full of colour and light, painted this picture the year after visiting an exhibition of Japanese art at the Ecole des Beaux-Arts in Paris, and the Japanese influence here is quite apparent. He was drawn to the simplicity of line and structure, as well as the broad areas of pure colour, in Japanese works, and brings both these elements to this painting, from the stylized blades of grass to the two carefully placed flowers. Bonnard was one of the leading painters of the Nabis, a group of French artists whose works were defined by their use of symbolism, brilliant colour and a strongly decorative design approach, and who worked in a wide range of media. He often included dogs in his work, although generally in a more passive form than is seen here (see *Greyhound and Still Life*, page 157).

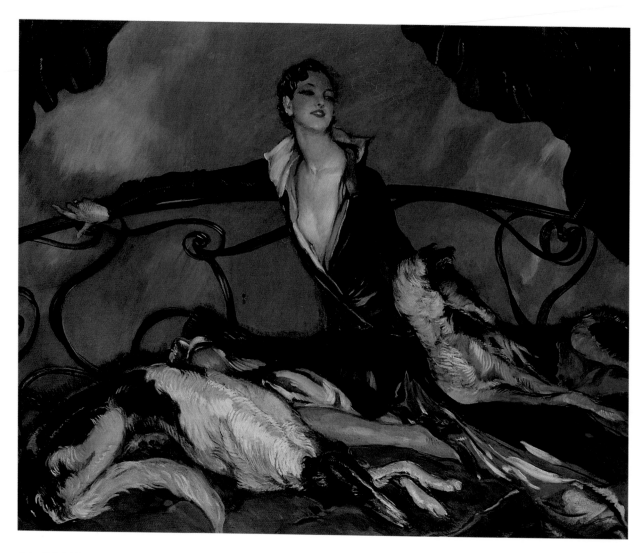

**Jean-Gabriel Domergue
(1889–1962)**
Woman with Greyhounds
1930
Oil on canvas
158 x 200 cm (62¼ x 78¾ in.)
Paris, Musée d'Art Moderne
de la Ville de Paris

These elegant and elongated greyhounds (as the title of the painting states, although they look much more like borzois) perfectly complement the equally sensuous female figure. With her dress slashed almost to the waist, and her brilliant red lips and cheeks, vibrant against the black-and-white pattern of the work, the woman reclines with the same easy grace as the dogs, although she is a provocative element. The dogs are viewed in the old tradition of the courtesan's pet (as the dog in, for example, Carpaccio's *Two Venetian Ladies*, page 144, may also be intended to be perceived), and symbolize human carnal desire, which is portrayed more explicitly in the figure of the woman.

Domergue was a popular painter who was immersed in the fashionable French society of the early twentieth century. He characteristically depicted beautiful, slender women at leisure, and often subtly crafted his paintings to fall just within the boundaries of acceptability, as here, where the figure's dress barely covers her breasts. His women flirt with virtuousness, tantalizingly gripping the edges of modesty.

Ditz (Date unknown)
The Royal Wedding
1986
Acrylic on board
25 x 35 cm (9⅞ x 13¾ in.)
Private collection

The contemporary artist known simply as Ditz works in a very individual and recognizable style, often bringing subtle humour to her work. This rather lighthearted and tongue-in-cheek painting marks the wedding of Prince Andrew and Sarah Ferguson in 1986, by portraying corgis,

the quintessential dog of Her Majesty Queen Elizabeth II, as the royal couple.

The British monarchy has a long tradition of being both dog- and horse-lovers, and often the general popularity of different breeds has been affected by which dogs the royal family owns at the time

– the King Charles spaniel being a good example. The Queen has had a long association with corgis, going back to her childhood, when she was given a Welsh corgi puppy. These powerful, short dogs do not appear very often in art, and this painting, although whimsical, is a rare

and delightful depiction of them. The fine jewels they wear are based on those in the Royal Collection.

The American Dog

THE HISTORY OF THE DOG IN THE AMERICAS, the way it evolved and its cultural importance, progressed along a path very different from that of the dog in Europe, and consequently the dog's depiction in art was also of a different nature. The earliest archaeological evidence placing humans on the American land mass dates to about 12,500 years ago, although it is believed that as many as 20,000–35,000 years ago ancestors of the native peoples migrated from Siberia over a land bridge; and it is conjectured that they took with them the earliest dogs. It is widely accepted that the dog is the descendant of *Canis lupus*, the grey wolf, and for a long period, even as the morphological diversity of *Canis familiaris* (dog) evolved, the two retained similar characteristics. Some of the earliest dog–wolf hybrid remains found in North America are those discovered at the Agate Basin site in Wyoming, dating to *c.* 8000 BC, while three complete dog skeletons were found in shallow graves dating to *c.* 6500 BC at Koster in the Illinois River Valley. These are of particular relevance not only because they are dog (not wolf) remains, but also because they were deliberately buried, which in itself has huge cultural implications.

There is little recorded evidence, artistic or otherwise, concerning the dog in pre-Columbian America, although it is known to have been the only domesticated animal within Native American cultures. The dog appears in many Native American myths, and across the huge geographic and cultural diversity of the peoples in question it remains fairly consistently a creature that traverses this world and the next, a guide to the spirit world and guardian of it – a belief seen in ancient cultures throughout the world. A modern view of this is realized in an untitled work by Keith Haring, who combines ancient symbolism with his twentieth-century spin to create a disturbing image of nightmarish spiritual resonance (page 249). On a practical level, the dog of ancient Native American cultures was used as guardian of the camp, hunting companion, worker, pack animal and commodity. Dogs were harnessed to travois (two poles linked together) or sledges, as seen in *Dog-Sledges of the Mandan Indians* (page 242), after Karl Bodmer. Dog hair was used for weaving blankets. In some cultures dogs were ritually sacrificed and/or eaten. They lived in and on the edge of the camps, and although prized hunting dogs may have been afforded special treatment, they were not elevated to the status of the pampered European dog.

The arrival of Christopher Columbus in 1492 heralded the opening of the floodgates to the Americas for the Europeans. Along with their own modes, manners and diseases, they also brought their animals. Early accounts indicate that Native American dogs were still wolf-, coyote- or spitz-like in appearance, or, in Central and South America,

It was not until later in the nineteenth century that the dog earned its position as a primary subject in American art. At the same time, it was welcomed into the domestic arena in a way that it had not been hitherto.

American School
Portrait of Pierre van Cortlandt
c. 1731
Oil on canvas
145 x 105 cm (57 x 41½ in.)
New York, Brooklyn Museum of Art

The charming and rather naïve style of this eighteenth-century work combines a Dutch manner with an evolving American tradition. The perspective evoked by the dramatic floor tiles and pedestal is not entirely worked through, and the background scenery is similar in feel to a theatre set, but the figure of the young Pierre van Cortlandt, his dog and the beautifully painted Oriental vase are exquisite. The boy, who was around ten years old at the time of the painting, steps forward and down, while his black greyhound- or whippet-like dog mirrors his movement in reverse. This device creates a balance in the centre of the work that pins down and grounds the uneasy perspective created through the patterned floor.

Van Cortlandt was an important historical figure and one of the founders of New York State. He became the first lieutenant governor of the state in 1777, sharing his leadership with George Clinton, who went on to become vice-president of the United States.

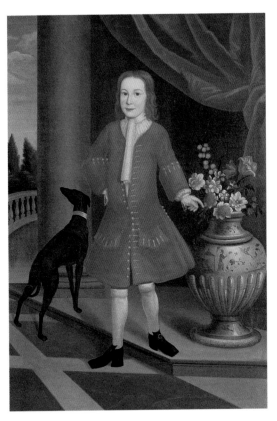

small and often hairless. Professor Glover Allen described just seventeen different types of dog living in Native American cultures in his monograph on dogs published in 1920, indicating that little breed diversification had occurred over a very long period. The influx of European breeds had a profound effect: these were dogs never before seen by the indigenous peoples, and very often they were to be feared. The Spanish conquistadors brought with them war dogs – mastiff types and greyhounds that were trained to hunt and kill men. In 1495 Columbus is said to have used his pack of dogs in the battle of Vega Real, on the island of Hispaniola, to devastating effect. Later, similarly trained dogs would be used to hunt down runaway slaves, as depicted in the nineteenth-century image *Hunting*

an Escaped Slave with Dogs (page 240). However, the European breeds were also beneficial to the Native Americans, who adopted them into their own lives and made use of the stronger, larger and more varied types, principally for working and hunting.

Dogs remained essential tools both to the Native Americans and to the European settlers as they spread gradually west. Despite the ubiquity of dogs, there are few painted images of them in American art until the nineteenth century, at which point a slow change began to occur in the dog's role in American life. Although they continued to be kept in a working capacity, they also started to be looked upon as pets, making the transition from the outdoor dog to the indoor one. In art the dog initially occupied only a subsidiary place: many images that document the American way of life, such as *Emigration to the Western Country* (page 238), after Felix Darley, include the dog as nothing more than a minor aspect of the narrative, and it was not until later in the nineteenth century that the dog earned its position as a primary subject. This shift occurred as more Europeans brought with them their prized dogs, such as the fine greyhound in James Beard's *A Greyhound in a Hilly Landscape* (page 237). At the same time, the dog was welcomed into the domestic arena as it had not been hitherto, and dog shows and field trials began to develop. That sparked an interest in sporting and pure-bred portraits in America, as had previously occurred in Britain (see page 185). Despite both this and the huge enthusiasm for fox-hunting, there did not at this time emerge a true school of animal painters in America, in contrast to what was happening in Europe.

After Samuel Howitt
(1756–1822)
North American Bear Hunt
Engraved by Matthew Dubourg
(active 1786–1838)
Published 1813 by Edward
Orme
Colour lithograph
21.9 x 33 cm (8⅝ x 13 in.)
Private collection

The characterization of the hound-dog types in this work is particularly effective. The black-and-white dog is caught mid-leap as it hurls itself towards the bear, and although facially it is aggressive, there is also a glimpse of something else, a recognition that it might not be so keen to encounter the bear after all. This is brilliantly and subtly done, just as the tan-and-white dog barks threateningly, yet cowers, tail tucked and hindquarters crouched. Both dogs put on a brave show, but neither truly wants to battle with the furious bear.

The scenery, although American, is stylized, as is the bear, and it is quite possible that the picture was based on written or oral accounts, and that the artist involved was not familiar with either the terrain or the animal. Matthew Dubourg was a British aquatint engraver who specialized in creating sporting, military and topographical scenes. Samuel Howitt was an artist and illustrator with an established reputation in London as a specialist in sporting scenes.

The lack of a monarchy was a decisive factor affecting the development of pure-bred dog breeds, the subsequent establishment of the American Kennel Club and even the dog's depiction in art. Over the centuries the royal families of Europe had owned, used, bred and played with all sorts of dogs, and royal preferences for certain types led national fashions. In America there was no royal fashion to follow. The other significant factor was the sheer size of the continent, making any official, country-wide regulatory association for dogs, at first, logistically difficult. In 1876 the National American Kennel Club was founded to oversee the registry of pure-bred dogs (becoming the American Kennel Club in 1884). Today the AKC recognizes more than 150 different breeds, and strives to maintain their continuity to the highest possible standard.

**James Henry Beard
(1811–1893)**
*A Greyhound in a
Hilly Landscape*
n.d.
Oil on canvas
55.9 x 76.2 cm (22 x 30 in.)
London, Victoria and Albert Museum

James Henry Beard was born in Buffalo, New York, and was largely self-taught as an artist. He spent much of his early career painting portraits, but later moved on to animal and dog painting, as well as portraits of children with their pets. Beard garnered quite a reputation for his dog painting, and in many instances imbued his dogs with anthropomorphic qualities. He also painted numerous pictures of children with their pet dogs, reflecting a fashion that was likewise much in evidence in England.

This painting of a magnificent and noble greyhound set against a sweeping landscape is among the best of Beard's œuvre, and reveals his skill in rendering realistic, rather poignant animals. The work has much in common with the pure-bred style of painting seen in Britain at the time: the dog is depicted in a pose characteristic of the genre, designed to accentuate the particular qualities of the breed. Pure-bred painting had become increasingly popular after the development of dog shows in America, the first of which is generally recognized to have been held by the Illinois State Sportsman's Association of Chicago on 2 June 1874. These early dog shows were devoted to sporting dogs, and it was not until January 1875 that the first show open to any breed was held.

After Felix Octavius Carr Darley (1822–1888)
Emigration to the Western Country
Engraved by Alfred Bobbett
(c. 1824–1888)
Engraving
Washington, D.C., Library
of Congress

Felix Darley is considered by many to be the 'father' of American illustrators, and created many similar scenes, including *Emigrants Crossing the Plains*, engraved by Henry Bryan Hall, which is very close in composition to this work. Both depict the emigration of families westward from the East coast, heading for the uncharted territories of the frontier land. The frontier was not described as closed until 1890, when the West was considered settled, although life remained hard and dangerous in those parts for many years.

Emigrants travelled by foot and on horseback with covered wagons, and accompanied by their dogs. These dogs, like the hound type in this illustration, were invaluable as both hunting companions and guardians of the road trains – the journey from East to West was precarious in the extreme, and many of those who set out for a better life in the new territories never made it.

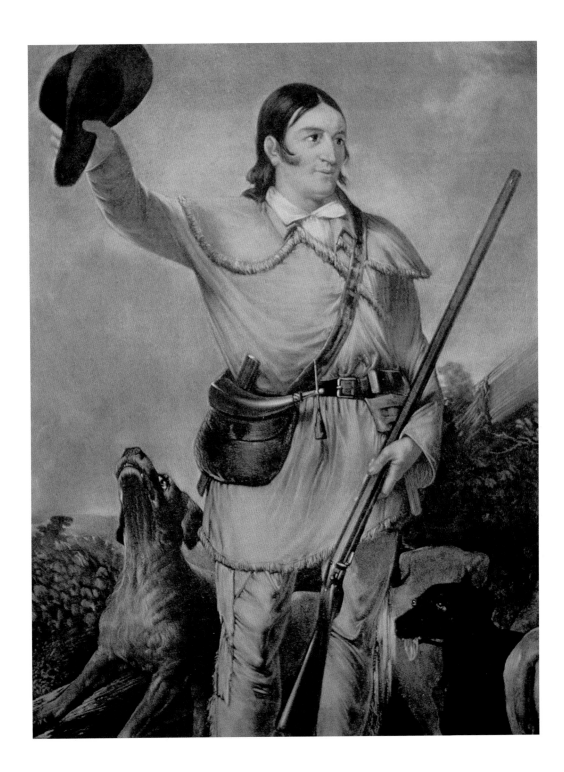

After John Gadsby Chapman (1808–1889)
David (Davy) Crockett with his Hunting Dogs in 1836
1836
Colour lithograph
49.5 x 34.3 cm (19½ x 13½ in.)
Private collection

Here the frontiersman who became an icon is pictured with hounds, ready to hunt. His pose is conceived heroically, hat raised in one hand as he greets an unknown party beyond the picture, or perhaps bids the East farewell as he heads West. By the time of this work Davy Crockett had established a reputation as a fearless bear-hunter, and had written of his hunting experiences in his autobiography of 1834. In it he talks of his dogs – eight great hunting dogs that would track and kill a bear in a heartbeat – and of his favourite gun, 'Old Betsy', with which he shot 125 bears. When Crockett was touring, promoting his book, he met the artist John Gadsby Chapman, who persuaded him to sit for his portrait. The two men had some difficulty in agreeing the pose and the nature of the picture. Crockett insisted on being portrayed as a hunter, so Chapman had to find some dogs to use, Crockett's own hounds having been left at home. Eventually he ended up using his own high-bred dog, but Crockett insisted that its wagging tail be concealed so that it had more the air of one of his fierce hounds. This lithograph is based on Chapman's painting, with just a few changes made to the composition. Crockett died the year it was made.

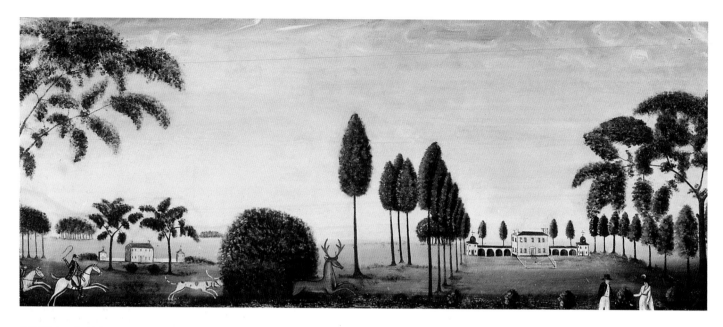

The powerful mastiff-type dog was used in ancient European civilizations for military purposes and was trained specifically to hunt down, attack and kill an enemy. When the Spanish conquistadors arrived in the Americas they brought with them the distant descendants of those ancient dogs, which would now play a part in the overpowering and destruction of the indigenous peoples. An account dating from 1542 by the missionary Bartolomé de las Casas recounts in horrifying detail how the dogs were used against men and fed the flesh of unfortunate captives to keep alive their taste for human beings.

More than 200 years later dogs were still being used in a similar capacity, this time to hunt down runaway slaves, as seen in this engraving. African slaves were brought to the Americas on a large scale in the sixteenth and seventeenth centuries, living in varying degrees of degradation until slavery was finally officially abolished in 1864. Slaves were considered the property of their masters, and attempts to escape, or other acts of insubordination, were punishable by death or maiming. Large dogs, such as the ferocious black animal seen here, were customarily used to hunt down and capture escapees.

Opposite, top
Rufus Porter (1792–1884)
(attrib.)
Hunting Scene
n.d.
Oil on canvas
68.6 x 170.4 cm (27 x 67⅛ in.)
Delaware, Henry Francis Dupont
Winterthur Museum

This striking primitive painting, thought to be by the charismatic self-taught artist Rufus Porter, depicts an elegant hunting scene set in a stately landscape. The huntsmen stream after the dogs, which in turn chase the stag, leading the viewer's eye into a separate scene at the right. In America deer were usually hunted using staghounds, which were also used for a number of other quarries, including men, bears and wolves, and were popular with hunters for their speed and tenacity. General George Custer was fond of the breed and kept several in his pack.

However, in this painting the dogs have the appearance of dalmatians rather than staghounds, and although most commonly associated with coaching, dalmatians are known to have been used for hunting stag and boar. The breed is believed to be an ancient one, and has appeared in the arts since the time of ancient Egypt.

Porter lived an itinerant lifestyle and earned a reputation as a leading mural painter, completing more than 150 decorative mural schemes in grand homes around the country. He also invented a method of painting a portrait in less than fifteen minutes; he would then sell it very cheaply, so bringing art within reach of the poor.

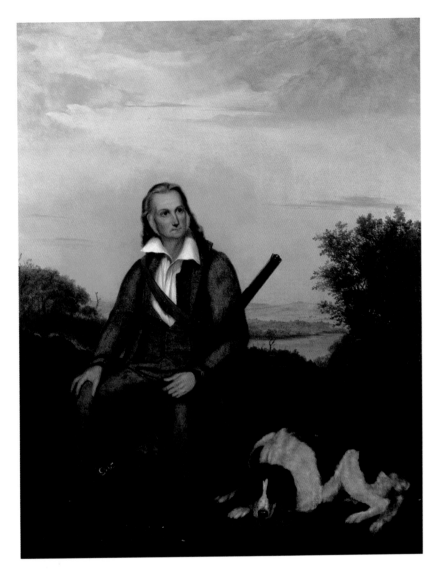

John Woodhouse Audubon
(1812–1862)
Portrait of John James
Audubon
c. 1840–41
Oil on linen
111.7 x 88.9 cm (44 x 35 in.)
New York, Collection of the New-York
Historical Society

This portrait of a serious John James Audubon accompanied by his handsome hunting dog was painted by the distinguished artist's son. John Woodhouse Audubon began his own artistic career concentrating on portraits, before turning towards the natural world and helping his father with his epic *Birds of America* (1827–38) and *Quadrupeds of North America* (1845–48). These two collections were an enormous undertaking and the result of Audubon senior's interest in natural history and his desire to depict all the birds and quadrupeds of the vast North American continent.

In 1837 father and son set off together on a painting trip along the Texas coast to find more birds, and this portrait may have been based on their expedition. Rather ironically, in order for the Audubons to paint their birds and animals, they first had to kill them, which they did using a fine shot to minimize cosmetic damage. Here Audubon senior sits, gun in hand, with an air of wistful contemplation, accompanied by his patient dog, no doubt a creature trained to retrieve skilfully.

Top
**After Karl Bodmer
(1809–1893)**
*Dog-Sledges of the
Mandan Indians*, plate 29
from volume I of *Travels
in the Interior of North
America*
Engraved by Laderer
and J. Hurlimann
1843
Aquatint
25.9 x 35.1 cm (10¼ x 13¾ in.)
Omaha, Joslyn Museum

Prince Alexander Philipp
Maximilian zu Wied-Neuwied
chose the young Swiss artist
Karl Bodmer to accompany
him on a trip to explore and
document the New World,
and it was during this time
(1833–34) that Bodmer made
his series of drawings and
paintings of the wild frontier
lands. The two men spent
the winter of 1833 living in the
Mandan and Hidatsa native
territories along the Missouri
River basin in the Dakotas,
and it was there that Bodmer
painted the scene from which
this aquatint was made.

The two dogs have been
harnessed to a heavy-looking
sledge, on which a huddled
figure rests with a pile of
family belongings. The lead
dog pulls earnestly, while the
dog behind appears fatigued
and miserable, creeping
along the frozen ground, its
body language echoing that
of the human behind it. Many
of the Native American tribes
used dogs for pulling sledges
and travois, particularly
before the introduction of
horses by the conquistadors.
The use of dogs in this
capacity is still widespread,
especially in Alaska, and
competitive dog-sledding
has become an extremely
popular sport.

Bottom
**Henry Rankin Poore
(1859–1940)**
*Vrelay–Old English
Stag Hounds*
n.d.
Oil on canvas
Dimensions unknown
London, Burlington Paintings

Henry Rankin Poore studied
with Peter Moran (1841–1914)
at the Pennsylvania School of
Fine Arts before graduating
from Pennsylvania University.
Between 1883 and 1885 he
lived in Paris, spending some
time at the Académie Julian,
and also travelled to England,
where he made extensive
studies of fox-hunting. He
later established himself
back in the United States
in Philadelphia, earning
a reputation as a leading
painter of dogs, hunting
scenes and rural landscapes.

This painting is particularly
evocative and delicately
executed, with the hounds
set against a chilly white
winter landscape. Poore's
use of a restricted palette
is very effective – the whole
scene is bathed in a rose-
tinged glacial white, as if
reflecting the fiery rays of
the sun dropping below the
horizon at the end of the day.

Owing to their speed and
tenacity, staghounds were
popular hunting dogs in
America, and were originally
bred there to hunt such
predators as wolves and
coyotes. General George
Custer kept staghounds as
part of his pack, two of which
are listed as being shown at
the inaugural Westminster
Kennel Club Show in 1877,
the year after Custer's death.

**Frederic Remington
(1861–1909)**
*Pueblo Indian Village
(Distribution of Beef at
San Carlos Agency)*
c. 1889
Oil on canvas
43.2 x 68.6 cm (17 x 27 in.)
Houston, Museum of Fine Arts

Frederic Remington is one
of the most famous artistic
documenters of the 'Wild
West', the frontier lands of
the Western states. After a
brief stint in military academy,
Remington moved west from
his home town of Canton,
New York, eventually buying
a ranch in Kansas. He began
painting the scenes around
him, extensively documenting
the Native Americans and the

cowboys of the late
nineteenth century. He then
moved back to New York
and worked for the famous
Harper's Weekly magazine,
which published his
illustrations of frontier life. He
continued to travel in the West
sporadically throughout his
life, encountering such scenes
as the one pictured here.
 A group of Native
Americans gathers around

the San Carlos Agency
building, where government
rations of beef are being
handed out. The dog that is
prominent in the foreground
is part of the scene and at the
same time remote – it belongs
with the Native American
group, but there is also a
sense of its heritage, its not-
so-distant wild cousins. It
appears to be here because
it has chosen to be and not

because it is a fettered
animal. In complete contrast
to another work painted about
the same time, *Her First Love*
by Arthur John Elsley (see
page 225), in which the dog
is portrayed as a beloved pet,
Remington's dog scavenges
around the group with an air
of self-sufficiency.

Harrison Fisher (1875–1934)
Final Instructions
1902
Watercolour, gouache and
pencil on paper
78.7 x 57.8 cm (31 x 22¾ in.)
New York, American Illustrators Gallery

The founding of the American
Kennel Club added
considerable impetus to
the growth in popularity of
pure-bred dogs, and the
mid-1880s saw a frenzied
scramble among the wealthy
to procure pure-bred dogs
of every kind, especially
European or Eastern breeds.
The collie was highly
admired. After being
presented with one, Queen
Victoria had taken a liking to
collies and started to breed
them. She subsequently
owned several. The royal
favour immediately raised
the breed's status among the
British public (previously
collies were regarded as the
working dog of the humble
shepherd), and then in the
United States. Collies were
imported to America in large
numbers and sold for vast
sums of money.

Harrison Fisher was a
famous illustrator whose
numerous and distinctive
paintings of elegant and
beautiful society women
were dubbed 'Fisher girls'.
His images appeared in
magazines, books and
newspapers, and in
June 1910 he was described
as 'the Father of a Thousand
Girls' in an article in
Cosmopolitan, for which
magazine he produced many
front-cover illustrations. He
often depicted his women
accompanied by beautiful
dogs, such as this collie,
which is every bit as elegant
as its mistress.

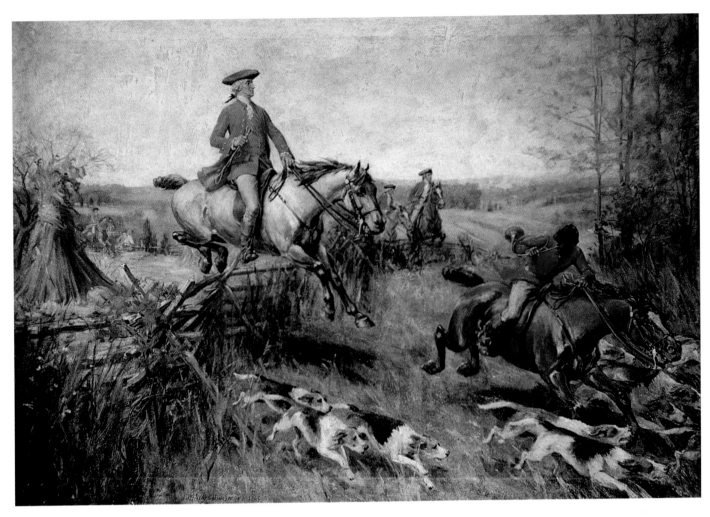

**After John Ward Dunsmore
(1856–1945)**
*The First Gentlemen
of Virginia*
1909
Colour lithograph
Dimensions unknown
Private collection

George Washington, who is depicted here, was the first president of the United States and an ardent horseman and great advocate of fox-hunting. He was born and brought up in Virginia, a state that today remains home to one of the oldest-established American hunt clubs, the Piedmont Foxhounds, founded in 1840.

In America, the practice of fox-hunting with a pack of hounds dates back to the 1650s, when the Reverend Robert Brooke emigrated with his English hounds to the area that is now Maryland. It seems likely that initially, he hunted the foxes as a way of controlling vermin. However, the sport quickly grew in popularity, and in 1747 the

first organized hunt and pack were founded. This led to hunting becoming a more public activity, enabling it to develop into an important social event and forum for networking. At first the packs of 'hounds' would have been ramshackle, incorporating not only true hounds, as Brooke's were, but also all sorts of other dogs. Soon,

however, a greater effort was made to keep the packs more specialized. Even so, John Ward Dunsmore has probably exercised more than a little artistic licence in this charming scene of Washington with his hounds, which are uniformly matched and models of athleticism as they stream after their quarry.

**Frank Tenney Johnson
(1874–1939)**
The Mountain Hunt
1917
Oil on canvas
91.4 x 61 cm (36 x 24 in.)
Private collection

Frank Tenney Johnson is regarded by many as one of the leading painters of the West, his works being conceived in an entirely different vein from the action scenes of his two famous contemporaries Frederic Remington and Charles Marion Russell (1864–1926). Johnson instead captured the cowboy at rest, the Native American with his horse, and the mountain man contemplating the natural world around him. Characteristically his works are bathed in translucent light, as seen here – the soft haze of dawn or dusk, or the sharp, blond moonlight of night.

Here the mountain man indicates to the hunter with his two powerful hounds the direction perhaps of his quarry, which might have been bear or mountain lion. Such dogs as these were (and still are in some areas) used to track and hunt this type of wild game. Although there is generally no sense of danger in Johnson's work, this sort of hunting can be highly perilous, and requires hounds with great stamina, speed and bravery.

Johnson's work was extremely popular during his lifetime, and has indeed remained so, now selling for substantial sums.

Joseph Christian Leyendecker (1874–1951)
Kuppenheimer: Wolfhound
c. 1925
Oil on board
67.9 x 52.7 cm (26¾ x 20¾ in.)
New York, American Illustrators Gallery

The Russian wolfhound is one of the most elegant dogs, and its use by Joseph Christian Leyendecker in this advertisement for the men's clothing store Kuppenheimer could not have been more appropriate. These dogs had enjoyed a tremendous surge in popularity in Britain towards the end of the nineteenth century, owing to the favour in which they were held by Queen Alexandra, wife of Edward VII; and they subsequently also became extremely fashionable in the United States. They were perceived as the epitome of exotic sophistication and class, with their sleek lines and sylphlike silhouettes matching those of the clothing fashions of the 1920s.

Leyendecker was the leading American illustrator of his day and had an instantly recognizable style, which functioned almost as a brand. During his career he painted 322 cover images for the *Saturday Evening Post* alone, as well as producing countless advertising images similar to this one, and working for numerous magazines and publications. He was a great influence on the young artist Norman Rockwell (see overleaf), who would go on to become America's most popular and prolific illustrator.

Norman Rockwell

**Norman Rockwell
(1894–1978)**
*Common Problems,
or Waiting for the Vet*
1952
Oil on masonite
43.2 x 39.4 cm (17 x 15 ½ in.)
Private collection

The popular artist and illustrator Norman Rockwell chose to paint ordinary scenes of everyday American life. Yet he brought to these apparently superficial images a sense of something else, a subtext. This is a charming depiction of a familiar scene – waiting to be summoned by the vet – but also conveys social isolation.

The little boy with his bandaged puppy is the focus of the canvas, at least for the viewer, while the expectant dogs have their eyes trained on the opening door: who will be next? They and their owners, grouped around the perimeter of the waiting-room, are well matched to each other and share a physical likeness, the bold Great Dane with his imposing master, the elegant borzoi with her white-coated mistress. The little boy is the misfit: he is alone, uncomfortable and sad, the bandaged puppy on his lap reinforcing the sense that the child is feeling dejected and isolated.

Rockwell's early illustrations captured the essence of small-town rural America, often with a nostalgic air, and were extremely popular; later in his career he addressed heavier subjects, such as racism and politics. He worked for many magazines and newspapers, including *Look* magazine and the *Saturday Evening Post*.

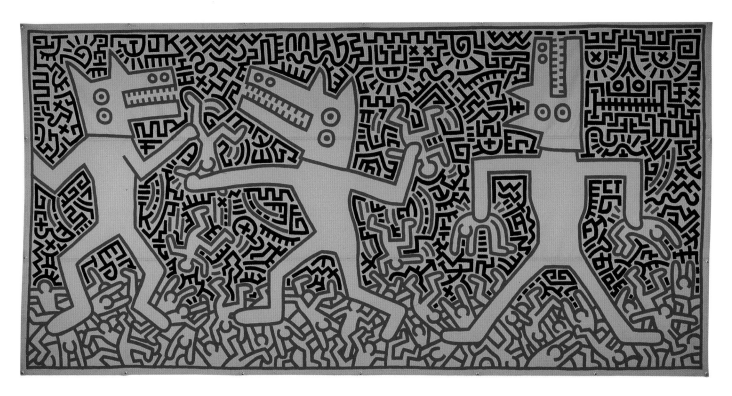

Keith Haring (1958–1990)
Untitled
1983
Silkscreen
Dimensions unknown
Hamburg, Deichtorhallen

This disturbing image resonates with ancient beliefs and symbolic associations. The doglike figures bring to mind Aztec and Mayan iconography, reconceived in Keith Haring's superbly original interpretation. They are also reminiscent of the various dog-headed figures of ancient myth and folklore, which were often feared and reviled, although conversely the Egyptian dog-headed god Anubis was worshipped and revered. Haring presents us with dog-god images drawn from the past and darkly construed: the guardians of the spirit world or perhaps the messengers of death, who trample underfoot and casually toss away thousands of tiny human figures.

Haring was a leading figure in New York's contemporary art scene in the 1980s, having first experimented with graffiti on subway walls. His work never lost its basic style, with simple, bold and solid outlined forms, such as the human figures seen here, that create pattern. Instantly recognizable, although not always palatable, Haring's art is consistently challenging and thought-provoking.

David Bates (born 1952)
Feeding the Dogs
1986
Oil on canvas
228.6 x 170 cm (90 x 67 in.)
Arizona, Phoenix Art Museum

This is a delightful painting from the contemporary artist David Bates, whose work generally combines photorealism with a naïve style. Typically his works are brightly coloured and full of boldly drawn detail that creates a patterned effect across the canvas. Added to this is the thick texture of his paint application, which gives the works a three-dimensional quality that contrasts with the two-dimensionality of his picture structure. He bases his paintings on simple tableaux from everyday life, making many preliminary sketches of the scene, and then working from imagination.

This picture, which is particularly naïve in style, celebrates the simple pleasure of a man feeding his dogs, and is as charming in concept as it is visually satisfying. The man is central to the work, as he is to the dogs' lives – together their tails form a circle around him, lending the composition balance. This equilibrium and harmony are further emphasized through the use of strongly repeated black and white, seen in the dog-food box and the dogs positioned in the foreground and background, in a way that reinforces the man's central placement and role.

Ben Schonzeit (born 1942)
Yellow Lab.
1998
Acrylic on canvas
76.2 x 81.3 cm (30 x 32 in.)
Private collection

The labrador is one of the best-loved and most popular dog breeds in the United States, and this painting by Ben Schonzeit is a fitting tribute to a dog that combines enormous athleticism and adaptability with brains and beauty. Little is known about the early history of the breed, but it is believed to have evolved on the island of Newfoundland, off the coast of Labrador, from stock similar to that of the long-haired Newfoundland dog, and was used by the fishermen of the region to retrieve fish that escaped the hook and to pull in the fishing nets.

Schonzeit is one of the most respected American photorealist artists. His work is defined by its strong, vibrant and inspiring colour, and can become at times almost surreal, or hyper-real. This painting, with the lovely dog set against a brilliant sea, is uplifting and energetic, and is one of several works, made in the 1990s, of almost iconic dogs seen against a background of vast sea and beach.

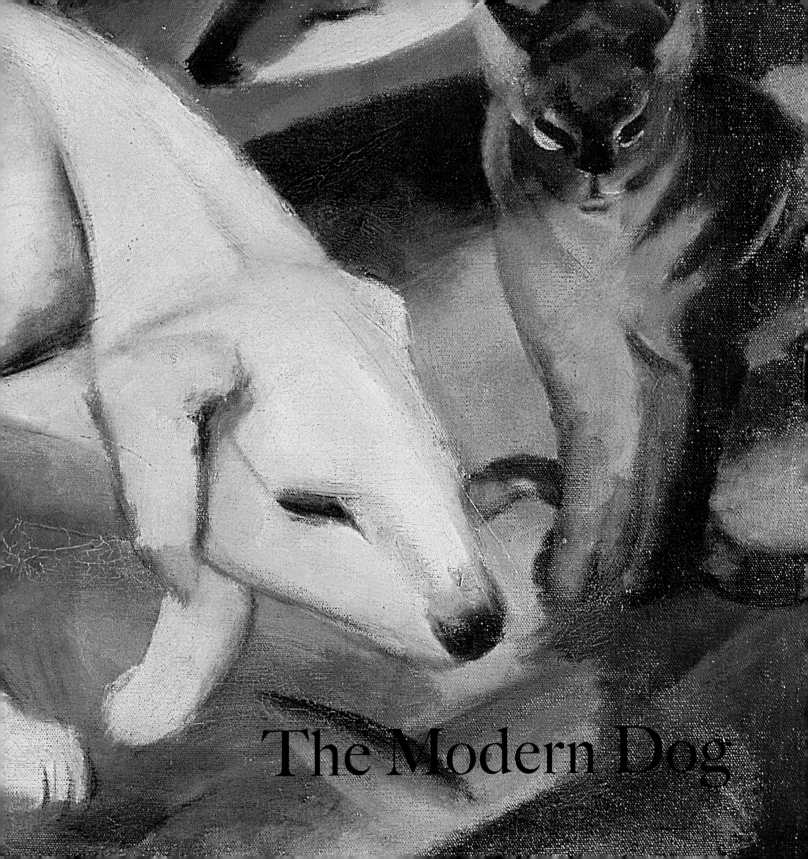

The Modern Dog

AT THE START OF THE TWENTIETH CENTURY there was a perceptible change in the depiction of the dog in art. While a body of artists continued in the nineteenth-century tradition of the straightforward pet portrait and sporting painting, elsewhere the arts were being stirred by the winds of Modernism, and in consequence some depictions of the dog came to be more heavily invested with a sense of metaphysical significance: they embodied greater depths of meaning than simple allusions to the dog as faithful or lustful. In this context, such artists as Franz Marc used animals, including dogs, to express a range of ideas; in Marc's case, a sense of organic harmony, of creature and landscape being at one, and to reflect his own concept of spirituality through his bold compositions.

The twentieth century brought enormous industrial, economic, political and social changes, and these were reflected in new attitudes in the arts, resulting in the Modernist movement. This developed from a deliberate rejection of historicism as artists sought to find new methods of expression, both technically through the actual physical rendering of artistic pieces, and also cerebrally, as they looked beyond the real to depict the surreal and the abstract, giving visual form to new interpretations of philosophies and concepts. Modernism altered the depiction of the dog, which hitherto had been fairly traditional, as evinced most clearly in the nineteenth century, when there was an upsurge in dog painting, including both pure-bred paintings and pet portraits. Particularly illustrative of the suddenness with which the traditional jumped into the new is the painting *Optician's Sign* (opposite).

This work was created by the fiercely conservative academician Jean-Léon Gérôme, whose artistic roots were so deeply grounded in the traditional that he had vehemently criticized the works of avant-garde artists displayed at the Paris World's Fair in 1900. Yet just two years later he painted this extraordinary advertising sign, with its appealing terrier dog, upright on its haunches and sporting a monocle in the manner of a French gentleman, taking the anthropomorphism of nineteenth-century works a step further, and investing the dog with a perceptibly human countenance. The work, made for an exhibition of advertising signs in Paris in 1902, marked a dramatic departure in Gérôme's approach, which, quite apart from the delightfully eccentric picture, also took the artist from the forum of academic art into the world of commercial work. The painting even leans towards the surreal in its use of optical illusion and the disturbing human eyes that peer through a pair of spectacles at the viewer.

A dog in a similar pose can be found in the drawing *The Circus* (page 257) by Marcel Vertes. Although this work is conceived along different lines from Gérôme's advertising sign, again the dog is upright and human-like, this time dressed in a coat

The dog is so firmly ingrained in human society that it will never fade, and as dog and human continue to walk the same path together, so the artist will continue to immortalize them in painting or sculpture, for centuries to come.

**Jean-Léon Gérôme
(1824–1904)**
Optician's Sign
1902
Oil on canvas
87 x 66 cm (34¼ x 26 in.)
Private collection

This whimsical and original
work was painted by Jean-
Léon Gérôme for an exhibition
of advertising signs in Paris in
1902. It was a bold step for the
artist, who had until then been
an academy traditionalist;
quite why he chose at this late
point in his life to effect such
a change is intriguing. For its
time, this piece was at the
cutting edge of the avant
garde, almost surrealist in
its effect, and it later came
to be particularly admired
by Salvador Dalí.

The wit of the pun on the
sign (*opticien* being rendered
typographically to be read
as '*oh, petit chien*', meaning
'little dog') would not have
been lost on its audience,
and the dog itself is rather
endearing, evocative of
a bewhiskered French
gentleman complete with
monocle. The dog has
been painted with extreme,
believable realism, which
amplifies the surreal nature
of the rest of the work. The
single line on which the
dog sits creates tension
and distorts the sense of
perspective. The viewer's eye
moves to interpret the spatial
aspect of the picture, but
is denied by the lack of any
detail. Other disturbing
elements are the spectacles
that hover above the dog
and the eyes that peer out,
inverting the sense of who is
the viewer and who the viewed.

and hat. Dogs had been popular circus acts for many
years, and are still sometimes used as such, but
Vertes has made this little dog, despite its diminu-
tive size, equal in importance to the female performer.

The year 1912 also saw Giacomo Balla paint
the fantastically modern *Dynamism of a Dog on a
Leash* (overleaf). On one hand the frenetically
painted movement of the dog, the silver-strand
lead reverberating over and over, and the woman's
swishing skirt hem reflect the advent of the
emerging machine age and the technical advances
of cinematography, while on the other they simply
evoke pure delight.

Working at the same time was the German artist
Franz Marc, who devoted his tragically short
career almost entirely to the depiction of animals,
especially horses and dogs. These were the years

leading up to the First World War, a time of
enormous innovation, technical advancement and
artistic change, coupled with political disaster. Marc's
paintings withdrew from the man-made world; such
images as *A Dog, a Fox and a Cat* (page 258) instead
depict the harmony of natural forces. His creatures
reflect his spirituality – dipping into the unconscious
stream of thought – as well as being manifestations
of their own real physical forms.

In 1916 – the year of Marc's death at the Battle of
Verdun – the British established their first military
dog-training school. Drafting the dog into battle was
an ancient tradition, but now the animals' training
was more specialized. They became messengers,
laid cables, carried ammunition, sought out mines
and guarded supplies. Dogs were used widely
by European countries and the Soviet Union
throughout the Second World War. Today these
brave animals are still being deployed, by the
United States as well.

The exceptional closeness of the relationship
between humans and dogs is in itself a straight-
forward topic for artists, as seen, for example, in
Lucian Freud's *Triple Portrait* (page 267), but it is
the nature of this closeness that invites a deeper
interpretation, built as it is on a shared base of
emotion. Dogs and humans seem to experience
similar states of feeling, and it is the empathy
between them that the artist recalls when invest-
ing the dog, as symbol, with identifiable human
emotions. So Elisabeth Frink's *Dog* (page 266), for
example, combines human and animal emotion,
uniting the primitive and the sophisticated: her
dog is the dog of the beginning and the dog of

Giacomo Balla (1871–1958)
Dynamism of a Dog on a Leash
1912
Oil on canvas
89.8 x 110.5 cm (35⅓ x 43⅓ in.)
New York, Buffalo, Albright Knox Art Gallery

The vibrant energy in this work is quite extraordinary; indeed, the image does actually appear to move, and it almost comes as a surprise that there is no rush of displaced air. The dachshund's short legs and tail reverberate with speed as they move in rapid succession to keep pace with its longer-legged mistress, whose own feet pound up and down. The swinging movement of the delicately painted silver chain is accurately rendered in a remarkable feat of artistic accomplishment.

Giacomo Balla was one of the leading painters of the Italian Futurist movement, and taught Umberto Boccioni (1882–1916) and Gino Severini (1883–1966), two other leading Futurists. This group aimed to break with the past, and celebrated the machine age and technical advances as the way forward. Balla was concerned with the depiction of light, speed and movement, thrusting forces that for him were as symbolic of the new age as they were integral to the new art style that was breaking away from traditionalism. He created these effects by superimposing sequential images, as seen here.

the end: godlike and demonic, revered and reprehensible. Similarly, George Underwood's magnificent *Leon* (page 273) is far more than a mere depiction of a dog. Here the dog has become an icon of wisdom, of infinite understanding and reason, rendered in a traditional portrait pose and faintly echoing such Old Masters as Giovanni Bellini (*c.* 1430–1516) in his *Portrait of a Young Man* (page 273).

Looking further into the past but conceived in firmly modern terms is *Dulcina* (page 268) by Frances Broomfield. The white bull terrier stands resolutely in the stone gateway, guardian of the

threshold between this world and the next. Such a stance recalls the role of the dog in the mythology of many ancient cultures as guardian of the entrance to the underworld or guide to the afterlife.

The dog's place in society and its visual representation continue to change, and every year opens a new chapter for this most popular of domestic animals. It is a book without an ending: the dog is so firmly ingrained in human society that it will never fade, and as dog and human continue to walk the same path together, so the artist will continue to immortalize them in painting or sculpture, for centuries to come.

Marcel Vertes (1895–1961)
The Circus
c. 1912
Engraved drawing
Dimensions unknown
Private collection

Dogs were a popular attraction at the circus and were trained to perform complicated tricks: poodles in particular and terrier types like the one seen here were valued for their intelligence. This work by the Hungarian-born illustrator Marcel Vertes is full of dogs: the little dressed-up dog in the foreground is a commanding figure despite its diminutive frame, while others go chasing across the background in a steady stream, and the seated dog appears ready to clamber on to the bowing horse.

Vertes moved from Hungary to Paris during the First World War, and immersed himself in a decadent, bohemian lifestyle. He documented scenes of highly popular circus acts and nightclubs, capturing the very spirit of Paris at the time. His work followed in the tradition of Henri Toulouse-Lautrec, and there is much of the older artist's influence in Vertes's work. In fact, Vertes had a profitable sideline in creating forgeries of Lautrec's paintings, and he later acted as consultant to the producers and set designers of the original version of the film *Moulin Rouge*, made in 1952, which documented Lautrec's life.

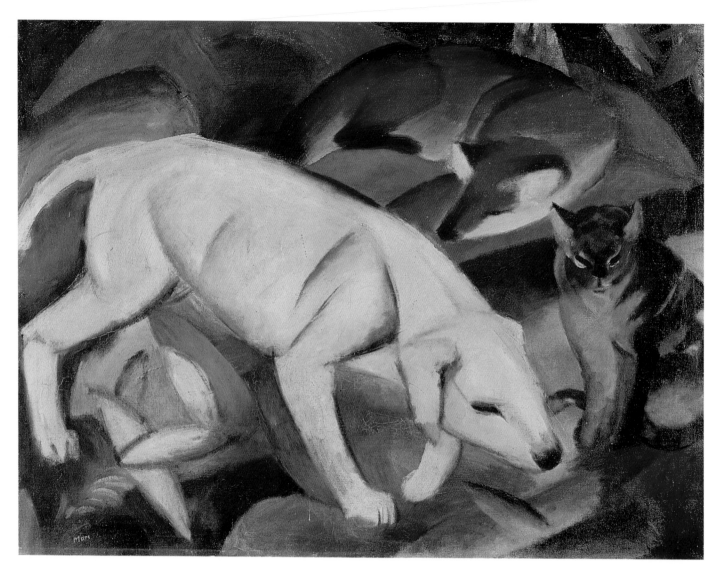

Franz Marc (1880–1916)
A Dog, a Fox and a Cat
1912
Oil on canvas
80 x 105 cm (31½ x 41⅛ in.)
Germany, Mannheim, Kunsthalle

Franz Marc was a founding member of the German artistic group *Der Blaue Reiter* (The Blue Rider), and author, along with Wassily Kandinsky (1866–1944), of the famous *Blaue Reiter* 'Almanac' (published in 1912, the year after the group was founded). Rather than sharing a cohesive artistic style, what they held in common was a feeling of inner spirituality and the need to express it through art. Marc concentrated on animal subjects, especially dogs and horses, and in his work tried to evoke what he saw as their innate spirituality, and the sense of harmony between living things and the landscape.

This is particularly evident in this painting, where three natural enemies – the dog, the fox and the cat – are shown in a harmonious situation. The fox sleeps, while the cat quietly watches the dog: the sense of tranquillity and ease is apparent. The dog is probably Marc's own, a white Siberian wolfhound called Russi. Marc focused on animal subjects during his short career, and – unlike many of his contemporaries – turned his back on painting the heavy industrialization and technological advances of the age.

**Henri Gaudier-Brzeska
(1891–1915)**
Dog
n.d.
Pastel on paper
25 x 20 cm (9⅞ x 7⅞ in.)
Private collection

This forceful pastel drawing
of a fiery little French bulldog
is one of many small sketches
made by the French sculptor
Henri Gaudier-Brzeska, and
is strongly sculptural in its
form. Every bold line counts:
it is a piece of minimalist
precision defined by the
deliberateness of colour and
stroke, and at the same time
it speaks of tremendous
character. This is a dog that
is alert, fierce and ready to
take on the world.

Gaudier-Brzeska was
another artist whose career
was cut tragically short by
the First World War. He was
extraordinarily eclectic in his
working methods and his
style is characterized by
its great diversity. He
concentrated on sculpture,
and moved to London in
1911 from his native Paris. In
England he became friendly
with the American poet Ezra
Pound and the artist and
author Wyndham Lewis
(1882–1957), through whom
he became involved in the
British avant-garde art
movement Vorticism.

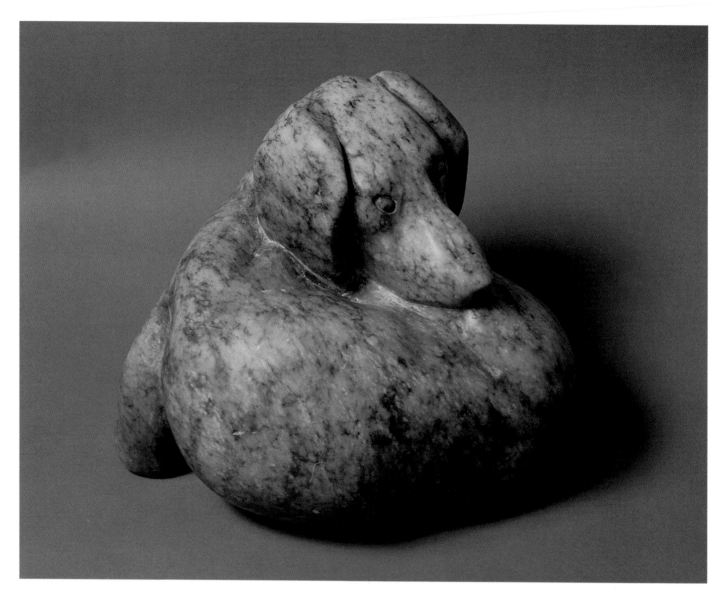

**John Rattenbury Skeaping
(1901–1980)**
Dachshund
1933
Granite
Height 24.1 cm (9½ in.)
Private collection

John Skeaping specialized in animal subjects throughout his career, working in two and three dimensions, and became one of the foremost animal sculptors of the twentieth century. In 1924 he won the Prix de Rome and travelled to Italy, where he furthered his sculptural training and met the British sculptor Barbara Hepworth (1903–1975), whom he married in 1925.

This resting dachshund, wrapped round on itself in a posture that is almost feline, was one of several sculptures Skeaping made of the little German dogs. The smooth, spare contours give it great tactile quality, while it is also strikingly realistic. Skeaping was a master of animal anatomy, and brought tremendous naturalism and life to his sculptural and painted works. Here the dog appears to have been just disturbed by something, and has stirred to look over its shoulder towards the interruption. The image combines stillness with energy, the dog being poised in the midst of a decision, whether to move or to go back to sleep.

**Nikos Hadjikyriakos-Ghikas
(1906–1994)**
Pekingese I
1939
Oil on canvas
48 x 32 cm (18⅞ x 12⅝ in.)
Athens, Benaki Museum

This is surely one of the most evocative paintings of a Pekingese, conveying the dog's playful nature and a sense of its noble past. The breed traces its ancestry back to ancient China; its image first started to appear in Chinese art in the eighth century. This was the dog of royalty that lived in the imperial palaces, and owing to its leonine facial features was later referred to as the 'lion dog', becoming conflated with the sacred guardian lion of the Buddhist faith. The Pekingese remained relatively unknown outside Eastern countries until 1860, when in the course of invading China the British discovered several of the little dogs, which they took back to Britain. The breed quickly became very fashionable in Victorian Britain, and remains popular to this day.

The Pekingese is renowned for having the personality of a much larger dog than its diminutive frame would seem to allow, and it is this that Nikos Hadjikyriakos-Ghikas has captured here. One of the foremost Greek modern artists, he combined an avant-garde, Cubist approach with influences from his Greek heritage and the Mediterranean countryside.

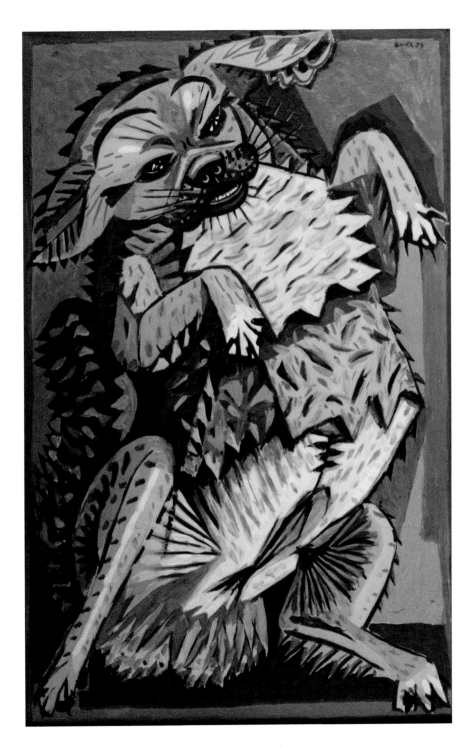

Henry Moore (1898–1986)
Dog's Head
1980
Bronze
Length 9.5 cm (3¾ in.)
Private collection

There is a rather haunting quality to this tiny bronze sculpture of a whippet or greyhound head, and that quality is accentuated by the punched-out eye sockets, which create a fathomless and unreadable dark eye. The head has an organic feel to it, as if it has been crafted from a piece of driftwood or a knotted branch, so that the work communicates a sense of dog and nature being inextricably bound, in a manner not unlike the paintings of Franz Marc (page 258).

Henry Moore is more commonly associated with his monumental public sculptures, often of abstract figures of women and children. His works inspire contemplation and reflection, seldom yielding their full meaning easily or immediately. Moore tended to give his works elusive titles, preferring not to explain them through a label in the hope that viewers would arrive at their own conclusions. This piece, with its small size and tactile quality (it appears to fit perfectly into the hand), was made towards the end of Moore's life, when he was eighty-two years old. It conveys a sense both of history – of the dog's ancient past and the sculptor's own long life – and of looking towards an unknown future.

**Camille Bombois
(1883–1970)**
*Bulldog, Thought to Look
like Winston Churchill*
n.d.
Oil on canvas
Dimensions unknown
Private collection

This whimsical image of
a bulldog indeed bears a
striking resemblance to
Winston Churchill. The
bulldog breed developed
in England, originally as a
guard dog and for use in the
popular if barbaric sports
of bull- and bear-baiting.
Possibly unequalled for its
tenacity, power and strength,
the bulldog has served as a
symbol of Britain since the
eighteenth century, as well as
more recently being used as
a symbol by the US Marine
Corps. The modern bulldog
is, however, physically a
rather different and – some
would say – inferior dog to its
bull-fighting ancestors, and
the specimen in this painting
differs further in that it is in
fact a French bulldog (with
the erect ears characteristic
of that variety), rather than
an English one.

The French artist Camille
Bombois has captured the
supposedly typical, rather
grumpy look of the breed,
but in fact bulldogs are not
usually grumpy in character.

Bombois was a charismatic
and eccentric character who
worked in a travelling circus
as a strongman and wrestler.
His own strength and
physical prowess seemed to
translate into his artistic style,
as is seen here in the bold,
strong outlines and striking
use of contrasting colour.

**Craigie Aitchison
(1926–2009)**
Crucifixion
1984–86
Oil on canvas
221 x 188 cm (87 x 74 in.)
Private collection

Craigie Aitchison's moving
and expressive paintings are
notable for a deep poetic
resonance and a reduction
of detail to pure, distilled
elements. Throughout
his distinguished career
Aitchison's work remained
largely unaffected by artistic
fashions and therefore stayed
utterly true to his original
vision. He looked to personal
experiences, such as those
deriving from his time spent
on the wild Scottish island of
Arran and in Italy, and picked
a single element in which he
then invested great meaning.

Many of Aitchison's
paintings include a dog similar
to the one seen here, and
always pared down to its most
simple, symbolic form. He
also returned frequently to
the subject of the Crucifixion,
often including a single dog,
simple landscape or other
element. These scenes are
not of an ecclesiastical nature
but suggest a wider, more
far-reaching spirituality. They
are full of mystery, the figures
floating between reality and the
supernatural, and set against
a base of vivid colour, and
they inspire intense reflection
on the part of the viewer.

Ditz
(Date unknown)
The Tree Whippet
1985
Acrylic on board
25 x 30 cm (9⅞ x 11⅞ in.)
Private collection

In this humorous painting a whippet is seen perched on a branch far above the landscape, much in the manner of a big cat. Ditz typically brings a touch of whimsy to her works, many of which include this whippet, which was her first dog. With

irony, the artist names her pets after the creature they most like to eat, so the whippet is Hasi (Austrian for bunny), while her cat was Mousie.

The whippet in the tree was inspired by a squirrel-chasing incident in which, to

Ditz's surprise, she saw Hasi tearing halfway up the tree before falling to earth again. By her own admission, the artist likes to place animals where they do not quite belong, and she does it so naturally that the scene is taken initially as 'fact', until

the viewer realizes something bizarre is afoot. In this work, with its charming naïve style, the whippet seems quite at home and perfectly content with its high wooden seat.

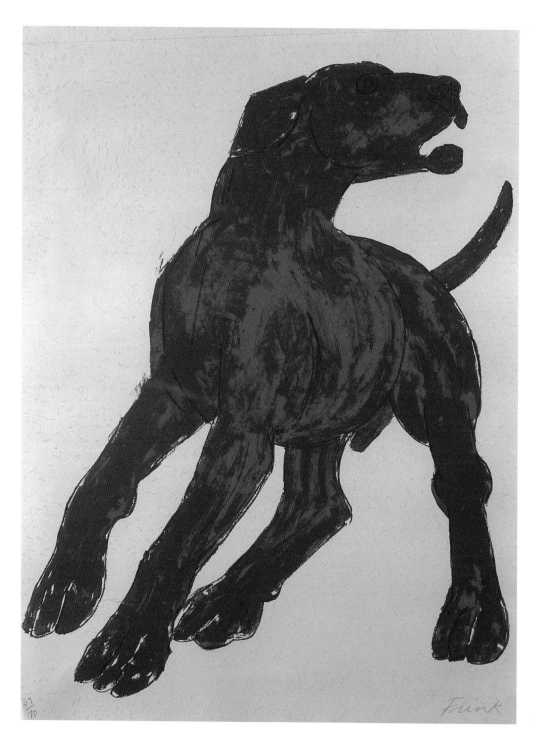

Elisabeth Frink (1930–1993)
Dog
1990
Lithograph
75 x 55.5 cm (29½ x 21⅞ in.)
Bristol, Royal West of England Academy

The world-renowned artist and sculptor Elisabeth Frink returned to three subjects continually through her career: the male figure, the horse and the dog, the last of which is shown magnificently here. Frink was an avowed animal-lover, and displayed enormous understanding of animals, including both their anatomy and their nature, two factors that are overwhelmingly apparent in her work. She never sentimentalized her dogs or horses; rather, her depictions concentrate on conveying their power. Tapping into the essential nature of the creature, she reveals, in an almost spiritual manner, the core dramas of the animal soul.

This image of a barking dog is particularly resonant. It recalls some primeval being and harks back in spirit to the wild ancestor of the modern dog, while retaining characteristics of the domestic dog. Simple as it may at first seem, this animal has a symbolic quality, evoking the bestial, dark side of human nature that, most of the time, is hidden and repressed.

Bill Jacklin (born 1943)
Poodle II
2001
Monotype
Dimensions unknown
Private collection

The highly atmospheric and evocative work of Bill Jacklin is instantly recognizable and very appealing. Here, a clipped poodle is seen standing in a pose vaguely reminiscent of nineteenth-century pure-bred dog paintings, against a dark, shadowy background. Jacklin produced the monotype as a study for a series of paintings done for the Westminster Dog Show at Madison Square Garden, New York, one of America's most prestigious shows, which has been running since 1877. Although many of Jacklin's works depict movement, this dog is still. Yet despite its static pose there is an idea of passing time, a sense that this blurred outline of a dog hovering in a mysterious landscape has been captured in a fleeting instant. This notion of time moving creates a sense of transience – the picture becoming a tiny slice of time committed to paper – that is characteristic of Jacklin's style.

The poodle is an ancient breed thought to have originated in Germany rather than France (contrary to general opinion), although it was also popular there, especially during the reign of Louis XVI in the eighteenth century. Despite the breed's antiquity and popularity, there are relatively few depictions of poodles in art, which makes this imaginative contemporary work all the more important.

Andy Warhol (1928–1987)
Pom
1976
Silkscreen on a primed canvas,
overlaid with acrylic paint
81.2 x 65.9 cm (32 x 26 in.)
Norwich, Norwich Castle Museum
and Art Gallery

During the 1970s the eccentric
and multi-talented artist Andy
Warhol turned his attention
towards commissioned pieces,
working with a number of
wealthy high-society families.
It was at this time that he made
several paintings of dogs,
including this elegant portrait
of a King Charles spaniel called
Pom, which belonged to Lady
Adeane. Warhol was himself a
great dog-lover and owned two
miniature dachshunds, Amos
and Archie, which he also
depicted frequently.

In this work and others
like it, Warhol creates through
the posed animal a sense of
grandeur and tradition that
harks back to conventional
portraiture, and he combines
this approach with his avant-
garde techniques. Here Pom
has the appearance and
demeanour of a society beauty,
parading her looks with that
part-demure, part-aware
stance commonly seen in the
pages of glossy magazines.
Warhol's technique of painting
over the silkscreen image
invests Pom with a shadowy
presence that suggests the
transience of a pet dog's
existence within the much
longer life of its owner.

**George Underwood
(born 1947)**
Leon
2006
Oil on canvas
23 x 31 cm (9 x 12¼ in.)
Private collection

The magnificent Leon in this painting is a German short-haired pointer, the much-loved pet of the artist, George Underwood. This poignant work transcends mere pictorial representation of a dog, for Underwood has invested the creature with a heroic and soulful countenance. The animal's wise expression is so subtly wrought that the dog becomes almost an icon, a symbol of some larger truth. The painting itself is small, but the subject in metaphysical terms appears enormous, so that the dog and its spirit seem to reach well beyond the limits of the picture frame.

There is a sense of history and tradition in this work, and it is interesting to compare it with Giovanni Bellini's *Portrait of a Young Man* (c. 1500; right). While this is a comparison that Bellini might not have appreciated, there is nonetheless a striking similarity in the expression and soul of his young man and those of Underwood's young dog.

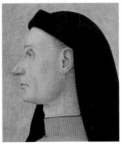

Kate Leiper (born 1973)
Awaiting Artemis
2007
Pastel, ink and acrylic on
handmade paper
100 x 100 cm (39⅜ x 39⅜ in.)
UK, Holt, The Red Dot Gallery

A sense of eager anticipation
pervades this work by
the highly innovative and
imaginative artist Kate Leiper.
The hounds are waiting for
their mistress Artemis, the
Greek goddess of the hunt,
watching her as she prepares to
set out, perhaps, for the chase.
The dogs turn towards her,
tails thumping the floor with
excitement, anxious to be on
their way and after their quarry.
 Leiper typically looks to the
myths of the ancient world and
such universal topics as love,
jealousy and death for her
inspiration, and invariably
includes expertly rendered
hounds or other animals. Her
love of dogs is quite apparent
and can be seen in the fluid
way in which she captures
their movement, anatomy and,
above all, character. For this
work she based the dogs on a
greyhound called Fuji, which is
the model for a number of her
paintings. In every instance
the artist conveys the elusive,
regal quality that is peculiar
to this breed. Leiper's unique
paintings provide a delightful,
new and bold interpretation of
some of the oldest of tales.

**George Rodrigue
(born 1944)**
You're a Head of Me
2007
Acrylic on canvas
91.4 x 121.9 cm (36 x 48 in.)
Private collection

The American artist George Rodrigue grew up in Louisiana in the heartland of Cajun country, and his work remains firmly rooted in the historical traditions of this rich culture. The famous works that form his 'Blue Dog' series were inspired by the myth of the *loup-garou*, the Cajun equivalent of the werewolf. Rodrigue was initially commissioned to paint the *loup-garou* for a book of Cajun ghost stories, but that turned out to be just the beginning of the evolution of his dog figure, which has since become something rather different. The dog was based on photographs of Rodrigue's own dog Tiffany, which had died some years previously but the shape of which seemed to fit his impressions of the *loup-garou*. After creating his vision initially with werewolf-red eyes, the artist then began to use the dog as a favourite motif, returning to it repeatedly, changing the eyes from red to a less threatening yellow, developing the strong blue and adding abstracted and vibrant coloured backgrounds.

The Blue Dog has become a personality in its own right, making the transition from being a painting of a dog to something more resonant and full of character. In some ways as the dog peers from the canvas with an unerringly direct gaze it seems to reflect the soul of the artist himself, a fact alluded to in Rodrigue's choice of title for the work.

Timeline

400,000 YEARS AGO Man and wolf share the same hunting ground and habitat, as indicated by evidence discovered at the site of Boxgrove, Kent, UK.

14,000 YEARS AGO Earliest evidence of domestic dog (a mandible), at Bonn-Oberkassel, Germany.

12,000 YEARS AGO Skeletons found at the Natufian site of Ein Mallaha, northern Israel, provide evidence that a puppy and human were buried cradled together.

10,000 YEARS AGO Dog–wolf hybrids in North America: remains are discovered at the Agate Basin site in Wyoming, USA.

8500 YEARS AGO Three dogs are deliberately buried: skeletons are discovered at Koster, Illinois, USA.

8000 YEARS AGO Dog remains dating from this time are found at Tocibara in Japan, alongside remains of the now-extinct Japanese wolf *Canis lupus hodophilax*.

c. 6000–1500 BC Rock paintings at Tassili N'Ajjer, Algeria, depict some of the earliest known images of the dog in art.

c. 5000–1000 BC The magnificent limestone 'Statue of a Dog' is made in Mesopotamia.

c. 2000–1000 BC Distinctly different types of dog emerge, identifiable from artworks, including the greyhound type, mastiff type and small, short-legged dog.

c. 3468 BC Fo-Hi, mythical founder of Chinese dynasties, extols the virtues of the 'sleeve dog', small enough to fit in a garment's wide sleeve.

c. 2600 BC Images of the dog-god Anubis are frequent in Egyptian funerary art of this time; dog burial is practised; dog mummies from this time have been found.

1200 BC Clay dog models depicting small, rotund dogs are made in the Basin of Mexico at Tlatilco.

800 BC The Chinese *Book of Rites*, one of the earliest known taxonomies of dogs, describes hunting dogs, guard dogs and edible dogs.

c. EIGHTH CENTURY BC Homer writes the *Odyssey*, which tells of Odysseus' faithful hound, Argus.

c. 771 BC The story of Romulus and Remus, founders of the city of Rome, who were nurtured by a she-wolf.

c. 668–626 BC King Assurbanipal of Assyria keeps large packs of formidable hunting dogs.

350 BC Aristotle (384–322 BC) writes his *History of Animals*, in which he describes different types of dog, including the Epirotic, the Laconian hound and the Molossian.

100 BC–AD 300 Lifelike half-seated earthenware dogs are made by the Colima culture in Mexico.

AD 77 Pliny the Elder (AD 23–79) writes his *Natural History*, including a chapter on dogs and their behaviour and characteristics.

AD 100 Pompeii mosaics *Dog on a Leash* and *Cave Canem* are made.

AD 200 A lifelike earthenware statue of a seated mastiff is made in China.

AD 476 Fall of the Roman Empire in the West; a dark period ensues for dogs and art.

c. 490 Clovis I, king of the Franks (*c.* 466–511), enforces laws protecting dogs, including one stating that a dog must be proved to have rabies before it can be put to death.

c. 727 The St Hubert hound is named after St Hubert (*c.* 656–727), who developed the breed, the ancestor of the bloodhound.

c. 700–800 Tradition of 'blessing the hounds' starts in France as priests come to the church doors to bless the noblemen waiting outside with their dogs.

c. 1001–1023 According to a Norwegian tale, King Eystein (reigned 1001–1023) was run off his lands. He returned with troops and in disgust offered the people the choice of a dog or a slave to be their king. They chose the former and a dog called Saur took the throne for three years.

1016 In England, Canute enacts the Forest Laws: forests become royal hunting domains and all those living there fall under strict regulations concerning their dogs.

ELEVENTH CENTURY In England, William the Conqueror (1028–1087) requires three toes to be amputated from any hound not from his pack and living in the vicinity of the royal forests.

1066–82 The Bayeux Tapestry depicting the Norman invasion of England includes some of the first embroidered dogs in art.

THIRTEENTH CENTURY Louis IX of France (1215–1270), a great hunter, introduces the gaze hound (used for hunting gazelle) to Europe from the Holy Land.

1388 Jean, duc de Berry (1340–1416) reputedly owns 1500 dogs.

c. 1389 *Le Livre de chasse*, a hunting manual, is written by Gaston Phébus de Foix (1331–1391), giving detailed information on hunting and dogs.

c. 1406–13 Spaniels are first mentioned in an English text, *Master of the Game* by Edward Plantagenet, 2nd Duke of York (1373–1415).

c. 1415 *Les Très Riches Heures du duc de Berry* by the Limbourg brothers (active 1400–1416).

FIFTEENTH CENTURY Louis XI of France (1423–1483) reputedly commissions a ruby-studded collar for his favourite hound.

1434 *The Arnolfini Marriage* by Jan van Eyck (*c.* 1390–1441). The little griffon terrier is one of the earliest and most famous dogs in portraiture.

c. 1438–42 *The Vision of St Eustachius* by Antonio Pisanello (1395–1455) includes several different types of dog, exquisitely rendered.

1465–1474 Andrea Mantegna (1431–1506) paints Rubino, the favourite dog of Ludovico II Gonzaga of Mantua, sitting under its master's chair.

1468 An inventory of the possessions of military leader Sigismondo Pandolfo Malatesta (1417–1468) reveals that he owned numerous valuable dog collars studded with silver.

FIFTEENTH CENTURY Charles VIII of France (1470–1498) reputedly allows his favourite hunting dogs to sleep in his bed.

c. 1495 *Satyr Mourning Over a Nymph* by Piero di Cosimo (*c.* 1462–1521), which features one of the loveliest dogs in the art of the Renaissance.

END OF FIFTEENTH CENTURY Spanish conquistadors introduce their fierce mastiffs and greyhounds to the Americas.

c. 1502 *Vision of St Augustine* by Vittore Carpaccio (*c.* 1460/65–1523/26) depicts the sage dog of religious art.

SIXTEENTH CENTURY Henry VIII of England (1491–1547) sends 400 mastiffs to Charles V of Spain (1500–1558) to aid in the war against France.

c. 1525–30 *Federico II Gonzaga, Duke of Mantua* by Titian (*c.* 1488–1576), the master of dog painting.

1538 (OR BEFORE) *Venus of Urbino* by Titian, with the spaniel type here in a symbolic role.

c. 1548–50 *Two Hunting Dogs Tied to a Tree Stump* by Jacopo Bassano (*c.* 1510–1592), one of the first paintings with dogs as the subject.

1570 Johannes Caius (1533–1603) publishes *De Canibus Britannicus*, the first work solely on dogs.

1572 At the Battle of Hermigny, a pug saves the life of William I of Orange (1533–1584) by raising the alarm. Pugs become the official dog of the House of Orange, and wear an orange ribbon on their collars.

1576 Abraham Flemming (*c.* 1552–1607) publishes the English translation of Johannes Caius's work, calling it *Of English Dogges*.

1576 Hare coursing, a sport in which greyhounds (and similar hounds) chase a hare, not necessarily with the aim of killing it, becomes popular in Europe. The 4th Duke of Norfolk (1558–1603) later draws up rules for coursing.

1576 George Turberville (*c.* 1540–1597) publishes *The Noble Arte of Venerie or Hunting*.

BY 1591 Packs of hounds are kept to hunt fox exclusively. The specialized foxhound starts to develop.

MID-SEVENTEENTH CENTURY English monarchs Charles I (1600–1649) and Charles II (1630–1685) are devoted to small spaniel-type dogs, later named the King Charles spaniel.

c. 1625 *A Dog Belonging to the Aldovrandi Family* by Guercino (1591–1666), one of the finest dog paintings of the seventeenth century.

c. 1634–35 *James Stuart, 4th Duke of Lennox and 1st Duke of Richmond* by Anthony van Dyck (1599–1641), a master of painting dogs.

c. 1650 The pointer type of dog, descended from Spanish stock, and a recognizable type, starts to appear in England, and is used with greyhounds for coursing.

c. 1650–52 *A Watchdog Chained to his Kennel* by Paulus Potter (1625–1654), an extraordinary image of a dog, painted with tremendous realism, so that it appears to be a living, breathing creature.

1664 Robert Boyle and Robert Hooke investigate the process of respiration by performing vivisection on a dog. Hooke later declares 'never again', owing to the suffering inflicted on the animal.

c. 1671–72 *Amsterdam Dog Market* by Abraham Hondius (*c.* 1631–1691), an unusual image, depicting a wide variety of dogs and collars.

1688 William III of Orange (1650–1702) and Mary (1662–1694) take their pugs with them when they travel to England to ascend the throne.

1749 *Self-Portrait* by William Hogarth (1697–1764) depicts the artist with his beloved pug called Trump. Hogarth also owned a pug called Pug.

1752 *Bitch Nursing her Puppies* by Jean-Baptiste Oudry (1686–1755), a groundbreaking work showing an intimate, maternal moment, the dog being invested with clearly human emotion.

1753 Georges-Louis Leclerc, comte de Buffon (1707–1788), publishes *Histoire naturelle*, in which he discusses his theories on the evolution of dogs, and other species.

FROM 1758 George Washington (1732–1799) keeps detailed records of his prize foxhounds.

1792 *Ringwood, a Brocklesby Foxhound* by George Stubbs (1724–1806).

1812 The borzoi, the Russian dog of the nobility, is first mentioned in English literature.

1814 Sir Walter Scott (1771–1832) publishes the novel *Guy Mannering*. The Dandie Dinmont terrier is later named after one of the characters in this book.

1824 The Society for the Prevention of Cruelty to Animals (SPCA) is formed in England, and the first meeting is held at Old Slaughter's Coffee House, St Martin's Lane, London.

1824 *Newfoundland Dog called Lion* by Edwin Landseer (1802–1873). Later, the black-and-white type of Newfoundland was named the Landseer Newfoundland, after the artist.

1825 Edward Laverack (1800–1877), a breeder, is credited with 'fixing' the characteristics of the English setter breed (descended from spaniel and pointer blood).

1826 *Mad Dog* by Thomas Busby (active 1804–1821), a lighthearted depiction of a dog infected with the deadly rabies virus.

1827 *Hound* by the French *Animalier* Grégoire Giraud (1783–1836).

1829 *Attachment* by Edwin Landseer, based on the story of the death of Charles Gough, an artist who died following a fall in the Lake District and was attended by his faithful dog.

1835 In Britain, Princess Victoria (1819–1901) becomes patron of the SPCA; later the prefix 'Royal' is added to the organization's name.

1835 Bull- and bear-baiting, sports popular since the time of King John (1199–1216), are banned in England.

1836 The Waterloo Cup is established, the most prestigious hare-coursing competition, likened to the Derby of the horse world.

1836 *Dash* by Edwin Landseer, depicting Princess Victoria's beloved King Charles spaniel.

1837 Victoria becomes Queen of Great Britain; her love of dogs is legendary.

1839 The Dog Cart Nuisance Law is passed in England prohibiting dog carts from within fifteen miles (24 km) of London's Charing Cross railway station.

1841 Queen Victoria's main kennels are built at Home Park, Windsor Castle, near London.

1841 *Eos* by Edwin Landseer, depicting Prince Albert's beloved greyhound.

1849 Ivan Pavlov, the Russian physiologist, is born. His experiments with dogs (especially on conditioned reflexes) will be famous, giving rise to the adjective 'Pavlovian'.

c. 1850 The Airedale terrier is developed in Yorkshire through otter-hound and terrier crosses.

c. 1850–52 *Rat-Catching at the Blue Anchor Tavern*, depicting Tiny the Wonder, a champion rat-catching Manchester terrier.

1855 *An Early Canine Meeting* by R. Marshall, thought to be the first painting of a dog show.

1855 Cart dogs are banned in England but remain in active use on the European continent.

1858–72 For fourteen years Greyfriars Bobby, a little Skye terrier, waits by the grave of his late master, John Gray, in Edinburgh's Greyfriars churchyard.

1859 England's first recognized dog show is held in Newcastle-upon-Tyne, with fifty sporting-dog entries.

1860 British officers remove and return to England five Pekingese dogs from the Imperial Palace in China, as British and French forces take control of Beijing (Peking).

1862 The Maltese dog, the ancestry of which is ancient, first appears at English dog shows.

1863 France's first recognized dog show is held at the Exposition Universelle des Races Canines in the Bois de Boulogne.

1864 *Chacun pour soi* by Philippe Rousseau (1816–1887), an important dog-based painting of social commentary.

1865 The first field trial for sporting dogs takes place at Southill, Bedfordshire, England.

1865 The official studbook for foxhounds is established in Britain.

1866 George R. Jesse publishes *Researches into the History of the British Dog*, the first book to deal with different breeds in detail.

1867 Arnold Burgess publishes *The American Kennel and Sporting Field*, the first attempt at a studbook in North America.

1870 The Yorkshire terrier is named as a breed.

1873 The formation of the Kennel Club in Britain and publication of the British Kennel Club Studbook.

1873 The first dog show run by the Kennel Club is held at Crystal Palace, London, and has 975 entries.

1874 The black-and-tan terrier becomes known officially as the Manchester terrier.

1874 The first official American dog show is held in Chicago, Illinois.

1876 The establishment of the Fox Terrier Club in Britain.

1876 The National American Kennel Club is formed and starts to develop a studbook for breeds.

1877 The American Westminster Kennel Club is founded and holds its first show in New York. It is still the most prestigious of its kind.

LATE NINETEENTH CENTURY The Reverend John (Jack) Russell develops the feisty terrier that is named after him.

1882 The official studbook for greyhounds is established in Britain.

1882 The French Kennel Club is established.

1882 The Italian Kennel Club is formed.

1882 *Portrait of Eugénie Graff* by Claude Monet (1840–1926).

1884 The National American Kennel Club changes its name to the National Field Trial Club.

1884 The American Kennel Club is formed to take over the jurisdiction of dog shows and the studbook.

1886 Charles Cruft (1852–1938) organizes the first Crufts Dog Show, held at the Royal Aquarium in London.

1888 The chihuahua becomes popular in America.

LATE NINETEENTH CENTURY In England, Princess Alexandra (1844–1925) is given a borzoi called Alex by her brother-in-law, Tsar Alexander II of Russia, and borzois become popular.

LATE NINETEENTH CENTURY Tibetan spaniels are imported into Britain from Tibet by the Hon. Mrs McLaren Morrison, an expert on exotic dog breeds.

1890 The Ladies Kennel Club is formed in Britain.

1895 The Netherlands establishes the Dutch Kennel Club.

1900 The Ladies Kennel Association of America is founded in New York.

1900 The Italian Greyhound Club is founded in England.

1902 The Pekingese Club is founded in England.

1902 *Optician's Sign* by Jean-Léon Gérôme (1824–1904).

1911 The Spanish Kennel Club is founded.

1912 *Dynamism of a Dog on a Leash* by Giacomo Balla (1871–1958).

1914 The first Norwich terrier arrives in America, where it becomes known as the Jones terrier.

1916 The first British military dog-training school is set up by Lieutenant Colonel E.H. Richardson in Essex.

1920 Major and Mrs G. Bell Murray and Miss Jean C. Manson import Afghan hounds into Scotland and start to breed them.

1923 The Saluki Breed Club is established in Britain.

1925–34 Every day, the Japanese Akita called Hachiko visits the subway station in Tokyo where his master died. A statue is erected in Hachiko's honour.

c. 1925 *Kuppenheimer: Wolfhound* by Joseph Christian Leyendecker (1874–1951).

1927 The first Morris and Essex Dog Show is held; the show is run annually by Geraldine Rockefeller Dodge (1882–1973) until 1953.

1929 Mick the Miller (1926–1939), one of the first champion greyhounds in England, wins the Greyhound Derby; he wins it again in 1930.

1933 Virginia Woolf (1882–1941) publishes *Flush, A Biography*, a fictitious story based on the life of Elizabeth Barrett Browning's cocker spaniel.

1938 The British author Eric Knight writes a short story called *Lassie Come Home*, based on an English collie. An instant success, the story is expanded into a book.

1939 Geraldine Rockefeller Dodge establishes the St Hubert's Giralda Animal Shelter.

1942 The Army War Dog School is set up in England at the former Greyhound Racing Kennels at Potters Bar, Hertfordshire.

1943 *Lassie Come Home* is released as a film in October, just months after the death of the original book's author, Eric Knight.

1955 Walt Disney produces the animated film *Lady and the Tramp*, the story of love between a cocker spaniel and a mutt.

1957 Laika, a Russian mongrel, is the first living thing to enter outer space, doing so aboard the Russian Sputnik 2. She dies several hours after launch.

1961 Walt Disney produces the animated film *101 Dalmatians*, based on the novel by author Dodie Smith, written in 1956.

1976 *Pom* by Andy Warhol (1928–1987), one of a series of dog portraits undertaken by the artist that have an iconic appeal.

1983 *Untitled* by Keith Haring (1958–1990), a disturbing reinvention of ancient symbolism attached to the dog.

1986–87 *Triple Portrait* by Lucian Freud (born 1922), depicting the whippet Pluto. The artist also used the dog's profile in his design for the Bella Freud clothing label.

1990 *Dog* by Elisabeth Frink (1930–1993), a moving depiction of the spiritual nature of the dog.

2001 *Poodle II* by Bill Jacklin (born 1943), a modern interpretation of the traditional pure-bred dog portraits of the eighteenth and nineteenth centuries.

2001 Around 350 search and rescue dogs provide invaluable assistance in the aftermath of the World Trade Center attacks in New York City on 11 September.

2007 *You're a Head of Me* by George Rodrigue (born 1944), part of his famous 'Blue Dog' series, in which the painted dog has taken on a character and life of its own.

Bibliography

Exhibition Catalogues

Best in Show, exhib. cat. by E.P. Bowron,
C.R. Rebbert, R. Rosenblum and W. Secord,
Greenwich, Conn., Bruce Museum of Arts and
Science, May–August 2006; Houston, Museum
of Fine Arts, October 2006–January 2007

Bonnard, exhib. cat. by Sarah Whitfield and
John Elderfield, London, Tate Gallery,
February–May 1998

Franz Marc: Horses, exhib. cat. by Christian
von Holst, Cambridge, Mass., Harvard
University Art Museums, Busch-Reisinger
Museum, September 2000–March 2001

George Stubbs 1724–1806, exhib. cat. by Judy
Egerton, London, New Haven, Conn. and
Washington, D.C., 1984–85

Lucian Freud, exhib. cat. by William Feaver,
London, Tate Gallery, June–September 2002

Lucian Freud Paintings, exhib. cat., essay by
Robert Hughes, The British Council, 1987;
Hirschhorn Museum, Washington, D.C. (from
15 September 1987); Musée d'Art Moderne de
la Ville de Paris, France (from 14 December
1987); Hayward Gallery, London (from
4 February 1988); Neue Nationalgalerie,
Berlin (from 29 April 1988)

*Masters of Seventeenth-Century Dutch Genre
Painting*, exhib. cat. by Christopher
Brown, Philadelphia Museum of Art,
March–May 1984

Pisanello, exhib. cat. by Luke Syson and
Dillian Gordon, London, National Gallery,
October 2001–January 2002

Rembrandt by Himself, exhib. cat.,
ed. Christopher White and Quentin Buvelot,
London, National Gallery, June–December
1999

Sir Edwin Landseer, exhib. cat. with
contributions by Richard Ormond, Joseph
Rishel and Robin Hamlyn, Philadelphia
Museum of Art, October 1981–January 1982;
London, Tate Gallery, February–April 1982

Splendours of the Gonzaga, exhib. cat.,
ed. David Chambers and Jane Martineau,
London, Victoria and Albert Museum,
November 1981–January 1982

The Vikings in England, exhib. cat., Brede-
Copenhagen, Aarhus and York, 1981–82

Journal Article

Caroline Haardt, 'The Rock Art of Tassili
N'Ajjer – Prehistoric Rock Paintings and
Engravings in Tassili N'Ajjer, Algeria',
UNESCO *Courier*, July 1991

Books

R. Almond, *Medieval Hunting*, Stroud (Sutton
Publishing) 2003

Arrian, *Arrian on Coursing: The Cynegeticus of the
Younger Xenophon*, Whitefish, Mont. (Kessinger
Publishing) 2007

T. Bayard (ed.), *A Medieval Home Companion:
Housekeeping in the Fourteenth Century*, London
(HarperCollins) 1991

H. Belsey, *Gainsborough and his House*, London
(Paul Holberton Publishing) 2002

P. Bentley, *The Brontës and their World*, London
(Book Club Associates) 1969

J. Bidder, *Partners for Life*, London (Orion) 2002

R. Blake, *George Stubbs and the Wide Creation*,
London (Chatto and Windus) 2005

G. Boudaille, *Picasso*, Secaucus, NJ (Wellfleet
Press) 1987

S. Budiansky, *The Truth about Dogs*, New York
(Penguin) 2000

J. Caius, *Of English Dogs*, Alcester (Vintage
Dog Books) 2005

H. Carter, A.C. Mace and J.M. White,
The Discovery of the Tomb of Tutankhamen,
New York (Dover Editions) 1985

V.W.F. Collier, *Dogs of China and Japan in
Nature and Art*, London (W. Heinemann) 1921

J. Cooper, *Animals in War*, London (Corgi
Books) 1984

R. and L. Coppinger, *Dogs*, London
(Crosskeys Select Books) 2004

M. Derr, *A Dog's History of America*, New York
(North Point Press) 2004

C. Desroches-Noblecourt, *Tutankhamen: Life and Death of a Pharaoh*, London (*The Connoisseur* and Michael Joseph Ltd) 1963

B. Fogle, *The New Encyclopedia of the Dog*, London (Dorling Kindersley) 2000

M. Foss, *Chivalry*, London (Michael Joseph) 1975

Colonel Sir R. Glyn, Bart, *Champion Dogs of the World*, London (George G. Harrap and Co.) 1967

R. Goffen (ed.), *Titian's Venus of Urbino*, Cambridge (Cambridge University Press) 1997

J.R. Hale, *The Civilization of Europe in the Renaissance*, London (HarperCollins) 1993

C. Harbison, *Jan van Eyck and the Play of Realism*, London (Reaktion Books) 1991

A. Holland, *Hunting, A Portrait*, London (Little, Brown) 2003

P. Houlihan, *Animal World of the Pharaohs*, London (Thames and Hudson) 1997

R. and J. Janssen, *Egyptian Household Animals*, Aylesbury (Shire Publications) 1989

P. Larkin and M.R.J. Stockman, *The Ultimate Encyclopedia of Dogs, Dog Breeds and Dog Care*, London (Southwater) 2000

C. Lloyd, *Enchanting the Eye*, London (Royal Collection Publications) 2004

S. McHugh, *Dog*, London (Reaktion Books) 2004

F. Mery, *The Life, History and Magic of the Dog*, New York (Madison Square Press) 1968

H. Opperman, *J.B. Oudry 1686–1755*, Fort Worth (Kimbell Art Museum) 1983

F. Pedrocco and M.A. Chiari Moretto Wiel, *Titian, The Complete Paintings*, London (Thames and Hudson) 2000

K. Roberts, *Bruegel*, London (Phaidon) 1971

D. Rosand, *Painting in Sixteenth-Century Venice: Titian, Veronese, Tintoretto*, Cambridge (Cambridge University Press) 1997

R. Rosenblum, *The Dog in Art*, New York (Harry N. Abrams) 1988

M. Rosenthal, *Franz Marc*, Munich (Prestel Verlag) 2004

M. Schwartz, *A History of Dogs in the Early Americas*, New Haven, Conn. and London (Yale University Press) 1997

W. Secord, *Dog Painting 1840–1940*, Woodbridge (Antique Collectors' Club) 1992

W. Secord, *Dog Painting, The European Breeds*, Woodbridge (Antique Collectors' Club) 2000

J. Serpell (ed.), *The Domestic Dog*, Cambridge (Cambridge University Press) 1995

A. Stassinopoulos and R. Berry, *The Gods of Greece*, London (Weidenfeld and Nicolson) 1983

S. Thompson, *The Artful Dog*, New York (Metropolitan Museum of Art) 2006

F.L. Wilder, *English Sporting Prints*, London (Thames and Hudson) 1974

I. Zaczek, *Dog*, New York (Watson-Guptill) 2000

Index

Picture Credits

© AKGimages/WalterGrunwald: 8, 29; Albright Knox Art Gallery, Buffalo, New York, USA, © DACS/The Bridgeman Art Library: 256; © American Illustrators Gallery, NYC/ www.asapworldwide.com/ The Bridgeman Art Library: 244, 247; American Museum of Natural History, New York, USA, Photo © Boltin Picture Library/ The Bridgeman Art Library: 57; Art Gallery of New South Wales, Sydney, Australia/The Bridgeman Art Library: 17, 180; Arthur M. Sackler Museum, Harvard University Art Museums, USA, Gift of Charles A. Coolidge/The Bridgeman Art Library: 50–51, 55; © Ashmolean Museum, University of Oxford, UK/The Bridgeman Art Library: 12, 35, 68, 108, 150; © The Barnes Foundation, Merion, Pennsylvania, USA/The Bridgeman Art Library: 10, 54; Basilique Saint-Denis, France, Lauros/Giraudon/The Bridgeman Art Library: 16; Benaki Museum, Athens, Greece/The Bridgeman Art Library: 261; Biblioteca Marciana, Venice, Italy/The Bridgeman Art Library: 145; Biblioteca Marciana, Venice, Italy, Giraudon/The Bridgeman Art Library: 163; Bibliothèque de L'Arsenal, Paris, France, Giraudon/The Bridgeman Art Library: 214; Bibliothèque Nationale, Paris, France, Archives Charmet/The Bridgeman Art Library: 96; Bildarchiv Steffens/The Bridgeman Art Library: 39; © Bradford Art Galleries and Museums, West Yorkshire, UK/ The Bridgeman Art Library: 109;

British Library, London, UK, © British Library Board. All Rights Reserved/The Bridgeman Art Library: 92–93, 95, 219; The British Museum, London, UK/The Bridgeman Art Library: 16, 46, 48; The British Sporting Art Trust/The Bridgeman Art Library: 23t and b; © Brontë Parsonage Museum, Haworth, Yorkshire, UK/The Bridgeman Art Library: 204; Brooklyn Museum of Art, New York, USA/The Bridgeman Art Library: 235; Brooklyn Museum of Art, New York, USA, Bequest of Irma B. Wilkinson in memory of her husband/The Bridgeman Art Library: 65; Burlington Paintings, London, UK/The Bridgeman Art Library: 242; Burrell Collection, Glasgow, Scotland, © Glasgow City Council (Museums)/The Bridgeman Art Library: 169; © Byzantine and Christian Museum, Athens: 97; Castello del Buonconsiglio, Trent, Italy, Giraudon/The Bridgeman Art Library: 164; © C.E. Brock/ Private Collection/The Bridgeman Art Library: 111; Chateau de Fontainebleau, Seine-Et-Marne, France, Lauros/Giraudon/The Bridgeman Art Library: 194; Colegiata de San Isidoro, Leon, Castilla y Leon, Spain/The Bridgeman Art Library: 73; © Collection of the New-York Historical Society, USA/The Bridgeman Art Library: 241; Collection of Walter J. Goodman & Robert A. Flanders: 21; © DACS, Photo © Southampton City Art Gallery, Hampshire, UK/The Bridgeman Art Library: 229; The Detroit Institute of

Arts, USA, Gift of Robert H. Tannahill in memory of Dr W.R. Valentiner/The Bridgeman Art Library: 66; Egyptian National Museum, Cairo, Egypt/The Bridgeman Art Library: 33; © The Estate of Keith Haring/ Photo © Deichtorhallen, Hamburg, Germany/Wolfgang Neeb/The Bridgeman Art Library: 249; Fitzwilliam Museum, University of Cambridge, UK/The Bridgeman Art Library: 12; Fogg Art Museum, Harvard University Art Museums, USA, Gift of the Wertheim Fund/The Bridgeman Art Library: 134; Galleria Borghese, Rome, Italy, Giraudon/ The Bridgeman Art Library: 14; Galleria degli Uffizi, Florence, Italy, Alinari/The Bridgeman Art Library: 104; Galleria degli Uffizi, Florence, Italy/The Bridgeman Art Library: 19, 102; Galleria dell' Accademia Carrara, Bergamo, Italy/The Bridgeman Art Library: 273b; Galleria Doria Pamphilj, Rome, Italy, Alinari/ The Bridgeman Art Library: 70–71, 79; Gallerie dell' Accademia, Venice, Italy, Cameraphoto Arte Venezia/ The Bridgeman Art Library: 80; © Geffrye Museum, London, UK/The Bridgeman Art Library: 149; Gemäldegalerie Alte Meister, Dresden, Germany, © Staatliche Kunstsammlungen Dresden/The Bridgeman Art Library: 118; Gemäldegalerie Alte Meister, Kassel, Germany, © Museumslandschaft Hessen Kassel/The Bridgeman Art Library: 217; © George Rodrigue: 275; Harris Museum and Art Gallery, Preston, Lancashire, UK/The Bridgeman

Art Library: 21; Hartlepool Museum Service, Cleveland, UK/The Bridgeman Art Library: 225; Henry Francis Dupont Winterthur Museum, Delaware, USA/The Bridgeman Art Library: 240; Hermitage, St. Petersburg, Russia/The Bridgeman Art Library: 148, 182–83, 192; Historiska Museet, Stockholm, Sweden/The Bridgeman Art Library: 47; House of Dionysus, Kato Paphos, Cyprus, Bildarchiv Steffens/The Bridgeman Art Library: 37; Indianapolis Museum of Art, USA, Eleanor Evans Stout and Margaret Stout Gibbs Memorial Fund/The Bridgeman Art Library: 53; Johnny van Haeften Gallery, London, UK/The Bridgeman Art Library: 107, 160–61, 171; Joslyn Museum, Omaha, Nebraska, USA, Alecto Historical Editions/ The Bridgeman Art Library: 232–33, 242; © Kate Leiper: by permission of the Red Dot Gallery, Holt, Norfolk: 12, 274; Kunsthalle, Mannheim, Germany, Interfoto/The Bridgeman Art Library: 252–53, 258; Kunsthistorisches Museum, Vienna, Austria/The Bridgeman Art Library: 87, 166, 168, 190, 216; © Leeds Museums and Galleries (City Art Gallery) UK/ The Bridgeman Art Library: 112; Library of Congress, Washington D.C., USA/The Bridgeman Art Library: 238; Louvre, Paris, France/The Bridgeman Art Library: 32; Louvre, Paris, France, Giraudon/The Bridgeman Art Library: 7, 185, 188, 202; Louvre, Paris, France, Lauros/Giraudon/The Bridgeman Art Library: 7;

Louvre, Paris, France, Peter Willi/The Bridgeman Art Library: 9, 74, 126, 215; The Metropolitan Museum of Art, Marquand Collection, Gift of Henry G. Marquand 1889. Image © The Metropolitan Museum of Art: 124; Monasterio de El Escorial, El Escorial, Spain, Giraudon/The Bridgeman Art Library: 88; Musée Barbier-Mueller, Geneva, Switzerland, Photo © Heini Schneebeli/ The Bridgeman Art Library: 11; Musée Claude Monet, Giverny, France, Giraudon/The Bridgeman Art Library: 60; Musée Condé, Chantilly, France, Giraudon/The Bridgeman Art Library: 17, 20, 165, 167, 193; Musée d'Art et d'Histoire, Geneva, Switzerland, Photo © Held Collection/The Bridgeman Art Library: 10, 66; Musée d'Art Moderne de la Ville de Paris, Paris, France, Lauros/ Giraudon/The Bridgeman Art Library: 210–211, 230; Musée de la Tapisserie, Bayeux, France, With special authorisation of the city of Bayeux/The Bridgeman Art Library: 26–27, 49; Musée de la Ville de Paris, Musée du Petit-Palais, France/The Bridgeman Art Library: 132; Musée de la Ville de Paris, Musée du Petit-Palais, France, Giraudon/The Bridgeman Art Library: 122; Musée de la Ville de Paris, Musée du Petit-Palais, France, Lauros/Giraudon/The Bridgeman Art Library: 114–115, 133; Musée des Beaux-Arts et d'Archéologie, Besançon, France, Lauros/Giraudon/The Bridgeman Art Library: 105; Musée des Beaux-Arts, Caen, France, Giraudon/The

For my father and Bill Ogden

Published by

Merrell Publishers Limited
81 Southwark Street
London SE1 0HX

merrellpublishers.com

First published 2008
Unabridged paperback compact edition first
published 2010

British Library Cataloguing-in-Publication Data:
Pickeral, Tamsin
The dog : 5000 years of the dog in art
1. Dogs in art
I. Title
704.9'4329772-dc22

ISBN 978-1-8589-4532-3

Produced by Merrell Publishers Limited
Layout by Jonny Burch
Original design by Nigel Soper
Copy-edited by Kirsty Seymour-Ure
Indexed by Vicki Robinson
Printed and bound in China

Front cover: Edwin Landseer, *Eos*, 1841
(see page 205)
Back cover, clockwise from top left:
The Euergides Painter, Detail of a Laconian
hound scratching its head, from an Attic red-
figure cup, *c.* 500 BC (see pages 12 and 35); Detail
of Giuseppe Velasco or Velasquez, *Joseph's Coat*,
1630 (see page 88); Elisabeth Frink, *Dog*, 1990
(see page 266); George Stubbs, *Ringwood, a
Brocklesby Foxhound*, 1792 (see page 174)

Page 1: Camille Bombois, *Bulldog, Thought to
Look like Winston Churchill*, n.d. (see page 263)
Page 2: Roman dog on a leash, from Pompeii,
1st century AD (see page 12)
Pages 4–5: Detail of Jean-Baptiste Greuze, *The
Souvenir (Fidelity)*, *c.* 1787–89 (see page 219)

I should like to offer my grateful thanks to all
those who have contributed to this publication,
in particular: John Hughes; Jami George;
Drusilla and Sam Stacy Waddy; Sue, Henry and
Lucinda Hawksley; Lady Joan Heath; Sarah
Kellam; Graham Hutt; Debbie and Ziggy
Symes; Rachel Hillier; Cindy and William
Ireland; Francesca Broomfield; Kate Leiper;
Ditz; Bill Jacklin; and George Underwood.
Thanks to Maddie, Lucy and Mousse for
inspiration. My thanks also go to the team at
Merrell Publishers, especially Julian Honer,
Lucy Smith, Nicola Bailey, Paul Shinn and
Nick Wheldon; and to Kirsty Seymour-Ure
and Nigel Soper.

Tamsin Pickeral